the CREATIVE EXPLOSION

Books by John E. Pfeiffer

THE HUMAN BRAIN

THE CHANGING UNIVERSE

FROM GALAXIES TO MAN

THE THINKING MACHINE

THE SEARCH FOR EARLY MAN

THE CELL

THE EMERGENCE OF MAN

THE EMERGENCE OF SOCIETY

THE CREATIVE EXPLOSION

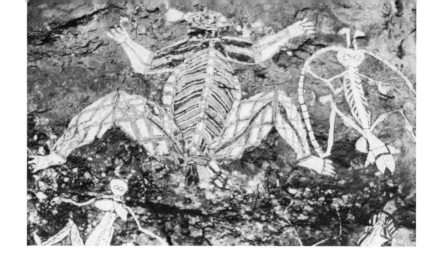

the CREATIVE

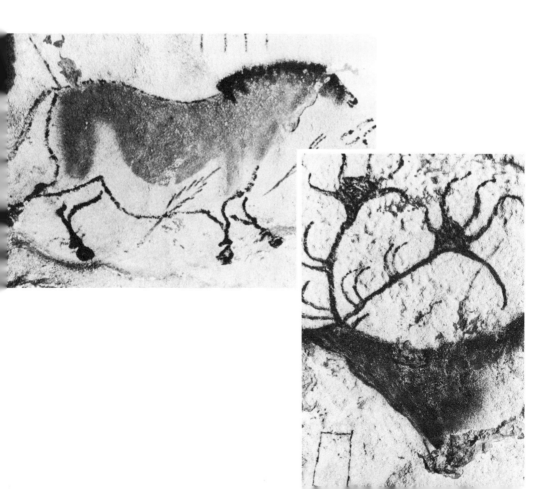

JOHN E. PFEIFFER

EXPLOSION

an inquiry into the origins of art and religion

CORNELL UNIVERSITY PRESS

ITHACA, NEW YORK

Cornell Paperbacks edition
first published 1985 by Cornell University Press.

International Standard Book Number 0-8014-9308-0
Library of Congress Catalog Card Number 84-72675
Printed in the United States of America

Text designed by Ruth Bornschlegel

To Tony, Ned, and Marga

Contents

Foreword *xiii*

1 Hidden Images *1*

2 The Discovery of Prehistoric Art *19*

3 An Industrial Revolution *40*

4 Hunter-Gatherers on the Move *53*

5 The First 10 Million Years *73*

6 Neanderthal Beginnings *88*

7 Special Places, Special Purposes *102*

8 The Information Explosion *119*

9 Surprise, Pattern, Illusion *132*

10 Living Hunter-Gatherers *153*

11 The Ceremonies of Times Past *174*

12 Pressure for Planning *191*

13 The Art of Memory *210*

14 Searching for Answers *226*

Notes *253*

Bibliography *263*

Index *265*

Illustrations

Major art developments during the Ice Age *xvii*

Caves and rock shelters in southwestern France *2–3*

Representative cave drawings of animals *4*

Maps of Lascaux, Altamira, and Niaux, indicating locations of art *6–7*

Rock sculpture, Le Fourneau du Diable, southwestern France *8*

Venus figurine from Willendorf, Austria *9*

Western Europe during the Upper Paleolithic *10*

Niaux bison partly covered by calcite *14*

Cave artists at work: a turn-of-the-century version *21*

Mammoth engraved on mammoth tusk *24*

The graceful Le Portel horse *28*

The legendary Robot, with two of the discoverers of Lascaux *29*

Lascaux visited shortly after its discovery more than forty years ago *29*

Lascaux "shaft of the dead man" *30*

Abbé Breuil drawings of Altamira bison *34*

Abbé Breuil drawings of polychrome reindeer from Font-de-Gaume, Dordogne *35*

The Rouffignac mammoth *37*

The Rouffignac rhinoceros *37*

Representative tool kits: Perigordian, Aurignacian, Solutrean, Magdalenian *43*

Upper Paleolithic toolmaking: producing blades from a flint core *44*

Neanderthal toolmaking: making Levallois flakes *45*

The art of archeological reconstruction *56–57*

Bison kill: Colorado Indian hunt 10,000 years ago *60*

Sungir grave, U.S.S.R.: close-up showing strings of ivory beads *66*

Sungir grave, U.S.S.R.: status burial with ivory spears *66*

Grottes des Enfants burial: clusters of perforated shells *67*

Australopithecine footprints: an African trail 3.6 to 3.8 million years old *78*

Remains of Lucy: a female Australopithecine *81*

Up the evolutionary scale: expansion of the brain *82*

Hand ax, found in Norfolk, England *84*

Statue commemorating the Neanderthals, Les Eyzies Museum *89*
Some Neanderthal tools *92*
Niaux: some of the figures in the Salon Noir *104*
Trois Frères: Bégouën brothers in the sanctuary they discovered; figure of the "sorcerer" *106*
Trois Frères: close-up of the "sorcerer" *108*
Trois Frères: Abbé Breuil's drawing of the "sorcerer" *108*
Tuc d'Audoubert: stalagmite crystal chamber *109*
Montespan: a stream running through it often floods it *112*
Nerja recess: figures found in the depths *129*
Nerja: Rotunda of the Red Fish, showing dolphins on stalagmite *130*
La Pileta: the flat fish *135*
La Pileta: the "pregnant" horse *135*
Commarque: horse's head *137*
Ambiguous fish, Mas d'Azil, France *138*
Purposeful strangeness: animal head, Mas d'Azil, France *138*
"Dachshund" horse, Ojo Guarena, Spain *139*
Distorted horse, Le Portel, France *139*
The human figure: distorted versions; naturalistic relief *140–141*
Signs, abstract forms *145*
Painted pebbles: Les Eysies "art" after the Magdalenians *150*
Hands and boomerangs: rock-art panel, Queensland, Australia *154*
Desert gorge: aboriginal rock art, Rawlinson Range, Australia *160*
Walbiri tribesmen, Western Desert, Australia *162*
Body painting for the corroboree, Northern Territory, Australia *164*
Animal dance, Northern Territory, Australia *165*
Spearthrower "map": decorations represent Gibson Desert, Australia *171*
Chest scars: marks of adult initiation ceremonies *171*
Trois Frères sanctuary: engravings including "sorcerer" *178*
Prehistoric percussion instruments? *181*
Mas d'Azil spearthrower *199*
Carved antler rods from southwestern France *201*
Venus figurine sites *203*
A place for ritual: Lion Chapel, Trois Frères *230*
Nerja: "draper" formation where signs are hidden *235*
Nerja: signs painted on limestone sheets *235*
Nerja: signs and a climbing hind *235*
Experimental Venus figurines *237*
Limestone lamp burning animal fat fuel *241*
Spray gun, prehistoric style *242–243*
Patterns in bone: stacked mammoth mandibles, Mezhirich, U.S.S.R. *245*
Drakensberg rock-art panel: puberty dance *249*

Color section follows page 142

1. LASCAUX: panoramic view of paintings in main hall
2. LASCAUX: close-up of part of main-hall panels
3. LASCAUX: horses
4. LASCAUX: "Chinese" horse
5. LASCAUX: three little horses
6. LASCAUX: horse
7. LASCAUX: the "unicorn"
8. LASCAUX: head of large black bull
9. LASCAUX: bull in outline
10. LASCAUX: group of small deer
11. LASCAUX: deer with elaborate antlers
12. TUC D'AUDOUBERT: clay bison sculptures in rotunda
13. PECH-MERLE: hand silhouettes and spotted horses
14. PECH-MERLE: red dots on ceiling
15. NIAUX: new gallery, on way to preserved footprints
16. ALTAMIRA: ceiling of Great Hall, with bison
17. Australian rock art, Northern Territory
18. Australian rock art, Northern Territory
19. Australian body painting, Western Desert
20. Australian rock art, Queensland
21. Kalahari rock art, Tsodillo Hills, Botswana: giraffes
22. Kalahari rock art, Tsodillo Hills, Botswana: human figures
23. Rock art of the Levant, eastern Spain: early-style bull

Foreword

▷ This book is an effort to account for the world's earliest known art in evolutionary terms, for the relatively sudden appearance some thirty millenniums ago of paintings and engravings on the walls of caves in France and Spain. It grew out of my association with the late François Bordes of the University of Bordeaux and André Leroi-Gourhan of the University of Paris, by slow stages, in conversations during and after excavations.

My first visit to Lascaux, including a climb down an iron ladder into the so-called shaft of the dead man, was with Bordes as guide. What came through along with the excitement of the cave and the magnificent paintings was his feeling for the people themselves. He respected them as fellow human beings, fellow workers engaged to the hilt in the business of living, doing what all of us would have had to do under similar conditions. A warmth of identification and involvement animated his research, his analysis of tools and tool kits, his focus on geological clues to ice-age climates. He conveyed the spirit as well as the substance of prehistory.

An awareness of planning in the caves, the amount of detail involved in the organization and placement of figures, comes as a surprise, and only after visiting and revisiting many caves. It came gradually to Leroi-Gourhan, when he began studying the art more than a generation ago. He expected something more personal, more individualistic, the works of artists concerned primarily with expressing themselves. Instead he found evidence for a tribal or collective phenomenon, a systematic use of space implying less improvisation and more established tradition. For him each cave was a "composition," and current studies tend increasingly to confirm his insights.

An important part of my own research was an intensive seven-week tour of more than 100 French and Spanish art sites. Seeing so much in so brief a period demanded tight schedules, some 7,000 miles of driving, mostly negotiating hairpin turns on mountain roads, special permissions, and meetings in out-of-the-way places. That everything worked out beautifully is due in large measure to Lawrence Straus of the University of New Mexico and Lya Dams of the Royal Belgian Society of Anthropology and Pre-

history, who not only made most of the advance arrangements but accompanied me on the first and second parts of the trip respectively, and helped make up for my language deficiencies by acting as interpreters.

I am also indebted to Robert Bégouën of Montesquieu-Avantès in the Pyrenees, who opened the gates to two of the grandest of all art caves, Trois Frères and Tuc d'Audoubert; also, to Jean Clottes, director of prehistoric research in the French Pyrenees, for opening other gates and providing basic information in the field and in subsequent correspondence.

The official custodians of the art, the guides who conduct visitors, laymen and experts alike, through passages leading to remote chambers, represent a rich and largely untapped source of information. They spend more time exploring the caves than anyone else, and know the locations of as yet unreported figures, many of which they themselves have discovered. Among the most committed of this group are Felipe Puente, whose regular beat is Monte Castillo, a honeycomb of underground galleries on the northern coast of Spain; Maria Louisa Quesada, in charge of the Buxu cave further to the west; and Christian and Claude Archambeau, Paulette Daubisse, and Jacques Marsal, all responsible for caves in southwestern France.

The following is a list of some of the investigators who shared their knowledge with me but are not mentioned in the text, mainly because space did not permit descriptions of their research or the sites with which they are associated: Claude Barrière of the University of Toulouse; Yves Coppens of the Museum of Man in Paris; Louis Duport of the Archeological and Historical Society of the Charente; James Fernandez of Princeton University; Jean Gaussen of Neuvic-sur-L'Isle; M.A. Garcia Guinea of the Museum of Archeology in Santander; James Moore of Queens College in New York; Aleth Plenier of the University of Toulouse; Jean-Philippe Rigaud of the University of Bordeaux; Carol Rivenq of the University of Toulouse; the late Romain Robert of Tarascon; J.A. Moure Romanillo of the University of Valladolid; Suzanne Sarradet of the Office of the Custodian of the Lascaux Cave in Périgueux; Christopher Stringer of the British Museum (Natural History); and Jean Vezian of Saubiac.

A grant from the Wenner-Gren Foundation for Anthropological Research made possible a preliminary trip to France and Spain to arrange my tour of art and living sites. The long haul, the tour itself, and the completion of my study and the book, was supported by a two-year grant from the Harry Frank Guggenheim Foundation. Writing is pressure enough, especially for a free-lancer, so I am doubly grateful to these institutions for helping to relieve financial pressures.

As far as background research is concerned, I drew heavily on the resources of libraries at Princeton University, Harvard University, the Wenner-Gren Foundation, the Marine Biological Laboratory in Woods

Hole, the Museum of Man in Paris, and the Institute of Archaeology in London.

Rita Chesterton did most of the typing and early checking. Special thanks go also to Buz Wyeth, Bonny Fetterman, and Terry Karten at Harper & Row, who encouraged me during the writing, and offered important editorial suggestions which came at the right time and which were followed to the letter. My wife, Naomi, read the manuscript thoroughly and also made important suggestions, also followed.

Major Art Developments During the Ice Age

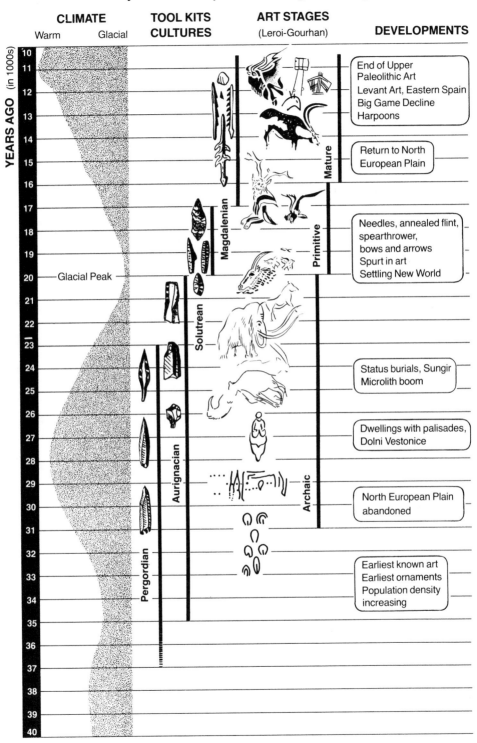

CLIMATE	TOOL KITS CULTURES	ART STAGES (Leroi-Gourhan)	DEVELOPMENTS

Warm Glacial

YEARS AGO (in 1000s)

Glacial Peak

Magdalenian

Solutrean

Aurignacian

Pergordian

Mature

Primitive

Archaic

End of Upper Paleolithic Art
Levant Art, Eastern Spain
Big Game Decline
Harpoons

Return to North European Plain

Needles, annealed flint, spearthrower, bows and arrows
Spurt in art
Settling New World

Status burials, Sungir
Microlith boom

Dwellings with palisades, Dolni Vestonice

North European Plain abandoned

Earliest known art
Earliest ornaments
Population density increasing

Hidden Images 1

▷ Prehistory has left no record more spectacular than the art in the main hall or rotunda of the Lascaux Cave in southern France. The way in leads through a metal door, down a flight of stairs, through another metal door, to the threshold of the hall. It is pitch dark inside, and then the lights are turned on. Without prelude, before the eye has a chance to become intellectual, to look at any single feature, you see it whole, painted in red and black and yellow, a burst of animals, a procession dominated by huge creatures with horns. The animals form two lines converging from left and right, seeming to stream into a funnel-mouth, toward and into a dark hole which marks the way into a deeper gallery.

After the initial shock of surprise, the experience begins breaking into fragments. There is time to examine the individual elements of the monumental frieze, a composition made up of some two dozen figures and parts of figures. It covers both sides of a wall that curves in front of you like a panoramic motion-picture screen, and includes an enigmatic animal which guides and investigators alike persist in calling the "unicorn," although it has two horns and resembles no species real or imagined, a row of solid black horses, a bull's head, several red horses, a group of small deer, and three giant bulls in black outline, one measuring 18 feet long, the largest known cave painting.

Lascaux is one of more than 200 caves in western Europe containing examples of the first prehistoric art, works dating back to the Upper Paleolithic or most recent phase of the Old Stone Age that began 30,000 years ago. About 90 percent of the sites are located in France and Spain, most of them concentrated in three regions: the Bay of Biscay coast of northern Spain, the foothills of the central Pyrenees and, the biggest cluster of all, within a 20-mile radius of the village of Les Eyzies in southwestern France. According to one estimate, some 10,000 to 15,000 paintings and engravings have been discovered to date, although a great deal depends on what one chooses to count and ignore, and the number might well be appreciably larger.

The figures are mainly animals, as might be expected of people living

1

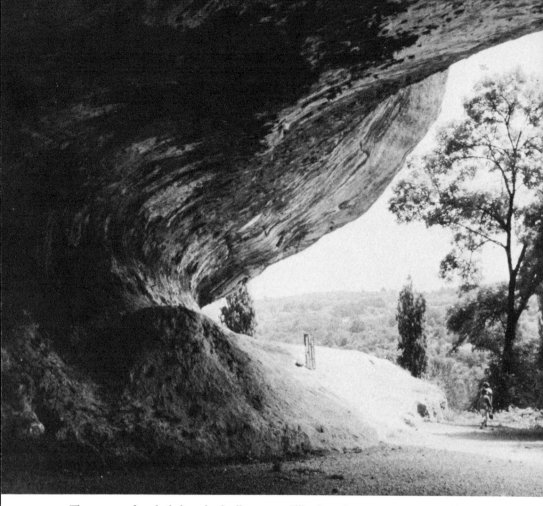

The caves and rock shelters in the limestone cliffs of southwestern France provided shelter and art sites for Upper Paleolithic people.

wilderness lives in a world utterly dominated by other animals. It is difficult for us, living in lands where the sight of a wild animal is becoming increasingly rare, to imagine the psychology of our ancestors, members of a minority species moving in small bands among herds numbering in the thousands or tens of thousands. Until recently, until the spread of agriculture and cities, we even ranked low among fellow primates as far as population is concerned. There were more orangutans than people on earth, some 30 to 60 million versus a mere 10 million, and in Africa baboons outnumbered our kind by more than fifty to one. Human beings rarely appear in cave-wall panels, and when they do, they are often, though not always, drawn crudely and strangely distorted. The prints of human hands are more common, one Pyrenean cave containing more than 200 of them.

Unrecognizable forms, many of them geometric patterns, appear among the animals and humans. Their names are legion—claviforms or

club-shaped, tectiforms or roof-shaped, scutiform or shield-shaped, tessel-
lated or checkered, bell-shaped, tree-shaped, quadrangular, rayed, barbed,
branched, serpentine scrawls known as meanders or "macaroni." Some are
so complicated that words fail. Some look like huts, corrals, traps, flying

Caves and rock shelters, southwestern France. *(French Cultural Services)*

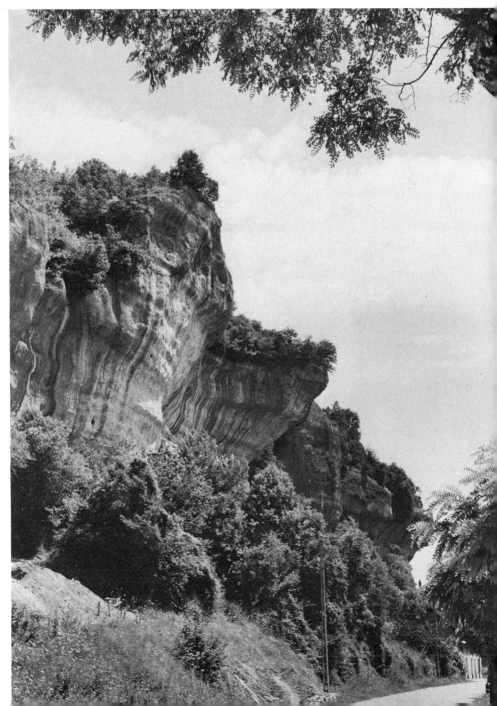

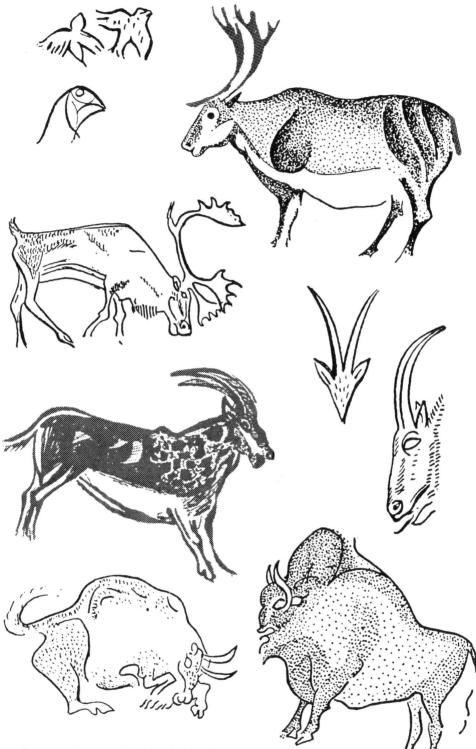

Representative cave drawings of animals.

objects, and have been interpreted as such. But in general trying to "read" these abstract signs or symbols is a futile game, vaguely reminiscent of Hamlet-Polonius dialogues concerning the shapes of clouds. We do not know what they mean, but we know they were full of meaning for the people of the Upper Paleolithic.

Nothing can substitute for experiencing the art first-hand, on the spot, in its underground settings. From the standpoint of adventure and physical challenge, the caves can be classified into three broad categories. First, the tourist caves offer easy, high wide passages, electric lighting, and paved stairs and paths, the sort you can walk into with shoes polished and clothes clean and pressed, and come out as well groomed as you went in. Then there are semitough caves where you can count on being splattered with mud, where dungarees, old shirts, and sneakers are recommended, since you must carry your own lamp and proceed along dark uneven passages, stooping and crawling and rarely standing upright.

Finally, the all-out horror caves are tackled only by fools, speleologists, and prehistoric-art devotees, or any combination thereof. These one enters wearing hard hats and mechanics' coveralls zipped over old clothes, deep-treaded boots, with nylon ropes and wire ladders to negotiate sheer walls, pits, and other assorted hazards. One should also be prepared to wriggle along through passages known as *chatières* or "cat holes," and to back all the way out if the passage happens to be a dead end.

No matter how many caves one has explored, no matter how magnificent or crude or abstract the figures, it always comes with a catch of the breath. It may be a bull or a bison drawn larger than life or an engraved horse no bigger than your little finger. It may appear high in a fissure or down close to the floor, on wide exposed surfaces for all to see or in private crawl-in places, painted in bare red or black outline or in rich polychrome, starkly grand or delicate in a low key—a variety of locations and styles, and yet all part of a single tradition that endured for some twenty millenniums.

Upper Paleolithic art includes a great deal more than paintings and engravings. Low-relief sculptures have been found on the walls of rock shelters and caves, near cave mouths; in many cases, the figures are on blocks, chunks of limestone that have fallen off the walls. But Angles-sur-Anglin, an unreported site at the foot of a cliff in a gorge some 150 miles south of Paris, contains part of a frieze on the grand scale. Covering an expanse of wall 10 to 12 feet high and more than 65-feet long, it features a beautifully carved horse looking back over its shoulder, a group of three women, a grazing horse, vulva signs, a niche enclosing a composition of three ibexes, and at least ten bison. Traces of color indicate that some of the figures may have been painted red with black eyes.

There is another kind of art, widespread and involving different tech-

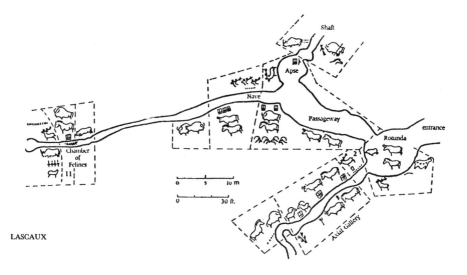

LASCAUX

Maps of Lascaux, Altamira, and Niaux, indicating locations of art.

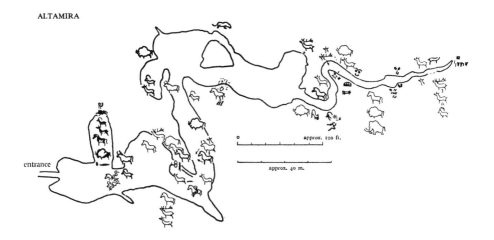

ALTAMIRA

niques, so-called portable or "mobiliary" art, objects generally small enough to hold in the hand and perhaps carry about—statuettes, figures engraved, carved, or painted on tools, limestone slabs or plaquettes, as well as on odd pieces of bone, antler, stone, and ivory. The most famous are highly stylized statuettes of women, Venus figurines found at a number of European sites and as far east as the Lake Baikal area of Siberia. I know of no official count of portable items, but they must number in the tens of thousands. Sites in a single province in the south of France have yielded about 2,500 duly recorded pieces, that is, pieces described in publications. But excavators have probably unearthed four or five times as many items, and tucked them away in private collections.

The art, however spectacular in its abundance and quality and underground settings, becomes all the more impressive viewed in the perspective of the remote past. Evolution before the Upper Paleolithic proceeded so slowly compared to the current human pace that one must look across spans of hundreds of thousands or millions of years to detect signs of notable change. Abysses of time separate the appearance of the first primates, among the survivors of a worldwide wave of extinctions which killed off the dinosaurs and half the forms of life on earth some 65 million years ago, from the first apes 30 million years ago and the first "hominids," representing the line which led to the human species, perhaps 6–10 million years ago.

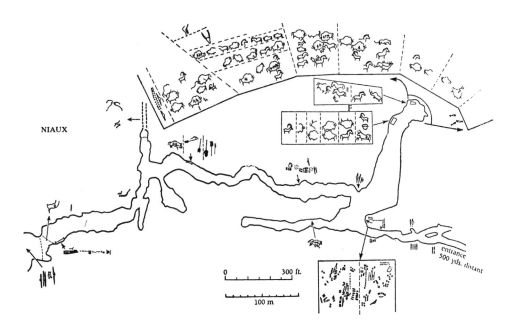

NIAUX

0 300 ft.

100 m

entrance
500 yds. distant

F

Early hominids, upright walkers big in tooth and jaw and small in brain and stature, rate as prehuman, not yet members of the genus *Homo*. They left no artifacts, no living sites, nothing but their bones, mainly teeth. At least 3 or 4 more million years passed before something besides fossils turns up in the record. The first stone tools are crude, unimpressive to look at, and often difficult to identify. But they mark a new need, the coming of a new complex of activities which we can only guess at. Our ancestors, previously living mainly on plant foods like other primates, may have been turning increasingly to meat, perhaps scavenging remains left by other predators, and using stone tools to dismember their victims.

Scavenging or kill sites, concentrations of stone and shattered fossils, appear along with the tools. Archeologists look long and hard at the evidence, sometimes spending hours and even entire days excavating an area no larger than the floor of a telephone booth, recording the features and precise positions of pieces of bone and stone and charcoal, noting changes in the color and texture of the soil, gathering samples of fossil pollen and

Rock sculpture, Le Fourneau du Diable, southwestern France.
(French Government Tourist Office)

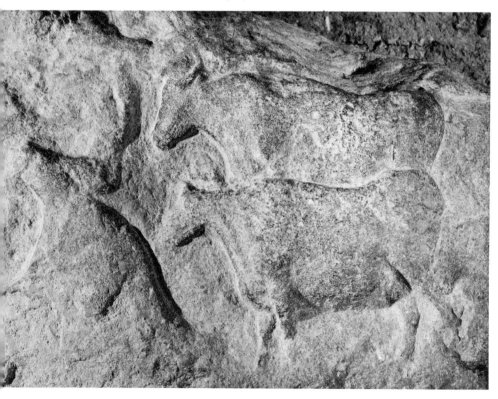

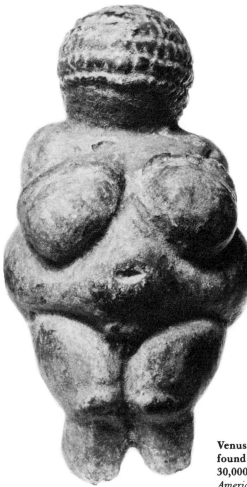

Venus figurine from Willendorf, Austria: found throughout Europe, starting about 30,000 years ago. *(Photograph courtesy the American Museum of Natural History)*

plant fragments. The search for changing patterns proceeds with increasing intensity, but unusual traces of human works are still few and far between—at the bottom of Tanzania's Olduvai Gorge, a rough semicircle of piled-up rocks which may be a windbreak or a hunting blind; ashes from the earliest known hearths in a cave near Peking; the remains of oval huts excavated on a French Riviera hillside site now covered by luxury apartments.

As far as the archeological record is concerned, the outstanding feature of the vast stretch of time from the first hominids to early *Homo sapiens* is that nothing much seems to have happened. Today things become out of date in a hurry, songs and fashions, slang and art styles, scientific theories and politics. There is a great deal to talk about, and often one generation has difficulty understanding what another is saying. But imaging suffering

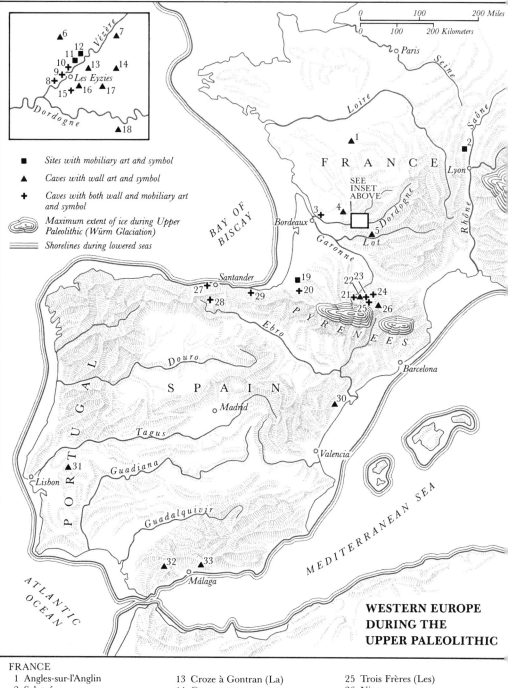

	
■	Sites with mobiliary art and symbol
▲	Caves with wall art and symbol
✛	Caves with both wall and mobiliary art and symbol
🗺	Maximum extent of ice during Upper Paleolithic (Würm Glaciation)
≡	Shorelines during lowered seas

WESTERN EUROPE DURING THE UPPER PALEOLITHIC

FRANCE
1 Angles-sur-l'Anglin
2 Solutré
3 Pair-Non-Pair
4 Gabillou (Le)
5 Pech-Merle
6 Rouffignac
7 Lascaux
8 Ferrassie (La)
9 Gorge d'Enfer (Abri Lartet)
10 Laugerie Basse, Laugerie Haute
11 Eyzies (Les)
12 Madeleine (La)

13 Croze à Gontran (La)
14 Commarque
15 Mouthe (La)
16 Font-de-Gaume
17 Bernifal
18 Cougnac
19 Duruthy
20 Isturitz
21 Gargas
22 Montespan
23 Tuc d'Audoubert (Le)
24 Mas d'Azil (Le)

25 Trois Frères (Les)
26 Niaux

SPAIN AND PORTUGAL
27 Altamira
28 Monte Castillo: Pasiega (La)
 Castillo (El)
29 Santimamiñe
30 Valtorta Gorge
31 Escoural
32 Pileta (La)
33 Nerja

from a lack of generation gap, in a static world in which people are living exactly by the same traditions and customs that prevailed 10,000 generations ago. That was the world of our ancestors. Their language was rather less complicated than ours; they had so little to talk about. Under such conditions, do not knock the weather as a topic of conversation. At least it changes and changes unpredictably.

A flicker of something really interesting turns up in sites dating back 100,000 years, give or take a few millenniums, to Neanderthal times. In western Europe, as in the rest of the world, people were still hunter-gatherers, still living in wildernesses on natural abundances of wild plants and wild animals; but something out of the ordinary was happening and we are not sure what. They were relying more and more on more efficient ways of making stone tools, ways of preparing flint cores beforehand to control the shape and thickness of struck-off flakes.

Also, the Neanderthals were burying their dead, placing tools in the graves and perhaps chunks of meat as if for use in an afterlife or spirit world. Bear skulls and ibex horns arranged in patterns around some graves suggest rituals. A cave in southern France contains the remains of at least half a dozen individuals, and may have been a family cemetery. Although the evidence does hint at faint stirrings of some sort, it is fragmentary and open to a number of conflicting interpretations.

There is nothing faint or uncertain, however, about the subsequent course of events, the phenomenon of the Upper Paleolithic. Art came with a bang as far as the archeological record is concerned. There is nothing to foreshadow its emergence, no sign of crude beginnings—which, by the way, does not necessarily mean that no one had ever drawn figures before. Indeed, it would be most surprising if that were the case. People had probably been making pictures in the sand and decorating wood, hides, and other perishable materials including their own bodies during earlier times, since some of the oldest known figures already show considerable sophistication.

But it was during the Upper Paleolithic that they began creating works that endured, and that poses problems of some complexity. We would like to know the reasons for this unprecedented outpouring of artistic endeavor. More specifically, we would like to arrive at tentative answers to three kinds of questions, questions of motive, questions of timing, and questions of location—why the art, why then, and why there? Art served many purposes at many levels, the deepest of which may well elude us. But not all its purposes are elusive; some are even relatively straightforward.

As far as motives are concerned, for example, one of them seems clear, at least on first examination. Among the limestone debris at or near mouths of some of the caves where people lived (not their art sites), in the shallower daylight and twilight zones where the sun still penetrates, colored

fragments have been found, parts of crumbled paintings like pieces from lost jigsaw-puzzle pictures. One fallen block has a red and black painted foot on it. The existence of open-air art at some home bases suggests that there were Upper Paleolithic families who, in common with their present-day counterparts, preferred decorated to bare walls, and took pains to make their living quarters more attractive. Some of their portable pieces may have served a similar purpose.

So a note of domesticity sounds across the ages, a message of a sort reassuring us that, for all the enormous differences in time and outlook and lifestyles, our remote ancestors included individuals who resembled us in at least one respect. They cared about appearances. It is not inconceivable that they discussed where to put the pictures and what figures and colors to use. Perhaps they even called on especially talented members of the group to do the decorating. We can identify with such people and such behavior, and that is all to the good.

But things tend to become considerably more complicated when one shifts from questions of motive to timing and locational questions. What brought about the use of art after hundreds of millenniums of unembellished and artless cave and open-air dwelling, and why in western Europe and apparently not as early in the rest of the world? Something must have happened to account for the difference, and it is a most significant difference. One wonders how society had changed, how people had changed. What new needs had to be satisfied, what new wants fulfilled? Were they more sensitive, more self-aware, more esthetic—and, above all, how could they have possibly benefited from such "impractical" behavior?

The problem becomes several orders of magnitude more complex when one considers the deep art: the art located in utter darkness, far from daylight and twilight zones and living places, on wide expanses of wall or doubly hidden inside tiny chambers, caves within caves, secrets within secrets. The purpose of this sort of art differed enormously from the purposes of the domestic variety. It suggests such things as intense rituals, ordeals, journeys underground for mystical reasons. The burst of art marked a burst of ceremony and, again, we wonder about its evolutionary payoffs, about the needs and wants it involved, about its selective and adaptive value. There is every reason to believe that individual artists benefited directly from their rare talents, that art would have withered if this had not been the case. But at the same time art also favored the advancement of the group, and the band and tribe.

The coming of art by itself would have been more than enough to distinguish the Upper Paleolithic, but a number of other major developments were under way during the same period. For one thing, a familiar newcomer appears for the first time in the fossil record, a new species. The

Neanderthals vanish without a trace, and their place is taken by the remains of modern-type individuals like ourselves, Cro-Magnon people and related breeds referred to collectively and somewhat euphemistically as "doubly wise," *Homo sapiens sapiens.*

New lifestyles appeared along with the new species. Changes were taking place across the board, in practically all areas of human endeavor. The Cro-Magnons made more tools and more kinds of tools than the Neanderthals, using a wider variety of raw materials more efficiently, exploiting a wider range of plants and animals. They seem to have been coming together in larger groups, perhaps for somewhat longer periods, a hint of full-scale settlements to come, and communicating with one another over greater distances. There are signs of a crumbling of age-old traditions. Things were happening faster than ever before.

All this marks the emergence of a new species—and, more significant than that, a brand-new kind of evolution. The human story began with the crossing long, long ago of a somewhat fuzzy borderline when something like an ape became something like a human being, an event which appears fateful in retrospect but which made no great splash at the time, leaving no outstanding traces in the record. It was followed by stretches of sheer monotony, almost-empty eons of gradual change. Biology was in control, the old-style organic evolution which works by the selection of random mutations, which dominated by an extravagant weeding-out process the development of all species, and which still dominates the development of all but the human species. Our ancestors were locked to their genes, in the grip of heredity.

The great release, the breaking away which is our uniqueness, came during the Upper Paleolithic. Furthermore, the release is not something remote that happened in times out of mind, in an interesting but essentially irrelevant past. From the standpoint of a human lifespan any change dating back 30,000 or more years must indeed seem like ancient history. But it is the blink of an eyelid ago on the evolutionary time scale. We are very young, an infant species just beginning to wonder and observe and explore. The process which gathered momentum among the Cro-Magnons continues to accelerate in our times. The same forces which drive us today drove our recent ancestors underground with paints, engraving tools, lamps, and notions about their place in the scheme of things. That is the basic reason for studying the art in its Upper Paleolithic context.

The figures are disappearing, however—and, ironically enough, time, our mortal enemy, is not the chief culprit. They might well be destroyed during the course of future ice ages and geological upheavals, but it is remarkable how much has endured so far, due largely to conditions deep inside caves where temperatures and humidities remain practically constant

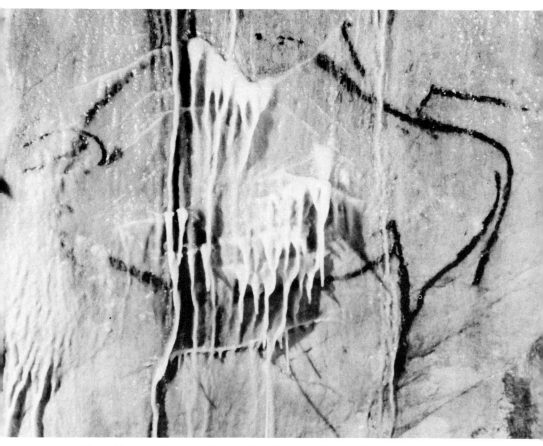

Niaux bison partly covered by calcite—layers of dissolved limestone. Many figures are completely obliterated. *(Jean Vertut)*

in all seasons. Unfortunately, commercialism and tourism can undo in a few years what nature has preserved for millenniums. Lascaux is a case in point. In one of the outstanding real-life adventure stories of childhood, it was discovered in 1940 by four boys searching for buried treasure.

Jacques Marsal, one of the original four and now the cave's official guardian-protector, tells how they were walking in the woods and came across a small hole in the ground where a tree had been uprooted during a storm. They proceeded to widen the hole, cutting away earth and undergrowth with penknives, dropping in rocks from time to time, and listening to the echoes fading away as the rocks bounced deeper and deeper into some sort of chamber. When the opening was big enough, they slid feetfirst down a rocky slope, their way lit by a homemade kerosene lamp brought along for just such a possibility (the region was well known for its caves), and landed in the main hall. Marsal has been associated with the cave ever since: "I never went back to school, and I'll never leave."

Lascaux went commercial in a hurry. The boys spent only about an hour in the cave on the day of discovery, September 12, because their lone lamp was beginning to sputter out. Next day, each equipped with a long-burning acetylene lamp and walking to the cave by separate routes so that no one would suspect that they were up to something special, they spent six hours taking it all in, making the most of their discovery. That was the end of their private adventure, the last time they had the cave and the secret of the cave to themselves.

Then the boys started charging admission, 40 centimes per head, children only, no adults of any sort, not even parents. On the third day, a Saturday, about fifteen visitors came; Sunday, the number jumped to fifty or so. Monday, Marsal and his companions told their first adult, their old retired schoolteacher, a member of the local prehistoric society who refused to come at first. "He wouldn't take us seriously. He thought that we were kidding him, that we were just children and nothing important could come from us." Curiosity overcame doubt, however, and he showed up Tuesday and was overwhelmed.

From this point on it was no longer a children-only proposition. Adults came in force—parents, archeologists, reporters, the general public. Some 300 visitors turned up on the last Sunday in September, at a price now inflated to 2 francs, and next day an agent of the Rochefoucauld family, the aristocrats who had owned the land for generations, demanded and received one half the boys' take. A week later the family took over Lascaux, and developed it into a highly lucrative tourist attraction, reaching a peak of about 125,000 visitors a year by the 1950s.

Problems arose not long afterward with the installation of electric lights and air conditioning, the sealing off of vents and fissures, and the draining off of water from standing pools. That made the cave more comfortable and cleaner, which was fine for the public but not for the art. The construction work apparently upset a delicate ecological balance that had preserved the vivid colors of the paintings for thousands of years. It caused changes in temperature, humidity, and circulation, somehow creating conditions ideal for the growth of microorganisms that had existed in the cave all along, but in limited numbers. Now they began multiplying at a faster and faster rate.

The first sign of trouble appeared during the summer of 1960: a tiny green patch growing on a red painting of a cow near the entrance to the side gallery, and identified by Pasteur Institute biologists as a colony of algae. The microscopic plants spread until there were some eighty patches by April 1963, at which time the cave was closed. The paintings have been saved. Various mixes of penicillin and other antibiotics stopped the algae dead in their tracks and later wiped them out, thus controlling the so-called

green disease, and the cave ecology has been restored to something approximating its original pre-tourism ecology.

Lascaux is closed for good now, as far as the general public is concerned, although qualified investigators may enter for limited periods with special permission, and other caves are sure to follow. But archeologists will have a fight on their hands. The pressure to keep the caves open is tremendous, and a number of cases are known of caves being kept open even after the art had deteriorated noticeably. Local authorities argue on economic grounds that it would be undemocratic to bar the public from viewing examples of their cultural heritage, and restricting entry to scholars and other elites.

Generally speaking, most archeologists agree with the principle of letting the public in, but not if that means destroying the prehistoric evidence. Perhaps the best compromise will be to do on a wider scale what has been planned at Lascaux. The idea is to create a new Lascaux in the same area, a man-made version dug underground as a replica of part of the original cave. On its walls, shaped in accordance with the original contours and illuminated by candlelight, will be beautifully executed copies of the friezes of converging animals in the main hall.

Speleologists, people dedicated to the exploration of caves, mainly on holidays and weekends, present another problem. Most of them are young, in it for the excitement and, like mountain climbers, they specialize in overcoming obstacles, the more hazardous the better. They frequently discover art in places where no one else would dare venture—in chambers at the top of perpendicular walls with no handholds or footholds, at the bottom of deep shafts, in chatieres so narrow that they must be widened with the aid of electric drills. Many of them appreciate the importance of the art as scientific evidence, cooperating fully with archeologists and taking special care not to brush against fragile decorated surfaces, and to preserve hearths and other features intact.

But turnover rates are high among speleologists. Experienced individuals often drop out after getting married because of their wives' persistent protests; novices do not always realize what they may be destroying and have to be educated from scratch. Furthermore, speleologists tend to regard the underworld as their private domain, and every barricade designed to protect the caves as a challenge to their formidable ingenuity. During a recent study I visited more than sixty art caves in France and Spain, and about a third of them had been broken into professionally, locks smashed, iron doors knocked off their hinges, and heavy steel bars bent back to allow ready access.

Collectors have done their share of damage. Otto Hauser, a Swiss excavator of the early 1900s, occupies a prominent place in the Rogue's Gal-

lery of archeology, Upper Paleolithic and earlier. One of his boldest and last projects involved the Abri de Poisson, a small rock shelter near Les Eyzies, noted for the figure of a salmon sculpted in low relief on the ceiling. Knowing he could make a lucrative sale to a museum in Berlin, he bought the shelter from a local fisherman, and was caught in the act of trying to cut the salmon out of the rock.

Most offenders never get caught, although their ranks have dwindled somewhat during the past few decades. The Hausers, for all their avarice and lack of scruples, are by no means the worst of the lot. Given the opportunity, they would gladly remove every painting and engraving from every cave. But at least they have some respect for the art and make every effort to handle it with care, if only for the cash it brings in—and of course this form of looting is sanctioned if not actively encouraged by some museum directors and private collectors, all in the good name of culture.

Worst of all, the hard-core destroyers, immune to education or conscience, are vandals who deliberately hack the art away with stones, hammers, and chisels, or scrawl their names and other graffiti over the figures. Christian Archambeau, overseer of all prehistoric sites in the Les Eyzies region, makes regular rounds and has on occasion apprehended vandals and seen to it that they were punished. But there are too many of them and too few of him, and his beat is too large for one person to patrol effectively. So greed, carelessness, and sheer malice add their effects to the slower ravages of time.

On the brighter side, a growing number of investigators are currently studying and helping to preserve the figures. Their work is the basis for many of the ideas in this book. The next five chapters include an account of the discovery of cave art, and the scandal it aroused, a disbelief too highly charged to be explained entirely on rational, scientific grounds. They also include a closer look at the work of the people who created and used the art. Adventure and appreciation are not enough. Going into the caves, however essential, is not enough either; studies confined exclusively to the art will get us nowhere. We must learn a great deal more about what else was happening even earlier among the Neanderthals, the most maligned of our prehistoric ancestors, and among their predecessors.

The notion of art for art's sake, of paintings and engravings executed by individuals concerned solely with expressing themselves, does not apply to the works found deep in prehistoric caves. Signs of intensive planning indicate the existence of collaboration among many individuals, the predominance of social purpose. The more one visits and revisits caves, the more time one devotes to studies of the placement of figures, the more evident the planning. The art becomes more accessible seen in the light of more mundane behavior, subsistence and other daily survival routines. Re-

search is expanding after a period of relative inactivity, and subsequent chapters present some examples of ongoing projects which promise to provide fresh insights. The list includes painstaking inventories, counts and descriptions of the paintings and engravings, maps showing the precise location of every figure, detailed analyses of individual figures viewed under magnifying lenses and by special photographic techniques, searches for more art, local and regional surveys, analyses of the works and purposes of present-day hunter-gathers.

The appearance of art is beginning to lose some of its mystery, but only some. There is more than enough left over for decades of investigation, as will be evident in the final chapters of the book. Whatever roles art may have played before the Upper Paleolithic—and for these the evidence simply does not exist—it became several orders of magnitude more important during that period. Art in the broadest sense evolved rapidly, and changed rapidly, in response to changes in the structure of society, Ultimately it became an essential aspect of prehistoric living, as essential as subsistence and reproduction for the survival of the human species.

The Discovery of Prehistoric Art 2

▷ The first person to recognize the cave paintings for what they were, the works of people who lived many thousands of years ago, rested his case on the art of Altamira, a cave located in the foothills of the Cantabrian Mountains of northern Spain—and died labeled as a charlatan. A century ago Don Marcelino de Sautuola, a Spanish nobleman and amateur archeologist, found himself holding views that conflicted with those of individuals who knew far more about times past than he did. He was ahead of his time, about a generation ahead. He saw something plain and clear, naively if you will, lacking the education to doubt himself or to appreciate the reasons for the doubts of the experts, to realize how startling his conclusion would be to them. So he ran headlong and innocently into a barrage of personal criticism severe even by the standards of a profession noted for such attacks.

In any case, his is one of the great tales in the annals of prehistory. He had dug near the entrance to Altamira on a number of occasions without noticing anything special, until one summer day in 1879 when, according to a story which has become legend, his daughter Maria, aged five, seven, or twelve depending on the storyteller, wandered into one of the cave's side chambers. Suddenly by the light of her lantern she saw paintings on the ceiling, large paintings of animals in vivid blacks and reds, pinks and browns, and ran out to tell her father.

Nothing had prepared Sautuola for the shock of such a discovery. He had explored that chamber, and thought he knew what was in it. He had been there several times before, stooping or crawling, since the chamber was only 3 to 5 feet high in most places, using his lantern to avoid bumping his head against rounded rocky protuberances on the ceiling. And yet he never noticed that there were paintings on those protuberances. They were covered with paintings. Artists had taken advantage of them some 15,000 years before to represent the bodies of animals in relief, to give a living, three-dimensional effect.

Archeological records include many cases of art overlooked. The eye never comes innocent to its subject. Everything seen is a blend of what

actually exists out there, the "real" object, and the viewer's expectations, upbringing, and current state òf mind. It is amazing what you can miss when you do not expect to see anything or, given a strong enough motive, what you can see that is not there. Unless the mind is properly adjusted or set, anticipating revelation of a particular sort, nothing happens. Things may remain invisible—like the figures at Altamira.

Actually, Sautuola had no real interest in the walls or ceilings of the cave. He was an excavator interested above all in what he could find at his feet, on the floor, such things as flint artifacts and bones and the remains of hearths. The low ceiling of the side chamber, now known as the Great Hall, was only a hazard to him, something to avoid. Bumping your head against rock is one of the dangers of exploring caves. Maria, being shorter, had rather less to fear on that score. Beyond that, she was too young to have acquired a bias against looking up rather than looking down.

Father and daughter spent the rest of the day, and many subsequent days, walking through the decorated galleries of Altamira. Theirs was the high excitement of being the first to experience the full impact of the totally unexpected. Finding a single polychrome painting in such a setting would have been enough of an adventure. Imagine the cumulative effect of moving from place to place, deeper and deeper into the galleries, and coming across figure after figure in a chain reaction of discovery. The experience was overwhelming even for visitors, entering a century later and knowing what to expect, having seen photographs and reproductions of the paintings in this cave and in many others.

The ceiling in the Great Hall is an undulating surface of hills, valleys, and "ripples" in rock, something like an upside-down relief map in three dimensions—and, from the large red and black bison immediately in the foreground to another bison nearby and on to other animals and shadow shapes further away, every contour used to the fullest extent by the artists of prehistory to enhance the feeling of full-bodied, living creatures.

The ceiling does not give the impression of angular, crystal-hard rock, but of something softer and flowing. It is not far away, perhaps 3 feet or so above your head, less in places, and as you move new forms come into sight, then pass behind you. In between the paintings you can see hanging down from the ceiling stalactites pale and gray-white like tiny buds, and hear the dripping of water in the dark. The more you look, the more you see: engravings among and in between and underneath the paintings, a deer's head, a small horse, enigmatic bar- or fern-shaped figures known as "rayed" tectiforms.

The paintings Sautuola and Maria saw on the vaulted ceiling were mostly bison, all of them big, from about 4 feet 6 inches to 6 feet long, in various positions: standing, walking, lying down with head turned looking

back, crouched and curled up, head raised and bellowing, and one drawn with no head. Also, painted over the body of a hind they saw a 5-foot horse, next to it a wild boar, and some distance away a controversial galloping boar which some investigators believe is actually a bison because it seems to have bison horns. The largest animal is a hind measuring more than 7 feet from muzzle to tail. In all, the 1,800-square-foot ceiling includes some twenty-five polychrome paintings, about twenty of them in good condition, perhaps three or four times as many faded or fragmentary paintings, and many many engravings.

A number of things must have been happening in the Great Hall. Artists came here time after time, redrawing parts of old figures and drawing new ones, often directly over the works of earlier artists. One area of

Cave artists at work: a turn-of-the-century version. *(Collection Musée de l'Homme, Paris)*

ceiling is an especially difficult, find-the-figures puzzle, a multidecker pigment sandwich. The uppermost figure, a small brown hind, was painted on top of a polychrome bison which, in turn, partly covers a larger red and yellow hind—and experts have made out traces of two still deeper animals for a total of at least five superimposed layers.

The discoverers saw all this and much more, fresh and clear, preserved over the millenniums in a constant-temperature, constant-humidity atmosphere. They must have spent a long time lying on their backs and looking up at a low section of ceiling which included two horses beautifully painted in red, four hands, a long-horned ibex drawn in outline, and numerous abstract signs. They were indeed fortunate. Many of the figures on this panel and others have since faded badly and the cave, like Lascaux, is now closed to tourists (although a replica of the Great Hall has been constructed in Madrid).

We do not know precisely how much Sautuola and Maria saw, how deeply they penetrated past the Great Hall, which is just one of the branches off the main gallery. This gallery extends nearly three football-field lengths deeper into the earth, zigging to the left, zagging to the right, and including many more figures—oxen, bison, and horses engraved and painted in black outline, two black ibexes at the back of a side chamber, a feline of some sort hidden in a niche, a tangle of lines traced with fingers on a clayey section of ceiling, and in the midst of the tangle the head of an ox.

After a stretch of walking and seeing nothing, one comes to a dark hole, the entrance to a tunnel, a long and narrow "tail" which gets narrower and lower the further in you go. In the beginning you can walk stooping only slightly, but soon you must go on hands and knees. This is the innermost gallery of Altamira. The way leads past animal figures, around a hairpin bend, past more animals, and then to the left looms one of the cave's most unusual features, a natural rock formation shaped something like the prow of a boat, with eyes painted on either side and a suggestion of a beard down below, forming what some investigators interpret as a human face or "mask" viewed head-on.

There is a similar figure nearby, also on the left wall and, directly opposite, a set of abstract quadrangular shapes with ladder-like and criss-cross patterns inside. The last part of the tunnel includes still another face, again on the left wall, and another set of abstract shapes opposite, as well as some ten deer and ibexes all clustered within an area about the size of a newspaper page. The tunnel dead-ends in a tight crawl-in space, and a final panel of black forms.

The discovery of Altamira, a deep cave filled with paintings widely publicized as the work of prehistoric artists, created a national sensation. It was a first, an event without precedent, and all Spain shared in the pride

and the excitement. Maria had her picture in the newspapers, and told her story over and over again to inquiring reporters. People began coming to view the figures, particularly the spectacular panels on the ceiling of the Great Hall. The most distinguished visitor of all came later in the year. The King of Spain, Alfonso XII, arrived in style with an entourage of servants holding candles to light his way, and saw everything there was to see, crawling into some of the lowest, narrowest galleries.

That marked a high point in Sautuola's life. From there, it was a downhill story. The public was impressed, but not most of the experts, who proceeded to demolish his ideas. The next year, 1880, brought scholars from all over the world to the International Congress of Anthropology and Prehistoric Archeology in Lisbon, where Juan Vilanova y Piera, a paleontologist at the University of Madrid, announced the Altamira discovery, pointing out, among other things, that the Great Hall had apparently not been entered since the time of the last ice age. His report was challenged by a prominent painter, who had also seen the art and argued as follows:

> There are perhaps twenty figures, some life-size, in profile, on the vault of the roof, attempting to imitate antediluvian quadrupeds. Their execution shows no signs of primitive art, especially the legs and hoofs, which are drawn with much mannerism, distorted with wide lines and disconnected, as they would not be being the work of a skilled artist. They have a facile roundness, though there is a certain awkwardness when their size is increased, due no doubt to the prints from which they were copied.
>
> This was not so, when a calf's head was drawn, it being a model the artist knew and remembered perfectly, and it is here that he chiefly gives himself away by his mannerism of suave distorted free lines, made, it seems, with a brush and smoke or bone black. . . . By their composition, strength of line and proportions, they show that their author was not uneducated; and, though he was not a Raphael, he must have studied Nature at least in pictures or well-made drawings, as is seen by the abandoned mannerism of their execution. Such paintings are simply the expression of a mediocre student of the modern school.

Note that this critic based his argument on stylistic grounds. There were other, more precise and more telling, objections. The paints looked as fresh as the day they were applied, and no one had experience of color remaining bright for anything approaching ice-age periods. Also, the animals must have been painted by the light of lamps or torches; yet the low ceilings showed no traces of soot or smoke-blackening. Another point. Looking back, it is easy enough to condemn people who did not know what we know today. Prehistoric painting was a phenomenon without precedent—and scientists, having learned the hard way that even the most plausibly presented case may be dead wrong, are trained to be skeptical.

On the other hand, Vilanova and many of his colleagues at the Congress knew that some solid evidence existed on the positive side. Prehistoric

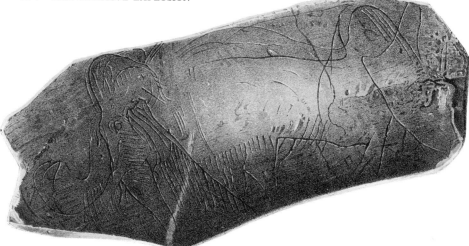

Mammoth engraved on mammoth tusk: one of the earliest recognized examples of prehistoric art. *(Copyright, British Museum, Natural History)*

art was nothing new, even in those days. It had been studied and accepted for some fifteen years, ever since deposits at the La Madeleine rock shelter in southern France had yielded a striking item of portable art, a 10-inch piece of mammoth-tusk ivory with a beautiful mammoth engraved on it, executed in fine clean-cut lines that could only have been produced on fresh bone. Since the mammoth has been extinct for a minimum of 10,000 years, it would be difficult to find more convincing proof that the work had been done at least that long ago.

To be sure, the find happened to be an engraving and not a painting. But it showed beyond a doubt that there were highly talented artists among people who lived during the Upper Paleolithic. As a matter of fact, the year before the Altamira discovery Sautuola himself had seen this very piece and many others like it at an exhibition in Paris. One reason he had no trouble accepting the antiquity of the cave paintings is that he immediately recognized similarities in style between them and the displayed engravings.

So Vilanova had every reason to expect serious consideration from his colleagues at the Congress, not complete on-the-spot acceptance, but at least curiosity and a readiness to come and see for themselves, which he invited them to do. But no Congress delegate bothered to visit Altamira. Even worse, and more difficult to explain, they discredited the entire report, pointing an accusing finger at an artist who was preparing copies of the cave paintings for a forthcoming publication, a friend of Sautuola who had stayed for a number of years as a guest at the Spanish nobleman's home.

The consensus seems to have been that the artist, presumably with

Sautuola's connivance, had sneaked into Altamira on numerous occasions with lamps and other accessories and done the paintings on the sly. In short, it was pure fraud. No official attempt was made to answer the obvious question of why two grown men would engage in such a dark, devious plot. But a widely believed rumor had it that they were conspirators acting in behalf of Spanish Jesuits, anti-evolutionists intent first on fooling students of prehistory and then on making them look ridiculous.

Skepticism, even disbelief, made a good deal of sense, all things considered. It is more difficult to account for the venom, at least on rational grounds. Part of the explanation may have involved matters of national pride and prejudice. French investigators, then as now, were preeminent in research on prehistory, and sometimes tended to look down with impatience on the work and ideas of other scholars, and not only on scholars from their neighbor across the Pyrenees. In their eyes, news of such a startling discovery would have been suspect under any circumstances, and was perhaps more so coming from an outsider.

Another factor—and this one has nothing to do with national pride— was probably the dying, and not still utterly dead, tendency to underrate our remote ancestors. A decade before Altamira, the Cro-Magnon rock shelter in Les Eyzies had yielded the remains of four or five individuals together with stone tools and other artifacts. We know now that these members of the so-called race of Cro-Magnon were modern-type humans equipped with brains as highly developed as ours and just as capable of artistic endeavor. A rather different image prevailed more than a century ago. It was inconceivable then that a species as advanced as ourselves could have origins so ancient, a vestige from a Bible-based bias to the effect that God created Adam some 6,000 years ago.

Any ancestor dated appreciably earlier than that could not have been fully human, and must represent something closer to apes or monkeys. So Cro-Magnon people were regarded as transitional beings, a combination of superior and inferior features, superior because of their large brains and high foreheads, but inferior because of a number of supposedly primitive skeletal traits. For example, an early report described Cro-Magnon legs and forearm bones as flattened and curved respectively in such a way as to signify "simian" affiliations, and the jaw as heavy and jutting, suggesting a savage, a member of "a violent and brutal race."

Given this strange creature, a science-fiction being, nineteenth-century investigators confronted a difficult situation as far as artistic abilities are concerned. Where to draw the line? What sort of art could one expect from such a savage, part human and part simian? They arrived at an intriguing majority decision: engraving, yes; painting, no. It seems to have been no great problem to imagine a talented Cro-Magnon man or woman taking a

flint tool and incising figures on pieces of bone, antler, or ivory. But people going deep into caves with lamps and prepared pigments and brushes and palettes of some sort—most specialists considered that too much to swallow. It was enough, however, to condemn Altamira as a deliberate fake, Vilanova as gullible at best, and Sautuola as a downright liar.

At the root of this blanket rejection was a persisting belief in special creation, or as much of the idea as could be salvaged in the face of increasing knowledge. Investigators, biologists as well as paleontologists and archeologists, tended to put the past as far behind them as possible on the principle that the greater the distance between themselves and all candidates for prehistoric ancestors the better. There was a general distrust of evolution, particularly human evolution and the notion of a descent from apes, a sentiment which lingers still. The consensus was on the side of the anonymous Victorian lady who commented: "Let us hope it is not true," adding a determined proviso just in case—"but if it is, let us pray that it will not become generally known."

Science advances, often slowly, as the weight of expert opinion is overbalanced by the weight of accumulating evidence to the contrary. Sautuola was vindicated, but by the time that happened he had been dead for fourteen years. What finally won the day was the discovery by the French of cave art in France. Actually, it was a series of discoveries, starting in the spring of 1895 when four boys met inside the recently cleared-out entrance to the cave of La Mouthe, at the edge of a meadow 2 miles from the Les Eyzies railroad station. One by one they crawled into a hole just big enough to worm through, kept crawling for more than 100 yards, and came out with news of an engraved figure seen by candlelight on the left-hand wall, a bison with great curving horns.

It was not long before archeologists came in to excavate the tight passage. Among them was Emile Cartailhac of the University of Toulouse, who had been a leader in discrediting Altamira at the Lisbon Congress—and who started having second thoughts about his verdict upon finding engraved figures on a section of wall which he himself had just exposed. He had in effect broken a seal, removing deposits laid down many millenniums ago. From that day on, resistance to accepting the cave art began crumbling. There were still mutterings about fakes and forgeries and gullibilities, but they had lost their sting.

The next year saw a report of engravings in another cave, Pair-non-Pair near Bordeaux, some 50 miles to the west and reputedly discovered after a cow fell through a hole in the ceiling. The owner of the cave, a winegrower and like Sautuola an interested amateur, had noted engraved lines on the walls more than a decade previously, and wondered whether they could be the work of prehistoric cave dwellers. Aware of what hap-

pened to the Spaniard, however, he kept his thoughts to himself. Now encouraged by the news from La Mouthe, he went back into his cave, washed off the walls with a pump-operated sprinkler used to spray insecticide on his vineyards, and found engravings of horses, deer, and other animals.

Three more art caves were reported in 1901, two just outside Les Eyzies and one in the Pyrenees. Doubters had their say as usual, attributing the engravings in one of the caves to artistic draft dodgers hiding out from Napoleon's recruiting sergeants, and the frescoes in another cave to archeologists in search of publicity. But the double discovery was enough to convince Cartailhac, and he said so publicly in an article entitled "Mea Culpa d'un Sceptique," which made his acceptance of cave art official.

Cartailhac revealed that he had been warned, and misled, by unnamed individuals who subscribed to the anti-evolutionary plot theory as far as the art in Altamira was concerned. He included an indirect apology to the deceased Sautuola and to Maria, qualified only by a comment to the effect that his original doubts had been justified in the light of what was known at the time: "I have been an accomplice to an error committed twenty years ago which I must confess to openly and rectify." His statement marked the end of the sheer-disbelief period and the beginning of a new phase in the appreciation of our Upper Paleolithic ancestors.

For the next half century or so, it was mainly a matter of taking stock, trying to keep up with a steady flow of discoveries, compiling inventories, and describing the cave art. Increasing acceptance drew attention to a number of earlier observations that had been ignored and now began to make sense. People had gone underground, come across figures and even written about them, but their experiences simply did not register. Their minds were not yet ready to grasp the significance of the images out there before their eyes.

Niaux, a Pyrenean cave with a concentration of figures in a huge chamber known as the Salon Noir, is a case in point. During the early 1800s a guide told local museum officials about horses and other animals drawn on the walls of the chamber. There was no follow-up, no sign that the news aroused anything but the most perfunctory response. Interest was still at a low ebb some fifty years later when an archeologist, no less, visited the Salon Noir, saw the same figures, and entered the following note in his diary: "There are some paintings on the wall. What on earth can they be?" No one took the question seriously, a high point in the annals of human incuriosity. So Niaux was not officially "discovered" until four years after Cartailhac's recantation.

The following decades brought reports of many more sites, the most spectacular of the lot being Lascaux. The cave gave a lift to the search for

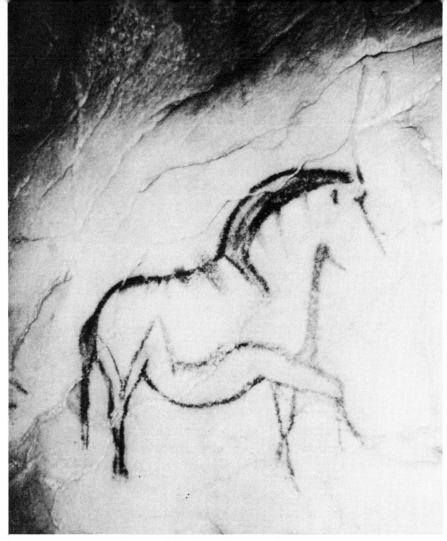

The graceful Le Portel horse. *(Jean Vertut)*

prehistoric art. Even with knowledge of Altamira and other sites, no one had ever expected a gallery of such outstanding paintings preserved in such beautiful condition—and discovered in such dramatic fashion. That story, by the way, was embellished a bit in the heat of the excitement. The version presented in most popular accounts, as well as in a widely used and otherwise reasonably accurate college text, has it that the boys were accompanied by a black-eared fox terrier answering to the name of Robot, which disappeared down the hole and led the boys to their find. In fact, there is actually a posed publicity picture of the dog being rescued. According to Marsal, however, there never was a dog. Reporters invented Robot for an extra touch of human interest, a fine example of gilding the lily.

Lascaux is almost unbelievably rich. It is not a large cave, consisting of a single main gallery about 110 yards long—as compared with miles and

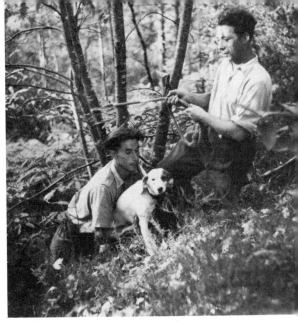

The legendary Robot, posing with two of the discoverers of Lascaux.

Lascaux visited shortly after its discovery more than forty years ago. The boys sitting in the foreground discovered it. *(Arlette Leroi-Gourhan)*

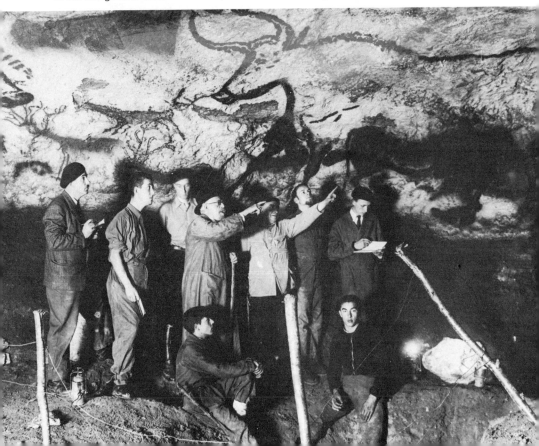

miles of passages for some of the really extensive cave systems—with a side gallery and side chamber. But an enormous amount of prehistory and art is crammed into it, over and above what exists in the main hall. The side gallery contains some sixty animal figures, among them a large leaping cow and, on an arched ceiling, a composition of three red cows and a "Chinese" horse, so named because of the delicacy of the drawing.

In some respects the side chamber tops all other parts of the cave for sheer remarkability. A high-vaulted complex of spaces and surfaces used for some especially important purpose, it is known as the "apse" and resembles a small chapel. A great deal has faded here. But the remains of a frieze of painted deer are still visible, including a wounded stag with large red antlers and black hooves, legs buckling as it collapses from the impact of a spear driven into its side.

There is a mystery scene at the back of the chamber. One passes through a narrow cleft to a 15-foot pit known as "the shaft of the dead man," the edge worn smooth and shiny indicating that many persons slid

Lascaux "shaft of the dead man." *(Institut Géographique National, France)*

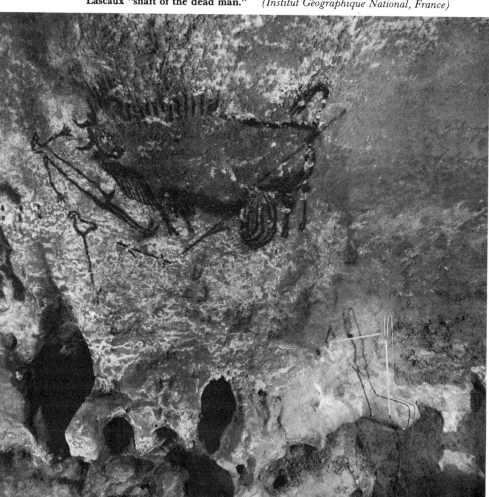

down during prehistoric times, probably with the aid of a rope. (Fragments of three-ply rope have been found in the cave.) Now the descent is by an iron ladder, and the scene is painted in black on a ledge at the bottom: a bison wounded in its hindquarters and attacking a stick-figure man with a bird's head and penis erect. The man is falling over backwards, and just below him to the left are a pole with a bird's head on top and a two-horned rhinoceros.

The scene has been called the most "suggestive" in the cave, but what it suggests is something else again. Among many interpretations, none of them provable or disprovable, that of the late François Bordes of the University of Bordeaux represents one of the most direct, and he offered it partly with tongue in cheek as a piece of science fiction: "Once upon a time a hunter who belonged to the bird totem was killed by a bison. One of his companions, a member of the rhinoceros totem, came into the cave and drew the scene of his friend's death—and of his revenge. The bison has spears or arrows in it and is disembowelled, probably by the horns of the rhinoceros."

The publicity involving these and other features and the prospect of more tourism put local people on the alert for more sites. A few months after the discovery of Lascaux, stonemasons repairing a collapsed wine-cellar wall in a village 40 miles away came upon a cave, joked about finding another prehistoric art gallery, lit matches, and saw the first engravings in a passage now known to house more than 220 engravings. Another cave was discovered partly through the good graces of a dowser using a plumb-line whose pendulum started swinging back and forth over various parts of a hillside, supposedly a sign of running water and possible caves. The list of sites has been growing ever since.

The major part of the task of authenticating, recording, and copying the art fell to a remarkable investigator who dominated the study of early art as completely and almost as long as Louis XIV dominated France. From the turn of the century until his death in 1961, the Abbé Henri Breuil, a Catholic priest, dedicated his life to "the land of dark caverns . . . and the harsh intoxicating silence of the painted rocks." Nothing could stop him en route to a new site. After long trips, often on muleback, into some of the most remote and rugged back-country regions of Europe, he would show up at a cave too excited at the prospect of plunging into underground galleries to think of catching up on sleep. Arrested as a spy in Portugal during World War I, he nevertheless arranged to continue his research under armed surveillance until officially cleared of all charges.

No one before or since has looked at cave walls as long and intensively as he did; only seasoned investigators can appreciate fully what Breuil achieved. Searching for art is a highly demanding business. Some figures

appear clear, impossible to miss, but the great majority are anything but obvious. They are drawn on surfaces of indescribable irregularity, jagged, curving convex and concave, mottled, covered in places by calcite flows, in a variety of textures. Natural rock-crystal colors (red and black and yellow and all in-between shades) as well as swirls of natural lines, cracks, and scratches, can easily be mistaken for the deliberate work—often faded and deteriorated—of prehistoric artists.

There is also the problem of what to look for in all this, which is partly a matter of scale. A vaguely analogous problem is trying to find the faces hidden in a puzzle-picture, the big difference being that in the puzzle you look within the frame of the picture and you know more or less the sizes of the faces. On a cave wall the figures may be half a dozen or more feet or only a few inches long, so that it becomes necessary to adjust and readjust one's field of view, in effect, to look large, medium, or small. Magnifying glasses are often called for, and strategically placed lights. Engravings can rarely be seen by direct light, which tends to kill the relief. They may become visible under light held at an angle, more often than not from below and to the left. The first clue is frequently the sight of a part of a figure, an eye or a muzzle or the curve of a hump, and then the figure suddenly appears in full detail.

The strain of looking must be taken into account. The eye and mind soon become exhausted, and for many persons fifteen minutes more or less seems to be about the limit for efficienct searching. No record exists of Breuil's limit, but if his energy in other respects is any clue, he probably could concentrate for somewhat longer periods. In any case, it is best to take frequent breaks. The imagination, always working overtime and particularly when stimulated by cave settings and the play of light and shadow, can play astonishing tricks. It is so easy to fool oneself, to see a face or a sign that somehow no one else can see.

One observer well versed in cave art and problems of depicting and finding figures was so carried away by his enthusiasm that he reported among natural cracks and hollows a series of extremely complex engravings and sculptures, some in high relief. Not only that, but several of his good friends, also by no means naive observers, saw the same things. Yet when archeologists who did not know him or them came to see for themselves, it was awkward. There was nothing there, absolutely nothing. Cases of self-hypnosis are not rare and must be guarded against. Cave-art experts, well aware of this occupational hazard, have a standard remedy—get out of the cave fast, and rest your eyes.

Overlooking what is actually there may be as much of a problem as seeing what is not there. On one occasion I spent the better part of an hour on an inch-by-inch inspection of a wall no bigger than a door, and saw

nothing. A colleague coming to look later, and we are constantly checking on one another, found right off what I had missed—a perfectly obvious horse 4 inches long, drawn in red outline about 2 feet below eye level. Such experiences are difficult to account for, more difficult than the false images of wishful thinking. A possible explanation is split-second lapses in attention as your eyes sweep across and past small irregular surfaces.

By the way, one's troubles are not entirely over once a figure has been identified beyond question. You had better map its position, preferably right away and precisely; otherwise, it may be difficult to relocate. There is at least one case of a "lost chord" engraving in a cave in southern Spain: the figure of a hind seen in a niche and never found again. One investigator found and photographed a figure in 1964, tried and failed to find it again early in 1979 after looking for more than an hour, and finally saw it right away a few months later.

Breuil had to contend with further complications. He often found himself trying to detect not a single figure placed on an otherwise empty surface, but numerous figures enmeshed in an incredible snarl of lines, a maze of animals and abstract forms superimposed, interlocking, and crammed together in all positions. He spent a month every summer for nine years copying "the frightful tangle of engravings" in an art-packed, bell-shaped chamber of the Trois Frères cave, located in the Pyrenees and named after the three brothers who discovered it on their father's estate back in 1914. On one astonishing panel of that chamber he managed to make out more than seventy animals and parts of animals.

During one of his visits to Altamira, Breuil painted eight hours a day for three weeks, doubled up in crawl-in spaces lit by candles, lying on sacks stuffed with ferns, making watercolor copies of the animals on the ceiling of the Great Hall. At the age of sixty-nine he negotiated a 200-foot chatière in a cave southeast of Paris, although he got stuck at one point and had to be pulled loose. From 1900 through 1956, he spent a total of more than 700 days in 73 caves.

Always a man of strong opinions and strong emotions, Breuil exploded upon occasion when others were foolhardy enough to try arguing with him. A colleague described such behavior in an obituary: "When he had pronounced about something, he had indeed pronounced, and nothing would make him change his mind. As he got older and perhaps less sure of touch in his intuitions . . . he did not become less pontifical and it became more personally difficult to disagree with him. He knew that in the past he had so often been right."

Breuil had problems at Rouffignac, for example, a maze of several levels and more than 5 miles of galleries in the Les Eyzies region. Speleologists and archeologists have explored it with a vengeance, sliding to the

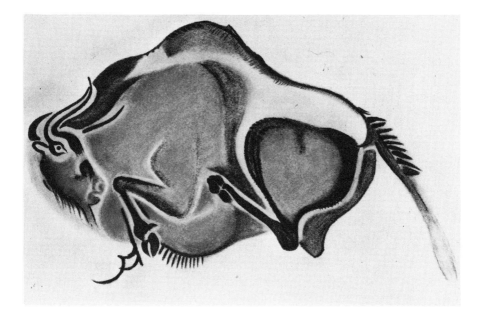

Abbé Breuil drawings of Altamira bison. *(Collection Musée de l'Homme, photograph by J. Oster)*

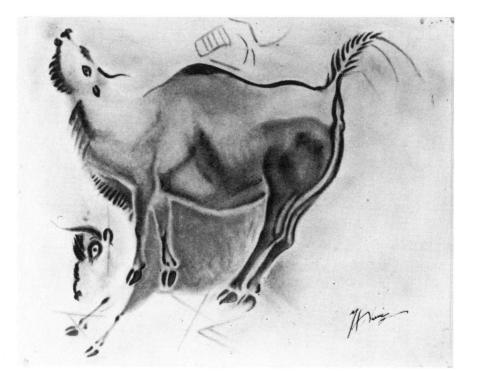

bottom of every pit and squeezing into the remotest dead-end passages and fissures. A lucrative tourist attraction, it has an electric railroad which runs nearly a mile past a host of drawings, including a frieze of two mammoth herds meeting, to a chamber whose ceiling is crammed with more than sixty animals painted in black.

The cave contains about 260 figures in all, more than 125 of them being mammoths (not all of which have been published). Another feature is a unique "serpentine" chamber. A number of other caves have panels of meandering lines drawn with fingers on clay, but usually there are animals among the scrawls or nearby. The ceiling of the serpentine chamber, all 1,600 square feet of it, is covered with such lines—and nothing else.

This supercave has aroused a supercontroversy involving the authenticity of its art, and of course Breuil played a leading role in the battle. (It was the last cave he ever visited.) Fakery is not unknown in the world of art, and the Upper Paleolithic has had its share. Sometimes it is done as a joke, sometimes out of malice, and sometimes for money. It would be difficult indeed to detect the work of modern forgers who engraved figures on bone or antler and then foisted the items on private collectors, but no one would be surprised to learn that many such cases exist. I have seen a number of imitation venus figurines, carved recently to study techniques used by prehistoric artists, that could easily have passed as the real thing.

Breuil had one encounter with a fake art cave before becoming involved in the Rouffignac affair. The site, located in the north of Spain, was discovered during the Spanish Civil War, and contains twelve bison, thirteen ibexes, and fifteen other animals, all drawn in the same style in black,

Abbé Breuil drawings of two polychrome reindeer from the cavern of Font-de-Gaume, Dordogne. *(Courtesy the American Museum of Natural History)*

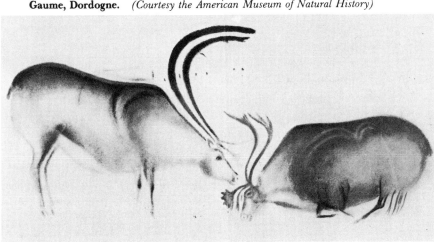

red, and brown. Going on the basis of photographs, Breuil was enthusiastic and accepted the paintings as genuine. Later, coming for a first-hand inspection, he had second thoughts about the figures: "They look modern and . . . their style is usually bad, and rather incoherent."

Rouffignac is a more complicated story. As far back as the sixteenth century, one explorer noted "a few altars and paintings" in the cave, which he described as a place "where our idolatrous fathers once went to sacrifice to Venus or the Infernal Gods." In 1947, a local speleologist had this to say in his dairy: "We're climbing back from the steep drop . . . a few paintings here and there, we can't judge whether they are prehistoric or not." To check, he consulted the head of prehistoric studies in the region, who came and saw and declared the paintings to be forgeries. That was that, until 1956 when two other scholars announced that the work was authentic beyond a doubt.

The same year a group of prehistorians, including Breuil and at least three archeologists who came in as skeptics and came out convinced, also opted for authenticity. Breuil expressed himself forcefully, as usual: "Only one man would have been capable of sketching those mammoths with such accuracy and realism, without omitting a single physiological detail, and that man—is I. However, I can assure you that I am not the one who did those frescoes." On the other hand, it was not a unanimous decision, and some investigators remained and remain overwhelmingly unimpressed.

It is always a difficult question, how to decide when experts disagree. But I am with the majority in this instance. For one thing, Hallam Movius of Harvard University pointed out a place where certain paintings have faded, precisely as one would expect from weathering, since they are located near a hole where the wind once came through, and the hole had been sealed tight for some time. Even more telling is the extent and distribution of the figures. Not long ago I spent nearly four hours in Rouffignac with head guide Louis Plassard and his son Jean, and could easily have spent twice as much time going into all the galleries with art in them.

They took me to many places hundreds of yards off the beaten track, like the pit with a hole at the bottom which descends another 60 feet deeper, and above the hole a small human face. They wanted me to see other places, but I had no time. It is hard for me to believe that forgers would have gone to the trouble of drawing so many figures in so many spots which no tourist and very few specialists would ever see. In any case, Breuil responded vehemently to one of his closest friends and associates, a British archeologist who suggested in the mildest of terms that perhaps there just might be room for doubt at Rouffignac. He never spoke to her again.

Such reactions are not rare in archeology, where the level of hurt feel-

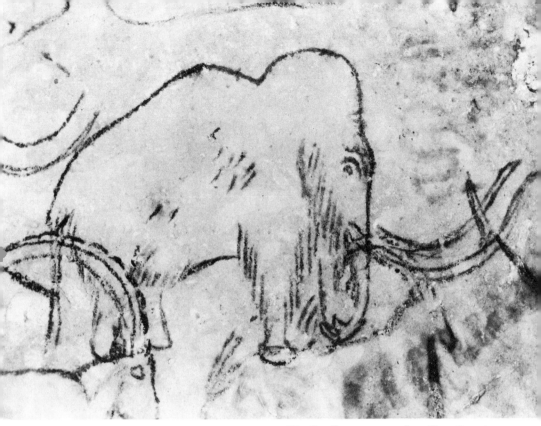

The Rouffignac mammoth. *(Jean Vertut)*

The Rouffignac rhinoceros. *(Jean Vertut)*

ings and bitterness seems to be considerably higher than it is in the biological and physical sciences. Often penetrating criticism, the life blood of science and scholarship, is offered and taken as a vicious personal insult, a direct attack on one's moral character, as if being wrong were a crime rather than the inevitable consequence of working hard and learning by experience. Backbiting among people concerned with prehistory is less common than it was. What remains is the mark of a field on the way to becoming a science, but not yet arrived.

The theme today, the thrust of current research, is pattern—a search for pattern more fundamental than anything attempted in the past—and the evidence is abundant and growing. Many of the most recent and most promising studies take off from ideas originally formulated by André Leroi-Gourhan, former director of the Musée de L'Homme in Paris and successor to Breuil as the most influential investigator of Upper Paleolithic art. He began visiting the caves in a systematic fashion more than a generation ago with one central purpose in mind, to place the paintings and engravings in some sort of chronological framework based primarily on sequences in the development of style.

Like all creative investigators, Leroi-Gourhan found a great deal more than he was looking for: "I did not find the cultural chaos I was expecting—works scattered over the walls in disorder by successive generations of hunters. Neither Lascaux nor Altamira struck me as a welter of epochs; rather, I was impressed by the unity each of the sets of figures embodies." Up to that point, until the late 1960s, the art had been appreciated almost exclusively as art, for its beauty and mystery. From here in, it will be more than appreciation. It will be appreciation plus analysis, and that means learning more and more about the extent of the unities, the patterns and plans, in the caves.

There is plenty to study. The number of known art sites has increased from some forty caves in the early 1920s to 70 or so about four decades later, and my estimate of more than 200 today is definitely on the conservative side. Furthermore, we can expect many more sites to be found during the years ahead. Large areas remain unexplored in southern and central Spain, and particularly in Portugal, which must have rather more than the single site reported to date. Discoveries continue to be made even in the Les Eyzies region, which has been searched and re-searched for more than a century. A list compiled by Archambeau includes half a dozen sites found during a recent two-year period.

Just for the record, there has also been a recent false alarm. It made headlines as the first art ever discovered in the British Isles, engravings of a bison and an unidentifiable two-horned animal in a cave near the southern border of Wales. Whether it was another one in a long series of cases of

sincere delusion, a fraudulent effort to obtain research funds, or a bit of both may never be determined beyond doubt. But half a dozen archeologists visited the cave within a few weeks of the announcement, and they found nothing.

In any event, genuine evidence is accumulating faster than we can keep up with it. There is so much to do by way of recording, mapping, and protecting the figures. Beyond that looms the massive job of analysis. The works in the caves were applied art, art being put to use for the first time on a large scale by people who were changing under pressure and who, ironically enough, were not primarily concerned with the art itself, but with creating a semblance of social order. That is why understanding their art involves, first of all, a close look at everyday life during the Upper Paleolithic.

3 *An Industrial Revolution*

▷ The odds are that gifted artists, then as now, made up only a small fraction of the population. They were probably specialists, among the first if not the first specialists in the human record. Then as now, they were probably sensitive and responsive to prehistoric winds of change, not in any remote sense as observers above the struggle, but actively involved in the accomplishments and uncertainties and tensions of their times. What moved them also moved their contemporaries. What they did in the beginning, what they were ultimately called upon to do, was all part of an effort to adapt to situations of unprecedented complexity.

The shift from organic to cultural evolution, human style, unleashed driving forces on a worldwide scale. We know the breakaway best from events that unfolded in one region, on an almost-island at the extreme western tip of the Eurasian continent. In terms of a rocket analogy, if Neanderthal times represented a period of imminence, the end of countdown, takeoff came 35,000 to 40,000 years ago with the Upper Paleolithic—slowly at first, especially going by twentieth century criteria, but fast and ever faster compared to the pace of earlier times.

Art appeared in times of upheaval. For one thing, there was a notable anatomical change in the humans of western Europe. From the beginning, members of the human family, like their primate relatives the anthropoid apes, had been robust, powerful creatures. The Neanderthals with their massive skulls and jaws, limb bones and muscles, were simply built along ancient established hominid lines. A new pattern, a new breed that broke sharply with the time-tried tradition of ruggedness, emerged during the Upper Paleolithic in the form of Cro-Magnon and related peoples. As indicated in Chapter 1, they were in effect moderns, like us in every essential respect, members in good standing of the species *Homo sapiens sapiens*.

Judging by sheer strength, the Cro-Magnons must be regarded as an evolutionary comedown. Their arm and leg bones were lightweight structures, with a relatively large-bore marrow channel running lengthwise down the center, while their immediate ancestors and all earlier hominids had more solid bones with smaller-bore marrow channels. Their jaws were

also lighter and less jutting, their brow ridges lighter and less prominent. In other words, they were weaklings compared to the Neanderthals, or, to put it in more complimentary anthropological jargon, they were more "gracile," which means "gracefully slender," beauty of course being in the eye of the beholder.

When it comes to comparative cerebral capacities, that is still an open question which will assume importance in a later chapter. In a sense, the issue seems to have been prejudged by the people who name species. "*Homo sapiens sapiens*" is a loaded term, conferring upon the Cro-Magnons the honor of that double epithet, while the Neanderthals rate only a single one in their official designation, "*Homo sapiens neanderthalensis.*" But no anatomical evidence exists to support the notion that modern-type humans had or have superior brains. Their foreheads are higher, less sloping, but not sufficiently to demonstrate markedly more developed frontal lobes.

If the double *sapiens* refers to behavior rather than anatomy, however, there are appreciable differences. Although the Cro-Magnons had to cope with winters as severe as those encountered by the Neanderthals, and during some periods even more severe, their gracile physique suggests that they were nevertheless leading less physical, less strenuous, lives. In many situations they presumably managed to substitute ingenuity for muscle, devising a variety of labor-saving devices and tactics. For example, if they had invented snowshoes or skis, a purely hypothetical point since the record includes no traces of such equipment, it would have been much easier to move about in deep snows, particularly the deep snows in forests which tend to be too soft to provide firm footing.

In any case the Neanderthals vanished, and no one knows what happened to speed their passing. Practically every possibility has been suggested at one time or another, and most possibilities are still entertained seriously by some investigators. The notion with the fewest advocates currently happens to be the one first forwarded during the last century—namely, that the Neanderthals were victims of prehistoric genocide, wiped out like the Tasmanians in historical times, by invaders with superior weapons and ideas of racial superiority. William Golding deals with this scenario in his classic reconstruction, *The Inheritors*. A less violent, less melodramatic, and more widely accepted view also includes newcomers who replaced the natives gradually, perhaps on occasion by killing or interbreeding, but mainly by being more fertile and reproducing more successfully.

There is further speculation about where the newcomers came from. In caves on the slopes of Mount Carmel near Haifa, Israel, investigators have unearthed an entire spectrum of specimens, ranging all the way from skulls with heavy brow ridges, jaws, and sloping foreheads to more gracile

forms approaching the double *sapiens* pattern. Such finds suggest that the Near East was a transitional region, where Neanderthals evolved into a modern-type species and migrated north to replace their recent ancestors in western Europe. An additional note is that these Near Easterners were themselves descended from still earlier moderns, who may have arisen some 60,000 to 80,000 years ago in southern Africa.

Finally, the changeover may have involved neither newcomers nor long-distance migrations. It may turn out that the transition from Neanderthal to modern-type humans took place within Europe itself. A number of sites in Yugoslavia and Czechoslovakia, for instance, have yielded skull specimens that appear to be intermediate between Neanderthals and Cro-Magnons on the gracility scale. Tooth size shows a similar trend, an extreme example being lower canines, which were reduced by nearly a third. This is actually a multi-origin or multi-transition theory, since it implies that modern peoples evolved independently in several regions, perhaps in southern Africa and Southeast Asia as well as Europe and the Near East. It also implies that major social forces were effecting changes on a worldwide basis, and roughly during the same period.

These forces, at work throughout the nearly twenty-five millenniums of the Upper Paleolithic, show up in the archeological record. If variety is the spice of life, then life was certainly becoming spicier. Innovation is the key word for this period—innovation expressed in many ways, but most directly in a spurt of industrial production, an unprecedented diversity of material objects. People were using new techniques to make more tools and more kinds of tools out of more materials, bone and ivory and antler as well as flint, than ever before. In France the period included four major tool kits, which were prominent during the following four subperiods:

1. *Perigordian*: From between 40,000 and 35,000 years ago to about 23,000 years ago, named after the southwest region which includes Les Eyzies.

2. *Aurignacian*: From about 35,000 to 20,000 years ago, named after the so-called type site where characteristic tools were discovered more than a century ago, a cave near the village of Aurignac in the Pyrenees.

3. *Solutrean*: From about 20,000 to 17,000 years ago, named after an open-air camp near the village of Solutré in east-central France.

4. *Magdalenian*: From about 17,000 to 10,000 or 11,000 years ago, named after the rich rock shelter of La Madeleine on a bend of the Vezère River near Les Eyzies.

The tool kits generally featured a special flintworking technique which may represent a refinement of the so-called Levallois technique (named after the Levallois-Perret site near Paris) used extensively by the Neander-

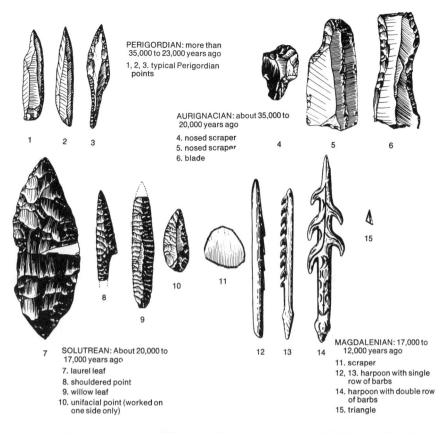

PERIGORDIAN: more than
35,000 to 23,000 years ago

1, 2, 3. typical Perigordian
points

AURIGNACIAN: about 35,000 to
20,000 years ago

4. nosed scraper
5. nosed scraper
6. blade

SOLUTREAN: About 20,000 to
17,000 years ago

7. laurel leaf
8. shouldered point
9. willow leaf
10. unifacial point (worked on
one side only)

MAGDALENIAN: 17,000 to
12,000 years ago

11. scraper
12, 13. harpoon with single
row of barbs
14. harpoon with double row
of barbs
15. triangle

Representative tool kits: Perigordian (1, 2, 3); Aurignacian (4, 5, 6); Solutrean (7, 8, 9, 10); Magdalenian (11, 12, 13, 14, 15).

thals. The first step in both cases was to select an appropriate chunk of flint and prepare it, not for the making of a single tool but for striking off a number of shaped flakes, each a blank for a separate tool. The Upper Paleolithic procedure involved the preliminary forming of a roughly cylindrical core, say 4 or so inches in diameter and 6 inches long, using one flattened end as a striking platform. A sharp blow, often delivered with a "soft" hammer of bone or antler rather than stone directed at a spot at the edge of the platform, produced a long, narrow, and thin sliver or blade of flint.

That was just the beginning of an ingenious peeling-off process. Another blow directed near the striking point used to detach the first blade produced a second blade—and successive blows continuing around the circumference of the striking platform produced further blades, one after the other, in a spiraling-in pattern as the core became smaller and smaller. The end product, in the words of John Witthoft of the University of Pennsylvania, was a series of "highly specialized long chips which have been split from cores as precisely as one might split shingles from a bolt of oak."

In all, the technique commonly resulted in forty to fifty blades, each a blank that would be worked into any one of a number of different tools. According to one estimate, making a Magdalenian knife required some 250 blows, more than twice the total required for a Neanderthal knife. The technique paid off handsomely, however, in terms of a notable increase in flintknapping efficiency, yielding about 40 feet of cutting edge per pound of flint as against the 40 inches yielded by the Levallois method.

The number of different tools also increased markedly, from the 60-odd items which made up Neanderthal kits to more than 130, and that

Upper Paleolithic toolmaking: producing blades from a flint core.

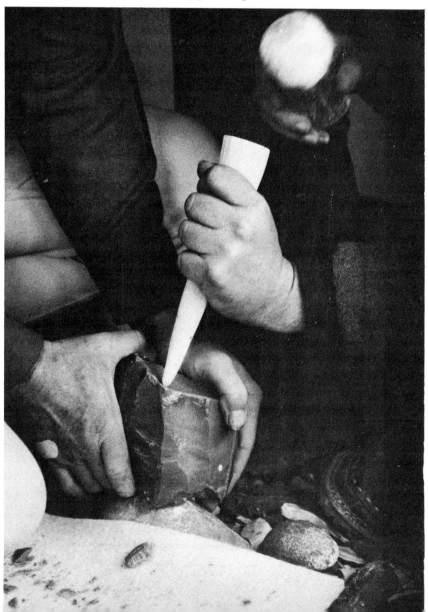

 edges of nodule trimmed

 top surface trimmed

 striking platform made

 flake struck from nucleus

finished tool

Neanderthal toolmaking: stages in making Levallois flakes, top and side views.

comparison tells only part of the story. Actually, no single site contains every tool in the list of possible tools. A typical figure for a Neanderthal site might be fifteen or so different kinds of tools, while the average Cro-Magnon site might contain forty to fifty kinds. Tasks involved longer sequences of operations, being broken down into a greater number of discrete steps, many of which required specially shaped tools. Seen in the context of changing lifestyles, the increasing complexity of technology suggests a corresponding increase in the complexity of social organization.

Of all the new special-purpose tools unearthed at Upper Paleolithic sites, the burin is perhaps the most representative, certainly the one produced in the widest variety and associated most frequently with innovative craftsmanship. It was designed for applying pressure concentrated at a point or across a narrow edge, for achieving variously shaped grooves, for carving, engraving, chiseling, and gouging—and ultimately served primarily in working bone, a new development in the use of tools to make tools. Rare and unimportant in Neanderthal tool kits, the burin is one of the most common items in many later assemblages, occurring in eighteen different forms, eighteen readily recognized and standardized "models," which implies a whole range of new operations.

Burins apparently came into their own with the large-scale production of tools made of bone, "bone" being a shorthand term applied somewhat loosely to include other hard organic materials such as ivory and antler. The Neanderthals had used bone upon occasion, but not to the fullest extent, not as a raw material in its own right. They treated it as if it were flint, knocking off flakes with hammerstones and generally turning out crude versions of hand axes, cleavers, and other stone tools. Upper Paleolithic people were more aware of the unique properties of bone which, being less brittle and softer than flint, could be worked more readily to produce a number of otherwise impractical implements.

One way of capitalizing on these properties involved using a burin to make two deep grooves side by side in a piece of bone or antler, and then working along the grooves to loosen a long sliver or splinter, a blank comparable to the long narrow flakes removed from flint cores. During Aurignacian times the splinters were shaped and polished into projectile points, tapering and narrow and rounded objects several inches long, designed to be mounted at the ends of spear or lance shafts. Superskilled craftsman could probably make such points out of flint, but it would take a long time, considerable patience, and many brittle failures.

Brittle failure would also defeat any effort to make, or use, needles fashioned out of flint. But Solutrean tool makers learned to turn out finely polished, sharp-pointed bone needles and eyes drilled with flint awls or perforators. The needles, by the way, mark the origin of "tailoring" as a regular practice, implying the invention of tightly sewn and fitted clothing. A high point in bone technology came 13,000 years ago during Magdalenian times: elaborately shaped harpoons, usually carved out of a single section of antler, often decorated, complete with rows of barbs at the sides. This is another item that would hardly make sense to attempt in flint.

Not that people neglected flint. In fact, finding examples of their imaginative use of this material can help relieve the often tedious process of excavating. Major developments in flint date back several hundred thou-

sand years to pre-Neanderthal workers who, in Bordes's words, "took out the basic patents in tool types.". He stresses that most of the Neanderthals were far more conservative: "During the first week of digging you are impressed with the number of fine scrapers they made. But after that, you see more and more scrapers, all the same, always fashioned according to the same tradition, and you get tired of them. These people made beautiful things stupidly! It can be very boring! Upper Paleolithic flintknappers, and some of the last of the Neanderthals as well, made many interesting, off-beat tools which are difficult to classify. They experimented a great deal, and their experiments worked."

Another item that appeared very rarely in Neanderthal times but more often later on is the combination, two-in-one tool. It makes up two or three to ten out of every hundred tools in some Magdalenian assemblages, chiefly blades with a burin at one end and a scraper at the other. The Solutrean tool kit contained a number of unusual tools. It not only included the first eyed needles, but also small "laurel-leaf" blades, striking examples of virtuoso craftmanship made by precisely controlled pressure flaking along the edges, removing small chips with a wooden or bone tool placed hard against the flint and pushed forward sharply (possibly another Solutrean innovation). A number of laurel leaves were more than a foot long and only about a quarter of an inch thick, far too thin to serve as an effective knife or point, suggesting some sort of luxury or ritual use.

At the other end of the size scale, considerable flintknapping finesse went into the making of microliths, tools so small that they may be extremely difficult to find. As a rule, how many you find depends largely on your methods of excavating. The practice half a century or more ago was simply to rely on the sharp eyes of experienced workers who, for all their conscientious watching, threw most microliths away with the back dirt, mistaking them for chipping debris or, more often, failing to see them at all. One French site first dug years ago by such methods yielded an assemblage of tools consisting of 4 percent microliths. Investigators returning more recently to the same part of the site excavated similar deposits, this time sifting their dirt through fine-mesh screens, and reported 49 percent microliths. Still later, after still more efficient sifting, conducted under water to wash away all clinging dirt, the proportion jumped to 79 percent.

These tools had a long prehistory. They were used more and more frequently in a definite trend toward increased miniaturization, starting in France more than 25,000 years ago. The increase took place gradually until early Magdalenian times, some ten millenniums later, which saw what Bordes calls "an explosion of microliths," many of them beautifully worked, with delicate trimming and retouching that can best be appreciated only when viewed through a magnifying lens. Collections include finger-

nail-sized end scrapers as well as star-shaped multipointed borers, knifelike bladelets and bladelets notched with saw teeth on both sides, triangular, trapezoidal, and rectangular bladelets—some items measuring less than ¾ inch long, about half as long as a paper match.

The microlith boom points to a boom in the art of hafting. Although you can do effective work with some of the tiny tools by gripping them with your fingers, especially with bladelets backed or blunted along one edge for holding, many of them were apparently designed to be inserted into grooved or slotted wood and bone handles, and set firmly in place with a resin cement. Mark Newcomer of the Institute of Archaeology in London, who has experimented with such cements—as well as practically everything else prehistoric from the making and use of harpoons, arrows, and other flint and bone tools to the techniques of the cave painters—reports that a mixture of pine resin and ochre makes a fine glue, and was probably used during the late Upper Paleolithic.

The increasing popularity of hafting calls for explanation. It certainly slows down tool making. A reasonably skilled flintknapper can make a burin or backed bladelet from an appropriate blank in thirty seconds or so, but he may spend more than an hour preparing a handle. Furthermore, Newcomer has learned from first-hand experience that the tendency with a handle is to bear down extra hard on whatever material you happen to be working, which appreciably increases the chances of the blade snapping in two. Then of course the broken piece must be removed and replaced. All in all, life was simpler, more spontaneous, in the good old days, in Neanderthal times and earlier, when people generally made tools for immediate use and discarded them when the work was done.

With so many things going against hafting, why did people bother? Economy is one possible reason. It may have been a way of making the most of the available flint supply, obtaining every possible extra inch of cutting edge. You can make a good knife even with only a fragment of flint. Also, a tool with a handle is more difficult to lose than one without. In any event, hafting had one effect which probably turned out to be as important as economy in the long run, an effect which no one could have foreseen.

Newcomer suggests that it resulted in a changing attitude toward tools: "Having put the extra effort into a tool, you become literally more conservative. The handle represents an investment, acquiring a special value as something long-lived that you want to keep." Hunter-gatherers who are frequently on the move generally travel light. They tend to keep the number of their possessions at a minimum, but the list seems to have been on the increase. Tools with handles readily acquired the aspects of private property.

Flint was the iron and steel of those days, the major all-purpose mate-

rial. But it varied widely in quality, and people often traveled for miles to exploit favorite quarry sites. Eventually they learned that they did not always have to accept the material readymade in its natural state, that they could improve its qualities deliberately. A kind of stiff liquid made up of interlocking silica microcrystals, flint can be modified by the treatment known as annealing, heating followed by slow cooling. This relieves or relaxes internal strains built into the crystal structure, producing a softer, more elastic substance, which can be trimmed and shaped with less applied pressure. Some flint deposits, including a number of the favored quarries, may have been annealed by nature—struck by lightning, exposed to forest fires, or covered with lava.

Evidence for early human annealing stems from the pioneer research of the late Don Crabtree at the Idaho State University Museum, another expert stoneworker of the twentieth century. During the 1930s he noticed that native flint picked up at local quarries used by American Indians had a dull luster and was difficult to work, while flint-debris flakes of the same material found at nearby living sites were greasy and shiny, often pinkish instead of gray, and easy to work. At first he managed to produce the same transformation by burying specimens of the unworked quarry material in sand and heating them with a bunsen burner. Later, using a ceramic kiln, he tested a wide variety of procedures, raising specimens to temperatures of 400 to 1100 degrees Fahrenheit, holding temperatures at various levels for hours or days, trying various cooling rates. He found that there is no single best heat treatment. Different sizes and types of flint require different annealing schedules.

Crabtree's studies indicate that prehistoric people must have accumulated an enormous amount of information by similar trial-and-error measures before mastering the basic techniques—and learning when to apply the techniques, because only certain flints are improved by annealing. We do not know how they first became aware of the practical possibilities, perhaps from observing chunks of flint dropped by accident into the embers and ashes of campfires. They may have developed primitive kilns in the form of special firing pits, although these features have yet to be identified. One would look for their firing pits in sites occupied during Solutrean or somewhat earlier times, because that is when the first heat-treated tools appeared. As a matter of fact, some suspected heat-treatment pits have turned up in southern France and the Great Plains of the United States.

Considering the talents of our recent ancestors in experimental testing and design, the odds are that they discovered ingenious ways of improving the working qualities of wood and bone as well as flint. For example, Newcomer has found that antler soaked in water for a few hours or days becomes "soft, flexible and easy to cut, chop, saw or drill." It has another

valuable property. If you straighten a piece of wet antler or bend it into a new shape, it will hold that shape permanently upon drying.

One of the most significant applications of tool-making knowledge involved inventions which extended, amplified, the power of human muscle. *The Hunters,* a motion picture made some years ago in the Kalahari of southern Africa, a semidesert region as large as France, shows a group of Bushmen closing in on a giraffe, throwing spears with all their might from distances of less than 10 to 15 feet, and achieving little for their effort. Most of the spears bounced off their thick-skinned prey; a few penetrated deep enough to stick but not deep enough to cause serious wounds. The giraffe finally toppled over dead, but not because of these puny weapons. It had been hit many hours before with a poisoned arrow.

The Bushmen would have done better with the benefit of a spearthrower, another device that first appeared in quantity during Solutrean times. Generally about 2 feet long and made of wood or antler, it had a barb at one end which hooks into the butt end of a spear shaft. Held over the shoulder with shaft in place and snapped forward by a sharp jerk of the wrist, it imparted considerable extra force to the spear, producing a swift flight and flat trajectory. Using a spear alone, it is rarely possible to kill a large animal unless you are close enough and fast enough to make repeated thrusts. Equipped with spearthrowers, Australian aborigines today can hit a target, say a kangaroo, three out of four times from more than 100 feet away, and kill from 30 to 50 feet.

The bow and arrow was something else again, another world when it came to advanced design and hunting efficiency. It may have come into its own with longer seasonal camping, when local game may have been scarcer and more difficult to hunt. Not only did it provide greater range and power, but it also increased the possibility of stealth and surprise. To hurl a spear you must spring out of your hiding place, move forward, and swing your arms and shoulders to achieve maximum momentum. With a bow and arrow you can stay put, practically motionless, shooting from your stationary, concealed position. This considerably raises the odds favoring a successful ambush, especially since it can all be done silently and invisibly, and you can take a second or third shot if you miss the first time.

There is some question about who invented this weapon. The earliest known bows date back some 8,000 years to a site in Denmark, but direct proof of arrows is more ancient. A pair of shafts has been preserved in 10,000-year-old water-logged deposits, also in Denmark, with tanged arrowheads still in place; and, perhaps two millenniums older in northern Germany, a cache of some 100 pine shafts was found, most of them slotted for arrowhead insertion at one end and notched at the other with a bowstring groove. But a cave in southeastern Spain, a Solutrean site, of course,

has yielded a collection of flint points which if mixed in with a collection of American Indian points known to be arrowheads would be accepted without question as the real thing. So it would surprise no one if future evidence shows that the bow and arrow is 17,000 years old.

The invention of power-amplifying devices represented an industrial revolution, and one of the most important signs of the cultural explosion. It was the beginning of a new coming of age, a pulling away from our fellow species. Other animals use tools, the readymade variety. Certain finches dig insects out of bark with the aid of thorns held in their beaks, and sea otters break open shellfish with rocks. But only apes have been observed actually making tools in the sense of modifying a natural object to suit their purpose. Chimpanzees break selected stems and stalks to a convenient length, trim off side shoots and leaves, insert the probes into termite-mound holes, and extract abundant supplies of the insects, one of their favorite foods. They have also been observed putting palm nuts on flat stones for anvils and using favorite stones as hammers to break the nuts open.

Tool making at this level takes place routinely in the wild. In a laboratory setting, with the prospect of appropriate rewards, it can go even further, as in the case of an inhabitant of the zoo in Bristol, England, a male orangutan named Abang. Abang was confronted with a large nodule of flint, a 3-pound hammerstone, and a smashproof container of fruit which could be opened in one way only, by cutting a nylon cord. Eventually he learned to use a tool to make another tool, knocking a sharp flake off the nodule and cutting the cord with it, a feat that required about fifteen minutes in a performance for an audience of British television viewers.

That seems to be pushing things rather close to the limit for apes. We do not expect them, however intelligent or painstakingly trained, to strive for and attain symmetry in a tool, prepare selected stones in advance, and strike off blanks for further working, nor to be guided by a series of mental templates or images in turning out a kit of standardized, specialized tools. Yet all this was accomplished by Neanderthals, and surpassed during later times, which brought tools in greater abundance and variety with a stress on exploiting a variety of materials, and a new level in the control and release of energy. Locking up energy in the curve, the spring, of a bow and a taut bowstring and translating it into an arrow's humming flight marks something radically different from what had gone before, a quantum leap in concept and technology.

Such developments played a role in making life less physical, and somewhat less dangerous. They were part of a continuing general trend which started much earlier, accounting for the transition from the Neanderthal to the Upper Paleolithic body build, and reducing the requirements for bones and muscles considerably more massive than ours. We have an

image, mainly intuitive, of Neanderthal hunters having to come in for the kill, near enough to attack with spear and lance and club, jabbing and thrusting and risking severe injury, often in direct physical contact with an animal fighting back for its life.

Presumably close encounters of this kind were rarer during Cro-Magnon times. Bows and arrows, and to a lesser extent spearthrowers, are action-at-a-distance weapons, and as the killing distances increased, so did a less tangible distance, the gap between human beings and the rest of the animal kingdom. A minority species was now on the make with a vengeance—just beginning, for better or worse, to upset the natural balance of things. Probably most people took life as it came. Only a few had a real sense of power already at hand, and a premonition of more power to come.

The swift pace of technological advance was a foreshadowing. The multiplication of tools, tool types, tool materials, and tool-making techniques, and especially the notable increase in the standardization of tools, represents a major quantum leap in human evolution. The trend can be seen in "sets" made up of different kinds of burins, scrapers, and other items. It hints at wider level agreement or conformity, the possibility that people were in closer and closer contact with one another, sharing information and doing things in the same way.

A further observation is even more intriguing, because it indicates that a strong opposing trend was under way at the same time. Standardization seems to have been restricted to relatively limited areas. Within these areas, tools tended to be shaped according to distinctive local designs. On the other hand, definite tool-kit differences existed between areas. In other words, tool-making diversity decreased locally and increased regionally. The pattern is significant, suggesting a shift from the lifestyles of small hunter-gatherer bands to something rather more complicated, larger and closer-knit groups, sharper differences between groups, the rise of new unities and a new restlessness.

Hunter-Gatherers on the Move 4

▷ The human tide was coming in everywhere. It spread into every cor-
ner, every ecological niche, of the earth, spilling across deserts and rivers
and continental divides, across narrow ocean passages. People advanced in
waves, no more than a dozen miles or so every generation, establishing
successive frontier camping sites in valley after valley. The same period
which saw the vanishing of the Neanderthals in western Europe, the emer-
gence of their successors with new tools and tool-making techniques and
portable and cave art, also saw migrations into places where no human
being had ever been before.

One of the great voyages of times past started somewhere off the coast
of Southeast Asia. It was the last of a series of landfalls, the last lap on an
island-hopping process that had been going on for generations, past the
shoals and reefs of archipelagos now submerged beneath the South China
Sea and adjacent waters. Navigators set out from the shores of the final
island into open ocean, guided by birds in flight and the behavior of the sea
itself and perhaps by the stars, until they saw new land looming dark and
low on the horizon, pulling up at last on an alien beach. The voyage cov-
ered a distance of only about 50 miles. But it took place 40,000 or more
years ago in a bark or dugout canoe or on a raft, and it opened up the
continent of Australia.

Another early migration route into new lands led from the easternmost
tip of Siberia into Alaska. Like the route to Australia, it could have re-
quired a trip across open water by raft or canoe, since the Bering Strait
which separates Asia from America and has always separated them during
relatively warm interglacial times such as ours, is also about 50 miles wide,
with two islands in between to make the crossing easier. It would have been
easier still during glacial periods when ice sheets locked up so much water
that the oceans were several hundred feet lower than they are today, and a
tundra plain more than 1,000 miles wide connected the two continents. We
do not know when hunting-gathering bands first entered the New World,
but they had certainly made it by about 15,000 years ago, and perhaps ten
or more millenniums before that.

This particular migration, this entering of lands once empty of human beings, implies a driving force, a prehistory of many pioneer excursions, many failures, extinctions of local bands, as well as successes. The Bering crossing involved earlier expansions out of tropical and temperate places, the comfortable zones, and coping with some of the world's most inhospitable climates. Only the high circumpolar barrens and the driest of deserts offer less attractive living conditions. Before making their moves into the New World our ancestors had to learn to contend with Siberia, with living and long journeys near and north of the Arctic Circle.

For one thing, they had to contend with tundras, the most difficult of all human adaptations up to that point. These bleak plains are not only treeless but seasonless as well, or nearly so. A tundra year has fewer than fifty frost-free days and may have none at all, which accounts for ground permanently frozen to depths of tens to hundreds of yards. Strong, cold winds are another permanent feature. The year offers a summer one to four weeks long, with daytime temperatures generally ranging from about 45 to 55 degrees Fahrenheit and perhaps 10 or more degrees lower at night. When summer passes, the whole land goes subzero. Temperatures tumble, the midwinter average being 30 to 40 Fahrenheit degrees below.

Such terrain, however uninviting it may seem to us, supported a surprising abundance of species. Human beings could never have endured in the tundra unless other species had preceded them by millions of years. Earlier plant migrants included grasses, sedges, and underlying layers of lichens and mosses, and stands of creeping shrubs such as dwarf willows and dwarf birches, especially along the banks of streams and on the lee sides of sheltering slopes. Plant-eating animals arrived somewhat later, reindeer and musk oxen, arctic hares, bison, giant elks, woolly rhinoceroses, and woolly mammoths 10 or more feet tall with 4-inch fat layers under their coats and curving tusks up to 13 feet long.

People came on the scene after the plants and animals. They followed their prey into the tundra, as well as into less rigorous glacial terrain, during Neanderthal times if not earlier. The archeological record, however, suggests that they did not use the land as fully or efficiently as their descendants. They may have taken off from home bases not too far away in forest-tundra or steppe climates, for relatively brief and infrequent excursions. As one example of tundra exploitation, the central Russian Plain north of the Black Sea and the Crimea, an area of some 150,000 square miles, contains only about half a dozen known Neanderthal sites, while the Cro-Magnon total is more than 500.

Trends, in prehistory as well as in history, are often difficult to make out. They are rarely clear-cut or neatly progressive through time, and many exceptions exist. But spreading into tundra lands probably took place

on a larger scale than before. Another trend, not as well documented as we might wish and by no means under way in all regions, represents an apparent paradox in a period of shifting populations and far-flung migrations. Along with all the moving about, we see definite signs of reduced mobility. In many cases, once people had selected suitable hunting-gathering territories, once they arrived, there seems to have been a notable tendency to settle down for longer periods.

A number of sites took on a more solid, somewhat more permanent quality. They became "stonier." Stone as a mark of the change was brought in not just for tools and tool making, but also for structural reasons, to modify the site, to make it more convenient for living. There were no stone-and-mortar houses on stone foundations, no large stone storage pits and chambers, no high stone defense walls. All that came later, toward the end of the Upper Paleolithic and in another part of the world, in the Near East just before the rise of agriculture.

Less sophisticated, less obvious, structures emerge in the record at the beginning of the Upper Paleolithic about 30,000 years ago—and even earlier. The 300,000-year-old Terra Amata site on the French Riviera overlooking the Mediterranean contains a small stone wall, possibly a windbreak, and a similarly interpreted feature has been reported from East Africa, at an Olduvai Gorge site in Tanzania dating back more than a million years before that. As in many other cases, things begin to get especially interesting during Neanderthal times. Some of their open-air sites feature prominent "rock scatter" pavements of a sort made up of thousands of cobblestone-like pebbles. The purpose of these artificial surfaces remains unknown; one suggestion is that they somehow made getting about more convenient during and after rainstorms.

A whole complex of unexplained features, undeciphered patterns in stone, appeared after the Neanderthals. An open-air site at Solvieux not far from Bergerac includes sixteen Upper Paleolithic occupation levels covering the period from about 30,000 to 14,000 years ago. James Sackett of the University of California in Los Angeles has spent more than a decade digging there, and has unearthed a wealth of patterns, everything from rock-scatter pavements to stones placed in straight and curving lines which may or may not be footpaths. There are rectangular and circular patterns of stones, once identified as mysterious symbols, purportedly of magical or ritual significance, and now regarded more prosaically as the remains of huts, being used to hold down the ground-level edges of skins placed over a wooden framework. Solvieux also includes large circular block structures made up of flattish chunks of limestone, which no one has yet been bold enough to interpret.

Bordes notes that in southwestern France Cro-Magnon heating, cook-

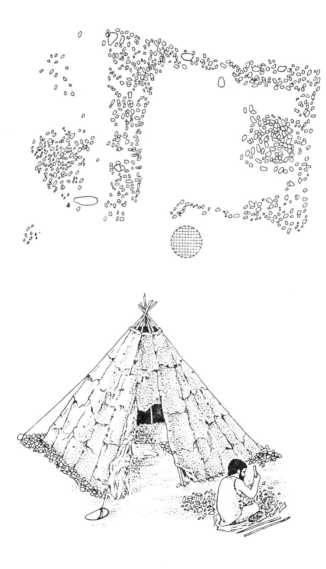

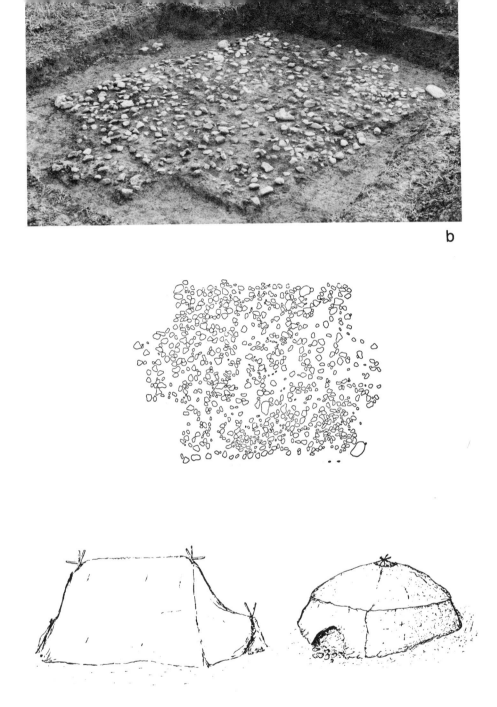

b

The art of archeological reconstruction. (a) Plateau site in southwestern France: exposed living floor, prehistoric objects in place; map showing pattern of distributed objects; reconstruction, interpretation of the pattern. (b) Le Cerisier site, southwestern France: living floor; map showing object distribution; reconstructions (two versions).

ing, and lighting arrangements were better than those of the Neanderthals, taking fuller advantage of a variety of innovations tried but not widely applied by their predecessors. Neanderthal home fires usually burned directly on flat living-floor surfaces, spread out over a relatively large area with perhaps a stone or two set up to protect against the wind. The fires of the Cro-Magnons were more compact, placed in prepared hollows, commonly encircled with stones, and often featuring a narrow channel or "tail" scooped out at the bottom to create a draft and hotter burning, a feature invented more than 200,000 years ago but not found in Neanderthal sites. They frequently used bone for fuel, which is difficult to ignite, requiring wood as a primer or starter but, once ignited, burns at high heat.

There is a suggestion of more elaborate sites, and the first assemblies of hunter-gatherer bands, probably on a seasonal basis. Some 27,000 years ago at a site known as Dolni Vestonice on the rolling glacial plains of south-central Czechoslovakia, people drove wooden posts into the ground near a stream (traces of the post holes are still visible as faint soil discolorations) as supports for the walls and roofs of a cluster of four huts, the largest measuring 50 by 20 feet. Posts of mammoth long bones and tusks formed the framework for a brush-and-dirt wall surrounding the huts, the earliest known palisade, presumably to keep out animals and icy winds. Another streamside cluster of dwellings complete with palisade, located not far away and perhaps a millennium or two more recent, may have housed 100 to 125 persons. No Neanderthal sites of comparable complexity have been found.

Everything from this time on adds up to a groundswell situation. The evidence, direct and circumstantial, indicates an increase of scale across the board, in every phase of human activity. The pace of change had been gathering momentum, of course, ever since the start of the Upper Paleolithic. But an extra spurt, the real upswing, began about 20,000 years ago during the peak of the last ice age, when the fronts of continental ice sheets more than a mile high moved south of a London-Berlin-Warsaw line in Europe (and in North America south of a line from New Jersey and Pennsylvania and deep into the Midwest).

The advance of glaciers accounts for gaps in the archeological record, periods when sites vanish from previously populated regions. The gap in Russia's central plain extended from about 22,000 to 18,000 years ago, and from about 25,000 to 15,000 years ago in southern Poland and southern Germany more than 1,000 miles to the west. Michael Jochim of the University of California in Santa Barbara sees "a gradual abandonment of the northern fringes of Europe," the extinction of some fringe populations, and "perhaps an influx of surviving peoples into southwestern Europe." The ice-age peak, incidentally, coincided with early Solutrean times in south-

western France and Spain, and with technological advances including increased use of the spearthrower and possibly the bow and arrow.

Another population influx may have been under way from the south. Noel Boaz of New York University, N. Ninkovich of Columbia University, and M. Rossignol-Stock of the National Museum of Natural History in Paris note climatic changes in North Africa and southwestern Asia where decreasing monsoon rains and spreading deserts drove people out of their homelands. So much water was locked up in glaciers that sea levels dropped more than 300 feet, providing a convenient land bridge across the Dardanelles. In other words, Europe served as an in-between zone offering prospects of more abundant game and plant foods.

Populations and population densities probably rose in European refuge areas. According to one estimate, 2,000 to 3,000 persons were living in France 20,000 years ago, and perhaps 6,000 to 10,000 more in all of Europe. The totals may have doubled or tripled during the next ten millenniums. The number of sites tended to increase, especially during late Magdalenian times when prehistoric "row housing" first appeared. A series of four or five rock shelters, extending along a stretch of the Dordogne River downstream from Les Eyzies, may have had 400 to 600 occupants, while an even denser concentration of sites has been found to the east in Russia along the Don.

The food quest, which became more and more of a problem, called for both mass kills of single species and the exploitation of a wider range of species. On the basis of excavations involving the analysis of the articulated remains of a bison herd and more than 4,000 scattered bones, Joe Ben Wheat of the University of Colorado describes a stampede which took place 10,000 years ago in a gully some 150 miles southeast of Denver and illustrates techniques applied during the Upper Paleolithic in Europe:

Animal after animal pressed from behind, spurred on by the shower of spears and the shouts of the Indians now in full pursuit.

The bison, impeded by the calves, tried to jump the gully, but many fell short and landed in the bottom of it. Others fell kicking, twisting and turning on top of them, pressing them below even tighter into the confines of the arroyo. In a matter of seconds, the arroyo was filled to overflowing with a writhing, bellowing mass of bison, forming a living bridge over which a few animals escaped. Now the hunters moved in and began to give the coup de grace to these animals on top, while underneath the first trapped animals kept up the bellows and groans and their struggle to free themselves, until finally the heavy burden of slain bison above crushed out their lives.

In minutes the struggle was over. One hundred ninety bison lay dead in and around the arroyo. Tons of meat awaited the knives of the hunters—meat enough for feasting, and plenty to dry for the months ahead—more meat, in fact, than they could use. . . .

We do not have equally good evidence for Europe. There is no telling whether the remains of more than 200 mammoths at a site on the Russian Plain, or the remains of more than 1,000 of the giant creatures at a Czechoslovakian site, were the victims of similar stampedes or simply the accumulations of many generations of small-scale hunts. But such finds contribute to the general picture of all-out hunting, hunting on a mass-produced scale. The most spectacular accumulation of all exists at Solutré, the Solutrean-type site discovered more than a century ago, at the foot of a steep cliff. Extensive deposits more than 3 feet thick contained bones representing 10,000 to 100,000 horses, either driven to their deaths off the top of the cliff or ambushed in a narrow pass down below.

Bison kill: remains of animals stampeded and trapped in Colorado Indian hunt 10,000 years ago. *(Joe Ben Wheat)*

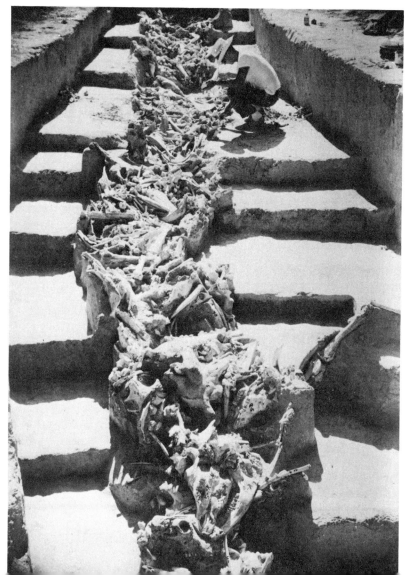

More precise studies conducted during the past few years provide a new perspective on the deadly effectiveness of such tactics. As a rule, there are two patterns among bones excavated at large-kill sites containing large numbers of animals presumably killed all at once. If the fossil specimens represent animals at the extremes of the age scale predominantly, the old and the young in a so-called bimodal distribution, the odds are that selective predation was involved—since early human hunters, like their carnivorous competitors the lions and wild dogs and hyenas, probably tended to go after the most vulnerable individuals in a herd, avoiding adults at the prime of life and focusing on those less capable of fighting back.

An all-ages pattern, on the other hand, implies the working of more impersonal forces. Floods, earthquakes, volcanoes, and other devastations do not operate selectively but wipe out entire populations, the strong as well as the weak and everything in between. It may be that for hundreds of thousands of years, as long as our ancestors were capable of killing large animals, they were bimodal killers, hunting in the ancient tradition of their nonhuman contemporaries. The all-ages pattern became an increasingly common feature during the course of the Upper Paleolithic. *Homo sapiens* had come a long way in his game drives. He was no longer killing like a normal predator, but like a natural catastrophe, an act of God.

People coming together for mass hunts do not go their separate ways in a hurry. Everyone has a share in the enterprise. There are rules for dividing the spoils, meat to be distributed and stored, dried or smoked or put into deep-freeze permafrost "lockers." As prehistoric hunter-gatherers tended to assemble for longer periods, subsistence patterns changed. In some areas animal populations declined as human populations rose, especially large herd animals which had provided most of the meat. That meant turning to other resources, broad-spectrum exploitation, going after a wider variety of species.

The trend may be seen at La Riera, a small cave in a glen near the northern coast of Spain, where Geoffrey Clark of Arizona State University and Lawrence Straus of the University of New Mexico have excavated about 8 feet of deposits covering some 12,000 years of hunting strategies. The remains of red deer, horses, and bovines, most likely bison, predominate in the earliest level, which is more than 21,000 years old. From there on the hunters apparently had to rely increasingly on species providing meat in smaller packages. Bison, which average about 800 to 900 pounds of meat each, are never again as abundant, being absent or present in low proportions in all subsequent levels. Horses (about 400 pounds of meat each) also tend to dwindle, while red deer (225 pounds) continue to serve as a meat staple throughout the sequence, probably being killed en masse, driven into traps or corrals or streams.

Another major source of meat was the mountain-dwelling ibex (110 pounds), a development which required more ingenuity and rather more energy than was the case for most herd animals. The first sight of an ibex dashing away at top speed on a mountain slope and vanishing in the distance is enough to discourage any inexperienced hunter. But prolonged observation reveals that these animals, like all animals, have vulnerabilities, built-in habits which may prove their undoing. Ibexes are instinctive climbers, tending to run uphill when threatened, an automatic response which has been effective in countless encounters and escapes over the ages—as far as nonhuman predators are concerned.

But they have not evolved ways of escaping from human predators, and they never will. Ibexes driven from below generally sprint headlong up steep slopes toward hunters concealed behind rocks and ready to spring shouting out of their hiding places. At that point the animals, caught between two lines of attack, panic. Some manage to escape in prodigious leaps; others kill themselves in leaps that fail, or are killed by the hunters. Judging by the cratefuls of ibex bones unearthed at La Riera, and at a number of other sites in or near mountainous regions, our ancestors were well aware of these tactics, and a good many more besides.

The first traces of sea food appear in La Riera deposits immediately overlying the 21,000-year-old level, probably within a few centuries of that date. Diets contained large quantities of limpets, mollusks with cone-shaped shells which cling to rocks, indicating the exploitation of a species adapted primarily to life in quiet waters, tidal basins, and estuaries where river and ocean meet. People were still eating the quiet-water limpets some 7,000 years later, only now they were also entering a new and more demanding environment, open waters off rocky shores. Continuing to broaden their subsistence base, they added a number of new marine species to their diets, mussels and sea urchins as well as an open-water species of limpet. The presence for the first time of wild boar remains in a level dated a millennium or so later suggests that they had begun exploiting the most ferocious and dangerous animals in the region, which in any case may have become abundant with the coming of milder climates.

The times must have seen a correspondingly intensive increase in the use of plants. Unfortunately, huge gaps exist in that part of the record. Samples of the soil from prehistoric sites often contain fragments of plants, fossil pollen, and crystalline phytoliths or plant opals which help identify vegetarian items in ancient diets. But this source of information has been neglected until recently, mainly because investigators, almost all of them males, tended to focus on bones and hunting rather than plant remains and gathering, traditionally women's work. Future research may be expected to demonstrate the crucial importance of strategies for harvesting wild fruits

and vegetables, herbs and nuts and cereals.

What all this amounted to was more efficient living, more efficient use of natural resources; and that had an interesting double effect as far as group mobility was concerned. People had to know more about the land, about a greater variety of plants and ripening times, about the ways of herd and solitary animals so that they could predict where and when the hunting would be best, where the animals would pass, where to hide for ambushes. Local exploitation certainly encouraged the settling-in, settling-down process, and yet at the same time it meant that members of the band had to range more widely than ever from their home bases.

As a general rule, efficiency demands a broader base of operations, knowledge not only of resources in the immediate area but further afield— because sooner or later the group will have no choice but to move away. Sooner or later, within a decade at best, the area will be hunted out; animals will avoid the area or be wiped out. Under such conditions it is wise to know in advance where to set up a new home base, and that implies keeping tabs on abundances of game, wild cereals, fruit and nut trees, and other resources in wider areas.

This is what modern hunter-gathers do, people who are still living off the land on wild plants and wild animals, or were until recently. To be sure, what they can teach us about the remote past is limited in many respects. Like the rest of us, they have evolved and are evolving; they are anything but relic populations of the Stone Age. Yet of all extant societies theirs most closely resemble the sorts of society that prevailed for most of human prehistory, and they are all masters of anticipation when it comes to knowing where to move when moving becomes necessary—which is hardly surprising since their survival depends on it, as it did for all our Upper Paleolithic ancestors.

The Nunamiut Eskimos of Alaska's Brooks Range, for example, regularly monitor large hunting territories. Lewis Binford of the University of New Mexico has records of one band of thirty-six persons with a total territory of some 8,700 square miles, or about the equivalent of a circular area with a 53-mile radius. That is the band's so-called extended range, the land it considers its own. But the people never exploit the whole territory at any one time. They live and confine most of their hunting activities to one of about half a dozen smaller and partly overlapping annual or residential ranges within the larger territory, shifting from one to another (the most abundant) as local resources dwindle. In other words, when the time for moving comes, they are ready. They know everything they need to know about subsistence conditions throughout their extended range, because they visit all parts periodically.

The people of the Upper Paleolithic probably practiced similar strate-

gies. Furthermore, as among the Eskimos and other present-day hunter-gatherers, they had still wider horizons, relationships among extended ranges and beyond. They were forming new contacts, new frontiers and outposts, becoming part of networks extending over greater and greater distances. Such contacts were unknown in Neanderthal times, but they became common thereafter. The Cro-Magnons frequently obtained fine-grained easily worked flint from 50 to 100 miles away. Quantities of so-called chocolate flint, a rich brown material extracted from clays in a mining region of central Poland, were carried as much as 250 miles to sites in Russia, Germany, and Czecholovakia, in some cases exchanged for supplies of jasper and the dark volcanic glass, obsidian.

Multicolored minerals and other items satisfied purely esthetic rather than technological demands. In the Ukraine, lumps of "the glowing golden stone"—amber—a fossil substance formed from resins produced 30 million years ago in primeval forests, found their way 100 or more miles from deposits to home bases. The long-distance record involves traffic in marine shells, a common trade or exchange item throughout Europe. Shells picked up on the shores of the Black Sea have been excavated at sites to the north some 400 miles away, or about three weeks of walking.

The demand for exotic materials is another sign of a revolution in living and thinking. Ornaments, like long-distance contacts, have never been found in early Neanderthal sites. But they appear suddenly and in quantity in sites dating back perhaps 35,000 to 40,000 years, and that calls for some explanation. Imagine a group of people who have never used any form of personal adornment, and whose ancestors for thousands and thousands of generations back went about similarly unadorned. What new communal forces could produce such a change, raising the level of self-awareness, self-concern, to such an extent that individuals would begin to wear pendants, bracelets, necklaces?

Part of the answer may be related to another basic change under way simultaneously, a breakdown of one of the oldest and most widespread of hunter-gatherer traditions. We begin to get the first signs of a departure from egalitarian principles that seem to have prevailed over thousands of previous millenniums. Present-day hunter-gatherers live by democratic principles, by an ethic of complete equality. There is a policy of ephemeral or dispersed leadership among the Bushmen of Africa's Kalahari Desert, different individuals being heeded under different circumstances. The best storyteller may take over at the end of the day around campfires, the best hunter carries extra weight in planning the search for meat on the hoof, the best shaman is consulted when people need consoling or healing. No single member of the band serves as official big man or full-time chief.

Of course this is only an ethic, and hunter-gatherers do not always live

up to their principles. There may indeed be cryptoleaders, people silently and most unobtrusively recognized as those to whom one regularly turns in times of decision. Even under such conditions, however, the slightest sign of pride or expected praise triggers elaborate and ruthless putdowns. A Bushman hunter may bring in a fine fat antelope, an especially welcome treat these days when game is often hard to come by, the equivalent of 100 pounds of lobster or filet mignon. But if he shows traces of pleasure or self-satisfaction with his contribution, and even if he doesn't, someone is sure to comment on the scrawniness of the animal or complain that only a single animal was bagged. The putdown is recognized as part of the insurance against arrogance, jealousy, and aggression.

Egalitarian principles also apply to the notion of ownership. If Kalahari men or women acquire valuable or beautiful objects, say a fine hunting knife or a colorful blouse or sweater, they are torn by conflicting emotions. They appreciate and treasure the object, and yet they feel exposed and threatened by having something which others do not have. The object becomes a psychological hot potato, something to be concealed for a while and gotten rid of as soon as possible. It will have been given to another member of the band within a few days, and within another two or three weeks it will probably be found in another band miles away. People tend to feel more comfortable not having an outstanding possession, and thereby sinking back into a less conspicuous and less envied position within the group.

Such behavior does not come naturally. It must be created, inculcated, by established custom. In the Kalahari, training to give things away starts from six weeks to six months after birth when the infant receives a necklace of colored beads (nowadays glass beads, made in Czechoslovakia). The necklace is cut off before the age of one, usually by a grandmother who puts the beads in the infant's hand, encourages it to give them to an older relative, and then replaces them with new beads. That seems to be starting rather early since children are not ready to give things away for another year or two, at least not in industrialized societies. In any case, Kalahari children often object strenuously to this sort of discipline before giving of their own free will between the ages of five and nine.

An inculcated ethic of egalitarianism and sharing is also observed among the Australian aborigines and other hunter-gatherers. We cannot be certain that prehistoric bands lived by similar principles. But the record contains no evidence for differences in status until the Upper Paleolithic; then we begin to get the first traces of an archeology of inequality. The evidence is clear and striking. A site 20,000 to 25,000 years old, known as Sungir and located about 125 miles northeast of Moscow, contains a complex of four burials: two adults identified as man and woman, and two

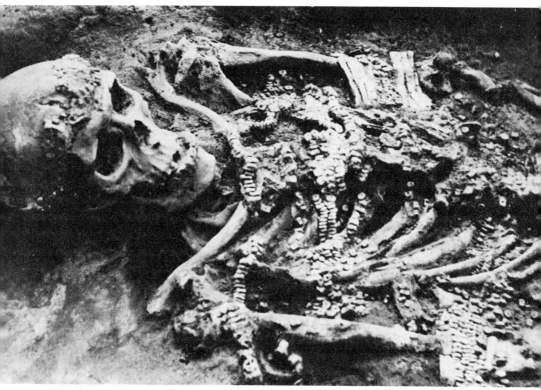

Sungir grave, U.S.S.R.: close-up showing strings of ivory beads.
(Copyright, Novosti Press Agency)

Sungir grave, U.S.S.R.: status burial with ivory spears.
(Copyright, Novosti Press Agency)

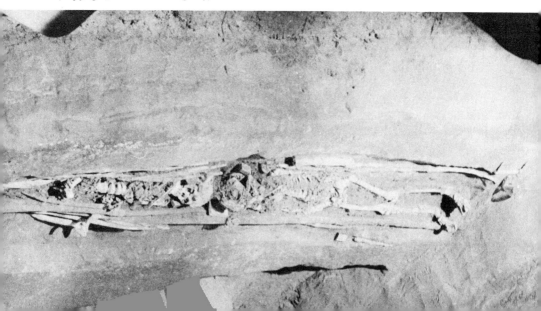

boys. Only a skull remains of the woman, who had been buried in a grave sprinkled with red ochre. The man, broad-shouldered and in his middle fifties, was laid to rest in state, dressed in some sort of garment decorated with hundreds of pierced mammoth-ivory beads, wearing several bracelets and a headband also made of mammoth ivory.

The boys, aged seven to nine and twelve to thirteen, respectively, were buried face up in the same narrow trench in a head-to-head position, and with an even more impressive array of grave goods—some 8,000 ivory beads, arctic-fox canine teeth, assorted rings and bracelets, and sixteen spears, darts, and daggers. Several spears demonstrate a high order of craftsmanship. More than 6 feet long, they are made of mammoth tusk, which is naturally curved. They had to be straightened, softened, and unbent step by step, probably steamed or immersed in hot water, a process that may have benefited from experience gained in the straightening of reindeer antler. A set of graves excavated in the Grottes des Enfants on the

Grottes des Enfants burial: clusters of perforated shells, probably traces of decorated clothing. *(Copyright, British Museum, Natural History)*

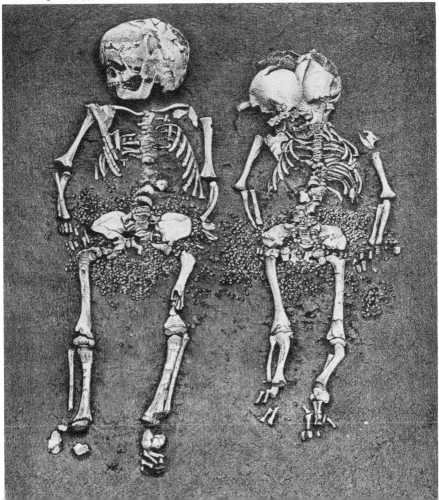

Italian Riviera also includes two young children with large clusters of perforated shells around their midsections, presumably the remains of decorated clothing, as well as an adult wearing a shell headdress. A child about seven years old was buried at the La Madeleine rock shelter, powdered with ochre and decorated with rings of strung-together shells on its head, neck, elbows, wrists, knees, and ankles.

The Grottes des Enfants site may have served as a special cemetery for people of distinction, perhaps members of a single extended family. It contained a total of some dozen burials, all with a variety of shell decorations. In addition, a number of the burials featured flint blades extraordinary for their length, 8 to 10 inches, requiring not only carefully selected materials but also a high order of craftsmanship. Similar blades have also been found at another site located not far away, next to a skeleton with stones placed on its hands and feet, as if to keep the individual from leaving the grave.

A great deal of effort went into these burials, and into the appropriately elaborate ceremonies that must have accompanied them. Such honors are not for everyone, only for special people, indicating the beginnings of formal social distinctions. The burying of young children suggests further developments. A leader who earns his position by actual deeds needs time to win recognition as hunter or shaman. He must keep proving himself, and when he can no longer do so, is replaced by someone else who can. But the existence of children buried with high honors before they are old enough to do anything outstanding raises the possibility of status by heredity rather than achievement. Note that this is only a possibility, since elite parents may simply choose to bury their offspring with special honors.

The analysis of mortuary practices can reveal signs of departure from strictly egalitarian principles. Nan Rothschild of New York University has studied customs at two hunter-gatherer sites dating back 3,500 to 5,000 years: Port au Choix on the western coast of Newfoundland (101 burials) and Frontenac Island in Cayuga Lake, New York (159 burials). People at the former site selected ten adults, five men and five women, for special treatment, burying them with large quantities and a greater variety of grave goods, and aligning half of them in a facing-east position. They also buried three groups of individuals in areas separated from all the rest.

These and a number of other features argue for the presence of singled-out individuals, and distinguish Port au Choix from Frontenac Island cemeteries. Rothschild suggests one possible reason for the difference. The island Indians probably shifted camp seasonally, relying on deer as a major source of meat, animals which tend to go about in small groups and are generally hunted on a small-scale basis. Port au Choix Indians, on the other hand, lived "in a coastal setting with a stable, rich resource base which could support year-round base camps," and had a subsistence style

comparable to that deduced at certain Upper Paleolithic sites in the Old World. They specialized in seal hunts and the mass killing of caribou, activities calling for planning, a more tightly organized social system than the islanders, and more leaders to do the organizing.

Incidentally, we see leaders emerging today among hunter-gatherers, abandoning nomadism and beginning to settle down in an effort to survive by adapting to the ways of agricultural and industrial societies. Whatever the triggering causes, whether mass hunting and related changes or the inroads of modern lifestyles, egalitarianism may pass when mobility is reduced and people must live together for extended periods. In any case, the appearance of people of distinction represented an enormous change in the rules of the game, the beginnings of a final break with ancient traditions.

Where life had probably proceeded largely along low-profile lines with no big men, and members of the band almost competing at times to remain inconspicuous, there was now room at the top. Instead of staying small and equal, a few individuals became very unequal indeed and proud of it, taking on the special responsibilities and privileges of leadership, enjoying the glamour of open recognition. Instead of giving things away, and the most valued things the most quickly, they accumulated possessions for public display, as marks of status.

The rapidly evolving world of the Upper Paleolithic demanded a new ethic to account for, to validate, status and everything that made status inevitable, a new set of values and beliefs. It is difficult to conceive of such radical social changes without correspondingly radical changes in language itself. In fact, some investigators believe that language first appeared during the Upper Paleolithic, that it was nonexistent or at best extremely primitive before then, a point of view which for some reason appeals strongly to novelists and is accordingly commemorated in fiction as well as nonfiction.

William Golding's classic *The Inheritors,* which presents the story of a band of Neanderthals that have known better times, endows them with a concrete here-and-now style of speech consisting mainly of simple utterances like: "I am hungry," "Do not tell her," "I ate meat," and, "I have a picture," the last phrase usually prefacing often-painful efforts to reconstruct the past or look ahead. They have only a slight capacity for abstraction, work with crude stone tools, and in the end are wiped out one after the other by a band of Cro-Magnons.

A more recent novel, *The Clan of the Cave Bear,* by Jean Auel is even harder on our ancestors as far as spoken language is concerned. In this tale the Neanderthals have undeveloped vocal cords and brains far inferior to ours, brains "with almost no frontal lobes," centers concerned with the most advanced abstract thinking, planning, and foresight. They are unable to speak in complete sentences, use only a few gutterally uttered words, and

do most of their communicating by sign language, a rich and comprehensive system of gestures.

Perhaps. In the absence of anything approaching direct evidence, we can do no more than guess. But to me this sounds like a holdover from an old and now-discarded image of the Neanderthals as low-browed, shuffling brutes. On the basis of considerations to be presented in Chapter 6, it seems just as plausible to suggest that they managed to communicate with something beyond mumbling and gesticulating. My feeling is that language in its most rudimentary form probably existed 3 or more million years ago among early hominids, a feeling based in part on the limited but nonetheless impressive linguistic capacities of nonhuman primates, notably chimpanzees.

Chimpanzees at the University of Nevada using Ameslan, the American sign language for the deaf, have been demonstrating their cleverness for more than fifteen years. Among their latest feats, according to Allen and Beatrice Gardner, is making new word combinations to name objects never seen before, such as "listen drink" for Alka-Seltzer, "metal hot" for cigarette lighter, and "metal cup drink coffee" for thermos bottle. Another group of University of Oklahoma chimpanzees continues to progress in communicating with one another, for example, signaling the request "drink" to a companion sipping soda pop through a straw.

The world's most linguistically sophisticated chimpanzee lives at the University of Pennsylvania's primate laboratory located in Honey Brook, in the heart of Amish country. Her name is Sarah, and David Premack and his associates have been educating her for twelve years, ever since she arrived from Africa at the age of five. She has a vocabulary of more than 130 words, represented by metal-backed plastic pieces of different shapes, colors, sizes, and textures, which she places on a magnetized board to form sentences and communicate with humans. Her abilities are considerable. She knows the meaning of "same" and "different," to the point where she knows which to match with a half-filled glass of water, half an apple, or three quarters of an apple. Also, she can comprehend an even more subtle form of sameness, matching such items as lock-and-key with can-and-can-opener as pairs of related objects.

Even more clever perhaps, Sarah has learned to recognize problems and the solutions to problems. Shown a picture of a human actor trying to get out of a locked cage or to play an unplugged phonograph, she has no trouble choosing pictures representing appropriate solutions, the use of a key or plugging a cord into an electrical outlet—something she learned without being "told," by direct observation. Furthermore, she deliberately chooses the wrong solutions when the human actor is someone whom she has had reason, from previous training sessions, to dislike. These and a

number of other tests show that she has an appreciable understanding of the world around her, and can express complex relationships.

Such findings suggest that although the cleverest of chimpanzees are quickly surpassed by human children, they have enough innate symbolic ability to imply that language may have developed quite early in the hominid line. On the other hand, whatever the state of language before the Upper Paleolithic, it must have undergone spectacular changes afterwards. Vocabularies must have expanded to keep pace with the increasing numbers of items to name, more ways of doing things and things to do, more kinds of everything from tools and tool making to hearths, pavements, decorated tools and ornaments, portable art, cave paintings, engraving, and sculptures—more gradations of meaning, more people, more intricate relationships between people and things, and between people and people.

Take the eighteen different types of burin, for example. They represent our classification, and it would be surprising indeed if Cro-Magnon people classified the tools the way we do. If variety is any indication, however, they must have had a burin vocabulary rather more extensive and detailed than that of the Neanderthals. And think of the effect on vocabulary of the bow and arrow, of every trial-and-error step from the selection of wood and bowstring material to emotional impact, since this weapon, like all radical innovations, must have aroused opposition in the beginning as dangerous, unnatural, and capable of wiping out entire species.

We can imagine a need for more precise words, moving toward number, quantitative as well as qualitative concepts. In annealing flints timing and scheduling can be critical. Different kinds of flint must be raised to different peak temperatures at certain rates, held there for different periods, and cooled at different rates, all of which demanded measurement and measuring devices and perhaps records. On the social side, coming together more often in larger groups may also have contributed to the multiplication of terms. According to speculations by Robert Dixon of the Australian National University in Canberra, "whereas adjectives such as 'big' and 'little' and 'black' and 'white' may have been included in the rather small vocabularies of relatively early and primitive languages, adjectives concerning what I call human propensities such as 'jealous,' 'rude,' 'happy,' 'kind,' and so on may have been added at a later stage."

At the same time, and more basically, there may have been trends working in the other direction. Language may have evolved words designed to save words, to improve the efficiency, convenience, and the speed of communicating. I am thinking among other things of broad-category, more abstract words such as "tools" instead of burins-scrapers-points-harpoons, "plants" instead of trees-bushes-vines-grasses, "animals" instead of an item-by-item listing of representative species. Abstraction must have served

admirably as a way of achieving more economical expression.

Rapidly expanding vocabularies could have put an increasingly severe strain on memory and brought about, forced, the development of rules to relieve the pressure. Suppose for the sake of argument that the singular and the plural of every noun were represented by two entirely different words, say "tree" having the plural "ulgh," and that people invented the notion of adding an "s" to the singular, thereby eliminating the need for the plural word. Suppose further than an analogous situation existed with respect to the present and the past tenses of verbs, and one could get rid of the past-tense words by simply adding "ed" to the present-tense words. Analogous developments reducing the pressure on memory-storage capacity may help to account for the fact that Cro-Magnon brains seem to have been slightly smaller than Neanderthal brains (by some 100 cubic centimeters or 6 cubic inches, about 770 million fewer nerve cells).

Finally, we can envision, as a further effect of the explosion of culture, an explosive increase in the use of imagery and emotionally charged communications. The sudden appearance of portable and cave art implies a heightened sense of drama, a drastic change in the way people in general, not just the artists, viewed themselves and their place in nature, faint foreshadowings perhaps of pomp and circumstance. We cannot see things through the eyes of the Neanderthals or the predecessors of the Neanderthals. But theirs was a world without enduring art, certainly a much simpler world in view of what came later, and a more subdued, grayer, strangely low-key world.

The world of the Cro-Magnons must have been comparatively vivid and exciting. Their paintings and engravings hint at new ways of seeing things, new perceptions, which must have been reflected in an everyday speech more expressive and richer in connotations. They were thinking differently, using their brains differently, and traces of the differences remain buried in our current languages. There is much to be discovered along such lines.

The First 10 Million Years 5

▷ Nothing in the twentieth century can match the Upper Paleolithic for its combination of art and setting, content and context. Nowhere in our lives are there comparable concentrations of modern art with a purpose, art in action, as contrasted with passive art hung in out-of-the-mainstream places designed solely for exhibition. The works in the caves speak together, individual styles but with an underlying unity, singing in unison like a chorus of individual voices expressing collective feelings, collective goals. That is their special power.

That is also their special challenge. Upper Paleolithic art, coming all at once so early and so distinctively human as to shock many investigators, raises basic questions about origins and definitions. The problem is to account for the emergence of a species governed predominantly by cultural evolution rather than the organic or biological variety characteristic of all other species. We would like to know more about our uniquenesses, what it means to be human, how something like us could arise from something like a chimpanzee. Understanding this process involves learning more about the remotest roots of prehistoric art, what came before, and its selective, adaptive value for the survival of the species.

Although the gap between ape and human remains enormous, it is not quite as enormous as we once believed. One of the surprising things about research on evolution during the last century is why, after Darwin suggested that there were apes in our family tree, researchers stayed at home as it were, instead of going out into the field to observe African and Asian apes in their native habitats. They concentrated largely on apes locked in cages, captive individuals in zoos and laboratories, which is something like drawing conclusions about human nature from the behavior of people in prisons.

In effect, investigators were loading the dice against apes, disavowing their remote ancestry. They observed mayhem among their caged subjects—bloody fighting and the killing of infants and an assortment of bizarre sexual activities—and reported what they observed as if apes generally behaved that way in the wild. What it all amounted to basically was putting as great a distance as possible between apes and themselves, by

designing conditions which practically guaranteed that the animals would behave pathologically. Extensive studies of apes and other primates roaming unconfined through their familiar forests and savannas are a development of the past generation or so.

Long recognized as our closest living relatives, chimpanzees turn out to be even closer to us than Darwin and many present-day investigators ever expected. No less than 99 percent of the genes in a chimpanzee ovum are identical to the genes in an ovum that will develop into a human being. We see the relationship most obviously in African homelands, game reserves, in the casual and brief encounters of everyday life. A male fidgets and munches absent-mindedly on a flower as he waits for a companion, presumably female, and "looks for all the world like an impatient man glancing at his wristwatch." A juvenile concealed behind bushes during a game of hide-and-seek sees the seeker stamping in frustration, bursts out laughing, and gives himself away. Individuals scratch their heads when puzzled, greet one another with hugs and kisses, squeeze fruit gently on the bough to test for ripeness.

Jane Goodall's studies in Tanzania indicate the existence of long-term kinship ties among chimpanzees. Brothers remain close in adult life, grooming one another and joining forces when disputes arise with higher-ranking males, and one fifty-year-old dowager often kept company with and was groomed by two sons, both over twenty. Chimpanzees have been seen hunting and, upon occasion, cooperating in the hunt to the extent that several troop members will join in encircling their prey and closing in for the kill. Sometimes they even share meat. They make tools by selecting a vine or stem, breaking it to a convenient length, and using it to extract termites from nesting places.

Special tests in the laboratory reveal surprising capacities never used in the wild or, if used, never observed. I have already mentioned Abang, the orangutan who used a hammerstone to make a flake tool (Chapter 3); the word-coining abilities of University of Nevada chimpanzees; and Sarah's advanced problem-solving under the guidance of David Premack (Chapter 4). Carefully controlled tests at the University of Edinburgh even suggest a faint, very faint, esthetic spark. Three chimpanzees were provided with crayons and sheets of paper, some blank and others having "stimulus figures," small black circles or squares placed in various positions. Although the apes preferred to draw with red crayons, they were given black or dark blue crayons only, because red crayons were favored as dietary items as well as drawing implements, and "were eaten too often to be useful." The apes also had short attention spans, being distracted from most drawings in about a minute. These tests indicated tendencies to draw on the stimulus figures and to fill in large empty spaces, and that was about it.

Studies at other laboratories are more glowing, perhaps as the result of working with more talented chimpanzees or more impressionable investigators. A number of years ago a London Zoo chimpanzee named Congo produced 384 paintings by the age of four, progressed from scribbles to a stage including rough circles and crosses, and actually sold a few of his paintings in what was probably the world's first exhibition of subhuman art. Unfortunately, Congo was speechless and could not tell us what was on his mind, a handicap which did not hold for Moja, a three-and-a-half-year-old female trained in Ameslan by the Gardners.

One day Moja used white chalk to produce a drawing which consisted of only four line segments, a right angle, and a sweeping curve. When she stopped and put the chalk down, an investigator handed it to her again, noting how little work she had done, and gestured the signs of "try more." Moja would have none of that. She promptly dropped the chalk, signalling a terse: "Finished." When asked: "What that?" she replied: "bird." Since then Moja's output has included her personal versions of grass, berry, and flower.

The trouble with such accounts is that in the course of being impressed with what other primates can do, and justifiably so, one loses sight of the amazing powers of the human animal. Moja may be an artist among chimpanzees but, as Premack was the first to emphasize, she has attained her peak and will never move on to more advanced figures and compositions. She will never exhibit the pattern of increasing sophistication that comes in humans without training, automatically, with growing up—starting with sheer scribbles, and then on successively to vaguely patterned scribbles eventually including circles, squares, and crosses, combinations of these and other elements, and so to stick figures and more complete figures and scenes. This is the pattern for human children all over the world. Moja will never try to draw fellow chimpanzees or the trees in the backyard where she sometimes plays or the people who spend so much time with her, while human children begin representing features of the world in their early preschool years. Congo never passed the circles-and-crosses stage which children generally reach before the age of three.

The same gap is evident in language. Chimpanzees have done many remarkable things but, as indicated in Chapter 4, they cannot compare with humans. At eighteen months most children have a speaking vocabulary of more than three and less than fifty words, and then takeoff begins in what is probably the most spectacular example of learning in the animal kingdom. Vocabularies soar to about 1,000 words at the age of three, more than 8,000 words at six, and about 18,000 words at eight. The Gardners' Washoe, the first of the "talking" chimpanzees and one of the cleverest, reached her limits at about the age of ten with some 175 Ameslan words.

The main point is that chimpanzees, apes in general, possess cerebral powers only partly tapped in the wild. Their brains seem to be more advanced than strictly necessary to deal with forests, with the lives they actually lead. The laboratory, however, may be more demanding. We not only establish conditions which elicit more sophisticated behavior from our fellow primates, but we also reward success with compliments, affection, food—and our presence, our company. Apes in cages often suffer from intense loneliness and boredom. They have been known to "act dumb," to learn slowly on purpose so that investigators will have to spend more time with them and make life much more interesting.

Apes do not change unless they have a reason to change, unless it is somehow to their benefit, and that goes for the apes that gave rise to the human line as well as for contemporary apes. So, as far as the evolutionary story is concerned, we would like to know more about nature's experiments in the remote past, about the sort of changing living conditions which elicited basic changes in the behavior of a breed of ancient apes, presumably close relatives of today's chimpanzees, and produced the first hominids. We would also like to know what the rewards were, precisely how the changes enabled the new species to thrive and spread.

This was the first of the two most significant events in human evolution (the second being the subject of this book, the explosion of culture), and at present we do not even know when it occurred. There are long and short time scales. Some investigators believe the shift from ape to human dates back as much as 15 million years to a widespread genus named *Ramapithecus* and known only by fragmentary tooth and jaw remains. It had a rugged lower jaw, large molar and premolar teeth with extra-thick enamel, and small canines—all typical hominid features—but a final verdict awaits discovery of other parts of its skeleton. Other investigators are convinced that the time span is much briefer, that we are much closer to the apes. Basing their views mainly on biochemical research involving similarities between chimpanzees and human blood proteins, they suggest that hominids appeared a mere 5 million years ago.

Long or short or in-between time scale, the ape-to-human transition apparently had something to do with worldwide climatic changes. Most primate evolution took place 65 to 20 million years ago in relatively uniform environments, in warm moist times when a belt of almost continuous tropical and subtropical forests covered most of the earth. Food tended to be concentrated, evenly distributed, and abundant everywhere. Falling temperatures, partly a result of intensive mountain-building and shifting air-mass circulation, broke up this consistent patten. Cooler and drier times brought a mix, a patchwork, of environments. There were still great stretches of dense forests, but also sparser woodlands and spreading grass-

lands, and edges and boundaries between the different zones.

Hominids were among the species that moved into this new multizone world. They abandoned a subsistence style based almost entirely on leaves, fruits, and other soft forest foods for a diet that also included tougher, coarser open-country items such as grass seeds, nuts, and roots, which required crushing-grinding action of more rugged teeth and jaws. They had to cover wider areas in their daily rounds, exploit a wider variety of foods, and watch out for more numerous predators. In other words, life became somewhat more complicated and more dangerous.

The earliest primates to be recognized beyond doubt as our ancestors have been reconstructed from thousands of specimens representing 400 to 450 individuals. Their remains have been found in Africa, in places like Ethiopia's Afar Triangle near the southern end of the Red Sea, the search area of expeditions organized by Donald Johanson of the Cleveland Museum of Natural History and two Parisians, Maurice Taieb of the National Center of Scientific Research and Yves Coppens of the Musée de l'Homme.

It is a dry and desolate land, featuring cliffs up to 2 miles high, heavily eroded hills, volcanic craters, temperatures soaring to more than 130 degrees Fahrenheit, and abundant fossils. One of the most godforsaken places on the face of the earth, the Afar Triangle was an Eden for members of the species *Australopithecus afarensis* who lived there 3 to 4 million years ago, a rich floodplain of swamps, grassy savannas, and gallery forests stretching like green ribbons along the banks of a meandering river. They are also known by fossils which Mary Leakey of the National Museums of Kenya in Nairobi found at Laetoli, the site she and her husband Louis discovered about 150 miles southeast of Lake Victoria.

These creatures, identified recently as a distinct species by Johanson and Tim White of the University of California in Berkeley, were a strange breed, like no animal alive today. It would be quite a shock to come across one of them for the first time—a creature resembling a chimpanzee in practically every way, a head or more shorter than we are and hairy, with muzzle-like face and long swinging arms, except that it strides forward fully erect like a human being. The erect posture is most striking. In fact, it is one of the chief reasons for classifying *afarensis* as a hominid.

An unusual body of evidence confirms this feature. The Afar Triangle alone has yielded a treasure of telltale fossil specimens, including vertebrae, parts of a knee joint, some 40 percent of a female known as Lucy who died at about the age of twenty, and a "paleograveyard" that contained the remains of at least thirteen individuals. But the most extraordinary find of all came from Mary Leakey's excavating team at Laetoli. Owing to a near-miracle of preservation and some virtuoso archeology by Tim White, we now have a trail of some seventy actual *afarensis* footprints.

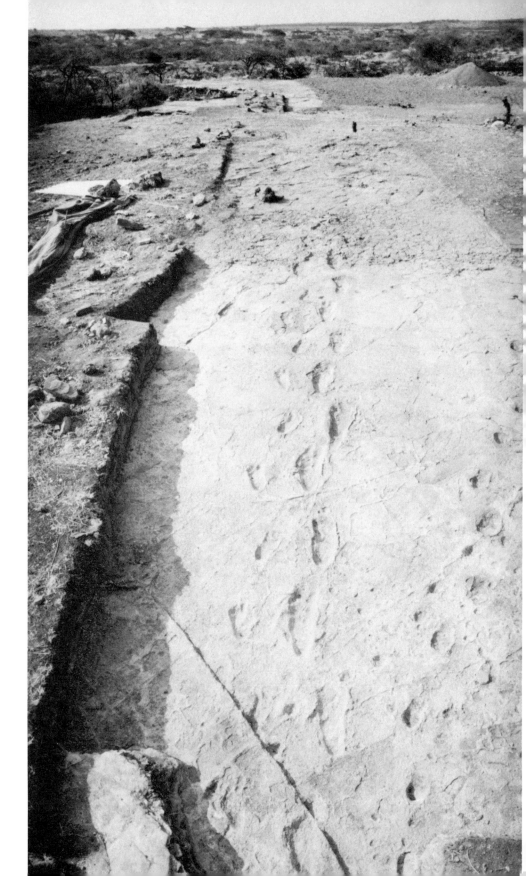

The trail was formed by three individuals heading due north across a stretch of grassy savanna 3.6 to 3.8 million years ago. They were walking during a light shower, perhaps in late September or early October at the beginning of the rainy season. The ground was just damp enough to register their footprints in clear outline. Then the sun came out and, in White's words, baked the traces "hard as a concrete freeway." Just to the right of the trail is the track of a prehistoric horse, and other parts of the excavated surface include the tracks of elephants, rhinoceroses, giraffes, hares, and ostriches.

To expose the footprints, overlying deposits had to be removed fleck by fleck with specially designed wooden tools, knives, dental picks, and paintbrushes. Grass and acacia-bush roots often had to be snipped away without destroying the evidence; in some cases, it took two to three days to uncover a single footprint. The impressions leave no doubt about the status of the foot. Featuring a well-developed arch and big toe pointing straight ahead rather than sideways as in apes, they could have been made by twentieth-century children. Of the three individuals, one was an estimated 4 feet 9 inches tall, another slightly shorter and walking directly behind, and the third measuring an even 4 feet and tagging along at the side. Father, mother, and offspring? Possibly; but we shall never know.

The picture is not quite as clear when it comes to the most interesting hominid feature, the most human thing about human beings, the brain. Viewed as a species in its own right, as one of the most advanced primates of its time rather than as an early step on the way to *Homo sapiens, afarensis* had a formidable brain, marking a high point in an evolutionary process that began in primeval seas more than 600 million years ago.

The first nervous system appeared in an unadventurous animal, a relative of the present-day sea anemone which looks something like a stewed tomato, fastens itself securely to the sides of coastal rock pools, and waits for whatever nourishment the tides happen to bring. This was a comparatively predictable creature. Equipped with a loosely organized network of nerve cells or neurons, it responded automatically and on an all-or-nothing basis to stimuli. Touched anywhere, it contracted all over into a tight ball, and it always reacted in the same way.

Imagine the evolution of the brain shown as a time-lapse motion picture, each frame representing 10,000 years or so. At first, the rate of change is exceedingly slow. The opening scene, an underwater sequence, shows the roughly globular nerve net typical of sessile invertebrates like anemones and drifters like jellyfish. The net begins to stretch out into a narrow cable of neurons and interconnecting fibers, the spinal cord, as directional creatures appear in the oceans, swift finned swimmers with prow-

Australopithecine footprints: an African trail 3.6 to 3.8 million years old, indicating a fully upright gait. *(John Reader; copyright, National Geographic Society)*

like heads cutting through the water. Now you can see a slight swelling at the head end of the cord, the first brain or brain-to-be. It expands into a kind of benign tumor, a dense clustering of millions of neurons into centers specialized for vision, smell, hearing, and for using coordinated sensory information to make quick decisions.

The final sequences take place on land, first at the edges of shores and pools, inside the skulls of amphibious things. As fishlike creatures with legs instead of fins move into a new rarefied world, a "stain" can be seen on the white surface of the brain, a tiny patch of gray matter added in the course of dealing with increasingly complex associations and behavior patterns. With the coming of reptiles and mammals, including apes, the patch spreads like a gray tide over the bulging white hemisphere, forcing its way into the depths, into every fissure and cleft, to form the highest center of all—the intricately convoluted and many-layered sheet of the cerebral cortex or brain's "outer bark."

This is the hominid heritage, a versatile organ adapted to multizone primate living. It can store a vast number of memory traces, and is incredibly flexible. Nerve-net creatures have few alternatives. They must respond in fixed ways to events in the outside world, because the messages they pick up pass along sensory-neuron fibers connected directly to the neurons that move their muscles. There is no waiting, no time or need for decision. Response follows stimulus swiftly, and as invariably as the start of an engine follows the flicking of a switch.

In higher species, clusters of special neurons known as "internuncials" (from "internuncio," an envoy or diplomatic go-between representing the Pope) are interposed between sense organs and muscles. They introduce delays, a multiplicity of nerve pathways, and the possibility of a choice among alternative behaviors. Notice that this puts a premium on inhibition. If an animal can respond to a signal in one and only one way, it confronts a simple yes-no decision, and its future is determined within narrow limits. But if it has ten alternatives and chooses one, the other nine are canceled, and in nervous-system terms that means the blocking off of nine nerve pathways. So evolution lengthens the time span between sensation and action, between wish and fulfillment, bringing a new order of variety to life.

The chimpanzee brain has a well-developed cerebral cortex, and we can assume that the brain of *afarensis* was of at least comparable quality. The fossil record provides information about volume chiefly, cranial capacity. One of the largest *afarensis* individuals, an adult male, had a brain of about 500 cubic centimeters, while Lucy's brain was probably 100 or more cubic centimeters smaller. That puts the species within the chimpanzee range of 300 to 500 cubic centimeters. Internal structure can be more significant than absolute size, however, and fossils tells us practically nothing

about that. Certain human dwarfs have brains no larger than Lucy's, and yet that limited volume contains all the centers needed to learn language. Although it is highly unlikely that such advanced centers had evolved by *afarensis* times, early hominids may nevertheless have had mental abilities beyond the ape level within an ape-sized brain.

In any case, the brain continued to expand. In 1972, Richard Leakey, who has taken his late father's place as head of the National Museums of Kenya, announced discovery of a skull near the eastern shore of Lake Turkana (formerly Lake Rudolf), some 500 miles southeast of the Afar Triangle. The skull was shattered to bits. Leakey and his associates recovered several hundred fragments, some no bigger than a rice grain, from deposits of volcanic ash, and succeeded in fitting and gluing more than 150 of them together. This specimen and others show that a hominid with a 750-cubic-centimeter brain, half again as large as the largest *afarensis* brain, was foraging on African savannas nearly 2 million years ago.

Remains of Lucy: a female Australopithecine 3.5 to 4 feet tall.
(Cleveland Museum of Natural History)

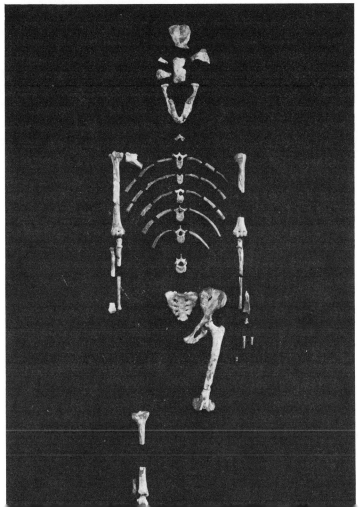

About half a million or more years earlier, artifacts appear in the archeological record which had previously included fossils only. The first stone tools consist mainly of "choppers," pebbles with one or more flakes knocked off to form rough cutting-bashing edges, or the flakes themselves—and are generally so crude and unimpressive-looking that it takes large-sample statistical analyses to distinguish them from more numerous chunks of naturally broken rock. The Abbé Breuil commented on the difficulty of identifying such implements: "Man made one, God made ten thousand—God help the man who tries to see the one in ten thousand!"

Some change in lifestyle must have called for the increasing use of stone tools. As suggested in Chapter 1, hominids may have been including larger proportions of meat in their diets and using the tools to cut through tough skins and break joints. Perhaps they were in the process of breaking completely with aboriginal forests. At one stage our ancestors may have made occasional excursions into grassy savanna lands, and hastened back before nightfall to sleep in the trees. Now it is just possible that they had become more effective predators, sufficiently dangerous to compete with and be avoided by lions and wild dogs and hyenas, and were spending all their time out in the open among the grazers and browsers, herds of antelopes and other fair game.

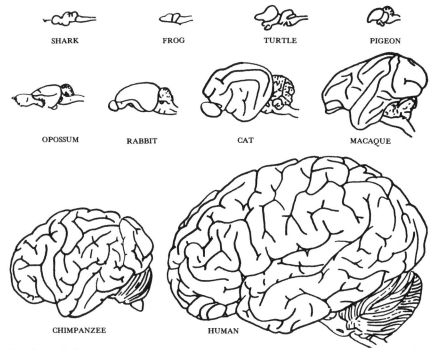

Up the evolutionary scale: expansion of the brain, with dominance of cerebral cortex in apes and human beings. *(John Lamendella)*

Another mark of the new hominids has turned up not far from the footprint site at Laetoli in Tanzania's Olduvai Gorge, where the Leakeys explored for years and made many of their most important discoveries. It is another spark, a hint of something out of the ordinary. The tool makers of Olduvai went out of their way to obtain and work a special kind of green lava. They also seem to have been attracted by smooth pink pebbles, apparently to look at and feel since the pebbles are not worked. It could have been a sense of the esthetic, or merely of the unusual. Certainly it indicates an early interest in "useless" color.

All this has a passive quality. At best it was appreciation rather than creation, only a matter of selecting raw and readymade chunks of colored mineral. Something more is involved in an item which began to appear about 1.5 million years ago in the tool kits of the first representatives of *Homo erectus,* individuals with brains of about 800 cubic centimeters. Earlier evidence shows no particular concern with the shaping of a tool, and no elaborate planning. Tool makers simply picked up handy pebbles, the overriding objective being to obtain cutting-bashing edges. Now we see the coming of design, the notion of a tool type.

Learning to make a chopper is easy. It can be done with two or three blows of a hammerstone. But making a so-called hand ax, an *erectus* invention, requires considerably more skill and forethought. Prehistoric workers selected an elongated rounded cobblestone, flattened it somewhat by knocking rough flakes off both sides, and then trimmed it on the sides to prepare a long, sharp cutting edge. The process required twenty-five to sixty-five well-directed blows. It resulted in a neatly proportioned tool, the first fashioned according to a preconceived design, generally an almond- or pear-shaped pattern.

The coming of symmetry raises a number of questions. Did it serve a specific purpose in the sense that balance in design may make for more efficient balance in actual handling and performance, or did it have no such function and reflect only a new feeling for regularity and proportion? In other words, was it applied or purely esthetic, craftsmanship or art for art's sake? The questions cannot be answered with any certainty. Since we do not know what hand axes were used for (only that they were not axes, and were not used for chopping or any other sort of heavy-duty work), it is impossible to tell whether or not symmetry would have helped.

On the other hand, some hand axes are so much more beautifully shaped than others that the odds definitely favor esthetic considerations. According to Glynn Isaac of the University of California, symmetry may have even wider implications, as a sign of a dawning awareness of regularities in general and increasing social organization: "My intuition in this matter is that we see in the stone tools the vestiges of change that were

Hand ax, about 5.5 inches from base to tip, found in Norfolk, England; example of first symmetrical tools, this one with a fossil shell left in place, presumably for esthetic reasons. *(Colin Renfrew)*

affecting culture as a whole, and whose functional significance can only be understood in this light. Probably more and more of all behavior, often but not always including tool-making behavior, involved complex rule systems."

There are other intimations of complexity. The fossil record indicates that hominids not only arose in Africa but made Africa their exclusive homeland for at least 5 million years. We do not know why they stayed so long or why, for that matter, they began spreading to other continents some million years ago. But the odds are that the pioneers were members of the *erectus* breed, which by that time had brains varying in size from about 900 to 1,200 cubic centimeters, within the range for modern man (1,000 to 2,000 cubic centimeters). *Erectus* was probably responsible for one of the great cultural advances in human evolution, the first domestication of a natural force—fire. If fire was ever put to use in Africa during earlier times, firm evidence has yet to be unearthed. It could conceivably have served upon occasion to take and keep possession of caves occupied by lions and other nonhuman predators, or perhaps to keep predators away from their kills. But the earliest known traces of fire in any form are hearths that

burned perhaps 750,000 years ago in France, not far from Marseilles in the Escale cave, where archeologists have found fragments of charcoal and ash, fire-cracked stones, and five reddened hearth areas about a yard across. Similar evidence, dating to 400,000 to 500,000 years ago, has been found in Chinese caves at the Dragon Bone Hill site near Peking.

Since fire first appeared in northern cold-winter climates, its original use on a regular basis was probably to keep warm. But like all major technological developments since then, it brought a number of radical changes, transforming lifestyles in ways which no one could have predicted. Bringing fire into caves was like inviting a guest who never left, adding a new member to the nuclear family. It demanded the taking on of extra responsibilities, catering to a presence that had to be tended and replenished and not neglected too long, a luxury at first perhaps, but ultimately a necessity.

Hearths burning bright in the mouths of caves produced a kind of interior within an interior, a domed and glowing space in universal darkness, a globule or bubble of heat and light. Fire represented an early step in the continuing domestication of the human species. The wilderness became a bit less wild at firesides, living a bit less automatic. In the process of flooding a small zone with light, people effectively lengthened their day, and were no longer coupled quite as tightly to the rising and setting of the sun.

The world was a richer place with fire close at hand in the night. I have watched flames playing on convoluted cave walls, patterns of flickering light and shadow on the gray-pink-white-black mottled surfaces of crevices and alcoves and niches, tubelike channels winding further into the depths—and witnessed a variety of special effects that would inspire any stage designer concerned with creating an atmosphere of mystery and the supernatural. When the time for art ultimately came, fire must have served to enhance and animate illusion. A stimulant, a psychedelic thing, it must have stirred the imaginations of our ancestors as it stirs us today.

The next stage in human evolution, the passing of *erectus* and the emergence of *Homo sapiens,* our immediate ancestor, probably took place about 300,000 years ago. The transition seems to have been gradual, and it is not easy to say just when one ends and the other begins. A case in point is a fossil discovered more than twenty years ago in northeastern Greece, and still being analyzed and argued about. A farmer searching for new sources of water on Goat Hill near the village of Petralona heard rushing sounds deep underground, and thought he had located a spring. Instead, he discovered a cave. The sounds were not water but winds blowing through galleries which contained huge pink stalagmites and extended more than a mile into the hillside. Later, another farmer crawled and squeezed his way

behind a large rock and saw, imbedded in the cave wall and staring directly at him, the skull of what he reported as a monkey.

Actually, there is nothing simian about it. But it does present a rather mixed bag of features. The back part of the skull is quite thick, a full inch to be precise, and that plus a number of other characteristics puts the specimen in the *erectus* category. On the other hand, the broad flattened face and large brow ridges are among the traits typical of *sapiens*. The brain capacity, probably about 1,225 cubic centimeters, has an in-between status. In a recent study involving a careful reevaluation of more than 100 separate measurements, Clark Howell of the University of California, Christopher Stringer of the British Museum of Natural History and John Melentis of the University of Thessaloniki conclude that the specimen represents an early form of *sapiens*.

By 250,000 years ago cranial capacity ranged between 1,250 and 1,550 cubic centimeters, about what it is for the great majority of people alive today. The brain had tripled in size since *afarensis* times. The record includes a number of interesting developments, such as the occasional hand ax 2 or more feet long and weighing 25 to 30 pounds, which is far too big to wield in any practical context and suggests the possibiliy of some sort of symbolic or ceremonial use. An unusual hand ax found in England includes a natural decoration: a fossil scallop shell imbedded firmly in the flint and deliberately left in place.

The deliberate use of color appears at Terra Amata, a 300,000-year-old beach site on the French Riviera overlooking the Mediterranean. In 1966, bulldozers excavating foundations for a complex of luxury apartments turned up some stone tools and bones and in accordance with French law, all work stopped for five months while archeologists moved in to dig the site scientifically. Among other things, they found more than sixty pieces of ochre in various shades of yellow, brown, red, and purple. People had brought the mineral pigment to the site for purposes unknown, perhaps to decorate their bodies or some vanished artifacts.

The oldest interestingly marked object known to date comes from a site in southwestern France. Bordes, who found it more than a decade ago, showed it to me in his laboratory. It is a piece of ox rib about 6 inches long, with markings on the surface including what looks like a pair of curved lines running parallel to one another. Viewed under the microscope, however, each line actually appears as a carefully incised double line, and the pattern certainly looks purposeful. Calling for precise execution, it is especially impressive when you consider that it is 200,000 to 300,000 years old. But it depicts nothing recognizable, and hardly rates as a work of art.

The search continues for art or further hints of sustained imagination in *erectus* or early *sapiens* times. Reports of success, findings of animal or

human figures, have turned up from time to time. Some years ago a prominent prehistorian showed me a 300,000-year-old horse's leg bone with indentations at one end which looked to him like the eyes and nose of a human face, but that claim has never been confirmed. The fact remains that aside from a relatively few unusual observations, there is not much clear-cut evidence telling us how the people of those times lived, their social organizations and traditions and taboos.

"The overriding impression of the technological evidence in the archeological record is one of almost unimaginable monotony," Arthur Jelinek of the University of Arizona concludes. "We are talking about tens of thousands of generations of hominids maintaining patterns of technological traditions without discernible change." It was this monotony, this snail's-pace tempo, which began breaking up during the Upper Paleolithic and just before.

6 *Neanderthal Beginnings*

▷ There was nothing earth-shaking about the earliest days of *Homo sapiens,* nothing to hint at mounting forces strong enough to overcome the inertia of those ages of almost unimaginable monotony. Things began stirring 80,000 to 100,000 years ago. It was a relatively warm interim time, with an ice age in the recent past and another ice age imminent. Temperatures were falling again in Europe, "that diminutive peninsula projecting from the western marches of Asia," and the land would once more be locked in millenniums of snowbound winters.

It was another glacial cycle, and there had been many such cycles during the preceding 2 million years. This one was different in that a new kind of hominid was at large, the Neanderthals, perhaps the first members of our species capable of dealing with ice ages, although the cost must have been considerable. They had to be strong and resourceful to endure under conditions in which maintaining morale was as important as getting food and trying to keep warm. Physically they were distinguished, among other things, by prominent brow ridges, a sloping forehead, large nasal cavities, forward-projecting nose and teeth, massive limb bones and muscles, and a brain often slightly larger than ours.

This combination of features, deduced from specimens accumulated since 1856 and representing about 350 individuals, has yet to be explained. It had some special survival value, and one theory mentioned in most textbooks involves adaptation to cold climates. The large nasal cavities, for example, helped warm extra-large volumes of inhaled air, and were located an extra distance in front of the brain to protect that delicate organ from low temperatures. The massive muscles produced extra heat during activity. All quite plausible, except that the identical features also existed among Neanderthals living in warm, nonglacial climates, which rather complicates the problem and calls for further research on other factors that may have been involved.

The strangest thing of all about these people, stranger even than their unique physical characteristics, is the revulsion they aroused among their nineteenth-century descendants. That revulsion, the shying away from any

Statue commemorating the Neanderthals: in front of Les Eyzies Museum.

hint of lowly origins for the human species, is still with us if in somewhat attenuated form today, and it was far more violent during the second half of the nineteenth century when Darwin's notions were brand-new. Indeed, the Neanderthals burst into the world of the Victorians like naked savages into a ladies' sewing circle. The Victorians, who had long suspected that every Dr. Jekyll had a Mr. Hyde lurking in his background, responded with a shock of horror and a grim determination to disown this member of the family of man as utterly as possible, which was rather utter.

An amazing phenomenon, that emotionally charged putdown of a fossil breed, not only by educated laymen but also by many investigators professionally concerned with the human past. The reaction was by no means

unanimous, but science fiction makes better reading than science, and the detractors received more widespread attention. They did their best to discredit and humiliate "Darwin's first witness," the first prehistoric hominid to be discovered, as a monster, hideous and brutal and certainly no ancestor of ours. A sick Cossack who had perished during Napoleon's retreat from Moscow, "a member of the Celtic race," "an old Dutchman," a "half-crazed" wild man, a victim of water on the brain—these were some of the verdicts about the hapless individual whose remains turned up in the valley of the Neander River near Düsseldorf, Germany.

The clincher came in 1872 from Rudolf Virchow of the University of Berlin, a pathologist and anthropologist and one of the most highly respected scientists in Europe. His brief but authoritative analysis left no room for doubt that the skeleton belonged to a sick modern man, fifty or more years old, who had suffered from rickets as a child and from arthritis in later life, and had received several "stupendous" blows on the head. A final argument rested on impeccable logic: prehistoric people were too savage to care for the ailing or elderly, the Neanderthal individual was both ailing and elderly, therefore he or she could not be prehistoric.

The downgrading process continued for decades, even after the finding of further fossils, including several almost complete skeletons. The status of the Neanderthals was duly documented in a remarkable study completed in 1913 by Marcellin Boule, director of the Institute of Human Paleontology in Paris, and presented in a text published ten years later (and available at bookstores until recently). By that time no one seriously questioned that these people were prehistoric, but they were still held in low esteem.

Starting with the head end, Boule commented on "the simplicity and coarse appearance of the convolutions" of the Neanderthal brain, which "more resembles the brains of the great anthropoid apes or of microcephalic man"; moreover, the frontal lobe, recognized as a higher center involved in planning and foresight, "is debased and slants backwards." His summary: "Neanderthal man must have possessed only a rudimentary psychic nature, superior certainly to that of the anthropoid apes, but markedly inferior to that of any modern race whatever."

It was the same story from the neck down, only more so. Examination of vertebrae and other anatomical features suggested curvature of the spine, bent knees, and a stooping shuffling gait rather than a fully upright posture. The Neanderthal thigh bone "resembles that of gorillas and chimpanzees"; the shinbone "resembles that of the Apes." "The foot, still only slightly arched, must have rested on the ground on its outer edge, and must have assumed naturally an in-toed position; the wide separation of the great toe shows that it may have played the part of a prehensile organ." The latter point represents a "simian" feature, implying a foot still capable

of grasping the branches of trees, and an arboreal lifestyle.

It is worth noting that not one of these carefully considered statements jibes with the facts. That supposedly separated big toe is an artifact, the result of a faulty reconstruction. It does not splay off to the side in apish fashion, but points straight ahead like our big toe. The Neanderthals' limb bones, upper as well as lower, do indeed differ from ours, but not in any way that can be rated as "primitive." They were far more robust. Erik Trinkaus of Harvard University points out that their bones were denser, more solid, and 10 to 20 percent heavier.

Their shinbones, for instance, could withstand bending and twisting forces which would snap our shinbones like dry twigs. Extra-large swellings at the lower ends of their forearm bones served as platforms for the attachment of powerful muscles. They had a hand grip two to three times stronger than ours, and their strongest individuals could probably lift weights of more than a ton. One headline writer referred to them as real-life "Incredible Hulks," by no means an unqualified compliment.

These people were respectable mentally as well as physically. Some investigators believe they were less well endowed cerebrally than we are, a viewpoint not as widely held as it was a decade or two ago. If so, the difference is not evident in the skull specimens. Their forehead does slope backward, but not enough to diminish appreciably the size, and presumably the quality, of their frontal lobes. In other words, if their intelligence is in question, it cannot be challenged on the basis of the anatomical evidence.

So much for the facts. But in a sense the damage has already been done, and it will be a long time before the general public accepts the Neanderthals as anything more than coarse-featured, slouching half-humans, even in light of a careful study which concludes that if they "could be reincarnated and placed in a New York subway" and "bathed, shaved and dressed in modern clothes," they would not attract undue attention. Monster myths die hard. Some interested parties, including a few scientists, believe that relic Neanderthal bands may still be roaming remote wildernesses in Asia and North America, and may account for reported sightings of yetis, almas, sasquatches, and other as yet unidentified creatures.

For insights into actual behavior, into the nature of Neanderthal traditions and work patterns, we turn from fossils to artifacts, from paleontology to archeology. Bordes attests to notable advances in the art of tool making. An expert flintworker himself, having made more than 100,000 Neanderthal-style tools (and examined perhaps fifteen times as many originals), he stresses the increasing variety of implements compared with the output of earlier times, the majority of them made by shaping flakes struck from selected chunks of flint.

Some Neanderthal tools: scrapers (1, 2, 3, 4) and notched and denticulate tools (5, 6, 7).

The most common tool found in Neanderthal deposits is the side scraper, which features fine retouching, the controlled removal of small chips, off one or more long flake edges. It comes in a number of different types and was used, among other things, in various stages of cleaning hides for clothing and tent material. Another commonly excavated tool is the so-called denticulate, which may have three or four closely spaced notches, and serves as an effective saw blade in making stakes and spear shafts. Bordes has compiled a list of sixty-odd types, including choppers, borers, knives, and a half a dozen kinds of point, as well as side scrapers, all of which suggests an increasingly elaborate technology, a multiplication of purposes.

Bordes sees something more significant than variety in Neanderthal tool making: a new style of thinking, a level of abstraction applied for the first time on a large scale. Stage 1, the ability to see that "inside the rock there is a cutting edge, ready to be released by some blows with another stone," can be traced back at least 2 million years to crude African choppers. Stage 2 comes half a million to a million years later with the emergence of symmetry in the hand ax, which depends on the ability to see not only a cutting edge inside the rock but a shape as well.

Bordes's Stage 3, the invention of the "prepared nucleus" or Levallois technique, demands a higher order of insight and foresight. It involves seeing a cutting edge and a shape and, beyond that, a way of controlling the shape before striking off a single flake. It calls for a roundabout procedure instead of direct, head-on action, inhibiting the natural impulse simply to

knock a flake from a convenient rock and doing something else first, in the name of increased efficiency.

In the Levallois technique you take a flint nodule or nucleus, trim it around the edges to obtain a roughly oval shape, and flatten it a bit on top by further trimming. The next job is to make a narrow, flat section at one end, the all-important striking platform. After these preparatory steps, you are now ready to produce flakes. By directing sharp, precise blows against the platform at just the right angle, you can successively knock off a series of sharp, thin flakes in a kind of slicing operation, finally shaping the flakes into specialized tools.

Prehistoric tool makers invented this procedure more than half a million years ago, probably as the result of accidents in fashioning hand axes. If you are trimming an almond-shaped piece of flint and strike it at too sharp an angle, you may knock off a large flake consisting of most of the hand-ax face instead of a small chip, and thus ruin the job. The Levallois technique, deliberately producing large pre-shaped flakes, could easily have evolved from such mistakes. It was exploited widely by the Neanderthals.

Learning the technique may take months, and some people never learn. Two to 3 blows for an early chopper, 25 to 65 blows for a hand ax, and perhaps 110 to 115 blows and four separate steps to make a Levallois-flake knife—this is a rough measure of the increasing complexity of prehistoric technology. As a rough measure of efficiency, 1 pound of flint shaped into a chopper or hand ax may yield from 2 to 8 inches of cutting edge, as compared with more than 40 inches when used to make Levallois knives.

There are patterns among the tools, relationships which can help in interpreting the past. But the patterns are not obvious. They must be extracted from the evidence, from the intensive and often tedious analysis of excavated features. I spent part of a summer with Bordes at Combe Grenal, a site on a hillside not far from Les Eyzies. The daily routine involved digging in a marked-off section of the site, a grid square 1 meter on a side, using trowel and brush to uncover artifact after artifact, and recording the precise location of each item in a notebook.

The work went on nine hours a day on the average, six or seven days a week, for at least three months during the season, plus occasional off-season weekends, for a total of nine years—all within an area no bigger than a tennis court. It produced a huge hole more than 40 feet deep in places, more than 19,000 tools, and some 55 archeological layers representing as many individual Neanderthal occupations during the period from 100,000 to 40,000 years ago. After identifying every one of the tools and calculating the proportion of each of the sixty-odd tool types in every layer, Bordes made an important discovery. There were four different tool kits, all including a variety of tools but distinguished by some of the following diagnostic proportions:

1. *Tool Kit I:* 5 to 40 percent hand axes, 5 to 20 percent side scrapers.

2. *Tool Kit II:* very few or no hand axes (½ of 1 percent at the most), 50 to 80 percent side scrapers, featuring a nicely shaped heavy-duty variety with delicate retouching along a curved edge.

3. *Tool Kit III:* very few or no hand axes, few side scrapers (usually less than 10 percent), up to 80 percent denticulates and notched tools.

4. *Tool Kit IV:* very few or no hand axes, moderate proportions of denticulates and notched tools, 25 to 55 percent side scrapers.

These tool kits and their variations, patterns of artifacts, point to patterns in Neanderthal ways of life. They are widespread. In general an occupation layer yielding a large enough sample of tools for valid statistical analysis includes just one of the four characteristic kits. That holds not only for Combe Grenal and other sites in France, but also for the great majority of sites in the rest of Europe and in North Africa and the Near East. Something basic was going on, basic and rather subtle, for this is another case where the experts disagree.

Bordes has interpreted the four tool kits as marks of four cultures, four tribes with different origins and customs, perhaps with different languages or dialects and kinds of clothing. The tribes led relatively isolated lives. All of France probably contained no more than a few thousand persons at most, perhaps fifty to sixty bands, so encounters would have been brief and generally unexpected. Furthermore, distrust of strangers ran even deeper in prehistoric times than it does today, suggesting that the tribes tended to avoid one another. "A man may well have lived all his life without more than a rare meeting with anyone from another tribe," Bordes points out, "and it is very possible that these contacts, when they did take place, were not always peaceful and fruitful."

Another interpretation was offered nearly twenty years ago by Lewis Binford. He believes the tool kits represent, not four tribes or peoples, but the same people everywhere doing different things. This is a functional rather than a cultural approach. It implies that Neanderthal bands did not have different traditions, but simply used the same site for different purposes at different times.

Binford recalls his first all-out exchange with Bordes in the latter's laboratory: "Our arms began to wave. . . . We must have argued for more than an hour, our voices getting higher and higher, standing up, sitting down, pacing back and forth, leaning over the charts." The argument has not yet been settled, because the actual situation seems to be rather more involved than either of the proponents' viewpoints. But right now investigators are leaning toward the functional viewpoint in interpreting the artifact patterns at Neanderthal sites, as well as at earlier and later sites.

At Combe Grenal there is evidence that kits in the general Type III

category are often associated with people specializing in horse hunting, and the large proportions of denticulates and notched tools may be used not only in woodworking but in some sort of food processing, say, shredding strips of meat for drying or smoking. The side scrapers predominating in Type II kits may have served in the large-scale cleaning of hides obtained during summer hunting trips and being worked into clothing for long hard winters to come. Also, three of the four Neanderthal kits turned up on different parts of the same living floor of a cave in northern Spain, indicating distinct activity areas within the camping ground.

Still, the last word has not been said. Bordes concedes that some of the differences in the composition of tool kits may support the notion of different activities. But he knows, and so does Binford, that function cannot account for many important observations. Different parts of France, for example, feature certain tool kits over periods of many generations. Sites in the Provence region bordering the Mediterranean coast have no Type I kits at all, while sites some 350 miles to the northwest in the Charente district feature Type II kits almost exclusively.

It does not make much sense to think of one area where only one class of activity is practiced, and another where an important activity is bypassed entirely. These and other points argue for territorial factors and a cultural viewpoint. So, imposed upon strictly functional or utilitarian patterns, patterns which may predominate under certain conditions, we also find expressions of style—socially accepted, socially dictated, ways of working and behaving.

A similar state of affairs, incidentally, most probably holds for Upper Paleolithic tool kits. Functional arguments, implying different kits as signs of different activities, may be relevant to certain Aurignacian and Perigordian assemblages which overlapped for 10,000 to 15,000 years. It may be a different story for Solutrean times, however. Pressure flaking, heat treatment, the first eyed needles, the making of such items as superthin laurel-leaf blades, hafting—these developments all seem to have come within 3,000 years or so, and may represent a cultural phenomenon, a spurt in experimentation as an adaptive response to new living conditions. Bordes sums up the situation: "As ever, reality is more complicated than was thought at the beginning."

Reality for the Neanderthals meant, above all, surviving through those long hard winters. There is nothing today to compare with the oscillating pattern of year-round climate that prevailed then in western Europe. The pattern combined generally cool, grassy prairie summers, averaging about 70 to 75 degrees Fahrenheit during the coldest glacial periods and perhaps 5 or so degrees higher during warmer interglacial periods, with grueling winters—five months of temperatures 20 or more degrees below zero, with-

out a break, and marked by dry spells and periods of storms and heavy snows.

Incidentally, there were far worse climates such as the tundras, "the vast, nearly level, treeless plains of the arctic regions of Europe, Asia and North America." The Neanderthals entered tundra lands upon occasion, but probably not for stays as extended as those of their Cro-Magnon descendants. They lived in huts as well as caves. Soviet archeologists have excavated one of their shelters in the Ukraine, in the foothills of the Carpathian Mountains, a large oval area surrounded by heavy mammoth bones which enclosed some fifteen hearths. This complex probably represents the remains of a hut, with the bones serving the same purpose as the stones at Solvieux (Chapter 4)—namely, as anchoring elements to hold down the edges of skins. It dates back at least 40,000 years and may be considerably older.

The Neanderthals had a number of hunting options during winter dry spells. They stalked their prey on the edges of snow meadows, exposed wind-swept places where herds of reindeer fed on grasses insulated from the cold and growing green beneath a foot or more of snow. Traps and snares set at strategic points along snow trails provided small game. But keeping the home fires burning became an increasingly serious problem as the winter progressed. It could not have been long before people used up all the firewood within a reasonable radius of their base camp, and had to move further and further in search of fuel. This lifestyle may account in part for their massive body build. They had to be unusually strong and rugged to walk perhaps 20 miles a day carrying heavy loads through deep snows, and all that, as far as we know, without snowshoes or any other form of specialized equipment.

The most severe living conditions prevailed during the snows, times of immobility and waiting and huddling. Blizzards lasting for days subjected hunter-gatherers to the ultimate test. Natural selection proceeded at a swift pace among isolated groups, small bands of one or two families confined to hillside caves and tents down in the valleys, weeding out the least healthy and the least resourceful, putting a special premium on foresight. There is no way they could have emerged alive from glacial winters without some sort of stockpiling, although the evidence is difficult to come by.

Some time ago, archeologists digging in a cave on the rocky Channel island of Jersey came across an unusual feature: a concentration of animal bones partly protected by an overhanging ledge. The site dates back about 60,000 years, when so much water was locked up in mile-high northern glaciers that the seas were more than 200 feet lower than their present levels and there was no Channel, the island being part of a wide plain between England and France. Neanderthal hunters had brought three rhi-

noceros heads into the cave, as well as the remains of at least five mammoths and an undetermined number of deer, and piled them in a pit. That was a lot of meat, but it takes a lot to nourish people living in subarctic climates, an estimated daily ration of 2 to 3 pounds per person.

There are other ways of storing meat. Perhaps the Neanderthals did what the Eskimos do today, making use of underground chambers hacked out of permafrost, soil frozen solid all year round. During a visit to the Nunamiut Eskimo village of Anaktuvuk in Alaska, where Binford was studying hunting and survival strategies (p. 63), I climbed down a wooden ladder into one of these so-called ice cellars and helped carry out a large cut of icy caribou meat, selected for supper from ample supplies piled up against frosted walls. Eskimos on the move, nomads shifting camp every month or so, rely on meat in more compact packages. They generally carry strips of dried meat such as the occupants of Combe Grenal may have processed with their denticulate tools.

When the chips are down, however, survival involves something more than run-of-the-mill ingenuity. Something extra is called for, an extra degree of imagination and a concern that seems groundless at the time, the ability in the midst of abundance to prepare for famine. The Eskimos at Anaktuvuk depend for their lives on herds of caribou which move year after year over mountain passes along traditional migration routes, so regularly and in such large numbers that you can see deep ruts worn in solid rock.

But even these compulsive creatures are not 100 percent predictable. Every now and then for reasons utterly unknown they leave the beaten track and take another route. Eskimos have starved to death waiting in deep snows for caribou that never came. Sometimes storms are so severe that hunting is impossible, and on rare occasions, perhaps once in half a century, caribou populations crash and there is not enough food to go around. The only insurance is to put in a supply of emergency or disaster foods, items such as the carcasses of wolves and foxes thrown on the roofs of houses beyond the reach of dogs and other scavengers.

Another item of disaster nourishment is the mandible or lower jawbone of the caribou. It does not rate as a good source of fat-rich marrow, contains a fibrous gristly tissue known as patik, and is generally discarded intact. But all specimens of the bone were broken in the debris of a house occupied nearly a century ago in times of severe food shortages. We can deduce similar emergencies among the Neanderthals at Combe Grenal. Out of the hundreds of reindeer, horse, and ox mandibles recovered from the site, all but one had been cracked open, presumably a last-resort measure to get at the patik inside.

The record has something to say about hunting methods, only a hint, but significant in the context of earlier and later practices. Many millen-

niums before the emergence of the Neanderthals, human beings had be-
come the most versatile and among the most dangerous of predators. "They
hunted anything and everything," Bordes notes. "There was nothing they
would not or could not go after, squirrels or rhinoceroses or mammoths,
but it was mainly opportunistic. They went out and killed whatever they
came across." Neanderthal hunters seem to have been somewhat more sys-
tematic, more specialized, as suggested by occupation layers at Combe
Grenal and elsewhere dominated by the bones of a single species, usually
horse or reindeer.

Also, analyzing skeletal remains can provide a few clues to the tactics
of the hunt. To most of us nothing is deader than bone, especially fossil
bone. But specialists know bone as a highly complex tissue which contains
information, a calcified record of behavior, a code that is extremely difficult
to crack. There are bumps, hollows, grooves, ridges, and contours, some so
subtle that you cannot see them with the naked eye and must turn to a
microscope, or the sense of touch. Sometimes you can detect invisible fea-
tures by taking a bone into a dark room and running your fingers over the
surfaces, a kind of deductive Braille system.

Trinkaus draws attention to "a curious feature" of the Neanderthal
scapula or shoulder bone. Its border has a groove for the attachment and
insertion of a muscle that imparts a rotary or rolling-out movement to the
upper arm. The groove is deeper than the corresponding groove in present-
day specimens, indicating that the muscle was larger, stronger, and more
highly developed. More significant, the groove is located at the back of the
border rather than at the front as in modern shoulder bones, providing a
larger area for muscle attachment.

On the basis of these and other observations, Trinkaus sees an anato-
my designed to combine finesse and power and, in a report prepared with
his colleague William Howells, points to "a finer control of the arm and
the hand in throwing a spear or retouching a flint, without any loss in the
great muscular strength of the limb." One can go a step further and deduce
more from such evidence. It may be stretching things a bit, but throwing a
heavy spear with a heavy point, the sort needed to penetrate thick skins,
implies not only strength but coming fairly close to your prey, certainly
within 25 feet. Furthermore, the throw must be followed up. Hunters had
to close in swiftly for the kill, for the final twisting and stabbing thrusts,
behavior which helps account for the Neanderthals' massive physique.

Like athletes and other physically active individuals, they had their
share of accidents. Their limb bones frequently show signs of healed frac-
tures, a characteristic of other prehistoric populations, one collection of
skeletons indicating an injury rate of more than 30 percent. Big-boned and
heavy, they were vulnerable to the wear-and-tear disease arthritis, and suf-

fered from symptoms which modern medicine and surgery are only beginning to alleviate. One of the eight Neanderthals found in Shanidar Cave in the highlands of northern Iraq, a man in his fifties who lived 45,000 or more years ago, was a victim of advanced arthritis. Trinkaus once showed me the man's heel and ankle bones, where cushioning cartilage had worn away from the joints, leaving bone to rub against bare bone. You could see, and almost feel, from the smooth, shiny surfaces the excruciating pain he had endured for years.

So we have glimpses of the Neanderthals' way of life. They demonstrated qualities common to all hunter-gatherers, only put to the test under extreme and critical conditions, particularly during the worst of glacial times. They endured as a species for a long time, apparently staying put in their home territories. But the rate of attrition must have been staggering. There was no escape, no moving away, during the height of Neanderthal winters. A death in the family was mourned no less than among hunter-gatherers living in warmer climates, no less than among ourselves for that matter—but with one big difference. In the woodlands of aboriginal America, the deserts of Australia and southern Africa, and most other environments, life can go on pretty much as usual after the passing of even an outstandingly successful provider. People are mobile; other providers and food sources are accessible.

In a Neanderthal winter setting, however, options were extremely limited. Aside from the grief, the death of a single adult could bring death to the entire family. Many hunter-gatherers must have been lost in blizzards or severely injured, while those back at base camps waited in vain for food and firewood, and perished one by one. Many must have succumbed to disease in their homes, with the same tragic outcome. From an evolutionary standpoint, these were times of rapid and ruthless selection, as individuals and bands were wiped out, and only the cleverest and strongest—and the luckiest—endured. There were strong reasons to think about, to account for, death.

The Neanderthals were the first to bury their dead, the first to believe in an afterlife. We have traces of their ceremonies: in a Shanidar occupation level 50 feet below the cave floor, in a niche of stones, lies the skeleton of a young man, and around the skeleton clusters of more than 2,000 grains of fossil pollen. One late spring or early summer day 60,000 years ago people had lain him to rest on a bed of yellow, red, white, and blue flowers, grape hyacinth, rose mallow, hollyhock, bachelor's button, groundsel. The flowers may have been chosen for medicinal reasons, since all of them are or were believed to have healing powers. For instance, Iraqi peasants still use extracts of hollyhock as "a poor man's aspirin" to relieve pain.

An entire family was found at La Ferrassie, a rock shelter in southern

France—two almost complete skeletons, male and female, presumably the parents of four children buried nearby and represented by fragmentary remains only, all laid to rest close together in separate graves. The graves contained side scrapers and other flint tools, some in mint condition as if made specifically for the use of the deceased. Other graves contained animal bones, many of them charred, indicating that chunks of roasted meat were buried together with the body. "Death itself seems to have been regarded as a kind of sleep," according to Clark Howell of the University of California in Berkeley, who notes that at a number of sites in Europe and the Near East the body had been placed on its side, legs bent, head resting on right arm.

This is the archeology of religion, of affirmation. Excavated grave goods and other traces of ritual state collectively, and as clearly as if it had been spelled out in plain English that "the dead are still among us, invisible but not far away, requiring attention and sustenance and commemoration." Implicit here is the concept of a passage, a journey, to another world with lines of communication still open. In other words, death is an illusion, an apparent ending only. The dead have not actually died, but exist in a new state and retain enduring ties with the living.

Such notions marked a new way of looking at the world, a declaration of independence. In effect, the idea of a continuing existence asserted the right to tinker with reality, to create new versions of nature which jibe better than the old version, or than no versions at all, with what we want to believe, even if that means going against the raw evidence of the senses. If things are not what they seem, then the sky is the limit. We are no longer bound by the dictates of ordinary common sense. The way is clear for all sorts of abstract thinking.

Given that the Neanderthals evolved belief in an afterlife and death rituals, the odds are that they also had some form of appropriate art. As far as we know, they did not go in for cave art or permanent art of any sort, certainly not on a large scale. But art and religion have been associated throughout history, and they were probably associated from the very beginning. Neanderthal sites commonly include pieces of black manganese and red ochre rounded and pointed like pencils, indicating that people were painting their bodies—a practice that may have started several hundred thousand years earlier with natural pigments found at the Riviera site of Terra Amata (Chapter 5). Also, they may have invented a new use for the red ochre, as a rouge to impart the illusion of health and life to the faces of the dead.

The Shanidar cave has more to tell us. The skulls of two of the adult males buried there are strangely shaped—unusually flat in front and unusually curved in back—and generally so out of line with representative

Neanderthal head contours that Trinkaus believes they were deliberately deformed. Judging by tribal practices in modern times, this could have been accomplished by repeatedly pressing the infant's head manually like molding clay, or else by binding the head with a flexible band for six to twelve months. In any case, it testifies to the existence of what Trinkaus calls "a sense of personal esthetic." The Neanderthals were doing on small scale what we do everywhere and on an enormous scale today, actively changing things, including their bodies, to suit their own purposes. It was the beginning of efforts toward evolution by human direction rather than natural selection.

Belittling the Neanderthals is no longer fashionable, at least not in scientific circles. Among the worthiest of our ancestors, they are to be taken seriously. Their lifestyle differed significantly from the lifestyle of Upper Paleolithic people, however, and we do not know why. The past two or three decades have seen a major concentration of research talent and funds on events that took place in Africa millions of years ago, on the transition from ape and near-ape to human being. In the future, investigators will be paying more attention to the Neanderthals and their role in developments of the last 100,000 years.

7 *Special Places, Special Purposes*

▷ The key to the Upper Paleolithic lies in Neanderthal times with the first signs of burials and burial customs. Whatever the Neanderthals thought of death and life after death, whatever sort of journey they launched their dead upon, they acted within the framework of an evolving system of beliefs. It was not only a matter of placing the body in a dug grave, on its side as if asleep or on a bed of flowers, with tools and roasted meat. There are other patterns in the record, other relics of ritual behavior.

Near Monte Circeo on the coast of the Mediterranean between Rome and Naples is a cave whose innermost chamber contained a ring of stones surrounding a skull with a hole bored in it. Another cave circle, this one of ibex horns stuck in the ground around the skull of a young boy, has been found in a deep ravine in central Asia. Shortly after World War II, a farmer hearing of the discovery of Lascaux and living not far away, decided that he too could discover something of importance. With nothing but expectation and luck to go on, he started digging in his front yard, and came across a skeleton complete except for the skull, stone drains, and a rectangular pit filled with the remains of more than twenty cave bears and covered by a large flat stone.

These and other excavated patterns, traces of organized structures, are difficult to reconcile with the old image of Neanderthals as subhuman beings, although some investigators managed. The patterns attest to behavior based on tradition, the presence of individuals who had buried fellow band members before, knew the right ways of doing things, and were convinced that the right ways would affect the course of future events. We may never learn the details of the procedures they worked out, the arrangements they made, but it is enough to recognize that they had evolved rituals and reasons for the rituals.

The art of the Upper Paleolithic arose out of such beginnings, but in a different context. As far as we know, people were not buried in the art caves. The Cro-Magnons elaborated for other purposes what the Neanderthals had invented to deal with death and the dead. Until recently archeologists in general avoided speculating about the new purposes, partly because

the prospects of learning or proving anything seemed remote, but mainly because they were busy focusing almost exclusively on economics, on the practical business of routine getting along.

They were and still are devoting most of their time to the sort of problems which appear to be more amenable to a hard-headed, hard-science approach, problems involving technology and the daily grind, such as those discussed in the preceding chapters—the tools people used, the food they ate, the places they lived in, the size and mobility of band societies. The result has been a growing body of evidence about the subsistence and survival strategies of hunter-gatherers, and the realization that this evidence now provides a solid basis for wider studies of the origins and uses of art.

The old tradition of not quite knowing what to make of art persists in some circles. Some archeologists still tend to think along Puritan lines; for them art is an activity, useless at best and potentially almost sinful, pursued by childish grown-ups with nothing better to do. One investigator who has made notable contributions to human evolution told me recently that "the people who painted in caves had a more leisurely life, time to think about such inessential things."

A baffled zoologist writes "only man's spontaneous tendency to create artistically is difficult to place in a biologically adapative context." Freud considered all art "psychoanalytically inaccessible." The conventional book or course on art history includes a few brief lip-service statements extolling the great painters of the Upper Paleolithic, and lets it go at that. Generally speaking, however, there is at long last a feeling for the essential seriousness of art as a significant expression of evolutionary focus in its own right rather than as a mere epiphenomenon, a by-product of higher intellectual capacities with no selective or adaptive value.

The new attitude is a direct outgrowth of the work of Leroi-Gourhan, the first scholar to make a strong argument for each cave as a unit, a composition of a sort: "A real order seemed to me to be reflected in the arrangement of the figures." We can see the order in parts of the caves, "hot spots" or nodes of organized expression where the art was applied most intensively—in the rotunda at Lascaux, the Great Hall at Altamira, and the Salon Noir of Niaux, another rotunda with a vast domed roof and an array of black animals including twenty-five bison, sixteen horses, six ibexes, and a deer. (The figures are fading, not because of tourists but because the paints are being washed away by waters seeping down through the porous limestone of the high cliff above the cave.) The 65-foot frieze of open-air sculptures at Angles-sur-Anglin is also a notable site of concentrated art.

Another partly lost frieze, this one underground, is located in Cougnac south of Les Eyzies. One of the most beautiful of the smaller art caves, not

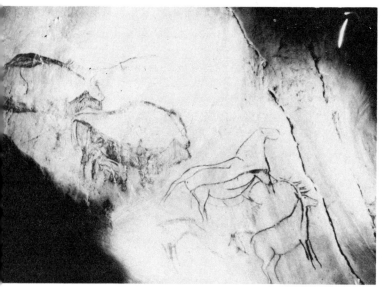

**Niaux:
some of the figures
concentrated in
the Salon Noir.**
(Jean Vertut)

only for its paintings but also for its white columns and sparkling crystal formations, it contains sections of what must have been a single composition. One set of figures, extending for about 15 feet, has half a dozen ibexes, three deer, and a man pierced by several lances—one of the very few examples of humans attacking a human—and nearby a pattern shaped something like a single-smokestack steamship. A second set of figures including two more wounded men lies further along the passage. Located between the two sets is a stretch of wall which appears blank at first glance.

On closer examination, however, one can see faint traces of paint underneath calcite layers, suggesting that in times past a single large panel existed here, extending more than 30 feet from a red deer in a niche on the left to a small mammoth on the right. Moreover, further to the left around a short bend are still more drawings, among them a mammoth and several human figures. So the original gallery may possibly have housed a long frieze which could be viewed while walking past, something comparable to an unrolled Chinese art scroll. Part of the Cougnac pattern is repeated at Pech-Merle, a cave about 20 miles away. It also contains the combination of a steamboat shape and a man impaled with lances and, located on a central panel of a large chamber, a widely reproduced pair of large spotted horses painted back to back, surrounded by five silhouettes of hands, the head of the right-hand horse drawn neatly to fit into a similarly shaped natural rock projection, and above it an engraving of a long narrow fish, probably a pike.

People sensitive to the uses of space and special effects planned even more impressive settings in a pair of Pyrenean caves—Trois Frères, which contains as its main feature the bell-shaped chamber where Breuil spent so much time copying engravings (Chapter 2); and Tuc d'Audoubert, or Tuc for short. The two caves, separated now by a distance of only about 15 yards, were one part of a single underground system, probably long before the appearance of the human species. In fact, the two entrances are located on opposite sides of the same hill and were discovered about sixty years ago by the same three Bégouën brothers. Another Bégouën, Robert, the son of one of the original discoverers, is currently conducting studies in the caves along with Jean Clottes, director of prehistoric research in the French Pyrenees.

Prehistoric planners must have considered the routes leading to selected chambers as well as the chambers themselves. Route and destination were part of the same design, a journey often deep into the cave and an ordeal, since depth is as much a matter of suspense and what you pass on the way in as of actual distance and difficulty of access. For example, getting to the Trois Frères chamber takes one past many dark holes to the side

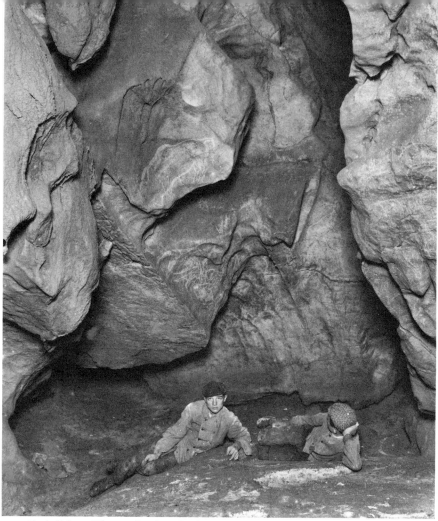

Trois Frères: Bégouën brothers in the sanctuary they discovered. Figure of the "sorcerer" barely visible, upper center.
(Courtesy Field Museum of Natural History, Chicago)

and underfoot, holes marking pits and plunging tunnels which lead to lower galleries where a river flows, and at certain listening-post holes you can hear the rushing of its waters faint below. Also, the route was not necessarily direct. It may have included digressions or off-the-track excursions to places like the side gallery jammed at one point with several massive blocks of stalagmite. According to Clottes, the blocks were dragged and hauled into position, a major effort accomplished with malice aforethought, namely, to make the going tougher.

Further into the cave and getting closer to the main chamber now, two large cave-lion heads are engraved on the right-hand wall, perhaps as guardians and vaguely reminiscent of more recent guardians like the pair of imperial lions in London's Trafalgar Square. Past the lions, along a pas-

sage cluttered with fallen rocks, and a half-slide down a slippery clay slope brings one into a large wide pit, the floor of the chamber. This place is known as the "sanctuary"—a highly loaded word implying a great deal that remains to be proved such as a belief in supernatural beings and a system of myth and ritual, a religion or protoreligion. But in surroundings like these, the word can be justified or at least forgiven, because of the use of art and topography to create an enhanced feeling of awe and mystery.

The chamber was well chosen for surfaces as well as secrecy, rough convolutions of ledges and overhangs, places for hundreds and hundreds of engravings, a dozen panels in expected and unexpected locations, representing in the words of one scholar "one of the finest moments in Franco-Cantabrian realism." One panel, the one where Breuil made out more than seventy animals and parts of animals, includes more than two dozen bison and at the bottom a half human–half bison figure—and there are about a dozen panels in all.

This place of engravings contains only one painting, probably the most widely reproduced of all Upper Paleolithic works of art. Viewed best from a point about halfway down the clay slope, it looms over the sanctuary from a high wall near the top of a deep crevice—a figure drawn in heavy black outline, bent over in an almost impossible crouching position, with legs and body that look human and short forelimbs with paws rather than hands, and only a faded black smudge at the left where the head should be.

That is about all one can see from below. But there is a way of coming quite close to the figure by crawling into a tunnel and climbing a hidden and very slippery side passage which rises abruptly, turns back on itself like a spiral staircase, and finally opens up on a kind of window overlooking the chamber. This is the way used by the prehistoric artist, and by investigators studying the figure, which is engraved as well as painted. From there you can make out the head twisted to the left, full face, with wide-staring owl-like eyes and the ears and antlers of a stag. Close up, the feet as well as the legs and body appear human, and so is the penis except that it is drawn in a position more appropriate for a feline than for a man. The figure has a horse's tail and a vaguely beak-shaped nose.

Many observers, including Bégouën and Clottes, believe it represents a masked man dressed in some sort of ceremonial costume, and refer to it as "the sorcerer" or "horned god." Others think of it as a mythical composite creature. It dominates the sanctuary, can be seen from certain positions only, and one wonders about its possible relationship to the other human-bison figure on the overhang panel, and to yet another "sorcerer" hidden in a short passage at the back of the pit and apparently playing a bow-shaped musical instrument.

Even more tantalizing is the relationship between the Trois Frères

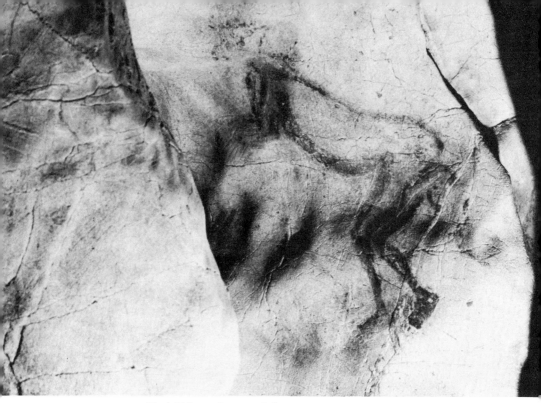

Trois Frères: close-up of the "sorcerer." *(Jean Vertut)*

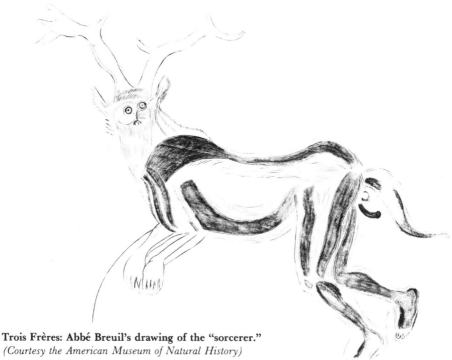

Trois Frères: Abbé Breuil's drawing of the "sorcerer."
(Courtesy the American Museum of Natural History)

sanctuary and the remarkable chamber at the very end of the Tuc cave, only 15 yards away as the mole burrows but isolated by tons of debris that filled in the connection ages ago. The French have a word for caves like Tuc, "sportif," suggesting difficult and challenging and fun. It is all that, and more. Half hidden among trees, the entrance is the outlet of a river which runs through the hill, and the Bégouën brothers originally poled their way in on a raft made of wooden crates and gasoline cans. Today one uses an inflatable raft and a paddle, pulling up on a beach inside the cave.

The journey from there on is sportif indeed. It starts in a chamber white as the inside of a huge calcite crystal, an arctic scene with encrusted white floor and, extending from floor and ceiling, tapering white icicle-like spikes which one must be careful not to break. A narrow iron ladder at the far end of the chamber helps in ascending a 30-foot chimney to an upper gallery where the three brothers passed on the day of discovery, only to confront a dead-end barrier in the form of a solid limestone sheet, which they managed to hammer and chisel through at a later date.

A great many things happen beyond this point. The route becomes more difficult, with a series of climbs aided for the present-day explorer by iron handholds driven into the rock and more ladders, but demanding ropes and some extremely tricky tactics on the part of prehistoric speleologists. A

Tuc d'Audoubert : stalagmite crystal chamber near entrance.
(Courtesy Field Museum of Natural History, Chicago)

climb up the last ladder brings one to a jagged hole that must be squeezed through and, further on, a belly-crawl through an extremely muddy chatiere. There is evidence of some sort of pattern along the way past the broken-through barrier to the innermost chamber, a series of features passed in sequence.

First, to the left one sees a pile of limestone slabs or plaquettes which have dissolved into one another over the millenniums so that they are welded together. Such slabs often have figures engraved on them. In fact, Clottes writes of recent excavations in other parts of the cave system: "This year we found 27 new engraved plaquettes, including some with human figures. ... The total number is now 218, and we have not finished looking." We do not know whether the Tuc plaquettes were blanks or had been engraved, nor the reasons for bringing them into the cave in the first place. A "macaroni" scrawl of curving lines or meanders appears on the ceiling a bit further in, and then a series of rearranged fossil bones of cave bears that lived, hibernated, and died in Tuc galleries—a smashed skull with teeth removed, a pair of lower jaws also toothless, and a rib aligned parallel to the path as if to serve as a direction marker.

Past the rib are more features, all strange and out of place in their cave settings, all there with a purpose and inviting guesses, and all frustrating as far as true understanding is concerned. The next feature, the complete skeleton of a snake, may have been brought in as an offering or a sacrifice or perhaps a totemic sign, in any case part of some ritual we may never reconstruct. And then, set in a row on a ledge snug against the wall, come three teeth, of a fox, a bison, and an ox respectively—all juvenile, pierced and painted with red ochre, possibly strung together originally, possibly a gift—but if so, to whom?

The most enigmatic feature of all, the last in the series before the innermost space at the cave's end, is a small side chamber. Some sort of activity went on here, and all we can say about it is that it must have been rather intense and probably noisy. Impressed on the clay floor are about fifty heelprints of children estimated to have been thirteen to fifteen years old. There is something puzzling about these vestiges. They seem to start at a place deeper in the chamber, and fan out in half a dozen rows toward the entrance, each row perhaps representing the path of a child. And why were the children walking or running on their heels? Furthermore, the chamber is so low, 5 feet high at the most and 3 feet or less in most places, that even children would have to stoop and stoop low.

These and other features were part of the build-up, preliminaries to the main attraction. Tuc ends in a small circular chamber, a rotunda with nothing on its walls, no paintings, no engravings. The entire space has been used to enclose a pair of sculptures placed on the floor, right in the center

of the rotunda, like jewels in a black setting. Two magnificent bison of unbaked clay, each about 2 feet long, are set upright and leaning against a rock fallen from the ceiling, preserved for 10,000 to 15,000 years by some miracle of topography, temperature, and humidity—delicate modeling and stroke marks in the clay indicating eyes, nostrils, manes, tails, horns, swelling humps and haunches.

The sculptor probably obtained his clay from deposits in a side chamber, the one with the children's heelprints. On the chamber floor to the right is a large hole where clay was scooped out, perhaps with a piece of stalagmite lying nearby. Behind the hole in a far corner one can see a mound of clay which might be a reserve supply or a damaged sculpture. To the left, lying in a heelprint, are two coils of clay, a pair of unused buffalo horns according to one theory. There is no theory to explain a final touch, a "construction" of tiny stalactitic spikes stuck upright in the clay.

The only comparable works in all of Upper Paleolithic art are located in a cave called Montespan just 15 miles to the west. It includes a gallery containing some two dozen sculptures molded in clay on the floor at about the same time as the Tuc bison. Unfortunately, the pieces have been ruined by flooding waters, most of them reduced to nondescript lumps. But they must have made an impressive display. One figure, located toward the deepest and lowest part of the gallery, is a nicely shaped horse. In another figure you can make out the remains of legs, the end of a tail, and the front part of the body, most experts agreeing that it was either a lion or a horse. The largest sculpture is a mass of clay which stands 3 feet high, weighs several hundred pounds, and is said to have been a cave bear. Montespan resembles Tuc in a number of interesting respects. It also extends through a hill, has a river running through it, and is difficult to negotiate. Incidentally, it also contains the skeleton of a snake.

Prehistoric artists created another very special place in a cave just outside Les Eyzies village. Font de Gaume, a narrow gallery extending into the side of a cliff, must be visited several times because many of its paintings have faded and are overlaid by calcite layers, some more than half an inch thick. It takes time to tune in on its art, to reconstruct the full image on the basis of the missing parts of graceful lines that continue faint or vanish entirely beneath some of the layers.

Past the midpoint of the gallery, opposite the entrance to a side gallery, is a scene which because of the fading appears slowly and in fragments, and the whole is elusive—seen only briefly like figures exposed for an instant through rifts in a mist. The only clear features are two long black, curving antlers and a black line sweeping up from them to the left, enough to convey the form of a stag. To the right and below the antlers is something which at first glance seems merely an area smudged with red. It

Montespan: a stream running through it often floods it. *(Collection Musée de l'Homme, photograph by F. Trombe)*

happens that these figures were engraved as well as painted, and the incised lines help to make out some of the contours where the paint is gone. What emerges as the eye detects traces of lines and the mind fills in the gaps between the traces is a black stag, head bent down, and nuzzling or licking the head of a doe painted red with black markings and kneeling in front of him.

Paulette Daubisse, who with her husband has been in charge of the cave for more than a generation, points out that the mood of this composition is typical of Font de Gaume: "The painted animals in Lascaux are grandiose and violent. Here they are at rest and at peace, more gentle,

more realistic." Bison dominate the cave. It includes a frieze of four or five bison—at least seven others having all but vanished some time ago—heading toward the entrance and the little valley outside, and a large polychrome bison with three tectiforms or roof-shaped forms and a mammoth painted over it. About 80 of the 250-odd figures or parts of figures visible in the cave are bison. The main gallery tapers off into a fissure which includes a rhinoceros in red outline and a "ghost," a human head with two black dots for eyes. The last figures, near the end of the fissure, are four small engraved horses and a larger feline, seen by climbing about 5 feet up the fissure and twisting around to your left.

Font de Gaume's inner sanctum is located not far from the end of the main gallery. A small side chamber or niche, it has a domed ceiling which had apparently been painted red and then used as a background for a pattern of about a dozen painted and engraved bison, including one drawn neatly to fit inside a circular hollow. The niche, vaulted and private and compact with so much work done in such a small space, produces a correspondingly intense or concentrated sense of ritual, a feeling which grows with every viewing. I know the chamber from half a dozen visits. Daubisse has been there thousands of times, and sees things I cannot see.

The impact of this special place and many others is all the more noteworthy considering the distance that separates us from the people of the Upper Paleolithic, considering how much more it meant to them than it can mean to us. The experience is enormously diluted for the present-day observer. After all, it was their world and their set of beliefs. Whatever the images conveyed, it was concrete and contemporary for them, significant in an immediate way. There was also the added force of images seen pristine and intact, unspoiled by time, in their full color and clarity of line and detail.

Beyond that, and perhaps even more important, the staging was entirely different, with emphasis on the use and power of special effects. Take the lighting as one example. Today we go into caves equipped with flashlights, which provide steady illumination and beamed or directed illumination, and with acetylene lamps, also steady as well as bright and intense. Our ancestors had nothing like that, nothing as controlled. They came into caves, singly or in groups, with torches and lamps. To see what they saw it would be necessary to do the same, to recreate the whole occasion; but as far as I know, that has not been attempted.

Occasionally and informally, however, cave experts in France have tried to duplicate parts of the prehistoric setting, and here is what one of them told me: "Ideally one should spend an hour or two in complete darkness before looking at the paintings. Modern eyes are not accustomed to viewing things with just a little bit of light, so you must first prepare your-

self, and get in the mood for what you are about to see. Then you can light your lamp, preferably the sort of lamp the artists used, animal fat in a hollowed-out slab of limestone with a wick burning in it.

"After you light your lamp, it takes a while for the experience to build up, perhaps as much as fifteen to thirty minutes, certainly much sooner for prehistoric people. The animals become animated in a flickering, yellow light which plays on the hollows and projections of the cave walls. Sometimes they seem to be moving together deeper into the cave or toward the entrance. Sometimes the flame gives a curious effect of imminence, a different kind of movement. The animals are not going anywhere. But they seem alive nevertheless—breathing, relaxed or tense, and ready to move."

The most recently announced special place, a surprise even in the light of decades of surprises, is very special indeed. Past discoveries have all involved the use of readymade locations, chambers and passages hollowed out of rock by flowing and seeping waters, and offering a variety of natural surfaces for paintings and engravings. Nature, in short, was the architect; the artist came along later to decorate and enhance. The new discovery, however, involves a completely unique structure, man-made from scratch, and located in a cave about as unmysterious and unspectacular as a cave can be.

Tourists will never flock to El Juyo, a small single-chamber cave tucked away among low hills at the end of a bumpy dirt road about 5 miles west of Santander on the northern coast of Spain. Excavated most recently by Leslie Freeman of the University of Chicago and J. Gonzales Echegaray, director of the Altamira Museum and Research Center, it had yielded much important information about the subsistence and technology of the hunting-gathering societies that produced the art, but none of the art itself—not, that is, until midsummer 1979. Then there was an unexpected development, or rather, a series of unexpected developments.

In archeology, as in cricket, not much happens most of the time, but you have to be ready for action all the time. Careful digging is a tedious process, and yet one cannot afford to relax for fear of missing vital clues. Major discoveries may start off with an observation of minor interest only, a rock in an unusual position or several artifacts lying close together or a sudden change in the color or texture of the soil. More often than not, that is the end of it. A follow-up, the scraping away of more dirt in a search for further features, uncovers nothing worth recording, the flicker of interest dies down, and routine digging continues. But every now and then—and this is what the archeologist dreams of and lives for—clues begin to multiply. One thing leads to another. A sense of imminence culminates in something really exciting.

One day a student working in El Juyo square 10Q, grid designation

for a 1-meter-by-1-meter area toward the back of the cave and to the right of the entrance, brushed some dirt aside and saw the top of a stone. More brushing exposed another stone, still another, and several more, forming a ring around a concentration of ash and charcoal. It turned out to be a hearth, nothing exceptional as far as hearths go, but enough in this case to cause a mild flurry of interest, because square 10Q was part of a larger area known to include a trench, a ramp of some sort, and other strange features.

The level of interest rose several notches when further digging nearby uncovered the edge of another stone, flat and perhaps part of another ringed hearth. This feature, however, was no hearth and the stone was no ordinary stone. Its surface went on and on until the entire object was laid bare, a slab of stalagmite 6 feet long, 4 feet wide, 6 inches thick, and weighing about 1 ton. It came from inside the cave, but nowhere near square 10Q. Some 14,000 years ago several individuals had picked it up, carried it a distance of at least 30 to 35 feet, and laid it in place, perhaps to cover a grave, although there was no precedent for a tombstone that massive.

At this point, Freeman explains, the students moved out and he and Echegaray moved in: "If anyone was going to make a mistake, it would be us." Using the usual knives and paintbrushes as well as wooden sculpting tools, working as carefully as Tim White had worked to uncover human footprints 3 to 4 million years older (Chapter 5), they began the challenging, delicate, and often frustrating task that confronts every archeologist: going after the evidence and, at the same time, trying not to destroy it forever in the process. The instant you expose an object and pick it up, you have changed a pattern that, for all the recording of position and other features, can never be restored to its former state.

The next items unearthed were several flat stones set upright in the earth to support the huge stalagmitic slab, and a row of twenty-six bone spear points, all of them intact as compared with only fourteen such points found during excavations in other parts of the cave, all broken. Deeper digging failed to yield any evidence of a grave. Instead, it revealed a confusing complex of bone, charcoal specks, traces of red ochre and other pigments, chunks of clay. An astonishing feature emerged gradually. It demanded some virtuoso digging, guided partly by faint differences in the color of the surface and partly by feel, a sensation in the fingers as the excavating tool scrapes against a place where the soil is slightly more compact and more resistant than that around it.

A layer had been built consisting of cylindrical columns of earth, apparently produced by turning straight-walled containers upside down, like buckets of sand used at the seashore to build sandcastles and fortifications.

The people at El Juyo had something rather more elaborate and abstract in mind. They arranged the columns in rosettes, one central column encircled symmetrically by six others, filling the empty spaces in between with white clay, and smearing the top of each rosette with colored clays, usually red or yellow or green, to form a mosaic pattern.

Beneath the rosette layer was another layer made up entirely of bones, burned plant material, and lumps of red ochre. The bones are of special interest. They consist mainly of jaw fragments and foot bones of the roe deer and red-deer toe and rib bones, obviously representing a selection of animal parts, perhaps for sacrifices or offerings. The impression that something unusual was going on is reinforced by the presence of the bones of the roe deer, a species rare in that region at that time and presumably demanding special hunting efforts.

As Freeman and Echegaray dug deeper, they found a repeating pattern. They unearthed at least four more bone or offering layers separated by alternate rosette layers. The rosette layers had different mosaic designs. In one case, the top of the central column was red and the outer columns alternately yellow and green; in another case, a black center was surrounded by six columns with red petal-like forms and black rays in between. The archeological sandwich built up into a mound some 3 feet high and encased in an outer coating or shell of yellow clay.

Another feature turned up later a few feet from the mound. Freeman, digging in a trench about 4 feet below the floor of the cave, came across a chunk of rock placed vertically in the ground, and began brushing off the left side of its surface. About a third of the way down he noted a deep triangular hole formed by an imbedded fossil, and duly reported his observation to Echegaray sitting above and taking notes. Then Freeman, working now on the right side of the rock a few inches away, uncovered a hollow spot where a flake had been struck off. The two features next to one another and facing him reminded him of a pair of eyes. Laughing, he called up to Echegaray: "This stone is looking at me."

Further clearing off lower down on the surface exposed a natural fissure which runs horizontally from side to side and which, on closer inspection, revealed a human touch. The fissure had been touched up with an engraving tool to indicate the outline of lips and mouth. All joking ceased with the piling up of detail after detail, engraved strokes suggesting a hairline at the forehead, the tip of a nose, a moustache, a sharp tooth, a beard and whiskers. That hollow on the right side turned out to be a mark intentionally created by deliberately knocking a flake off the rock.

It was a stone face, crudely worked but unmistakable, the face of an imaginary creature. Here is the archeologists' description:

The proper right side of the face is that of an adult male human, with moustache

and beard. The proper left side is a large carnivore with oblique eye. . . . The chin is triangular, and a sharply pointed tooth or fang projects above the mouth. On the muzzle there are three subparallel lines of black spots suggesting the bases of whiskers or vibrissae, a characteristic feature of felids. Taken as a whole these features represent a large cat, probably a lion or leopard. Both existed near El Juyo in Magdalenian times.

There was more to the structure than the face and the mound nearby. A trench had been dug beneath the mound, and limpet and periwinkle shells strewn around a piece of unidentified white material. These items were covered by a layer of sand and deer bones, another layer with more bones, and a final thin layer of rose-colored ochre with a 6-inch antler tip stuck vertically in the center. There were also a number of pits containing bits of ochre, more limpet and periwinkle shells, and many bone needles with eyes. All this and more concentrated in a corner of the cave, an area of about 12 square feet.

It took some two months of digging to excavate this area, and considerable study after that to arrive at a partial and preliminary reconstruction of what was going on. Freeman and Echegaray place special emphasis on the layout inside the cave, the position of the stone face particularly. The face was placed at such an angle that people coming in at the entrance more than 20 feet away saw only its right side, the human side. To see the feline side they had to come up close and, more than that, examine the image by the light of a lamp or torch.

So our analyses must take into account a dualism, a double theme. The face had a public and a private aspect, perhaps indicating "an exoteric meaning accessible to all who entered the cave and an occult, esoteric significance known only to those who had been shown its mysteries." There are other dualisms, other mysteries, beyond that. The face is half human and half beast, suggesting a Jekyll-Hyde version of human nature. Further possibilities are hinted at by the fact that the face can also be interpreted as half male, bearded and moustached, and half female or feline. It seems that the habit of dividing the world into opposite or opposing forces existed among prehistoric people and, again, we see a continuity between their way of thinking and ours.

In any case, there was nothing casual about the El Juyo complex, which Freeman and Echegaray regard as a sanctuary unlike anything yet excavated: "It is evident that we are not dealing here with the whimsical behavior of a single person. Its construction required the participation of a large number of people—ten to fifteen at the very least." The group probably worked for more than a month, and it almost certainly worked according to a procedure spelled out in some detail, the equivalent of a blueprint, a representation of the shape and layout of the final structure and some

idea of step-by-step order and schedules. The nature of every offering, the design of every color mosaic in the rosette layers of the mound, the placement of bone spear points, antler tip, bone needles, and other features as well as the stone face, all this was part of a master plan.

The El Juyo dig is an important example of modern archeological techniques in action, and a sad reminder of evidence destroyed by earlier workers, well meaning and otherwise. Only within the past few decades has it become standard practice to note and plot the position of practically everything uncovered, rocks and broken flints, chips and other flintworking debris, bits of pigment and bone and charcoal—an all-important task, however tedious and time-consuming. Before that too many workers collected museum pieces only, finely shaped tools and figurines and carved bone and stone, ignoring and throwing away the far more numerous "junk" items that might have provided deeper insights into the rituals of times past. If one of these treasure hunters had dug beneath that 1-ton slab, he would have been mildly interested in the twenty-six spear points, gone after more prizes underneath, found nothing impressive, and ruined everything in his fruitless search; he might well have missed the stone face, since it is not a beautiful sculpture. We can mourn the loss of a multitude of El Juyos.

Wherever they occur, sanctuaries and related locations attest to the prevalence of planning in cave art. Indeed, the planning probably started with surveys of possible sites. Presumably, the topographies and contours of some caves jibed more or less closely than others with the particular requirements of the artists. There are many kinds of caves—single chambers, some large enough to hold crowds, others so small that only one person can enter at a time; some easy and others exeedingly difficult to get around in; some with beautiful limestone formations and others simply plain and dirty; some consisting solely of a long narrow passage, others consisting of many branches and many levels, and still others combining various features, vast distances, and crawl-in galleries, public as well as private places.

There was certainly plenty to choose from. The Les Eyzies region, for example, includes several thousand caves, and no more than a hundred at the most have art in them. I remember one afternoon walking back through a forest, having just spent hours exploring a local cave with many pits and steep crevices. It was good being out in the sun again, but signs of other caves and entrances were everywhere, holes at ground level among leaves, in ledges behind trees, to the right and left of my path. I was aware of dark countrysides beneath my feet, an intricate geography of underground landscapes, and some of the people of the Upper Paleolithic knew that world as well as they knew the open-air world. We may yet deduce something about their purposes from the nature of the caves they finally selected for their art.

8 *The Information Explosion*

▷ Given the planning and the apparent close relationship between art and ceremony, we can begin to ask new questions or, rather, old questions more pointedly and precisely. It is no news that Upper Paleolithic art had a social group function over and above its meaning for a small number of gifted individuals. As a matter of fact, in many cases it is all that remains to indicate that rituals and ceremonies were indeed taking place. Whatever the Neanderthals were doing in the way of organizing such occasions, the Cro-Magnons seem to have developed considerably more complicated procedures. The sudden appearance of art in the archeological record marks a sharp increase in ritual and ceremony, and the challenge of explaining the art becomes in the last analysis secondary to the central challenge of explaining that development.

The most widely accepted explanation, or at least the most widely cited, has a distinctly functional and materialistic focus. It stresses the food quest, specifically the overwhelming importance of obtaining a steady supply of meat and the devastating effect of periodical scarcities due to unexplained "crashes" in herd populations. Meat meant survival, and people did everything in their power, and more, to assure success in the hunt. Above all, they killed animals ritually by drawing them on cave walls and piercing them with spears and arrows, essentially a variation on the sympathetic-magic theme, reminiscent of the voodoo practice of molding figures in wax and sticking pins in them. Another variety of ritual, designed to avoid overkill and guarantee a continuing abundance of game, involved fertility cults and the drawing of pregnant animals and sex organs.

It is further speculated that Upper Paleolithic people, like many existing and recent societies, believed in a Master of the Hunt or Keeper of the Animals, an exalted being who provides game, establishes rules for the chase and punishments if the rules are broken, and who must be obeyed and appeased when angry. The sorcerer painted high on the wall of the Trois Frères sanctuary and similar figures are believed to represent such beings. According to Mircea Eliade of the University of Chicago, the Master of the Hunt can be regarded as "the most divine figure in all prehistory," the prototype of all subsequent gods.

There are reasonable arguments against as well as for this notion, none of them decisive. Skeptics emphasize that at many sites the animals depicted are not the ones exploited most heavily, and a cave may feature horses or bison or mammoths when the food debris recovered from occupation levels consists predominantly of reindeer bones. It happens that this is by no means an unanswerable objection. The hunting-magic notion has a certain plausibility and it may even be true, but, and this is the main point, it has never been presented in terms of a hypothesis capable of accounting for the facts.

Hunting magic offers a possible answer to questions of motive, but it founders on questions of timing. Any hypothesis worth its salt, whether it involves hunting magic or some other factor, must account for the null or nonoccurrence case. It is not sufficient to explain why art or ceremony appeared as a major phenomenon at a certain time. Its absence at an earlier time is just as significant and must also be explained. The problem is that the Neanderthals also depended on hunting for survival, that they also included large proportions of meat in their diets, and yet there is no evidence that they painted on cave walls or evolved ceremonies in which animal images played a major role.

According to one suggestion, their intelligence was simply not up to the level of such sophisticated behavior. Although they had large and well-developed brains, their frontal lobes nevertheless lacked the capacity for the sort of high-order abstract thinking demonstrated by their successors. This is certainly a possibility but, as pointed out in Chapter 6, as far as anatomical analysis is concerned, there is no evidence either way. The Neanderthals could have been more or less intelligent than the Cro-Magnons, or equally intelligent for that matter. The absence of a good reason to choose among these alternatives effectively rules out comparative intelligence as an explanation, and favors consideration of other possible reasons. The appearance of art was a positive thing. It cannot be accounted for on negative grounds, by an innate deficiency such as an inferior brain. It is more fruitful to assume that the Neanderthals had sufficiently advanced brains to produce cave art, and that they would have done so if their survival had depended on it, if they had been subjected to the same living pressures as the Cro-Magnons.

As indicated in Chapter 1, the odds are that the Neanderthals and perhaps their predecessors drew figures with some skill, although we cannot prove it. Art had probably been around for a long while before the Upper Paleolithic, pursued for its own sake as a more or less casual or intermittent activity, one of a vast number of inessential activities pursued not only then but always at any given time in any given society, in the spirit of play, experiment, self-expression, exploration. All but a tiny frac-

tion of such activities remain forever inessential. Every now and then, however, circumstances change and the pressure is on, and all of a sudden the survival of the group depends on previously useless skills and insights.

Something like this may have occurred about 10,000 years ago, for example, with the fateful shift from a hunting-gathering to an agricultural way of life. It is highly unlikely that at that late date people whose lives had long depended on knowing the ways of wild animals and wild plants suddenly discovered the elements of domestication. They had almost certainly known all that for many thousands of generations. They probably took care of occasional pets and did some gardening on the side, although life would have gone along perfectly well if they had not.

If we can judge by present-day hunter-gatherers, however, knowledge about agriculture has never been sufficient reason to take it up in a big way. No sane hunter-gatherer would have taken on the task of planting acres of seeds, of weeding and tending and protecting herds of penned animals, as long as wild foods were abundant. It was hardly worth the trouble. But when faced with famine, when the land became less productive or there were too many mouths to feed, people were ready. They had already acquired the basic information needed to obtain more and more food out of every available acre.

Art, too, had its prolonged period of uselessness—and was also available when needed. Notice that we are concerned here, not with the origin of art, but with the origin of the social uses of art. Also, the emphasis is primarily on the deep art, the figures and patterns of figures placed in remote chambers and passages, rather than on the domestic art, the paintings and engravings that may have served to decorate living quarters. We do not know for certain why the deep art was needed, only that the need must have been crucial, that it must have arisen in response to a threat to the survival of the species as serious as the threat of famine.

People were in danger. People have been in danger ever since. Evolution was off on a new tack, just entering an as yet unfinished stage of acceleration. The struggle to adapt, to attain an Eden existence of peace and security, the old search, became more intensive than ever before, and more unattainable, in the teeth of mounting change. The enormous increase in complexity, documented in Chapters 3 and 4, took place all along the line. It appears in the archeological record as an unprecedented burst of innovation, the hallmark of the Upper Paleolithic, practically everything new—new technologies and new traditions and new ethics.

Innovations in tool making are especially striking viewed in evolutionary perspective. The earliest known stone tools, dating back at least 2.5 million years, were made rapidly and for immediate, on-the-spot butchering. The early hominid practice was to pick up a handy chunk or core of

basalt or chert, knock a few flakes off, use the flakes as knives to cut through tough skins and scrape meat off bones, and perhaps use the core as a bone-breaking device. The first symmetrical tools turn up a million or so years later, and ever since then tool making has been less and less spontaneous, more and more planned and time-consuming.

There was rather less spontaneity during the Upper Paleolithic. The process started with selecting a material, bone or wood or antler or ivory or flint and, if flint, determining what kind, a local variety or an "import" obtained from quarries 100 or more miles away, whether or not to heat-treat it in some sort of fire pit and, if heat-treated, how fast and how long. The working of flint involved a finely controlled peeling-off process from a prepared core, and resulted in a set of blades which served as blanks for further shaping into any one of dozens of different tool types, which may or may not have been hafted. There were two-in-one combination tools, composite tools made up of a number of microlithic elements set in antler, harpoons with variously designed barbs, and the action-at-a-distance weapons, the spearthrower and the bow and arrow, which enhanced man's killing powers. We see increasing finesse and attention to detail, an enormous multiplication of problems, alternatives and manual operations and technical decisions.

So much for tool making. But imagine the additional, cumulative impact of comparable innovations throughout the range of human activity. Increasing reliance on mass hunting called for predicting where herds would be, being there at the right time with perhaps two dozen able-bodied males recruited from several cooperating bands totaling some 100 to 150 individuals, located in strategic positions, ready with weapons, perhaps torches and other gear to close in for the stampede—ready afterwards to join with all band members collectively in mass butchering, mass feasting, mass storage, and dividing the spoils.

People were becoming more interconnected, often despite themselves. One thinks of the Neanderthals as a fragmented breed, relatively fragmented, that is, in the sense that individual bands and groups of bands managed to get along fairly well on their own most of the time, and had rather less to do with one another than was the case among their successors. The appearance of long-distance exchange or trade during the Upper Paleolithic suggests a more extensive reaching out beyond the home range to the edges of and into other home ranges, a move offering great risks and great benefits. There is much to learn from strangers—new ways of doing things and thinking, new dialects and languages. Wider networks were being established, mating as well as communication networks, and it is a safe assumption that individual and group conflict increased along with the sharing.

There must have been considerable confusion, resistance, the tempo-

rary use of innovation followed by much backtracking before general acceptance. People resented change, adapting reluctantly. The first sign of change probably came as a severe shock. We can imagine that a band which had always enjoyed success in the hunt may have suddenly encountered a dwindling of herds in its range and, goaded by the prospect of starvation, joined up with other bands, which meant wider sharing and less meat for its members. But it was back to the old ways and habits again next season or the season after, when herd populations rose, perhaps not quite to previous levels, but enough to put the crisis out of mind.

The effort to forget was never completely successful, however, because of the impact of that initial shock. After being forced to join with other bands a few years or a decade later, and then again and again, resistance gradually melted and mass hunting became more of a way of life. We face an analogous situation today after the shock of our first gasoline shortages and queuing up, with temporary intervals of business as usual in between, and always knowing in our bones that it is all part of major changes that are here to stay.

What it all added up to was more to know, more to learn, more and more information. An information explosion occurred together with the explosion of ceremony and the explosion of art. Although today's complete records permit an estimate of our rate of learning (about 100 trillion new bits of information per year, or enough knowledge to fill about 2 million volumes of the *Encyclopaedia Britannica*), there is no way of estimating prehistoric rates. All we can say is that the Cro-Magnon rate must have been several orders of magnitude greater than the Neanderthal rate, and that the amount which had to be learned was not only considerably greater during the Upper Paleolithic, but was piling up faster and faster.

The crisis, as severe as the threat of famine, threatened chaos. The collective knowledge of the band society was on the rise, demanding far more powerful systems of record-keeping—and there was no writing. Writing might have helped to some extent, and steps that would eventually lead to the earliest notations with complex signs and symbols were already well under way. But writing as we know it lay some twenty millenniums in the future. The here-and-now emergency gave rise to measures of a different sort, measures created to transmit the expanding contents of "the tribal encyclopedia" intact and indelibly from generation to generation.

That put the pressure squarely on the human brain itself. It meant pushing things further, exploiting natural and hitherto-unused storage capacities more and more fully, putting what the tribe had learned and needed to preserve into memory. The Neanderthals must have faced storage problems of their own, and worked out techniques which have left few traces. But whatever the nature of those techniques, they became increas-

ingly inadequate for handling the flood of new information during the Upper Paleolithic. New developments were needed in the art of remembering or mnemonics, ways of imprinting far larger quantities of information, and the cave art was part of ceremonies which accomplished precisely that.

Most of this was done unconsciously. People, from the first users of fire to the designers of the first high-speed electronic computers, have never been aware of the most important consequences of what they were doing, and it is doubtful that the hunter-gatherers of the Upper Paleolithic were any wiser. They did not convene to design ceremonies for memory's sake. They were too involved, too swept up in concerns of the daily grind, to act in such a calculating manner. But they saw their world changing, a crumbling of traditions, bands meeting and sharing and fighting more often than ever before, perhaps children acting more on their own and paying less attention to the advice of their parents, and they felt the need to come together more often and more intensely, to reestablish common interests, common goals.

Furthermore, art was never used solely to help transmit information. It had many functions and operated at many different levels simultaneously. I am stressing the mnemonic level, because so much research has been done recently on information and information processing, the nature of memory, and ways of using our built-in memory centers more efficiently that we are now in a position to look at the art and all that went with it in a new perspective, to see at least one of its many aspects more clearly. At this point it may be appropriate to emphasize once again that my concern is chiefly with the deep, remotest art.

One way of preparing people for imprinting has been known for a long time by tribes everywhere, modern as well as prehistoric: bring them into unfamiliar, alien, and unpleasant places, part of the procedure known in recent times as brainwashing. This is designed to precede the imparting of information. Shaking an individual up, arranging to erase or undermine his everyday world as completely as possible, apparently serves as an effective preliminary to making him remember. Confused and uncertain about what is happening and what is about to happen, he becomes submissive, ready to listen and see and believe practically anything, or at least a good deal more than he would in a familiar setting.

For such purposes the caves provided a convenient underworld. Even before entering, before the plunge into darkness, approaching the mouth of a cave must have had a special impact. Imagination, apprehension, must have been aroused at the very start. Some cave mouths are huge and yawning, vast chambers gouged out of mountainsides and large enough to sail an ocean liner into. In some respects the caves with small entrances may have been even more imposing, because they are often more deceptive and seem

to conceal more. It is difficult to believe how much may lie beyond innocent-looking openings, what mazes and limestone formations.

Once inside, everything changes; things go into reverse. Reaching a cave almost always requires a steep climb of anything from a few hundred yards to a few miles but, once inside, you generally find yourself going down instead of up, since water runs downhill and caves are formed by running water. One encounters temperature as well as topographical reversals. Since cave temperatures are constant, hovering at about 50 degrees Fahrenheit, entering a cave in summer brings a sudden chill, while it seems warm and sometimes actually hot inside during the winter. The most radical reversal of all is the shift from sun and open air and panoramas into a system of enclosed, enclosing, and labyrinthine spaces.

Right away the world contracts to a slit. Lamps swing in narrow arcs, down to see which way the erratic floor happens to be going, to avoid slippery places and pits and rocks that may trip you—and up, to keep tabs on the ceiling and avoid striking your head against rocky projections, all of which represents no great problem in passages high enough to permit walking upright. But that is seldom possible underground. Most of the time one moves forward in a stooped-over, Groucho Marx posture or crawls on hands and knees or slides flat on one's stomach through chatieres, digging in with fingers, elbows, and knees to drag oneself along.

The night inside caves is somehow deepened by the feeling of being shut inside solid rock, in passages which may go on for miles and miles, and being aware of the darkness that fills all of them. The feeling is reinforced by the puniness of one's light source, a speck of illumination, "a yellow seed in a great black fruit," all that exists to stave off utter blackness. No portable lamp, however powerful, can reveal the scale, the full contours and variety, of the spaces one is moving through.

Limestone, the stuff out of which caves are made, was formed in water and is continuously being shaped by water. It consists of the shell-skeletons of colonies of tiny coral-like animals which consolidated into reefs and reefs upon reefs, until they became great underwater plateaus in the warm shallow sea that covered most of Europe more than 100 million years ago. When the sea retreated, water seeped down through cracks in the limestone, dissolving calcium compounds away and hollowing out small cavities at first, then gradually chambers, long passages, caves, and cave systems. There are jagged rocks inside, recently fallen from ceilings, smooth curving limestone flows and folds, columns and projections of stalactites and stalagmites everywhere. Lamplight reveals only shadowy fragments of these landscapes.

The silence amplifies the darkness. In the words of a veteran cave explorer: "The grass must stop growing, and the stars hold their breath, to

give you, above ground, any idea of that silence." When a sound comes, a pure individual event undiluted by competing sounds, it has an extra impact—water drops, each landing with a metallic ping on the surface of a pool somewhere off to the side, the rushing of a deep river heard at the opening of a passage that leads to lower galleries, the squeaks of bats reverberating in a chamber high overhead, the faintly ominous muffled echoes feet make as one walks over hollow places not far underfoot.

Every step of the way is taken in anticipation of what will come next. Richard Watson of Washington University in St. Louis, another cave explorer and co-author of *The Longest Cave,* a classic in the literature of adventure, calls it "the unknown ahead." This account of explorations in the Kentucky limestone system that includes Mammoth Cave and more than 150 miles of galleries captures the spirit and suspense of moving along underground. You keep going, grateful for the places where you can stand up straight and walk at a relatively normal pace, ready for the next series of contortions in that corridor looming up ahead.

The experience of any cave, and especially the most difficult ones, always has the elements of ordeal. The undercurrent of fear may have been all the more intense for Upper Paleolithic people being brought for the first time into the most unfamiliar and remote parts of underground systems. After all, they probably believed in the existence of supernatural beings, powerful and close at hand. The lurking fear of being lost and never finding one's way out, a common feeling during journeys into new caves, must have flared up when a lamp started to go dim or sputtered out, or when someone was left alone for a spell, suddenly and perhaps on purpose. The explorers of times past were apparently experts at finding their way back, remembering every twist and turn en route. In all the galleries of all the art caves no one has ever found skeletal remains of lost individuals.

The fear of getting stuck may have been more common than the fear of getting lost. Chatières existed everywhere; worming through them without the benefit of protective cave clothing, steady lights, and heavy boots could have been painful as well as frightening upon occasion. By the way, our ancestors were probably aware of the danger of becoming scared in a chatiere. That only makes things worse. The consequent stiffening and expansion of the muscles actually increases the circumference of the body, so that the very fear of getting stuck puts one in a tighter jam. It also creates a sensation of suffocation, a purely psychological effect since there is always plenty of air in caves, but nonetheless paralyzing. Chatiere panic may grip even experienced investigators. A friend of mine who has gone through some of the most hair-raising passages panicked just once in a particularly nasty tunnel, fainted (a grim but effective way of relaxing), and had to be pulled out.

The caves by themselves, in their pristine condition, offered an abundance of strange and otherworldly settings, enough one would think to put anyone in a state of confusion, ready to accept anything. As the existence of sanctuaries and other special places testifies, however, that was by no means enough for the purposes of those responsible for preserving and passing on the accumulated wisdom of the group. They went beyond what nature had shaped, beyond the natural mysteries and ambiguities of landscapes in the dark, adding still further mysteries and ambiguities. They imposed the mark of man on the caves, touching up a feature here and there, modifying other features, making an animal out of a natural rock formation suggesting the shape of an animal, as in the case of one of the spotted horses at Pech-Merle.

This was not art for art's sake, no play, nothing casual. It was bare survival-necessity. The development of prehistoric, preliterate mnemonics must have been the result of considerable trial and error. As an analogy, think of how many illnesses and deaths from eating poisonous and low-nutrition plants preceded the selection of grass seeds, legumes, and other basic foods. Failures of communication, misunderstandings and forgettings, late arrivals and nonarrivals, were just as lethal. The same ingenuity and attention to detail which we apply today in planning political campaigns, the design of buildings and machines, and theatrical productions went into the uses of art and special effects in the caves.

The underground offered more than mystery and danger. It was a world set apart, shut off from the restless, unpredictable open-air world of herds and predators on the prowl, seasons and thunderstorms and high winds. Nothing seemed to change in the caves. What people put there tended to stay put, undisturbed. There were miles and miles of empty space, blank surfaces ready to be used as panels for paintings and engravings, miles and miles of darkness ready to be punctuated with spots of flame, patterns of light, silences ready to be broken. Where better to produce art designed to endure, and to hold ceremonies designed to help preserve information and tradition?

The messages on cave walls remain undeciphered. At best one must settle for the general drift, which may be unmistakable as in the sanctuaries where some sort of worship or mystical contemplation was called for. But what about the extra-secret places often located in or near some of the sanctuaries? The Lascaux Cave has its main gallery featuring the rotunda, a chapel-like chamber or apse off the gallery, and "the shaft of the dead man" pit off the chamber. This use of spaces is a message in itself—a message we may yet read. It implies a system of classification, bodies of information separated by increasing difficulty of access, degrees of concealment, a hierarchy of knowledge.

Similar patterns exist at other sites. A few feet from the domed inner-sanctum chamber around a bend off the main gallery at Font de Gaume is an even more private place. You slide on your stomach through a short chatiere into a dead-end tunnel, on the sides of which is a pair of human heads which have been called "two grotesque profiles facing each other." In the bell-shaped sanctuary at Trois Frères, at the bottom of the pit is a crevice so narrow that Bégouën and I had to squeeze in, pressing our backs hard against one surface, the surface without engravings, to make sure that our heads and shoulders did not brush against the other engraved surface. In that cramped position I made out, among many figures in another one of those figure-packed panels, an ibex and a horse and five reindeer—one with arrows in it leaping to the right, another drawn vertically head-down, another with knees buckling—all only a few inches from my face.

So many things are going on in such spots, so many impressions and the combined impact of all the impressions. The art itself is only part of the experience, often a rather small part at that. Except for a relatively small proportion of outstanding paintings and engravings, the figures may be more or less interesting but they are not exciting, especially viewed out of context and in two dimensions, reproduced in books or projected on screens. The setting is a major factor in the effect of the figures, and the process of getting there, a series of successive narrowings, from the outside world into the cave mouth, and on into galleries, side chambers and niches in or beyond the chambers. A kind of extended zooming or closing in enhances the figures. Then they are exciting.

The heightening of effect has a special force in an outstandingly difficult place to reach in the Nerja cave, a vast multilevel system of underground galleries on Spain's southern coast not far from Malaga. Lya Dams, a Belgian investigator trained at the University of Toulouse, is studying the cave with her husband Marcel, who discovered the place recently after some intrepid climbing. The way in calls for scaling a 45-foot wall, inch-by-inch scrambling and crawling, searching all the while for footholds and handholds, up a slippery limestone flow. It leads into a narrow chamber invisible from below, a cave within a cave. It is not an easy climb. In fact, one experienced cave explorer who made it not long ago has vowed never to do it again.

Paintings at least 15,000 years old have been found in the chamber: a fish in black outline, a number of abstract forms, and what may be a hand imprint in red. At the far end, blocking direct access to deeper places, is a huge stalagmitic column, and the only way to get around it is by a careful straddling maneuver—by hugging tight, stretching a foot over a sheer drop to a ledge on the other side, and pulling yourself across. That brings you into a recess where you stoop and crawl, then turn over on your back to see

more abstract forms, a long-necked engraved hind, a red ibex, and a fish. Incidentally, there are paintings on that stalagmite—on the sheer-drop side, of course. Somehow a prehistoric artist managed to suspend himself over the edge long enough to paint a black stag there, and a large red spot.

The cave includes another wall, this one sheer and more than 120 feet or twelve stories high, leading to an upper gallery, a favorite spot for squeaking bats. Described by Lya Dams as "a nightmare jumble of pits and chasms and huge fallen blocks, some still unstable," its more than a mile and a half of passages are still being explored with the aid of knotted ropes, wire ladders, chains, and other speleological gear. It features a circular formation of stalagmitic pillars tinted red, green, and yellow, and so close together that one must force oneself through. That brings you into a private space with paintings on the inner sides of the pillars, three dolphins on one pillar, two on another, and a flounder-like, flatfish on a third.

It is an unforgettable experience to come all of a sudden upon something as human as a drawn figure in the depths of such rock-dominated settings. One could wander for days or weeks in some of the largest caves without ever finding the art. A mammoth cave in northern Spain, on a mountainside overlooking two valleys, has fifty-odd figures and all but a few of them are concentrated in a single small chamber with a 6-foot pas-

Nerja recess: figures found in the depths. *(Marcel Dams)*

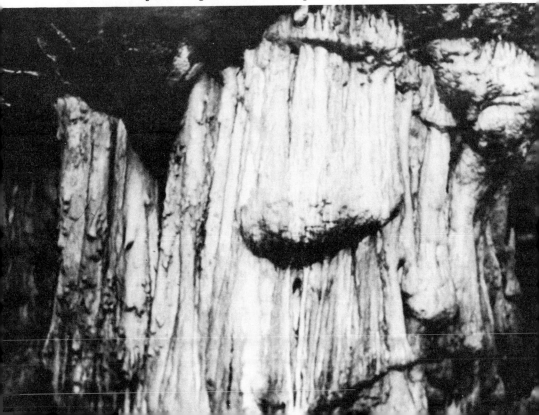

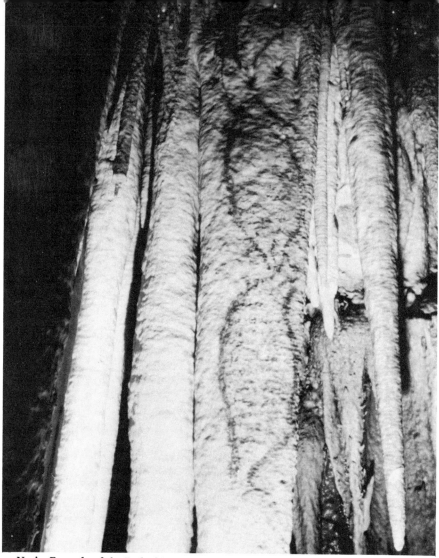

Nerja: Rotunda of the Red Fish, showing dolphins on stalagmite. *(Marcel Dams)*

sage or antechamber leading to it. In the antechamber are some figures faded beyond recognition and three bison, one of which was partly destroyed by people taking refuge from the bombing of nearby Guernica in 1937 during the civil war.

The artist or artists had a field day covering selected surfaces of the room with a variety of paintings, all in black outline. One panel to the left as you enter from the antechamber includes six beautifully clear bison drawn on a slanting section of ceiling, a galloping horse with tail flying below the bison, and below the horse another bison strangely elongated and distorted as if seen in a trick mirror. The room contains more than thirty recognizable figures, mainly bison, some painted in vertical positions and one upside down. Another huge cave some 40 miles to the west contains

only two known animal drawings, horses, located more than half a mile from the entrance, and a lone group of red dots and claviforms.

At the other extreme are midget caves, like two in the Les Eyzies region. One, located on a hillside along the road to Lascaux, has an opening smaller than a manhole cover and must be entered backward, a feet-first slide through a narrow hole down into a pit with just enough room for crouching. Then a twist around for another slide through a chatiere to a place where it is possible to stand up and see a group of figures including an ibex and, off by itself, a fine 8-inch engraving of a reindeer. The other site also involves a slide into a pit and a squeeze through a chatière with two sharp bends to a dead end where you roll over on your back. From that position you see close to your face a red and black horse, the only figure in the cave.

Chambers with room for only one or at most two persons may have been reserved for ordeals, long and lone vigils in the dark. But one wonders if it made any difference whether the confined space was part of a larger cave system or the entire cave. Again, the basic problem concerns the use of spaces and patterns of spaces by people who made elaborate plans and had many caves to choose from. In all the caves we have presented so far, however, they chose secrecy and darkness.

Note the apparent paradox of using secrecy and darkness to impart information. If the objective was teaching, doing it out in the open where all could attend and share would seem to make more sense. But that would not have served the group's purpose, to achieve imprinted, verbatim memory. Upper Paleolithic teaching was not a matter of lessons to be learned more or less casually, with only relatively mild penalties for second-rate performances or failures. It was life or death, all or nothing. Everything had to be remembered by rote and forever, indoctrinated so deeply that people would act without thinking, obeying automatically and unquestioningly and absolutely. For that kind of teaching, to achieve that kind of behavior in those days and those regions, secrecy and darkness were essential.

9 *Surprise, Pattern, Illusion*

▷ Imprinting enormous amounts of information in memory called for every device I have discussed so far—the use of confined spaces, obstacles and difficult routes, and hidden images to heighten the natural strangeness of underground settings—and a great deal more. We are only beginning to appreciate the subtlety of what was going on. Considering the technologies available at the time, the people of the Upper Paleolithic seem to have made use of every trick in the book, piling special effect upon special effect in an effort to ensure the preservation and transmission of the tribal encyclopedia.

The slow approach and the building up of expectation, the process of working one's way up and down and through narrow, twisting places, served to make arrival at the destination, a great painted hall or sanctuary, all the more memorable. But that was only part of the ceremonial complex, a very small part of a long and detailed imprinting process. Additional work and ingenuity went into the final experience, the purpose of all the arranged suspense. It demanded something more, an extra-intense act of creation, to bring together and top everything that had gone before, like the last scene of a drama or the last verses of an epic poem.

For example, during my first visit to Tuc d'Audoubert, Robert Bégouën was not content merely to conduct me to the rotunda containing the two clay bison. He did it with finesse and a flourish. After hours of going deeper and deeper into a cave, one gathers a kind of psychological forward momentum, absorbed utterly in going on and on, in the sheer mechanics of avoiding projecting rocks and stalagmites and watching one's step. It was that way in Tuc. I had just passed the side chamber with the children's heelprints and was moving ahead, concentrating on underfoot obstacles and certainly not thinking about the sculptures or how much further I would have to go—when all of a sudden, like a shout coming out of the silence, I heard a stage-whispered: "C'est ici!" I turned and saw ahead and to the left Bégouën kneeling, his lamp throwing light directly on the figures near the center of the rotunda.

At that moment, and for a moment only, I saw, not two miniature clay

bison close at hand but two real-life, full-sized bison at a great distance. They were climbing together up a slope, side by side, every line of mane and muscle sharp and in focus as if caught in photoflash, in a motion-picture frame. My perspective, my frame of reference, was transformed. For that moment I was no longer in the dark, underground and enclosed and looking at clay figures, but standing on the edge of a cliff out in the open and looking at animals on a hillside across a wide prairie. A double illusion, because at that distance I would have needed high-power binoculars, plus direct sunlight, to see the bison in such detail.

It was no idle stunt, this switch in a split second and after a long rough passage through a maze of galleries, from one world to another, from a purely physical to a purely esthetic set of mind—and no accident. Bégouën had participated in a prehistoric ritual. He had engineered a reenactment of something that must have happened in the rotunda on a number of occasions 10,000 to 15,000 years ago, an event designed deliberately to evoke a feeling of displacement, an unreal dreamlike setting, a shock of surprise. The entire Tuc experience, the way in and the pierced animal teeth and meanders and other features along the route, was dedicated to the achievement of this instant illusion. Under such conditions, probably intensified by other effects, people formed powerful associations and remembered for a lifetime what they heard and saw.

Tuc provides one of the great moments of Upper Paleolithic art. Another, of course, is the magnificent moment at Lascaux when you are standing silent in the dark at the threshold of the main hall, the lights are switched on, and you see in a burst of color the two rows of large animals seeming to stream toward deeper parts of the cave. Still another charged moment occurs in Candamo, the westernmost of the art caves on the northern coast of Spain. You enter a large high hall at the end of the cave, move to a spot near three large rocks, and turn off your acetylene lamps. For the most dramatic effect it is best to remain immersed in total darkness for a few minutes. Then someone in the know flicks a switch concealed behind one of the rocks.

Everything remains pitch dark, except for a single chamber located two or three stories high in the wall to your left. You look up and see illuminated sharp on a recessed panel, framed by stalagmites, a horse with head lowered as if drinking or grazing. It is a breathtaking, stop-action apparition, but only a diluted version of what must have been arranged in prehistoric times. We see horses rarely and in tamed, uninvolved context, being ridden or pulling a carriage. Our ancestors, still comparatively wild animals themselves, lived in wildernesses among other wild animals. We can never see what they saw in that recess, which also includes another horse and the head of a bull. The images must have seemed alive, and yet

they knew they were not looking at real animals. It was something created and all the more real for that. Again, people were being exposed suddenly and deliberately to tension, a clash between first impression and second thought, between fiction and fact.

The staging of another kind of effect took place deep in La Pileta, located among gorges and cliffs in Spanish badlands not far from Gibraltar. I went in with Lya Dams, who knows the site as well as she knows her home in Brussels, having written a book about it after more than 400 hours of study. We spent about seven hours exploring the cave, and at one point she brought me to a spot where we could rest and I could catch up on my notes. As I was starting to write, I heard her say, "Now look behind you." It was all a plot, Bégouën-style. Dams had arranged things for maximum dramatic effect so that when I turned my head I saw on a high wall a set of some of the most complex and enigmatic abstract forms of the Upper Paleolithic, done in red and black, and illuminated from the side by the light of her raised lamp.

It is easier to describe the separate elements than their collective impact. The three most striking forms, located to the right, are made up of a series of close-together strokes, drawn in curving patterns and giving a sort of dotted impression. The highest form is a parabola with pairs of strokes scattered inside, and down below it are two enclosed oval forms, one with a single extending branch and the other with four branches and, again, pairs of strokes inside. Originally called "turtles" simply for convenience, they look like nothing alive. Other forms to the left include a fishlike shape, a curious branching structure, and a rectangular figure painted in black dotted lines with a fringe at the bottom.

The main thing about these forms, taken individually, is their precision. They are not writing, nothing that formalized or standardized, nothing linear, up and down or left to right. But there is nothing casual about them, either. Each one represents the result of deliberate, painstaking effort, and the "turtle" forms were almost certainly related in some way. Looking up at the panel was like hearing a shout in an utterly alien tongue where even the quality of the intonations is strange and unfamiliar.

The individuals who drew the forms on the wall knew exactly what they were doing, and the individuals who came to look knew exactly what the forms meant. This is the one message that comes through loud and clear across the ages. The panel is overwhelming for its other messages, the ones that we will never be able to read. Standing there, looking up with the lamplight on the panel in front of me and the darkness behind me and everywhere else, I felt in a rush the gap between those people and ourselves. Like us in so many ways, not just physically and cerebrally, they had such different things to say. We shall need a major act of imagination to reconstruct their world view, even in broad outline.

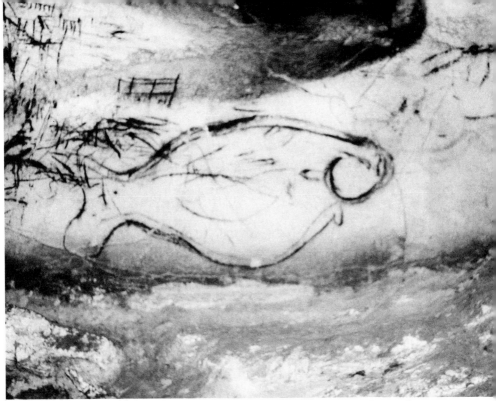

La Pileta: the flat fish. *(Marcel Dams)*

La Pileta: the "pregnant" horse. *(Marcel Dams)*

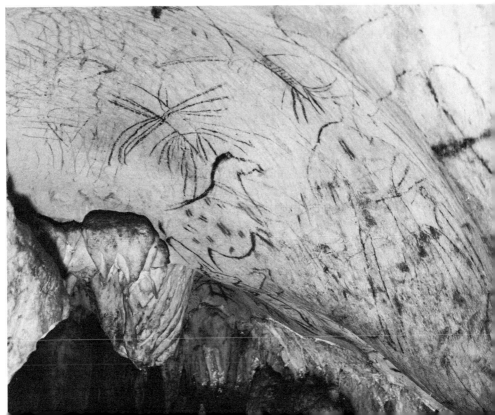

A word about prehistoric lighting. Notice that the flicking of an electric switch in Lascaux and Candamo produced an effect similar to that produced in Tuc and Pileta by controlling the movements of an individual, by bringing me to a certain spot and then by voice signal getting me to turn my head, a maneuver probably used in prehistoric times. Other possible ways of causing images to appear suddenly include removing blindfolds, leading people around a sharp bend into an illuminated side chamber, and running from a hiding place with burning torches into a dark painted chamber.

One can also play tricks with light by taking advantage of the fact that it may be extremely difficult to spot engravings on irregular limestone surfaces. Recently, Echegaray, co-director of the El Juyo excavations, discovered an engraving in a small high-ceilinged cave which archeologists had explored on a number of occasions without finding anything, and no wonder. Although the engraving is unusually large, measuring more than 6 feet high, it is not deeply incised and lies on a rough surface, so that it can be seen only under certain rather strictly determined conditions.

In fact, Echegaray saw nothing at first. He was playing his electric lamp across what seemed to be a blank wall at the back of a niche, when suddenly, as if projected by a magic lantern, a figure appeared. He had moved the lamp only a few inches to the left, enough so that the light struck the rock at just the right angle to reveal the engraved head of a man viewed in profile and apparently wearing a beret-like cap. It is a perfect light-switch effect. The image can be turned on and off by moving the light source. Furthermore, the same part of the cave contains two slightly smaller heads, and all three heads can be seen at once, but only by placing two lamps in the right positions.

Such experiences are not rare. A small T-shaped cave called Commarque in the south of France, one of my favorites, features a large horse's head. Before my first visit I had been told to look in the right-hand branch of the T, on the right-hand wall and at about eye level. The gallery is short and no trouble to negotiate, so finding the figure should have been easy. But the search took more than half an hour and, again, the head appeared suddenly when I finally happened to move the lamp into the right position: a staring eye and a natural pit used for the nostril, and a natural swelling in the rock used to depict the swelling cheekbone.

One of the most striking arrangements of figures can be seen in the cave of La Pasiega in northern Spain, half way up to a 1,200-foot hill not far from Altamira. You walk through a gallery with animals everywhere, drawn in red with some black retouching. It includes on three consecutive panels to the left a dozen deer, eight horses, and a bison; then four horses, an ox, and three deer on the ceiling; then to the right seven deer, an ox, and

Commarque: elusive engraving—a horse's head more than two feet long.
(Photograph by Hugo P. Herdeg. Courtesy Princeton University Press)

four horses; and so on, panel after panel, around a bend for a total of more than seventy figures.

The surprise comes after this concentration, this barrage, of animals: a final barrage of abstract forms, even more concentrated—about two dozen red quadrangles, some with strips of short parallel lines in ladder-like patterns, all placed at the entrance of and deep inside a tapering fissure that marks the dead end of the gallery. Come upon suddenly, these precisely drawn shapes make an especially strong impression after that long build-up of realistic figures. Whatever messages people were conveying with the animals, they were conveying something quite different with the abstract shapes. Another cave on the same hill contains a similar pattern, another

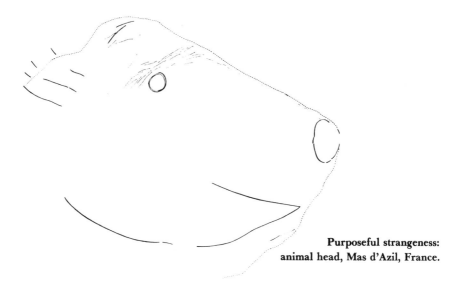

Purposeful strangeness:
animal head, Mas d'Azil, France.

burst of red symbols at the end of a gallery, crammed into a crevice so narrow that one must slip in sideways.

There are more surprises, more strangenesses, in the way many of the animals were drawn. For example, animals commonly have parts missing, and until a few years ago it was assumed that this was the result of deterioration, of fading or the crumbling of fragile limestone. Current research, however, suggests a different conclusion. One archeologist spent some fifty hours investigating a single engraving, a horse without a head, examining it through magnifying goggles, studying close-up photographs and enlargements of the photographs and silicone casts of incised lines in the neck region. Finding no irregularities, no traces of fading or breaks in the lines, he concluded that the horse had been drawn headless originally, and deliberately.

Ambiguous fish, among other forms, Mas d'Azil, France.

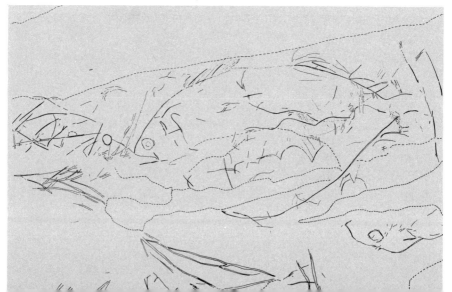

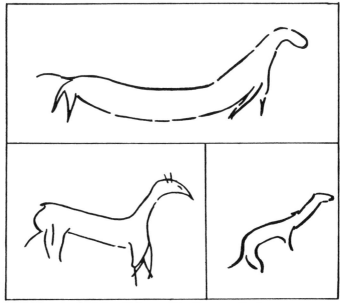

"Dachshund" horse, Ojo Guarena, Spain.

Distorted horse, Le Portel, France.

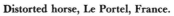

Artists frequently drew parts without bodies as well as bodies without parts, isolated horns, heads, legs, necks, and so on. They also had a variety of ways of distorting animal forms, depicting horses for example with round ballooning or sausage-like "dachshund" bodies, long snakelike necks, and tiny heads some with weird "duckbill" mouths. Their works included ambiguous animals, ill-defined creatures which could be horses or oxen or deer, bison or ibexes, figures about which experts continue to disagree—not to mention an abundant menagerie of "monsters" or imaginary species like the so-called unicorn in Lascaux, bears with wolf heads and bison tails, reindeer with webbed feet.

Ever since the discovery of cave art, investigators have tended to ignore or neglect these somewhat offbeat figures. Influenced by the traditional art-for-art's-sake viewpoint, they effectively edited the record, praising and stressing the beautiful paintings and engravings to the practical exclusion of everything that failed to live up to their esthetic standards. As a result, only the most beautiful works are reproduced in art-history books and encyclopedias, which is fair enough if the only objective is to appreciate. But this approach is not the way to do research. It is reminiscent of old methods of excavating when only finely shaped tools were selected for study and museum exhibits, and all the rest, the great majority, discarded. It accounts for the fact that the estimate of 10,000 to 15,000 figures for the Upper Paleolithic in western Europe may be distinctly on the conservative side. Denis Vialou of the Institute of Human Paleontology in Paris, who recently completed a study of Magdalenian works in the art-rich Ariège Valley region of the Pyrenees, estimates that the caves contain two to three incomplete figures for every complete figure.

Rather more important than the undercounting, however, is the ignoring of basic evidence. "There are no unfinished or unachieved figures," Vialou emphasizes, "if the implication is that the artists began something

and were unable to complete it for some reason, that they failed in some way. They knew their animals down to the finest detail, and were perfectly capable of drawing striking likenesses. We must assume that every incomplete figure, every ambiguous and imaginary figure, was drawn that way with a purpose." It was all part of a highly organized effort to exploit every possible effect in the cause of making naturally strange settings stranger.

The human figure: typically distorted versions, Los Casares, Spain, *opposite;* **naturalistic relief, Angles-sur-l'Anglin, France and La Magdaleine, France,** *above.* *(Rosemary Powers)*

An ingenious use of distortion has been found in the Spanish cave of Tito Bustillo, named after one of the original discoverers, a young speleologist who fell to his death there some fifteen years ago while exploring a 300-foot shaft. The cave is so vast, penetrating through a hill, but it is only one branch of a vaster complex of passages which continues for miles. Here, more perhaps than in any other cave, one is aware of galleries underfoot, a lower underworld where a river rushes, audible from time to time through crevices, corridors, chutes, and wells, all offering twisting, sliding ways into the depths. The main upper gallery, the river's ancient channel, is dry and pebbly with sandy banks.

Things begin to happen at a great forking place where the gallery widens. To the right is a massive mountain scene set underground, an opening so huge and black that one's lamp produces more shadows only, and does nothing to reveal its shape or dimensions. The opening extends behind a high projecting wall, another listening post where you can hear rushing water at the bottom of a chasm somewhere. The paintings are located in a chamber beyond this spot, polychromes, more than twenty animals in all, including a large reindeer in black and brown with purple-violet shading, and black horses, one of them nearly 10 feet long.

These paintings represent the highlights of Tito Bustillo from an esthetic viewpoint. As far as mnemonics and the staging of special effects are concerned, however, the outstanding figure is another horse nearby, a large red horse outlined in black with a body drawn in normal proportions. But the head and neck are distorted, elongated and snouty. When I commented on this feature to Moure Romanillo of the University of Valladolid, who is excavating in the cave, he smiled, took me to one side, and told me to lie on my back beneath an overhanging ledge. Viewed from that position, the image is transformed. The head and neck appear normal, and one sees a perfectly proportioned horse.

A real surprise, not only for the effect itself, but also for the sophistication. This is an early example of anamorphic art, images designed so that what appears depends on the use of mirrors, trick and normal mirrors, or on the position of the viewer. Another example has been discovered recently at Lascaux—the head and neck of a large red bull, appearing deformed when viewed from one angle and normal when viewed from another. The earliest examples from historical times date back to the early Renaissance. One of Leonardo da Vinci's sketches is merely a set of vertical strokes when viewed head-on, but if you close one eye and look at it at a sharp angle from the right, you see a baby's head. Originally the products of experiments in perspective, these trick drawings were used to startle and amuse, often concealing obscene and erotic scenes.

1. *Lascaux:* panoramic view of paintings in main hall.
(Commissariat Général au Tourisme, photograph by C. Pécha)

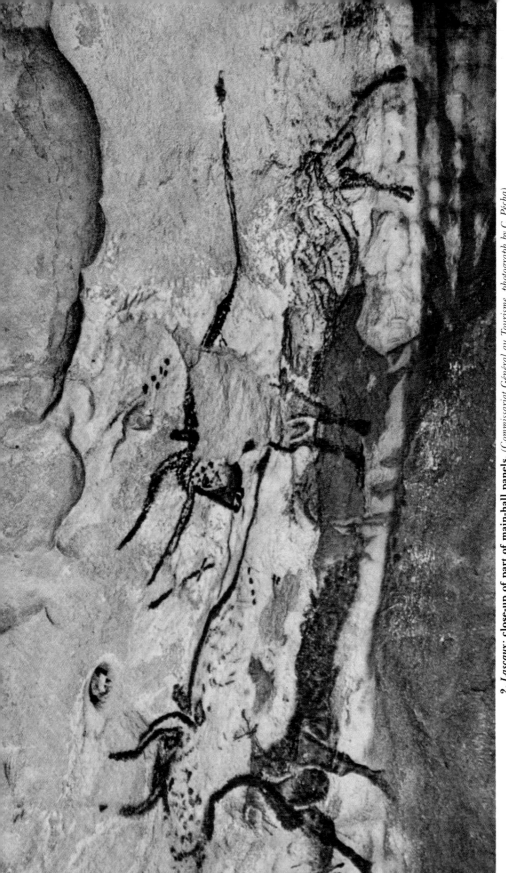

2. *Lascaux:* **close-up of part of main-hall panels.** *(Commissariat Général au Tourisme, photograph by C. Pécha)*

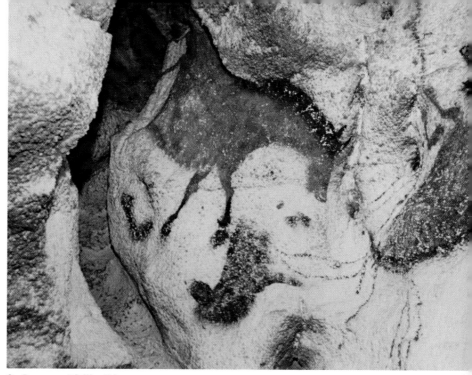

3. *Lascaux:* "falling" horse.
 (Jean Vertut)

4. *Lascaux:* "Chinese" horse.

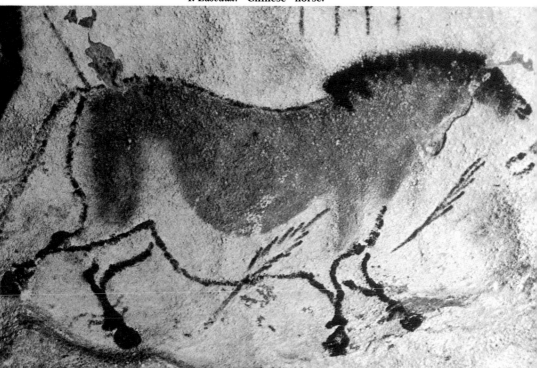

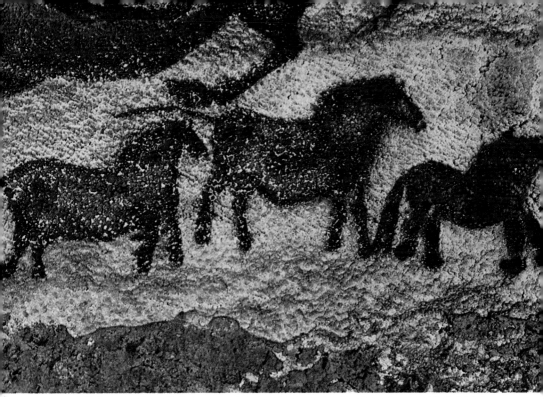

5. *Lascaux:* **three little horses.** *(Commissariat Général au Tourisme, photograph by C. Pécha)*

6. *Lascaux:* **horse.** *(Commissariat Général au Tourisme, photograph by C. Pécha)*

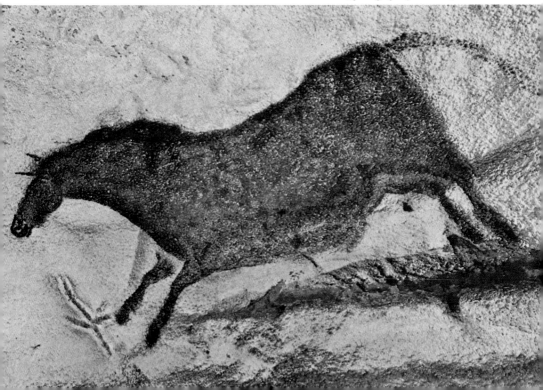

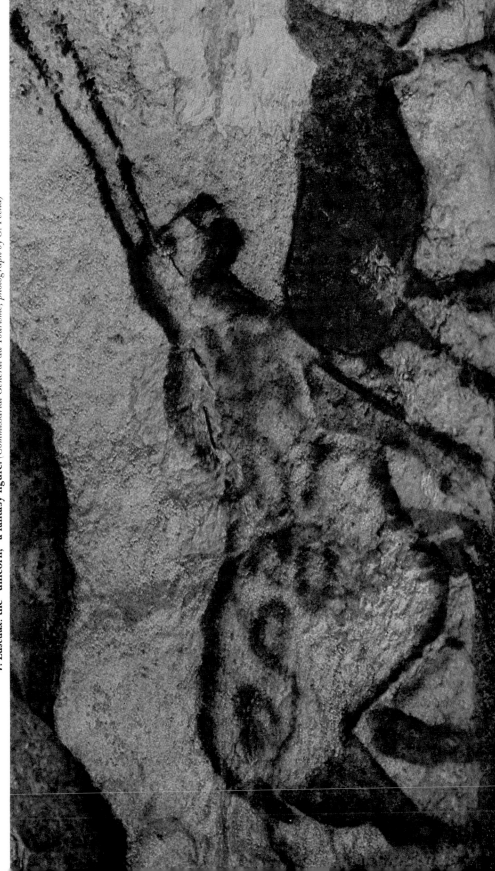

7. *Lascaux*: the "unicorn," a fantasy figure. *(Commissariat Général au Tourisme, photograph by C. Pécha)*

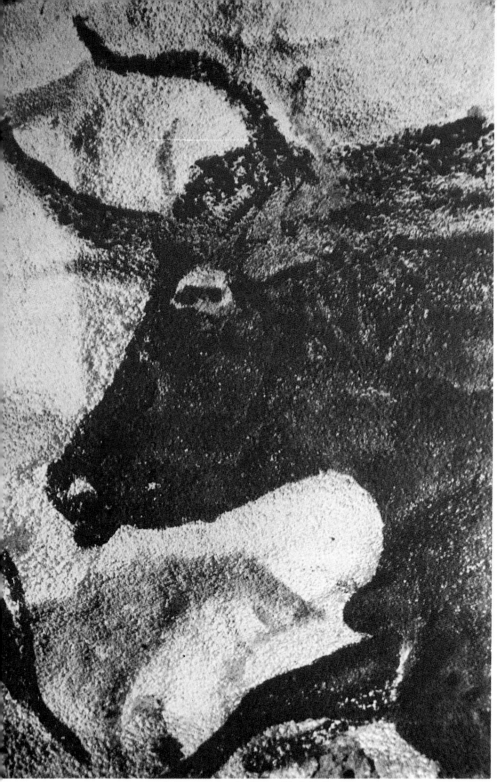

8. *Lascaux:* head of large black bull.

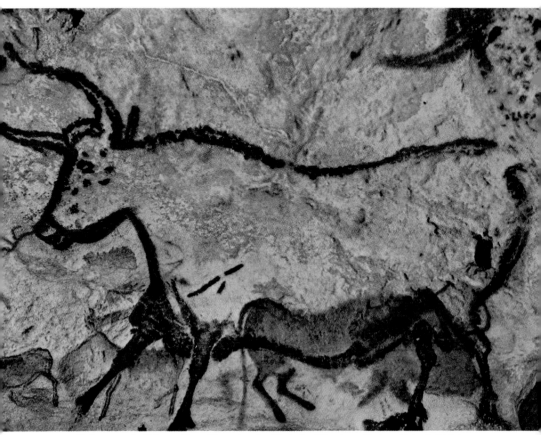

9. _Lascaux:_ bull in outline. _(Commissariat Général au Tourisme, photograph by C. Pécha)_

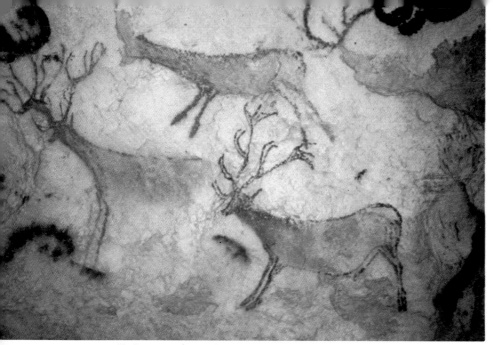

10. *Lascaux:* **group of small deer.** *(Arlette Leroi-Gourhan)*

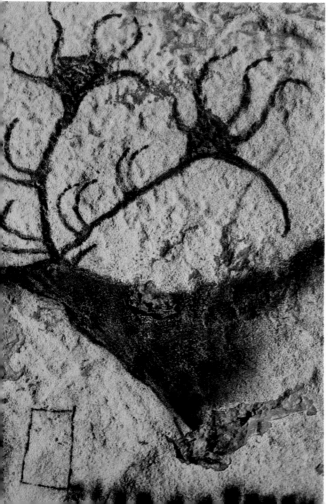

11.
Lascaux: **deer with elaborate antlers.** *(Commissariat Général au Tourisme, photograph by C. Pécha)*

12. *Tuc d'Audoubert:* **clay bison sculptures in rotunda.** *(Jean Vertut)*

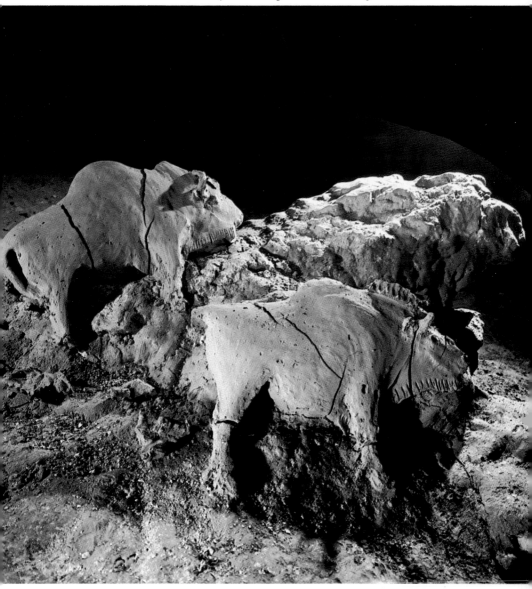

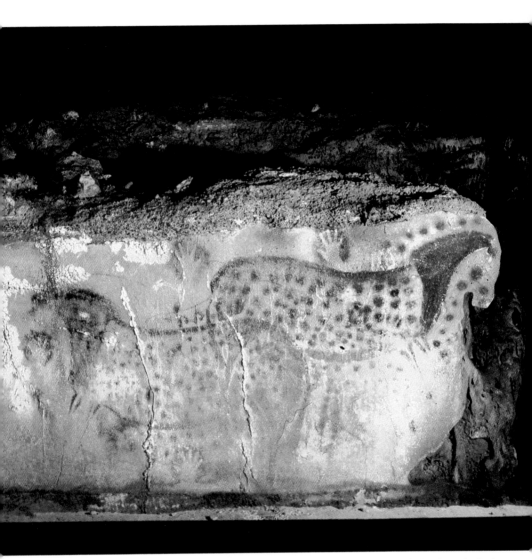

13. *Pech-Merle:* **hand silhouettes and spotted horses, head of right-hand horse fitting into similarly shaped rock projection.** *(Jean Vertut)*

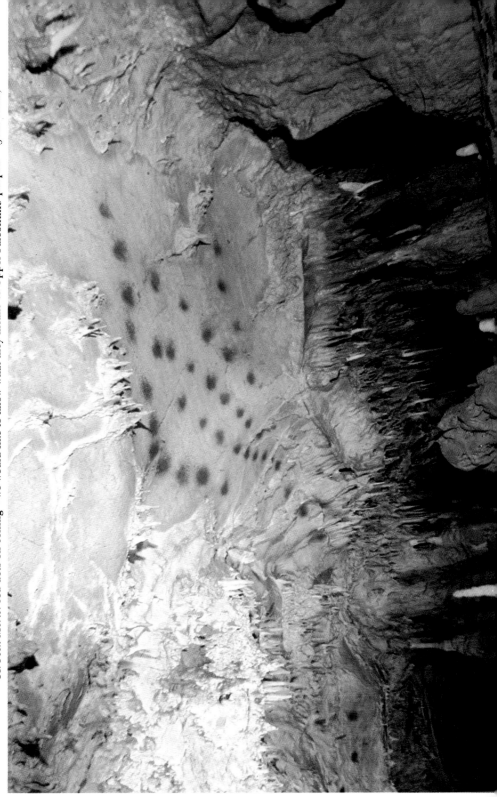

14. *Pech-Merle*: red dots on ceiling—we would like to know what they meant to Upper Paleolithic people. (*Jean Vertut*)

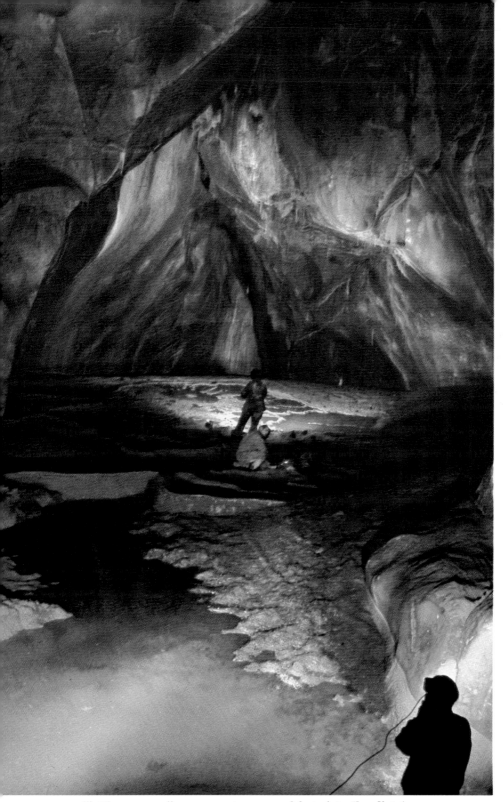

15. *Niaux:* **new gallery, on way to preserved footprints.** (*Jean Vertut*)

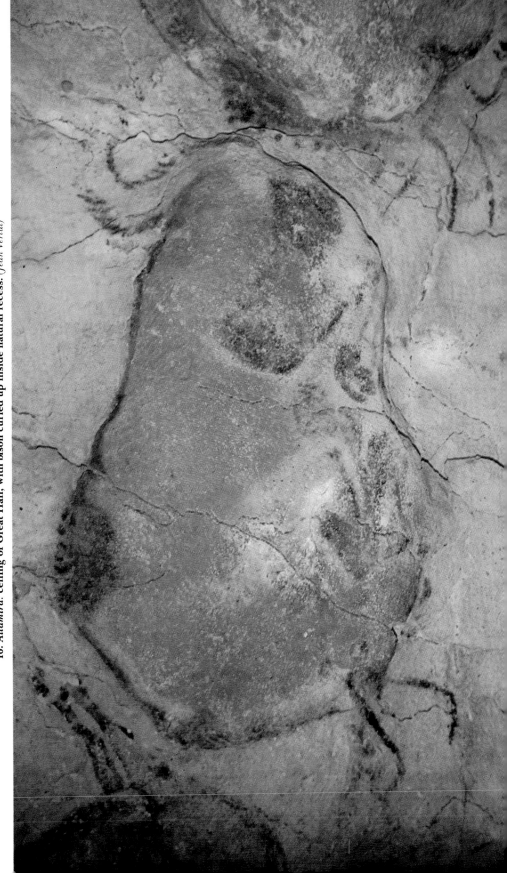

16. *Altamira:* ceiling of Great Hall, with bison curled up inside natural recess. *(Jean Vertut)*

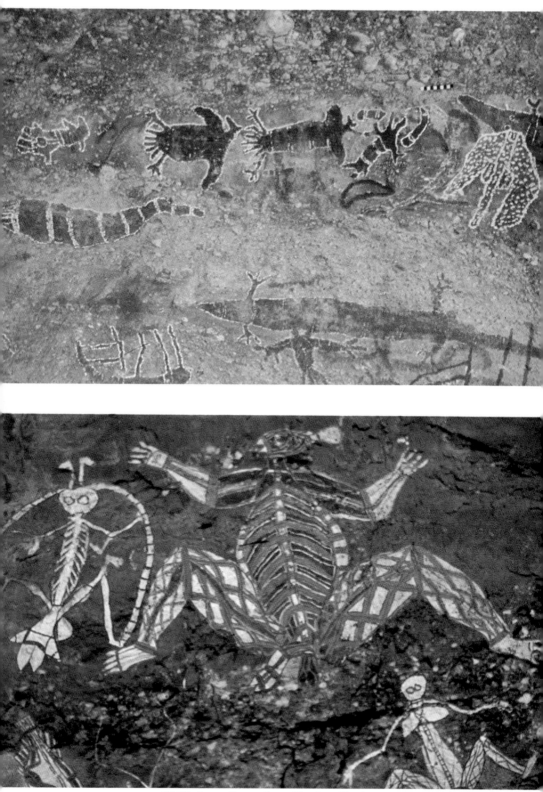

17–18. Australian rock art, Northern Territory.

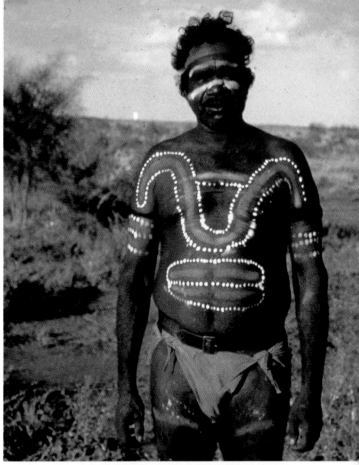

19. Australian body painting, Western Desert.

20. Australian rock art, Queensland.

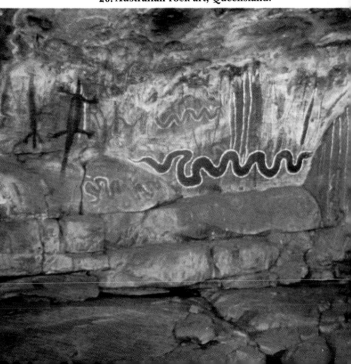

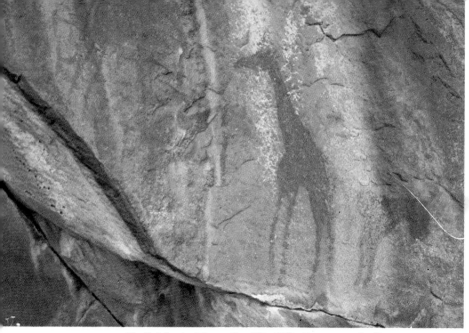

21. Kalahari rock art, Tsodillo Hills, Botswana: giraffes.

22. Kalahari rock art, Tsodillo Hills, Botswana: abstract human figures.

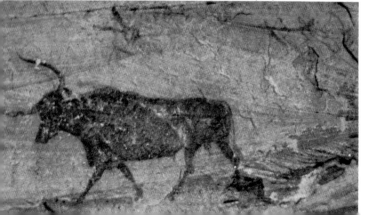

23. Rock art of the Levant, eastern Spain: early-style bull.

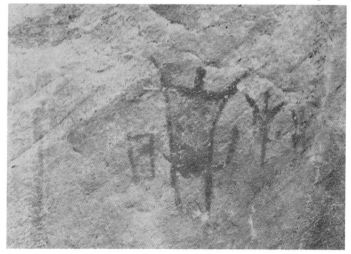

Anamorphic effects also played an important role in religious art of the Renaissance and later. At the entrance to a corridor in the Church of Saint Ignazio in Rome the paintings on the densely decorated walls and ceiling are unrecognizable, a chaos of blurred forms. But everything takes shape a few feet further into the corridor, and the blurs seem to rearrange themselves into archways and niches, becoming an array of angels, cherubs, and other sacred figures. A late Baroque chapel housing the shroud of Christ had a high dome designed to produce the illusion of a shaft of light when viewed from below. The specific purposes of analogous tricks of perspective at Tito Bustillo and other cave-art sites, the specific beliefs of Upper Paleolithic people, remain obscure. But the objective was the same—to produce an intensified feeling of awe and mystery.

The cave experience is a cumulative thing. The more caves one explores and re-explores, the more one becomes aware of the devices and tricks used in creating illusion. No single observation proves anything. In many individual cases, one cannot hope to demonstrate beyond a doubt that planning was involved. For example, the switching on of lights in Lascaux's main hall or Bégouën's little plot to make me see the Tuc bison suddenly can certainly be regarded as measures taken in a twentieth-century spirit of adventure, without concluding that prehistoric people engineered similar effects. If someone were to point to an unusual figure, a headless or distorted animal or an isolated pair of horns, and ask me to prove that it was drawn that way deliberately to add an element of strangeness, I could not do it.

At this stage of cave-art investigation we are dealing with circumstantial evidence rather than proof. There is a pile-up of suggestive detail, of convergent observations, which makes sense in the context of everything else that was being done, an intensive process of selection—selecting caves, places within the caves to decorate, abstract and realistic and distorted figures to be drawn, the placement of the figures, the approach to the figures, and so on. Taken together, it is more than enough to justify the Vialou principle as a guide for continuing research, the assumption that what we see was not done casually or haphazardly, but as a result of serious planning.

This does not mean that planning existed from the beginning. Indeed, it probably came late in the game, considerably later than the art itself. Art appeared all of a sudden, but developed very slowly thereafter. Some of the oldest examples are valued museum pieces, in particular a number of the venus figurines, and two beautiful miniature sculptures from southern Germany, a horse and a mammoth carved out of a mammoth ivory. In general, however, the earliest known art is not impressive. It consisted mostly of parts of animals and vulvas engraved roughly on plaquettes or blocks of

limestone, as well as a few figures engraved or painted on cave walls, all of them crude compared to what came later, and typical of what Leroi-Gourhan calls the primitive period. This period includes everything produced between 35,000 and 20,000 years ago, which comes to about 60 percent of the entire span of the Upper Paleolithic.

From here in, the art became more complicated. Primitive-period animals, usually depicted roughly at the start and more carefully later on, were generally drawn in contour, bare outlines of figures, empty inside. After that, artists put more within the boundaries of the figures, more parallel strokes and cross-hatchings in the neck, head, back, and underbelly to indicate muscle and hair, and perhaps to achieve a three-dimensional effect—and made increasing use of color and shading. The abstract forms also tended to become more complicated. For example, rectangular and hut-shaped and other forms had more, and more elaborate, design elements inside; and dots, isolated or in short rows at first, were later arranged in long multiple rows and cross patterns.

From the art critic's standpoint, these changes represent developments in the sophistication, the skills and perceptive powers and sensitivity, of the artists, a move from naive or crude depictions toward fine art. From an evolutionary standpoint, the changes represent an adaptive response to social pressures, and tell us something about the size if not the contents of the tribal encyclopedia. If one function of art was to help convey information, increasingly complicated or sophisticated art could be interpreted as a sign that people were dealing with increasingly complicated bodies of information.

An analogous development took place somewhat later in prehistory. Some 8,000 or more years ago in the Near East people began using stone seals to stamp their "signatures" or "brand marks" on clay jars and other containers as signs of ownership. The designs of the early seals included sets of parallel lines, stylized animal figures and other simple patterns, while later designs combined animal and abstract forms or depicted elaborate scenes such as men marching or in battle. This was one of many changes associated with a major shift from life in small villages with relatively few people requiring identifying seals to larger settlements and administrative centers—and a busier world of many transactions and many owners, with a correspondingly greater need for more intricate and distinctive seals.

We have a general idea of what was happening during the Upper Paleolithic. People were not settlers then; they were still nomads. But they were coming together in larger groups for longer periods and some of them, those engaged in mass hunting, had to establish new roles and rules for getting along and sharing. They had to determine who would obtain how

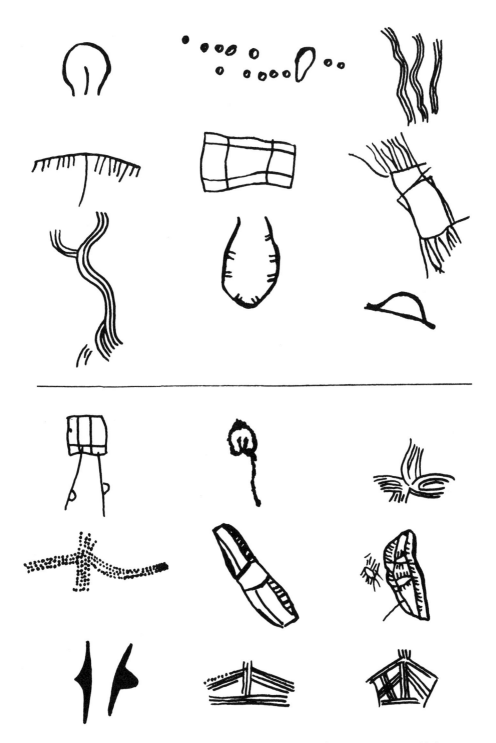

Signs, abstract forms: upper panel, more than 30,000 to about 20,000 years old; lower panel, about 18,000 to 11,000 years old. *(Lya Dams)*

much of the spoils and in what order, decide who would do the deciding, and oversee equitable distribution and conduct exchanges of goods with other band societies. Some of the figures used in portable and cave art may have involved identification, perhaps of groups and groups within groups more often than individuals, and may have become more intricate with the increased intricacy of social relationships.

The pace of events is significant, and the timing. The sudden appearance of art seems to have been followed by 15,000 years of gradual stylistic change, a span and a pace incomprehensible to us, whose lifestyles are certain to change radically within a few decades. That was the primitive period which also witnessed, on the social front, more frequent seasonal band meetings, clusters of dwellings, long-distance trade, and status burials. Then there were new stirrings, an acceleration of change. The improvement in the quality of art, the increase in complexity, the filling in of contours, the use of color and shading, the selection of figures and places to put the figures—all this becomes increasingly apparent in the archeological record starting some 20,000 years ago, give or take a few thousand years.

Other changes were under way at the same time. The glaciers had made their deepest advance into Europe. In France and Spain, people were experimenting with the heat treatment of selected flints and pressure flaking, accomplishing virtuoso feats of flintworking, developing revolutionary action-at-a-distance weapons such as the spearthrower and probably the bow and arrow. The golden age of the Cro-Magnons, the culmination of their way of life, occurred during the final five millenniums from about 15,000 to 10,000 years ago, the classical period which included 80 percent of all the known art of the Upper Paleolithic.

According to Leroi-Gourhan, the organized use of the art and the ceremonies that went with it reached a peak during this period. More than a generation ago he launched an ambitious search for patterns in the caves, the first of its kind and in all likelihood the last for a long time to come, if only because of the amount of time and effort it required. His objective was nothing less than to get at the ideas, the beliefs, behind the art by an intensive statistical analysis of associations among the figures.

It was essentially an exercise in code cracking. As a first step in decoding secret messages, cryptanalysts are guided by the frequencies of letters and combinations of letters. In English, for example, the most common vowel and the most common letter, "e," occurs precisely 131.05 times out of every 1,000 letters; the most common consonant is "t" (about 70 out of every 1,000 letters), followed by "n," "r," "s," and "h" in that order; the commonest two-letter combination is "th," and the commonest three-letter combination "the." There are also patterns of words. If a sentence starts with "I," the odds are that the next word will be a verb rather than a noun

or adjective; and if a verb like "believe," that the next word will be "in" or "that." This sort of information has been tabulated in considerable detail in the interests of military intelligence.

Leroi-Gourhan approached prehistoric art in a similar spirit. Archeo-logical code cracking, like the military variety, requires a large sample of material for analysis. So, starting in 1957, he and a team of colleagues spent three years visiting 66 out of the 110 art caves and rock shelters known at the time in France and Spain, most of them on two or more occasions, and counting and mapping the positions of every one of 2,188 animal figures (610 horses, 510 bison, 205 mammoths, 176 ibexes, 137 oxen, and so on down to the rare species such as 8 fishes, 6 birds, 2 boars, 2 probable chamois, and a lone probable saiga antelope). Such work repre-sented a break with tradition. Although statistical techniques are widely used today, they were rather less popular a generation or so ago when the focus was still on esthetics and appreciation rather than analysis.

The final report, a formidable oversized volume of more than five hun-dred pages, noted tendencies for certain animals to be located in certain parts of the caves. The most striking single observation is that 92 percent of the occurrences of oxen, 91 percent of the bison occurrences, and 86 percent of the horse occurrences appear in the central zones, among the panels in main chambers and halls. Other animals tend to occur more commonly near entrances, in passages connecting major parts of the caves, and in the most remote chambers. Furthermore, there seems to be some sort of pairing tendency, horses or ibexes paired with bison or oxen or mammoths—which Leroi-Gourhan originally interpreted in sexual terms, horses and ibexes representing males, bison and oxen and mammoths representing females. He also classified the abstract forms in two groups, male and female sym-bols.

The report has been widely praised and widely attacked. On the nega-tive side, it is vulnerable to a number of objections on statistical and other grounds. For one thing, dividing a cave into zones may not be simple. A cave may have had several entrances, and there is no guarantee that the one we use today was used in prehistoric times. Consequently, in some cases Leroi-Gourhan had no choice but to make arbitrary decisions. The effort to classify all animals and all abstract forms as either male or female has turned out to be unproductive. Sex certainly played an important role in the art, but not necessarily as the sole or even the predominant motif. Choosing the bison as a female symbol and the horse as a male symbol must also seem rather arbitrary and, as a matter of fact, a colleague whom Leroi-Gourhan agrees with on most other issues identified these animals the other way around.

On the positive side—and it is on the basis of positives that research

moves forward—the concentration of horses, bison, and oxen in central parts of caves calls for further study and explanation. Also, some sort of dualistic principle is at work in the caves, whether or not it is always a matter of male-female. For all the complications and qualifications, the notion of opposing and conflicting forces is fundamental in any system of symbols and ceremonies. Even more important than any individual observation, however, is the general impact of Leroi-Gourhan's study. As a disciplined gathering of hard fact, it established a precedent for all subsequent investigators, a signal that we shall have to be a bit more cautious about our intuitions, our pure hunches. They can spur research and the framing of hypotheses, but they can also lead us spectacularly astray. From now on, we shall have to try harder than ever to hitch them to solid evidence.

The list of problems as yet unsolved includes the use of human beings in Upper Paleolithic art. In the first place, as pointed out in Chapter 1, they are few and far between among all the other figures. More often than not they are drawn crudely, distorted or in sketchy outline with little if any detail. Yet we know from a number of sites, such as a French cave noted for two reclining nudes sculpted in low relief on opposite sides of a corridor near the entrance, that the artists were capable of drawing the human figure as realistically as they drew animal figures. So the rare and unimpressive depictions seem to have been a matter of convention, deliberate choice, especially in the depths of the caves. My feeling is that there was little need to feature drawings of humans, since real-life humans were present and actively participating in ceremonies.

Another problem involves the geographic distribution of abstract forms which, according to Paolo Graziosi of the Italian Institute of Prehistory in Florence, tend to become more numerous and more varied as one moves southwest from France to Spain. The tendency appears to be progressively more marked in the Pyrenees than in the Les Eyzies region, in northern Spain than in the Pyrenees, and perhaps in southern than northern Spain. Since no such regional trend has been observed in the animals figures, it may be that they were transmitting a kind of information different from that transmitted by the abstract forms, and that the latter type of information was on the increase. Perhaps, to put it as unsubtly as possible, the animals represent a story line and the abstract forms represent commentaries. If so, the question still remains as to why commentary should increase along a north-south axis. As one step in studying such a possibility, we shall need statistical studies of how frequently and under what conditions the two kinds of figures occur together and separately.

As far as geographical distribution is concerned, it would also be interesting to know why cave art seems to be concentrated in France and Spain, where more than 200 sites are located, or about 85 percent of the total

known. To date, 18 sites have been found in Italy and ten in Sicily, yet so far in the entire Soviet Union, which has yielded hundreds of human and animal figurines, investigators have found only a single cave with paintings, a site in the Ural Mountains. All regions had ceremonies, but we cannot begin to account for differences in regional traditions.

The Upper Paleolithic, art and all, came to an end about 10,000 years ago. In the Les Eyzies region, for example, the Magdalenians of the classical period left thick archeological layers, rich in tools and portable art, and extending out into the open beyond the entrances of caves and rock shelters. Their descendants left only thin and meager deposits, confined typically to areas under and inside rocky overhangs. The art they produced, if one can call it that, may have played a role in conveying information; but esthetically speaking, it marked quite a comedown from Magdalenian times, consisting solely of abstract designs painted on pebbles.

An entire culture had dwindled and passed, and that is never easy to explain. But one of the reasons was a change in climate, ironically enough a change for the better. The glaciers were retreating. Conditions became more moderate, warmer and more humid, with shorter less rigorous winters. Tundra lands were replaced by widespread forests, reindeer and other herd animals by red deer, wild boar, and other species that forage alone or in small groups, and can vanish quickly among the trees. A different lifestyle, a less spectacular set of adaptations on a smaller scale, replaced the lifestyle of the Magdalenians who, according to Bordes, created "the first of the great civilizations."

Although art vanished from the regions where it arose, it flourished elsewhere. A continuity existed in western Europe, an overlap in fact. People began painting in a new region, in eastern Spain, the so-called Spanish Levant, 11,000 or more years ago, more than a millennium before the passing of the Magdalenians—and their work, important enough in its own right, is especially interesting because it points up by sharp and dramatic contrast the distinguishing marks of the Upper Paleolithic. The most obvious difference is the setting. There was nothing dark or secret about the new art. Instead of being hidden away in remote underground passages, it was out in the open, in shallow rock shelters, overlooking bright sunny landscapes.

The Valltorta Gorge, north of Valencia and not far from the Mediterranean coast, contains one of the great concentrations of Levantine art. The steep cliffs of this miniature Grand Canyon, which winds on for 4 to 5 miles, are pitted with at least 300 rock shelters, 33 of which have art in them. There were waterfalls here in prehistoric times, a white-water river, open plains and forests and abundant game. The land is dead now. The water has gone, along with everything else. Water-worn pebbles and a

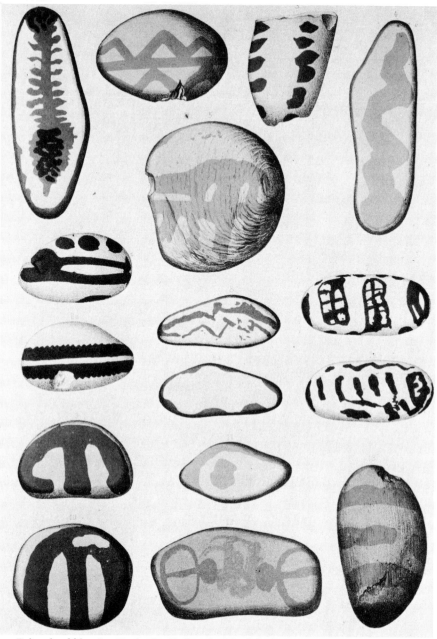

Painted pebbles: Les Eyzies "art" after the Magdalenians. *(Courtesy the American Museum of Natural History)*

bone-dry meandering ribbon of white sand, like the skeleton of a giant snake, mark the ancient riverbed.

It takes some scrambling and climbing to reach the art. One shelter, visible far below from the edge of the gorge as a red-pink gouge halfway up a vertical gray cliff, seems impossible to reach by any means short of a rope

ladder dangled down over the edge. But it can be approached through a narrow cleft where the cliff has split. This site features a panel showing to the left a herd of red deer, all with arrows in their sides, running headlong into an arc of hidden archers, while archers to the left are driving more deer into the ambush.

As a general rule Levantine sites, a total of about 300 including a spectacular cluster at the end of a formidable mountain road leading to the village of Nerpio some 220 miles to the south, are packed with figures, most of them quite small compared to the cave figures. They range in size from 1/5 of an inch or about the length of the head of a paper match to a bit less than 4 feet, with the great majority measuring no more than 2 or 3 inches. The panels feature animals, mostly deer and ibexes and oxen, wounded and running away from archers, along with less frequent drawings of men fighting men, women dancing, women working with digging sticks in the fields, and so on.

So the contrast between Levantine and Upper Paleolithic art is far more than a matter of out-in-the-open versus hidden images. As Lya Dams stresses in a recently completed study, the two traditions differ in almost every respect. Scenes of any sort are practically nonexistent in the caves. Lascaux has that dying man in the pit and a panel of deer which seem to be swimming across a river. But such work is extremely rare. For pictures of how hunter-gatherers lived, one must turn to the rock shelters of eastern Spain. Furthermore, the figures in the deep caves are predominantly static, again, the notable exception being Lascaux, which includes more motion than all the rest of the cave sites combined. The art in the shelters is teeming with life, animals and people running for their lives and leaping and falling—at least after the first 2,000 years.

According to Dams, the earliest Levantine figures were done in Upper Paleolithic style, consisting mainly of large and motionless oxen and bison, an indication that one tradition may have developed directly out of the other. She also notes that pain and distress, rarely depicted in the caves where most animals with spears or arrows in their bodies show no more signs of being in trouble than unimpaled animals, appeared as a prominent feature in the Spanish Levant, the indications being mouths open as if crying out and legs giving way. These signs appeared in quantity starting about 8,000 years ago, raising the usual question of why then—of what changes in lifestyle occurred at that time to make artists include the sufferings of wounded animals in more of their paintings.

Finally we can point to two other major differences, perhaps related and the most significant of all. While human beings played only a minor role in the cave art, making up less than 3 percent of all figures, they were all over the place in the art of the rock shelters, more than 40 percent

according to the latest count. The reverse situation holds in the case of the abstract forms. They dwindled in the rock shelters as the proportion of human figures rose. A dominant element in the caves, more than 45 percent of all drawings, they decreased to less than 10 percent in the shelters. Dams notes a striking bias as far as human depictions are concerned: "Out of some 3,000 human figures only one can be definitely identified as a child, and there are no pregnant women."

We have here a total and profound shift, a glimpse of basic changes in the nature of art and the uses to which it was put. One is among people in the art of the Spanish Levant, most often among hunters who seem to have gone after their prey with enthusiasm. For them the world was apparently a more secular place, bright and sensual. An animal was an animal, food on the hoof, a spirited thing of flesh and blood, as well as a symbol of something else. They apparently enjoyed the hunt as an exciting game or contest.

There is little joy in the art produced by the people of the Upper Paleolithic, little matter-of-factness. Things do not seem to have come easy for them. Theirs was a religious, mystical world, a place of transitions and tensions and uncertainties, calling rather more for creative talents and trailblazing. They were struggling hard to establish new ways of building order and security. Their successors in eastern Spain may have found those principles readymade, lived by them, and taken them for granted.

Living Hunter-Gatherers 10

▷ Now we take a leap forward, away from the caves and the Upper Paleolithic to the twentieth century and to a few bands of people who are considered somewhat eccentric, people still living off the land as hunter-gatherers. They have a rich art tradition. Many of them remember the paintings of their fathers and grandfathers, some in their youth were painters themselves, and some continue to paint. Their homeland is Australia, an island continent the size of Europe with a variety of local and regional art styles—realistic drawings of kangaroos and boomerangs, fish including a stingray more than 26 feet long, negative images of hands, animal footprints, whales with human beings inside them, abstract forms and meandering lines, ghostlike creatures without mouths, "X-ray" drawings which show the skeletons and innards of animals.

The art of the Australian aborigines is everywhere, in all environments. Their X-ray figures, for example, are found in north-central regions, in Arnhem Land, a place of monsoonal rain forests and mangrove swamps. A number of rock shelters on the Cape York Peninsula, an 80-mile water gap away from New Guinea, feature kangaroos measuring more than 10 feet from the tip of tail to the tip of snout and human figures up to 21 feet tall. There are handprints on rock-shelter walls on the outskirts of Sydney and among the red stick figures and boomerangs depicted at rarely visited sites on islands 5 to 6 miles off the coast of Queensland in Great Barrier Reef waters.

As far as current and recent painting is concerned, however, our focus will be on Australia's arid interior, some 500,000 square miles of desert, most of which averages less than 8 inches of rainfall a year. This is one of the last frontiers of rock art. Until a few decades ago the people were still relatively free to live traditional lives, their reservations being too barren to interest "white fellas," and investigators compiled extensive records of their work. The situation is quite different today. The desert has become more useful to us, among other things as a place to test rockets and guided missiles. Only a few individuals still paint there, and rarely at that.

As indicated in Chapter 4, in no sense do the desert aborigines repre-

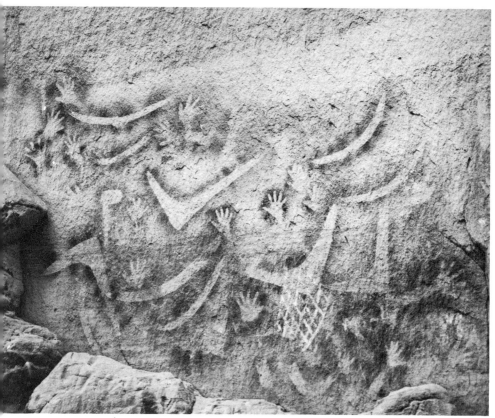

Hands and boomerangs: rock-art panel in a secluded canyon, Carnarvon National Park, Queensland, Australia.

(Australian News and Information Service, photograph by Harry Frauca)

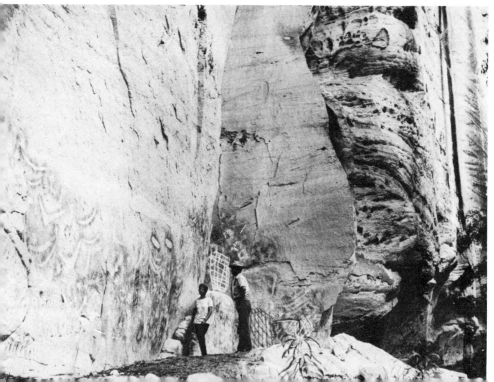

sent relics of the Stone Age. They have been adapting for millenniums, and they are still trying to adapt, although the dice are loaded against them. We are not accustomed to associating sophisticated thinking with half-naked, dark-skinned people, houseless in a wilderness, squatting on the ground around a campfire, eating foods unknown in supermarkets. But the effort to make sense of the way one must live, to create order and hope and security, is universal. Everywhere and among all societies it produces art, rituals, and belief systems of incredible complexity. In that respect at least there are strong links between present-day peoples, hunter-gatherers and urban troglodytes alike, and their Upper Paleolithic ancestors. For all the differences, the last bands of foraging aborigines are the closest we can come to our prehistory. Any effort to understand them, their art and iconography and ceremonies, must start with the land they live in.

Australia's central deserts include vast stretches of sandhills, miles and miles of parallel ridges one after the other which, in the words of Richard Gould of Brown University, extend to the horizon "like stationary waves viewed from the shore of a petrified red sea." It is a barren landscape dotted with scrub acacia trees, white-barked ghost gums, pale green clumps of spiky spinifex grass, occasional cliffs and rocky outcrops. Summer temperatures may soar above 120 degrees in the shade and drop below zero on winter evenings. This is the world of the aborigines, a world which they never made but which they are making the most of. They share it with bandicoots, kangaroos, wallabies, and other native marsupials, as well as a variety of introduced species such as rabbits, foxes, cats, and mice.

Place is everything in such a setting, knowledge of precisely where water may be found. The aborigines follow water as systematically as hunter-gatherers in more abundant lands follow migratory herds—with one big difference. In general herds can be relied on, tending to follow traditional routes on a regular seasonal basis. Water is rather less dependable. Aside from rare springs and permanent waterholes in widely scattered localities, most sources are catchments and basins, claypan depressions that hold water for a while, "soaks" where water must be dug for, billabongs or stream beds with a few standing pools, rock holes and clefts, hollow places in trees. These are rain-dependent sources, and not even experienced aborigines can predict accurately where or when rains will come.

Statistics can be deceptive. It is one thing to cite annual averages which, however low, manage to convey a definite, quantitative impression, and something quite different when it comes to coping with reality. People live and die by actual rains, not averages. A region with an annual average of 8 inches may have more than 40 inches one year and only an inch or two the next, and droughts lasting two or three years are not unusual. Furthermore, there is no way of telling how any year's quota will be distributed.

One territory may be in the throes of a drought, while another territory 100 or 200 miles away flourishes, so that the desert may be a patchwork of localized environments, some bone-dry and others relatively lush.

The aborigines have learned to live and deal effectively with these and other uncertainties. For one thing, they are ready for any providential gift of water, whether from the skies or from other sources, and their storage capacity is prodigious. An unexpected occasion arose late one afternoon for an aborigine who had been walking for hours under a hot sun, a routine trip. He was not particularly thirsty and had not asked for a drink. But when Gould passed him a waterbag, he unconcernedly proceeded to empty its contents, almost 2 gallons, in a few hearty gulps. His philosophy: such an opportunity may never arise again, and you take what you can get.

In the absence of visiting archeologists, they resort to more basic strategies, one of the most basic being to expect the worst and to act accordingly. Any other policy would be suicidal. They are generally cautious about the business of "chasing rain," which they can see falling as much as 50 miles away. Even if they are feeling the pinch and know they must move on soon, they think twice about breaking camp and heading for an area where rain has been spotted. As Gould points out, there are many factors to be weighed. On the plus side, they may know that the area is rich in fruits, seeds, and other foods; on the minus side, they may also know that it contains only a few good catchments which the rain may have missed.

On rare occasions they make the wrong decisions. During the 1960s, for example, an aborigine took a chance and paid for it with her life. From her camp in the Great Victoria Desert of central Australia she had apparently seen distant rain clouds to the west, over a region with only a few rockhole catchments. There was no guarantee that the rain had filled these basins, but she set off anyway with her young son and daughter, perhaps fearing a local shortage of water. In any case, the rockholes turned out to be empty and, too far from camp to go back, they pressed on. They were found a few days later, the mother dead and the children near death, although they recovered.

I do not know why she decided to act on her own. The usual practice is for the members of a band to move together, and to fan out so that they come at a possible source of water from a number of different directions, each of which includes one or more other places where water may be found. The first person to find a source informs the others by smoke signals. The trick is never to go too far from the few relatively reliable waterholes and always to have options. Even when heading for such a place, however, bands rarely make a direct, beeline approach. They generally follow some sort of spiraling-in pattern, covering the surrounding territory by circuitous routes and establishing temporary foraging camps along the way at smaller, short-lived water sources.

Hunter-gatherers have a thousand and one strategies and substrategies. Their nomadism is based on hundreds of generations of trial and error, on mistakes made so often and so fatally in the remote past that they will never be made again. We know only a fraction of what they can articulate which, in turn, represents only part of their total knowledge. There is so much that they know intuitively and could never tell us, any more than a grand master at chess can describe his subtlest moves and strategies. If this could all be written down, the alternatives and the probabilities and the intuited mathematics and logic behind crucial decisions, it would fill volumes.

The aborigines have no choice but to keep on the move. The art of desert survival depends on arriving at the right place at the right time, staying as long as the available supply of water and food will allow, and when the time comes for moving on again, knowing in what direction to go. Gould reports that one Gibson Desert band of a dozen persons moved nine times within a three-month period, walking more than 250 miles from camp to camp in a foraging area of nearly 1,000 square miles, and his records include many comparable cases.

One cannot settle down in such a world. "A house is a good thing," an aborigine commented recently. "You can lock it up, and go and live anywhere you please." The warm domestic glow of being together with family cannot be attached to any single location. It cannot be associated with a concentration of compact enclosed spaces on a fenced-off plot of ground. The feeling of being at home is no less intense in the desert than in lands of plenty. But it must be spread out, distributed over wide territories, over an entire mosaic of many many places, all of them known intimately and loved. Gould emphasizes that "One of the most pervasive misconceptions by Europeans about aborigines is the notion that because they are nomadic hunter-gatherers they lack any sense of ownership of, or belonging to, the land."

To acquire a sense of place so deeply rooted, one needs maps and emotion. The maps, which may cover areas forty to fifty times larger than Manhattan Island, are not printed in color with neatly marked-off grids of numbered streets and avenues. They are memorized maps. Yet the aborigines know their deserts in finer detail than people in cities know their condominium blocks, and they can locate places and meet there as precisely as if every site were identified by a unique designation such as 900 East 78th Street, complete with appropriate zip code. The emotion comes in because without emotion, sufficiently vivid and intense and pointed, learning massive amounts of information by heart may be extremely difficult, perhaps impossible for most individuals. Indeed, in large measure emotion makes up for the absence of writing.

The desert is full of "addresses," places where water and food may be

found, places to meet and "poison" places or places to avoid, places impor-
tant mainly as markers on the way to other places, thousands and thou-
sands of features, most of them anything but obvious—a slight rise or de-
pression in what appears to the untrained eye to be a perfectly flat bit of
ground, a bump on a small hill, the shape of a tree, a pile of stones, clumps
of spinifex, and so on and on and on.

The aborigines have created their image of the desert, and it differs
from ours. Both images include the same basic features, but ours consists of
relatively unvarnished descriptions, an inventory or gazetteer of listed
places, which is fine for the sort of latitude-longitude thinking that goes
into the making of maps and charts. It is our way of representing what we
see, an untamed wilderness, a random scattering of features over enormous
stretches of sand and scrub. That image of the desert, the "real" or "objec-
tive" desert, happens to be of absolutely no interest or use to the aborigines.
In fact, it does not exist for them.

Their image, their reality, is a good deal more exciting. It has to be;
otherwise they would forget it. They see a world densely populated by
mythical beings who, among other things, help them move confidently and
wisely through the desert. It all started with, and is tied to, a creation myth.
In the beginning the world was chaos, not the hectic sort with everything
flying about in a state of turmoil, but a dead, blank-slate, cold chaos of
universal sameness, a level plain without features and without motion.
"Everything was resting in perpetual darkness," according to one aborigi-
nal version of Genesis. "Night oppressed all the earth like an impenetrable
thicket. . . . As yet there was no water in it, but all was dry ground."

Everything that was yet to be, all imminence, lay underground. The
sun, the moon, and the evening star were sleeping in tunnels and caverns
beneath the earth's crust, along with totemic ancestors and an embryonic
gel-like mass of half-developed human infants. Then in the "dreamtime," a
remote golden age when all the world was young and green, things began
stirring. Sun, moon, evening star, and ancestors awoke and broke through
the crust. The ancestors roamed over the earth in a variety of human and
nonhuman guises, heroes bringing life and knowledge to the human mass
and having adventures wherever they went, and every adventure creating
order and places, embodied forever in landscape, leaving its marks on a
once-featureless plain.

In one tale the totemic lizard, running west to east to escape a band of
hunters, found a hole and slid into it, leaving the tip of his tail sticking out.
The hunters tried to pull him out, but he pulled them in and they all
turned to stone—and a slit in a rock escarpment marks the spot today.
That was only one episode, the last installment in a long series of episodes
that occurred during the lizard's journey, and each episode is manifested or

commemorated as a distinct feature of the desert. Gould followed the entire lizard route in an airplane, flying low over a line of cliffs with an aborigine informant who pointed out waterholes, caves, hills, individual trees and rocks, and other features for a distance of some 200 miles. Later he visited many of these places on the ground. Wherever the dreamtime ancestors went in the course of shaping a world out of chaos, they left tracks, tracks everywhere crisscrossing one another, a dense and intricate network of tracks extending in all directions for hundreds and hundreds of miles. This culturally created desert is filled with interconnected places, links in narrative chains.

Ronald Berndt of the University of Adelaide has described some of the features in a small section of the Great Sandy Desert of northwestern Australia. It includes a track about 100 miles long, starting at a rockhole where in the dreamtime the Great Rainbow Snake went underground. Then come in succession a soak and a rockhole followed by three more rockholes where a group of ritual-performing beings known as "dingari" sang, gathered seeds in wooden bowls, and painted on the rocks. Further along are places marking events in journeys of the totemic dove, bandicoot, dog, crow, and lizard; thirty-five major sites represent nineteen rockholes, nine soaks, and seven springs. This is only a partial listing, however; it omits many smaller locations. Clustered around one dingari site, for example, are a dozen subsites, soaks and rockholes, claypans and billabongs, each with its own dreamtime episode.

These are some of the details for one of many tracks. The thirty-five-site track is not a straight line, in accordance with the aborigine strategy of circuitous trips en route to water sources. It loops around in a hairpin bend, intersecting two other curving tracks, which extend to the north and south and are made up respectively of seventeen and sixteen sites (and perhaps four to five times as many subsites). Furthermore, interlaced among these major tracks are dozens of minor meandering tracks, each associated with its sequence of places and each place associated with the activities of one of the dreamtime ancestors.

Considering how much mythology is involved in the layout of one small area, think of the amount of lore accumulated over the millenniums for an entire desert—and think of the problem of passing on all the information intact from generation to generation. This is an old problem, dating back at least to the Upper Paleolithic and perhaps thousands of years earlier. The aborigines, like many other groups, have solved it without a system of writing. They implant the information in memory by drilling, strict discipline, and repetition, and art finds a central place in ceremonies performed from cradle to grave designed to impose remembered patterns on the desert.

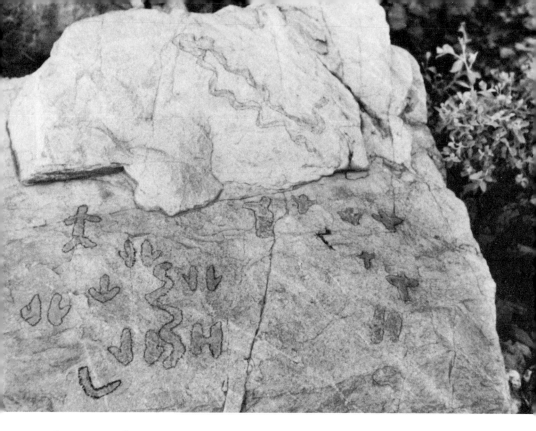

Desert gorge: aboriginal rock art in Rawlinson Range, Australia, painted July 31, 1966.
(Richard Gould)

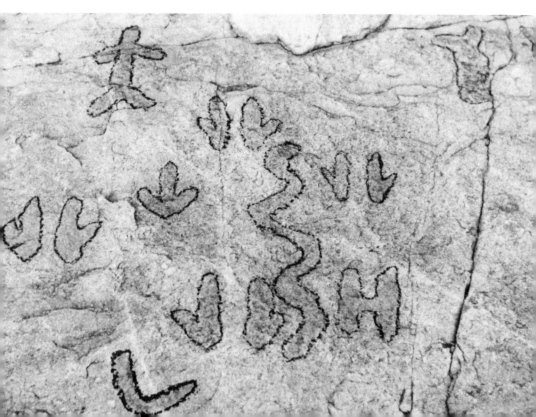

Among those still painting as their ancestors painted generations ago, using the same pigments and figures to commemorate the same dreamtime beings, are a number of Gibson Desert aborigines. Richard Gould, who has lived in the outback for extended periods, had a once-in-a-lifetime opportunity to see their work in progress. It happened by accident on a July afternoon some fifteen years ago, among the red and yellow rocks of the Rawlinson Range, mountains "scored by deep cavities and pits, like a mouthful of enormous old, decayed teeth." The range includes a sacred gorge formed during the dreamtime by an ancestor who split a cliff face while pursuing seven sisters, a gorge so deep and narrow that sunlight rarely reaches the bottom and rains accumulate in large, long-lasting pools.

Gould, rounding a bend in the company of an aborigine guide, came suddenly upon two men painting on a rock near the entrance to a small cave with spring water dripping from the ceiling. Using a traditional mix of crushed charcoal and saliva, with dried kangaroo dung added to give a yellow-green color, they were completing an elaborate design consisting of abstractions and nothing else, a combination of purely decorative elements—that is, to people not in the know. The painters obligingly "translated" what they had drawn, an oval form enclosing fourteen doughnut-like concentric circles connected by black lines. The circles represented real places, waterholes where Tjikari the totemic Carpet Snake had stopped during his dreamtime trip through the desert, and the lines represented real routes mythicized as the tracks he made between stops.

Other figures in the shadows of the gorge represented other waterholes along the tracks of the Blue-tongue Lizard, the Bush-turkey or Bustard, and other totemic beings. It became evident that in executing their designs the painters had selected from an extensive repertoire of abstract figures, symbols for sand ridges, hills, cliffs, and other landscape features as well as for the tracks of a variety of ancestors. The men thus had to take on some extra memorizing for the sake of preserving information in memory. Those symbols, possibly numbering in the hundreds, had to be learned in order to execute paintings which served as reminders of actual topographies, indicating in a general way the locations of vital water sources.

Another form of art, more ephemeral and perishable, is just as important and often serves similar purposes. On a number of occasions during that summer afternoon tour of the art in the gorge, Gould was baffled when the artists, pointing out a particular design element and identifying it as a waterhole or a track, would add the word for "chest" or "back" or some other body part. The pattern looked nothing like the part mentioned. Did it have a double meaning, anatomical as well as topographical? Only later did he realize what the men had been trying to tell him, namely, that the patterns were also used in body painting, and there were rules specify-

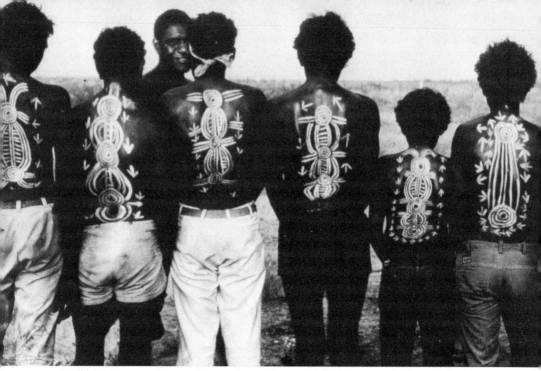

Walbiri tribesmen, Western Desert, Australia: central design represents sacred dream-time site; arrow-point symbols represent tracks of totemic Wintiki bird or stone curlew. *(Stephen Wild)*

ing position, what patterns should be reproduced on what parts of the body.

As a matter of fact, body painting involves a whole complex of specifications, not only where the patterns should be placed, but the pigments to be used, ways of mixing and applying them, and even the number and order of strokes. The individual being painted may have to lie or sit still for several hours while the painter applies each line painstakingly in accordance with the rules. Sometimes it is a mass-participation process with two groups, one doing the painting and the other being painted. Minor stylistic differences inevitably creep in, but mainly by default since perfect replication is impossible. The principle is strict adherence to the rules. Major innovation, individual expression of any sort, is out of the question.

The existence of common design elements in rock and body art, identical patterns symbolizing landscape features, represents a kind of insurance. Remembrances of things past and present are far too important to be left to one and only one set of techniques. Rock painting alone is not enough. Neither is the combination of rock painting and body painting. All of the senses must be stimulated, all at once. The aborigines have many additional ways of preserving information about dreamtime tracks and water sources, of implanting mental maps of the desert.

Body painting itself is simply part of the preparation for further ceremony, for dances performed on carefully prepared dance grounds, and that

in turn involves another world of rites and things to be remembered. Most of the time life proceeds as uneventfully for the aborigines as it does for the rest of us. Work must be done and they do it, routinely and efficiently, and in general with good humor. They come alive during their dances, however. Life is heightened, dramatized, and more exciting. In Gould's words, "the dreamtime past fuses with the present." The dancers become their ancestors, identifying completely with the spirit and journeys and adventures of totemic beings.

Like the works of rock and body painters, their performances are related directly to the land they live in. They reenact dreamtime episodes along dreamtime tracks, and they also have an extensive repertoire of "design elements," stylized movements derived from the movements of totemic desert species, accentuated and made more vivid by the figures painted on their bodies. One sequence during the dance of the totemic spiny anteater, for example, represents its characteristic hiding-escape tactics. A primitive mammal belonging to the same order as the duck-billed platypus, it looks something like a porcupine and burrows its way into the ground in a series of jerking movements leaving its quills exposed, an operation which talented dancers imitate to perfection.

There is singing as well as dancing, singing that carries for miles in the desert—and, again, there is a repertoire of songs and intonations for different occasions. The words are heavy with connotation; and a single short phrase may refer to an entire episode, so that it has meaning only for individuals who have already committed the relevant myth to memory. One phrase, "*mirkalu* [vegetable food] *dampupala* [a tomato-like bush fruit] *ninara* [sitting] *yalaringu* [seed become open]," condenses an episode associated with a group of rock piles not far from a missionary station, a long story about totemic lizard women who were attacked by other lizard people and ran away, leaving piles of the fruit which turned to stone. A phrase which takes only a few seconds to sing may be repeated over and over again in a chant lasting half an hour.

The singers, like the dancers they accompany, perform with a control that can come only with frequent drilling. Two groups may sing back and forth to one another, picking up words and cadences in precise timing, or a hundred individuals may sing together in descending tones and in such close harmony that it sounds like three or four voices. No one has ever made a complete inventory of how many songs veteran singers hold in memory. As an indication of part of what has been passed along over the years, however, one poetic cycle consists of 188 songs, which investigators have duly recorded in a manuscript of more than 90 printed pages.

In the Gibson Desert, singing and dancing take place without musical instruments. The aborigines whom Gould studied have only the churinga

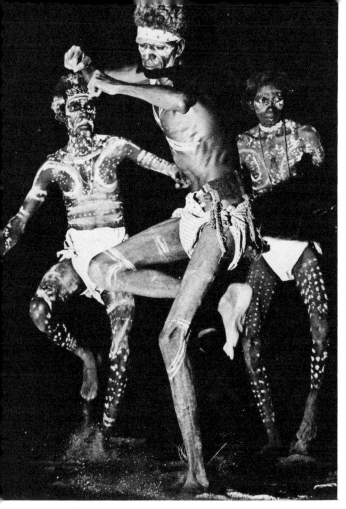

Body painting for the corroboree, Northern Territory, Australia: group ceremony featuring dances, singing, shouting-chanting, and percussion sound.
(Australian News and Information Bureau, photographs by M. Jensen and J. Crowther)

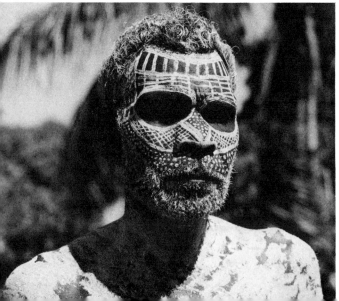

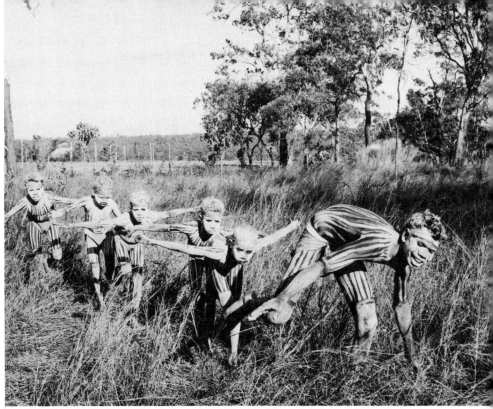

Animal dance, Northern Territory, Australia: mimicking the wings-outspread rush of the brolga, a native brush bird. *(Australian News and Information Bureau, photograph by Don Edwards)*

or bullroarer, a carved board which when twirled on a cord makes a weird whining-moaning sound. The focus is on intricate rhythms, the beat of spears tapped against spearthrowers, or the pounding of sticks against the ground, representing the thump-thump of the tail of the totemic kangaroo as it hops along its dreamtime track. Aborigines in other parts of Australia use stretched skins as drums, or a wind instrument 4 to 5 feet long, a kind of hand-held organ pipe which can produce a deep bagpipe-like drone.

Everything described so far represents only the tip of the tip of the iceberg. The myths, paintings, dances, songs, and the rhythms, all mobilized in the service of memory, are combined with much more during the course of major ceremonies. One of the most memorable and effectively produced ceremonies, a key stage in the implanting of information, is the initiation of boys into manhood. It generally begins between the ages of fourteen and eighteen, with an event made all the more traumatic considering how easy the living has been up to that point.

Children are reared in a highly permissive atmosphere. They may be allowed to suckle until they are four to five years old, and routinely get away with the most unruly behavior. Only under extreme provocation, and after trying all other forms of persuasion, will a parent punish a child. One

day after a long hot walk with everyone tired and resting in the shade, a boy about four years old went into a temper tantrum and, finding himself ignored, started throwing handfuls of sand in people's eyes and refused to be distracted. Finally, in a last-straw reaction his mother put a stop to the proceedings with a smack across his face. It was the only punishment Gould observed during some fifteen months of living among the aborigines.

Initiation marks the end of indulgence, the end of the pleasure and the luxury of casual learning. Boys have already mastered a good deal under such conditions. As soon as they can walk they become small-time hunters, learning to track lizards which they dig out and cook. By the age of six or seven they observe more tracks, often move out of their parents' sight in search of food, and begin target practice with tiny spears and hooked-stick spearthrowers. Landscape features are continually being pointed out to them, so that they acquire a respectably detailed knowledge of the desert at an early age. On one recent occasion two boys aged eight and ten knew the locations of water and food sources well enough to complete a trek of more than 500 miles.

But the Gibson Desert is a big place, and there is still too much to be remembered at the easy pace of early-childhood learning. Sooner or later life must become more disciplined, and the transformation takes place abruptly. According to one account of Gibson Desert practices, here is how it happens: "At the first indications of puberty and of giving attention to girls, the women . . . suddenly turn on the boy, and he is driven from his mother's camp. He has now to live outside the main circle, an outcast together with others of his age, to await the day . . . when he is seized and made into a half man."

This shock, this sudden breaking of the family bond and especially of the bond between mother and son, signals the beginning of formal indoctrination into the sacred life. It is followed by a period of seclusion, which may last as little as a few months or as much as a year or two. The boy, now a novice in the charge of a man other than his father, preferably a maternal uncle if available, has a little camp of his own off in the outback with a fire and a little windbreak. He may forage for himself, or younger boys or his uncle may bring him food. When the camp moves, he moves too, but alone and at a distance.

Wrenched for a time out of one world, the world of home and family and two sexes, he makes new connections in an exciting and often bewildering all-male world. Eventually he becomes more and more involved in the affairs of secret societies or cult-lodges made up of men descended from the same totemic ancestors. Like all novices, he is automatically a member of the two universal cult-lodges of the kangaroo and the dingo (a breed of dog introduced into Australia about 3,000 years ago). Beyond that he has a

special place as a member of the cult-lodge he was born into.

His instruction, his road to learning, proceeds in steps as significant as the landmarks along dreamtime routes. Parts of mysteries are revealed to him, just enough to let him feel the vastness of what remains unrevealed. He is always kept a bit off balance, encouraged to learn and at the same time continually made aware of what he does not yet know, a form of humbling and a preparation for ceremonies yet to come. He lives with the tension of wanting to understand, since that is his way to manhood, and not understanding. He must never ask questions. He must wait until answers come in the course of subsequent revelations. The older men who are teaching him guard their secrets jealously.

He hears songs that he never heard before, beautiful songs repeated many times in their entirety. But the meanings are elusive at best. Phrases contain strange words mixed with familiar words, obsolete and archaic expressions which, incidentally, seem to be a feature of many important songs. After all, "Oh, beautiful for spacious skies" is hardly a colloquial or straightforward way of putting things, and I would not advise anyone to ponder long over the meaning of "My country, 'tis of thee." Furthermore, to make things even more difficult, the aborigines have invented a way of scrambling messages. Words are broken into parts and attached to parts of adjacent words, so that the novice memorizes phrases analogous to "oerth eland oft hefree" before the true sense, "o'er the land of the free" is revealed to him. This is the purest, most difficult sort of by-rote learning, roughly the equivalent of memorizing nonsense syllables.

The novice works on a full-time schedule. He goes on extended trips with his teacher, entering places hitherto forbidden to him and forever forbidden to women, sacred sites identified as off-limits by such things as sticks placed horizontally in trees or slabs of rock set upright. These markers are as prominent to the aborigines as STOP or DANGER—HIGH VOLTAGE signs are to us, and as carefully heeded, since ignorance of the law is no excuse and any ineligible individual who enters the site by mistake or with ulterior motive may be put to death.

The grand tour of the desert calls for the following of tracks made by the novice's totemic ancestors, the universal ancestors, and some of those associated with other cult-lodges. Of course, these are introductory visits only, involving but a fraction of what will have to be learned later on. The kangaroo and dingo tracks—which crisscross at so many places that they almost merge into a single track—extend for hundreds of miles and include thousands of landmarks, each with its own set of rituals expressed in myth, painting, dance, and rhythm as well as song.

All this is preamble to the final ordeal, circumcision, part of a long slow build-up. The pace of things quickens noticeably more than a month

beforehand, with most of the novice's education packed into a last fortnight of increasingly intensive ceremony. The timing has a lot to do with the weather. Gibson Desert aborigines spend most of their lives in bands of less than fifteen persons, because water and food are rarely concentrated in sufficient quantities to support larger groups. So initiations generally take place after heavy rains, when resources are abundant and batches of up to half a dozen or so boys can be processed at once.

The excitement mounts at such times. A number of bands and cult-lodges come together for the big event, usually 100 to 150 individuals, and since the aborigines are not used to crowds, that in itself has a powerful rousing effect, an almost intoxicating effect. There is singing and dancing every day, starting early in the afternoon and usually continuing all night and into the next morning, with time out between performances for sessions of elaborate body painting which may last longer than the dances themselves. The beat comes on loud and steady. Men sit in two circles pounding out the rhythms, sticks thudding against the ground to produce the hopping sound of the dreamtime kangaroo. The singers may bring an episode to an end by touching dancers with their hands or drumming sticks, thus breaking the spell of the collective trancelike retreat into the dreamtime past.

The novices remain as calm as they can in the midst of this turmoil, this human storm. But they are scared and confused, overwhelmed by successive floods of sensation, and in a state of chronic suspense. They know what they must yet endure, circumcision in public with a stone knife, but they do not know when. If they had ever been tempted to make light of any aspect of dreamtime myths or beliefs, if they had ever felt a trace of skepticism or rebellion, all that is wiped out now, buried beyond recall. Their mood is unquestioning in the extreme, characterized by an utter readiness to believe and do anything. Thoroughly brainwashed, they are under the complete control of older men, the absolute arbiters in initiations and all phases of the sacred life.

The first act of the initiation drama takes place at nightfall on the dance ground, men gathered in two circles at one end of the clearing and women with their children at the other end about 100 feet away. A fight opens the proceedings, a ritual battle of the sexes complete with fireworks, as some of the men and women hurl burning sticks at one another, shouting and exchanging insults and challenges. The din dies down after five minutes or so. The men sing softly and build two huge bonfires which light up the desert and at the same time serve as a screen, because one cannot see what is going on beyond them.

The stage is set for the novices' big moment. All day they have been kept in the dark, literally, lying on the ground covered with blankets, ex-

cept for brief intervals when they were instructed to sit up and watch dances. Now they move into center stage. Gould describes how they emerge from between the bonfires," running in a line in perfect step with one another and with the rhythm of the singers . . . a brilliantly engineered dramatic climax." This triggers a striking display of the death-rebirth theme of all rites of passage, as the women and children start to wail, the same loud prolonged cry that signals a death in the group, and now proclaims the end of childhood with manhood imminent. Almost immediately an even more chilling sound rises weird and high-pitched above the cries. The bull-roarer goes into action, the unearthly whirring voice of the totemic kangaroo, and the women and children run screaming away from the dance ground and disappear into the night.

More singing follows, and a lull in the performance as the bonfires are replenished for the last rites and the ordeal. Suddenly the singing becomes louder, the beat more pronounced, and painted dancers come leaping out from behind the fires, weaving toward and in front of the novices who are sitting dazed between the song-circles. The dancers carry one of the most sacred and secret items of the kangaroo cult-lodge, a cross made of string on a long spear and representing the body of the totemic marsupial. At this point hands are clamped over the eyes of the novices so that they cannot get a full view of the cross, but half-see it through separated fingers. This object is so powerful that if they looked at it directly, they would become very sick and perhaps die.

A final hush as the dancers vanish into the darkness and the singing stops short as if shut off with a switch. Four or five young men rush forward, fall on their hands and knees and across one another, forming a platform, a "human table." One by one the novices are carried to the platform and placed on their backs, as their maternal uncles perform the circumcisions, which have been interpreted as symbolic severings of the golden cord, the umbilical connection between mother and son. The operation is painful, but no one cries. The novices remain silent for several days to a week or two, as long as it takes their wounds to heal. They return to camp, relieved and proud, as men launched on the journey toward full adulthood.

Every step of the process from grand tour to final ordeal—and this has been a bare outline only—is dedicated to the preservation of memory. Not a trick has been missed. What more could one do to ensure retention than start with young subjects, work them into a state of readiness to listen and accept, and conclude with an act of pain? Initiation combines many effects, all calculated to attach emotion to information, an aura of mystery and secrecy, the dark of night, images seen suddenly coming out of the dark, movement enhanced by body painting, information mythicized and sung and repeated to a beat, fear and fire, pain and the strange triumph of

having come through suffering without crying out.

Further rituals lie ahead, some even more painful. The desert contains so many places, so many tracks. An aborigine could spend his life studying nothing but the tracks of the kangaroo and dingo, and there are other things to be learned, such as the complex set of rules governing kinship and marriage and, in general, how to conform. Women also have secret ceremonies which, however, are not held as often or conducted with such prolonged intensity. Arranging and participating in major ceremonies is the men's job, probably their most important social activity, at least in the Gibson Desert where hunting is rarely successful.

Learning during ceremonies is an intense, high-tension process. But it also takes place under more relaxed conditions after the ordeals and the rites are done, and throughout life. Among the aborigines, as among other people who do not write, art is the closest thing to writing. Information is stored in the form of portable art as well as in the figures painted on rock. A spearthrower, for example, is a multipurpose tool, which serves not only as a propulsion device but also as a cutting tool (a flake is hafted at one end), a drumming surface, an easel for mixing pigments—and a memory-aid. It may be carved with abstract designs, the same sort used in rock and body painting—concentric circles, squares, zigzag and herringbone and hatched-line patterns, which depict sand hills, rock formations, totemic tracks, waterholes, and other places along the tracks. In fact, a spearthrower can be regarded as a kind of map, its length of 30 inches or so representing a scaled-down section of track 100 to 150 miles long.

The most frequently used portable memory-aids are sacred boards measuring from a few inches to more than 15 feet long. Covered with the usual carved patterns, they are designed especially and solely for the storage of information. They may include twenty or more concentric circles or squares in a row, all identical, but each one associated by virtue of its position in the row with a different site in the desert and a different set of memorized myths, songs, and dances. "Libraries" of sacred boards, hidden away in secret places, may be brought out when visitors come, and discussed in detail.

It is no surprise that these people are never lost, that they know the locations of more than 400 possible water sources. But it goes much deeper than that, much deeper than a matter of forming mental maps. The aborigine has created a unique desert, a homeland which Theodor Strehlow of the University of Adelaide has described as follows:

Mountains and creeks and springs and waterholes are to him, not merely interesting or beautiful scenic features in which his eyes may take a passing delight; they are the handiwork of ancestors from whom he himself was descended. He sees recorded in the surrounding landscape the ancient story of the lives and deeds of

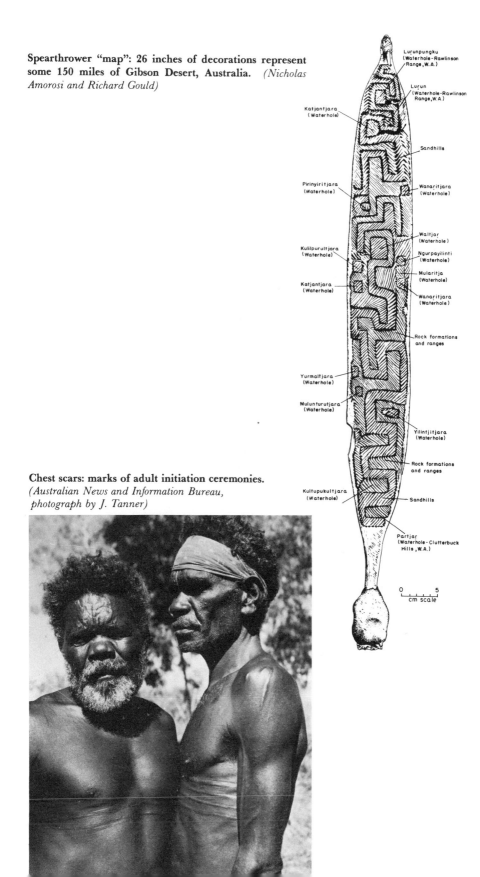

Spearthrower "map": 26 inches of decorations represent some 150 miles of Gibson Desert, Australia. *(Nicholas Amorosi and Richard Gould)*

Lurunpungku
(Waterhole-Rawlinson Range, W.A.)

Lurun
(Waterhole-Rawlinson Range, W.A.)

Katjantjara
(Waterhole)

Sandhills

Pirinyiritjara
(Waterhole)

Wanaritjara
(Waterhole)

Waltjar
(Waterhole)

Kulilpurultjara
(Waterhole)

Ngurpayilinti
(Waterhole)

Mularitja
(Waterhole)

Katjantjara
(Waterhole)

Wanaritjara
(Waterhole)

Rock formations and ranges

Yurmaltjara
(Waterhole)

Mulunturutjara
(Waterhole)

Yilintjitjara
(Waterhole)

Rock formations and ranges

Kultupukultjara
(Waterhole)

Sandhills

Partjar
(Waterhole-Clutterbuck Hills, W.A.)

0 5
cm scale

Chest scars: marks of adult initiation ceremonies. *(Australian News and Information Bureau, photograph by J. Tanner)*

immortal beings whom he reveres; beings who for a brief space may take on human shape once more, beings many of whom he has known in his own experience as his fathers and grandfathers and brothers, and as his mothers and sisters.

The whole countryside is his living, age-old family tree. The story of his own totemic ancestor is to the native the account of his own doings at the beginning of time, at the dim dawn of life, when the world as he knows it now was being shaped and moulded by all-powerful hands. He himself has played a part in the first glorious adventure, a part smaller or greater according to the original rank of the ancestor of whom he is the present reincarnated form. . . . Today, tears will come into his eyes when he mentions an ancestral home site which has been, sometimes unwittingly, desecrated by the white usurpers of his group territory.

In addition to reinforcing memories of real-life places, real-life stretches of desert, the art and ceremonies of the aborigines reinforce a basic way of looking at the world. They play a powerful role in evoking feelings of design in nature and the universe as well as in art, of related meanings as well as pathways, of an underlying connectedness among all things. Such notions must also be implanted, but deeper than the sort of information that one can recall at will, analyze, and modify. They must go beyond the ability to remember and summon up, accepted so completely that they shape behavior and belief at the unconscious level.

The aborigines provide a classic example of the uses of initiations in the absence of writing, although their symbols and design elements represent systems in the process of evolving into writing. Similar uses have been investigated, if not as thoroughly from the standpoint of mnemonics, among other groups. The initiation of boys typically starts abruptly, after early years of easy living, with "an act of rupture," removal from women and the family, and ends with circumcision. It involves a ritual death, a mourning for the end of childhood expressed, as among the aborigines, by the death-wail and the sound of the bullroarer, and by having the novice lie down covered and motionless on the ground. As reported by Victor Turner of the University of Virginia in a series of comparative studies of rites of passage, he may also be buried for a time, painted black, or "forced to live for a while in the company of masked and monstrous mummers representing . . . the dead, or worse still, the un-dead."

In a paper appropriately enough entitled "Betwixt and Between," Turner stresses the ambiguity of the novice's position. The novice exists in limbo, dead and yet not dead since soon to be reborn, in a state of "liminality" or "fruitful darkness," confusion and dissociation deliberately promoted in every way that human ingenuity can think up. He is taken into dark places, places with a double death-life connotation, caves and chambers which symbolize at once tomb and womb. He is shown such things as "relics of deities, heroes or ancestors, aboriginal churingas, sacred drums or other musical instruments, the contents of Amerindian medicine bundles,

and the fan, cist and tympanum of Greek and Near Eastern mystery cults."
There are distorted and incomplete images, masks and figures with abnormally large or small heads, noses or penises, missing arms or legs, dragons and monsters combining male-female or human-animal features. Some surrealistic masks combine human and landscape features as, for instance, part of a face and a grassy plain.

Language can serve as a superbly effective device for enhancing confusion. The aborigines use obscure and scrambled words and phrases, not only in the myths and songs they teach but also in their instructions. Initiations in Liberia and other West African nations may involve instructions given in a kind of pig Latin or double-talk, ambiguous tasks like "Go fetch water that isn't lying on the ground," and a variety of riddles, including the one about how to ferry a goat and a lion and a sheep across a river in three trips without leaving the lion alone with either of the other animals.

Terror is another common feature of initiations, terror and pain. At nightfall in the forests of West Africa, boys are led to dark places where men wearing grotesque masks leap out at them, seize them, press their faces against the ground, and make crisscross cuts on the backs of their necks, representing the tooth marks of the Dadawe or Great Male Spirit. Somewhat less frightening perhaps but no less pointed was the old English custom, repeated every year, of leading boys along the boundaries of a village and thrashing them with a cane at selected places along the way, so that they would never forget where their home territory ended.

All this is part of a hard-line, grinding-down process, a kind of training less widely approved today than it was in times past. Today teachers, at least good teachers, encourage their students to ask questions, to experiment and check and find out for themselves, to take as little as possible for granted. But the spirit of free inquiry has no place in education by initiation. Survival demands nothing less than utter, unquestioning obedience, passive and submissive students, dominating all-powerful teachers, and by-rote memory. The novice learns the elements of everything from landscape features and how to track animals and set up camps to systems of ethics, creation myths and songs, social obligations, rules and laws—in short, the contents of the tribal encyclopedia. That is his new beginning, his rebirth as an adult. In Turner's words, "it is not a mere acquisition of knowledge, but a change in being."

11 *The Ceremonies of Times Past*

▷ The gap between past and present, between the aborigines of Austra-
lia's central deserts and their ancestors at large in the tundra lands of ice-
age Europe, is appreciable. People in the process of adapting to such wide-
ly different environments, people separated from one another by half a
world and more than 20,000 years, could hardly be expected to arrive at
identical lifestyles, identical ways of transmitting information and viewing
the universe. After all, the men and women of the Upper Paleolithic were
moving in new directions, inventors and discoverers on a new scale. They
were pioneers, working out techniques which later generations would build
upon, modify, and elaborate.

The similarities, however, turn out to be at least as striking and signif-
icant as the differences. Humans living in groups have so much in common
independent of time and place. They confront many of the same basic prob-
lems, especially when they are members in good standing of the *Homo
sapiens sapiens* breed, and especially when they pursue a nonliterate, hunt-
ing-gathering wilderness existence. They must acquire all the knowledge
they can about their home ranges, and about the species which compete
with them for resources and provide them with food. They must evolve
ceremonies and other mnemonic systems which, among other things, help
organize and preserve that knowledge. These considerations in themselves
argue strongly for analogous behavior and thought processes across the
ages.

The Cro-Magnons, like the Australian aborigines and other twentieth-
century peoples, used secrecy and darkness as major elements in their cere-
monies. Secrecy has been associated with knowledge for some time, mainly
for power purposes to control people, to gain advantages over enemies or
rivals, in trade and love and war. In fact, the notion that knowledge about
sacred affairs, or knowledge of any sort for that matter, should be shared as
widely as possible is a relatively recent thing. There were probably grades
of secrecy in connection with prehistoric ceremonies, corresponding roughly
to "top-secret," "secret," "confidential," and "restricted" in military classi-
fication schemes. Top-secret information, including information about ways

of producing special lighting or echo effects to create illusion and instill awe, would have been limited to a small number of individuals, while lower grades of information were revealed to larger and larger groups. Revelation has a special "placebo" effect in its own right, since people being let in on information denied to others are flattered and all the more likely to pay attention and retain what they learn.

Darkness has always worked hand in hand with secrecy and revelation. It frames, accentuates, action. Performers moving out of the night or out of hiding places in caves into illuminated spaces command a degree of attention difficult to achieve in any other setting. Audiences are truly and completely captive. Eyes locked in position, they have nowhere else to look but straight ahead, nothing to do but concentrate on the events unfolding before them. They are likely to remember what they see and hear and feel under such conditions, and if it all happens suddenly and in an atmosphere of fear and confusion, so much the better.

Out-of-the-ordinary images serve a double purpose. They not only convey information symbolically but also add to the otherworldliness of Upper Paleolithic as well as aboriginal ceremonial settings. Heads without bodies, bodies without heads, familiar elements put together in unfamiliar ways, animal and human parts combined, disproportionately large or small features, and other varieties of imagined monsters—these are among the devices commonly serving to shake viewers out of habitual ways of seeing and thinking, to prepare them for the acceptance of further strangenesses. They are part of the process of creating that in-between state of liminality which, according to Victor Turner, represents "the realm of primitive hypothesis, where there is a certain freedom to juggle with the factors of existence. As in the works of Rabelais there is a promiscuous intermingling and juxtaposing of the categories of event, experience, and knowledge, with a pedagogic intention."

Anamorphic effects, images drawn in trick perspective so that their appearance depends on the angle of viewing or the use of mirrors, play a similar role. Chapter 9 describes a fine example in the huge Spanish cave of Tito Bustillo, the red and black horse drawn with an elongated snakelike neck which assumes normal proportions only when seen lying flat on one's back beneath a certain ledge; but no one has undertaken a systematic study of distorted cave figures to find out how many of them have this double aspect. As far as I know, the same situation applies to the distorted figures of aboriginal art, although the discovery of anamorphic effects would come as no surprise.

The aborigines consider some of their paintings to be especially important and, as Michel Lorblanchet of the French National Center of Scientific Research has learned, so did the Cro-Magnons. He spent several months

in the outback of northeastern Australia copying the art at remote sites and discussing it with aborigines, some of whom had painted on rocks when they were young. They still visit the sites occasionally to check on the state of the paintings, retouching the ones that are fading. Lorblanchet suggests that by preserving the paintings, an activity which "goes on all the time," they may be preserving the sacred life and fulfilling age-old obligations to dreamtime ancestors.

Alerted to the prevalence of this practice, he began searching for signs of retouching when he returned to his own home territory, a region not far to the southeast of Les Eyzies. He did not have to look long. The region contains about thirty art sites, including Pech–Merle with its famous pair of spotted horses (Chapter 7), and Upper Paleolithic artists had freshened up part of the figure of another horse in a less accessible chamber of the cave, applying brown paint on top of fading red. Lorblanchet found further traces of retouching in Cougnac, parts of a large red deer and several heads painted over in black, as well as in a number of other caves, possibly marks of ritual preservation in prehistoric times.

However, there are also many cases of figures disregarded and deliberately obliterated, where artists drew directly over earlier works as if they did not exist. The Great Hall of Altamira includes a surface with at least five animals, five layers of pigment, painted one on top of the other (Chapter 2), and heavily painted-over surfaces are a common feature of the art caves. Apparently in such cases the placement of the paintings was more important than the painting itself or its quality. The fact that artists frequently ignored nearby surfaces which were just as convenient for painting or engraving, just as smooth and otherwise suitable, suggests that the surfaces they did select may have been sacred spots, places of special significance within the overall pattern of the cave. Why they painted where they did is one of the many important questions that remain unanswered.

Turning for hints to the art of Australia is no help. Indeed, it rather complicates the problem by introducing a possible regional factor. The aborigines of the Western Desert are superimposers, do not hesitate to paint new designs over old ones, and have never made a practice of freshening up fading figures. The aborigines of the Central Desert, on the other hand, are retouchers by long-established custom, and they do not go in for superimpositions. Yet, as Gould points out, both groups hold their ancestors in high esteem, indicating the existence of rules and traditions about which we know nothing.

Nothing is known about the extent or nature of prehistoric painting beyond what remains on stone and bone, work dating back 30,000 to 35,000 years at most. Red ocher and other pigments have been found at living sites as much as several hundred thousand years old, however, so

people must have been putting colors on something long before the earliest known art. A site about 100 miles southeast of Paris dug by Leroi-Gourhan includes early Upper Paleolithic deposits solid red all the way through and more than a foot thick, which suggests that many generations of hunter-gatherers were bringing in large quantities of pigment.

If they were painting wood, hides, and other perishable materials, it is difficult to believe that they did not also paint one another upon occasion. "The coloring is so intense," comments Leroi-Gourhan, speaking of such pigment-rich sites, "that practically all the loose ground seems to consist of ocher. One can imagine that with it the Aurignacians regularly painted their bodies red, dyed their animal skins, coated their weapons, and sprinkled the ground of their dwellings, and that a paste of ocher was used for decorative purposes in every other phase of their domestic life. We must assume no less, if we are to account for the veritable mines of ocher on which some of them lived." On the other hand, arguments—even, and sometimes especially, the most plausible—fall far short of direct evidence. For the time being the verdict on body painting must be "quite probable." But I wish we knew.

For all our ignorance, for all the questions remaining unanswered and perhaps never to be answered, the archeological record still has a great deal to tell us. A study of the art itself tells us that art alone was not enough, that more than art was involved in the sacred life of times past. The uses of caves and images to arouse certain kinds of emotion and attention tend to confirm what is apparent in studies of the aborigines and other present-day hunter-gatherers. Two points are reasonably clear: (1) images, painted and engraved on cave walls and sacred objects, served a most important function in prehistoric ceremonies; and (2) they were nevertheless only a part of those ceremonies, which drew on and combined all the arts.

Take the dance, for example. A number of human figures, shown singly or in groups have been interpreted as dancers. The painted figure looming over the sanctuary in Trois Frères, the famous "sorcerer" with wide-staring eyes and reindeer antlers, is in a low crouching position and could well be imitating the movements of some animal as part of a dance sequence. His posture reminded Breuil of a "cakewalk dance." There is a similar male figure not far away in the same cave, on the panels that include more than seventy animals. He is surrounded by horses and horned bison, wears a pair of long curving bison horns, and seems to be executing some sort of high-stepping dance.

There is another sort of evidence, most of which has been destroyed during the past half century or so by the discoverers and exploiters of art caves. Even the most conscientious investigators have unwittingly contributed to the loss. Primarily interested in finding paintings and engravings,

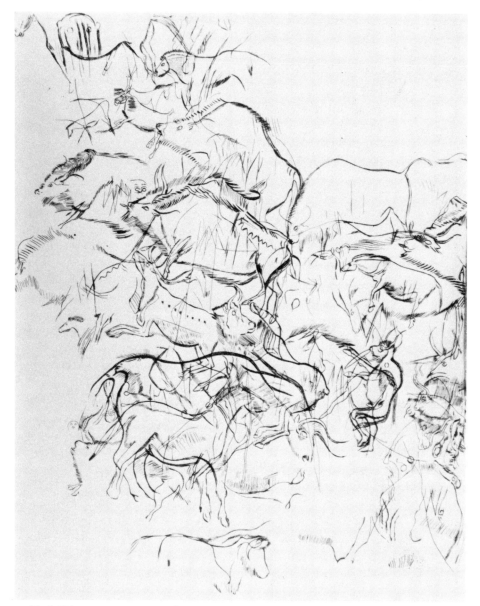

Trois Frères sanctuary: part of panel of engravings, including high-stepping "sorcerer" with bison horns (lower right). *(Collection Musée de l'Homme)*

they concentrated on walls and ceilings, taking the usual precautions such as not brushing against likely-looking surfaces, not bringing acetylene lamps too close, and so on. Yet all the time they were probably trampling on and ruining important traces on cave floors. They duly noted hearths and tools and bones, but missed less obvious features that might have fur-

nished clues to past ceremonies in general and to dancing in particular, notably footprints preserved over the ages in mud and clay.

We are somewhat wiser today. A model procedure is that which Jean Clottes followed at Fontanet, located high on the side of a valley in the Ariège region of the Pyrenees. The site, which can be reached only by a nylon-ladder climb into a small black hole at the top of a slippery and absolutely vertical 20-foot wall, was discovered not long ago by Luc Wahl, head of the Secours Française Spéléologie, the local rescue squad for lost or injured speleologists. It contains a niche with some twenty-five engravings, among them a wounded bison and three human figures; a panel of eleven bison, a horse, two ibexes, and two more human figures; and another panel consisting entirely of abstract forms, more than fifty, including claviforms, parallel lines, and patterns of black and red dots. On a wall near the end of the gallery, fading but still striking, is a bison 2 feet 6 inches long, painted in red and black, with mane and curving horns.

Before investigating the art, however, Clottes had to deal with a number of problems. Politically, he had to keep commercial interests at bay and keep the cave closed to tourists, a move accomplished over some resistance and with the active backing of the French Ministry of Culture. Archeologically, the first thing he did was to lay out a path weaving along "empty" stretches of the cave floor, places without signs of prehistoric activity, and mark the way with white lines on both sides. At one point there were so many features that he could not find a clear way through, so he and Wahl rigged up a special catwalk, an aluminum-mesh screen suspended from the walls, so that one can walk a couple of feet above the floor and examine the evidence closely without doing any damage.

The catwalk area is covered with the vestiges of Upper Paleolithic people impressed in clay. There are footprints all over the place, some looking so fresh that they could have been made yesterday, toes and heels marked in sharp outline. Only one footprint shows signs of a shoe, which appears to be an open-toe sandal. The area includes handprints and knuckleprints as well as footprints, more than a hundred in all, and every one plotted on maps and cast in latex. This is precisely the kind of evidence that needs to be preserved and studied for clues to dancing. If the small size of the three hearths found in the cave and the general sparseness of food debris are any indication, people did not stay long. Clottes believes that they spent only a night at the site, or perhaps two nights at most.

Yet within such a brief span they managed to accomplish a great deal, leaving that collection of art. They also left five flint tools with associated chips all lying close together where they were made, two balls of orange clay lying on a slope and, on a ledge a little further along, the complete skeleton of a salmon. The possibility that these features had ritual signifi-

cance and that they were part of intensive ceremonies would certainly be reinforced if patterns of movement could be deduced from an analysis of the placement of footprints and handprints, a project for the future.

More raw data of this sort lie directly opposite Fontanet, on the other side of the valley. Niaux is located there, with its widely visited Salon Noir, and with an unpublicized gallery which is strictly off limits for tourists. The gallery is one of the most difficult to explore in this or any other cave. It is blocked off by three lakes, the first of which was crossed on a raft during a winter dry spell in 1925. An even more impassable lake frustrated explorers until 1940, while Lake No. 3 was finally crossed in December 1970 after pumps had been brought in to lower the water level. That opened the way to about 3,300 feet of new passages, currently sealed off by a protective wall. The passages have only five simple paintings, three bison and a horse and a marten or weasel (the only one depicted in Upper Paleolithic art). But they contain about 500 footprints, more than have been found in all other known art caves combined.

These traces, like those in Fontanet, will be studied in greater detail as part of the continuing search for patterns. So far the best evidence for dancing comes from the Tuc d'Audoubert cave, in the side chamber to the right just before one reaches the chamber with the two clay bison (Chapter 7). The half dozen rows of heelprints, which start deep in the chamber and fan out toward the entrance, suggest the disciplined movements of a group of dancers. Furthermore, we can speculate about their postures and how they were dancing. The ceiling is so low that they would have had to be stooping or crouching, possibly imitating the actions of some four-footed animal, perhaps the bison.

Musicians probably accompanied the dancers. Oval bone and ivory objects with abstract designs carved on them and a hole at one end make a high whining hum when whirled from a string, suggesting that the sound of the bullroarer moved people in Upper Paleolithic as well as in modern times. Some so-called batons made of bone may have been drumsticks, while Soviet archeologists digging at a site on a tributary of the Dnieper River northeast of Kiev unearthed a set of mammoth bones painted red which they believe served as percussion instruments: hip-bone xylophone, skull and shoulderblade drums, and jawbone castanets. To prove their point, the excavators played the bones in an informal jam session inside a hut supported by mammoth tusks, a reconstruction of a typical prehistoric Russian dwelling. As indicated in Chapter 7, the high-stepping, bison-horned man in Trois Frères seems to be playing an instrument which has been interpreted as a pipe or a musical bow.

Flutes and fragments of flutes have been found in the caves, about twenty in all, generally made of bird or cave-bear bone with three to seven

Prehistoric percussion instruments? Mammoth hipborn xylophone with antler hammer.
(Copyright, Novosti Press Agency)

holes or stops, measuring up to about 8 inches long, and designed to be played by holding clarinet-style and blowing through one end. As far as the nature of the music played on the instruments is concerned, we have something more than pure speculation to go on, as the result of a unique study that is still under way.

The study started several years ago when Mark Newcomer, the London archeologist whose experimental work with hafted tools is described in Chapter 3, took a sheep's foot bone, cut it to size, and bored holes in it with a bow-drill such as might have been used during the Upper Paleolithic—and produced an exact replica of a six-hole, 4.375-inch flute found in a cave in southern France. No musician, he tried playing it from time to time without much success.

Now the flute is in the hands of Lyle Davidson of Harvard and the New England Conservatory of Music, a musicologist and composer who has borrowed it for experiments of his own. At first he spent time getting the feel or heft of the instrument, balancing it and holding it in various positions like a new tool: "When you pick it up, it settles into your fingers so that the left hand rests comfortably on three of the top holes and the right hand rests on the other three holes. The curvature of the bone encourages this position."

During early practice sessions he began to suspect, as Newcomer had

suspected, that the flute was not complete. An unexpected difficulty in producing steady notes and the presence of two notches at the blow-through end suggested that it was meant to be played using a special attachment, a fipple or whistle-head which directs air flow as in a recorder. With this added element fitted into the notches, he was able to produce strong and clear notes instead of faint piping sounds. It turns out that the flute is pitched an octave above soprano at about piccolo level, and has a pentatonic or five-tone scale which, incidentally, also serves as the basis for one form of Hindu music, Anglo-Saxon folk melodies, and certain music played in the Japanese Kabuki theater.

Davidson is impressed with the sophistication of Upper Paleolithic musicians: "The flute by its very existence and design indicates something fixed and planned about the melodies played, something fixed in the composer's mind. It is anything but haphazard, delicate and sensitive with a level of technological subtlety which implies a corresponding subtlety of use. Controlling it requires considerable exertion and practice. Of course, a modern flute also requires an enormous amount of practice, but it is designed to play music you know. You have mental templates of contemporary notes and scales, and can tell when you produce the right sound. But with this prehistoric instrument you have no such guidelines. You must figure out what it wants to do, discover what is difficult and what is easy or natural."

The process is something like working with a strange horse, not breaking it in but adapting to it, understanding its disposition and natural pace. At this stage it is clear that the music must have had an unusual offbeat quality, since the two sets of stops produce two very different kinds of sound. The upper stops produce distinct and discrete notes, much like the notes in modern scales. The lower stops, however, yield notes with shorter intervals and having almost the same pitch; it is the color or timbre, the resonant quality, that changes. The result is a more continuous, nearly steady tonal effect.

Davidson is still taking the measure of the flute, testing its range and the sort of finger action to which it responds best, exploring its strengths and limitations. The ultimate objective is reconstruction. There are many graphic versions of what the artists did and how they did it, illustrations showing them at work engraving mammoth tusks, shaping figurines, preparing pigments and painting on cave walls, sculpting animals in rock. It may not be long before Davidson and his colleagues produce analogous versions of the music played in times past. In any case, he enjoys the challenge: "The music is very rich and warm, not at all light or airy—very serious. I must say that this is lots of fun, and I am learning a great deal about the flutes of the world."

Our picture of Upper Paleolithic ceremonies expands, fills out. In addition to art, they quite probably made use of dancing and music, and perhaps body painting as well. What about singing and chanting? The question brings up once more a chronic problem of research in prehistory, the need so often to lean so heavily on inference. There is no direct evidence in this case, and it is difficult to imagine how there could be, short of figures and scenes which might lend themselves to the interpretation of singing. So we depend again on circumstantial evidence, and negative circumstantial evidence at that. But it does seem rather unlikely that people would remain mute in the midst of all those images, sounds, rhythms, and all that excitement.

Investigations to date have focused almost entirely on the visual aspects of the caves, on lamps and lighting and shadows, on painted and engraved figures and their strange settings deep past squeeze-through corridors and chatieres among convoluted limestone formations. It is the images which bring us underground. We are constantly on the lookout for images, and pay special attention to where they were located and why. But caves are wonderful places for acoustic as well as visual effects. Underground ceremonies must have been designed to take advantage of and shatter the silence as well as the darkness, to bombard the ear as well as the eye with a variety of sensations planned to arouse and inform. Breuil had a feeling for the uses of sound. Speaking of the setting of the Trois Frères sanctuary, he noted that "the effect of songs, cries or other noises, objects thrown from no one knows where, was easy to arrange in such a place."

Think of the acoustic effects that can be produced in caves, sound waves like surf rolling and ricocheting through winding passage-ducts, sound waves trapped and bouncing back and forth off jagged reflecting surfaces in natural echo chambers, sound waves muffled and scrambled and reverberating—swelling and fading, soft and thunderous, rustling and rasping, sustained and coming from a great distance and approaching slowly, or loud and sudden and close at hand. Imagine the sound of bullroarers nearby in an underground labyrinth, the sound of flutes rising high and clear as a human cry or a bird from some place impossible to locate.

A song sung inside a tubelike corridor would not be heard until someone passed directly in front of the opening, directly across the sound beam, which is roughly the acoustical equivalent of a light switch or coming suddenly around a bend upon an illuminated painting. The playing of fragments of familiar melodies or entire melodies inside echoing spaces would correspond to displays of incomplete or distorted images respectively. Anamorphic music could be created as readily as anamorphic art—music unrecognizable from one position and taking on the shape of a known melody from another. Sound can be used in many ways to arouse emotion and

control movement, to frighten and confuse and steer people, to make them stop short, turn around, come closer, back away.

If studies among the aborigines of Australia and elsewhere are any indication, the Upper Paleolithic ceremonies which incorporated such effects probably included initiations. Archeology provides a few hints that this was indeed the case. Freeman and Echegaray have devoted special attention to the placement of the stone face they unearthed at El Juyo (Chapter 7). They note the significance of the placement of the face, clearly that of a stylized human being when viewed from a distance, from just inside the entrance to the cave, and something out of this world when viewed close to, an imaginary half-human, half-feline creature. In other words, things might have been arranged so that the secret would be revealed only to a select few who were permitted to come in all the way.

Freeman and Echegaray have reconstructed, re-staged, how it might have happened. They are reasonably sure that the revelation upon coming close was as carefully planned as the rest of the El Juyo sanctuary: "Artists so capable that they could convincingly portray the features of a feline or a man with such economy of means, a few blows and scratches and dots of paint, could obviously have exaggerated those features to make them perceptible at a distance. . . . It seems likely that this representation was actually intended to be read at two levels." In their opinion, everything points to an initiation involving the composite face, as "the synthesis of a dual nature, animal and human, into a harmonious whole."

There is little doubt for whom at least some of the presumed ceremonies were devised. The individuals moving in possible dance patterns out of the Tuc d'Audoubert side chamber were all children about thirteen to fifteen years old (Chapter 7). Children are represented among the footprints in Fontanet, and also in a French cave near the Mediterranean coast where they were apparently running and left a trail in clay. Interestingly enough, no traces have been found suggesting all-adult ceremonies; all known sites with many footprints feature groups of children and adults together. If ceremonies were continued at later stages in life, they may have been held elsewhere, with caves used mainly for children.

An intriguing record exists in the Niaux gallery currently blocked off by a wall and three lakes. "One small area alone includes 120 to 140 footprints," Clottes told me. "Three children were walking on a sand dune close to the wall, side by side. One cannot help imagining that they were holding hands. There is a wet spot in the center of the dune, a very shiny layer of calcite, and the children stopped there, probably attracted by the shininess. Their footprints are 18 to 20 centimeters long, so we estimate that they must have been eight to ten years old." Of the 500 footprints in the gallery, one third to one half belong to children, but whether they were

boys or girls or a mixed group is another question. Boys are generally the participants in the vigils and ordeals of early aboriginal initiations, and the same situation may hold for prehistoric times, although no way has yet been found to distinguish cave footprints by sex.

So the archeological record provides a few glimpses of education for survival. Out of necessity new forms were created in all the arts, repertoires of new images, gestures, movements, rhythms, and melodies arranged in patterns for ceremonies designed to shape new forms of behavior. Language must have expanded along with the other arts. People must have invented new words and word patterns, new idioms and metaphors in the interests of by-rote memory. What were they singing about, and what were the myths which animated and structured their paintings and engravings, dances and music? These questions may well turn out to be unanswerable, but that is all the more reason for trying and going as far as possible.

The task would be considerably lightened if we had some versions of "prehistoric," preliterate myths in writing—and it so happens that we do. When a society is shifting from nonliteracy to literacy, a process which started some 5,500 years ago in Egypt and the Near East and is not yet completed, its earliest legends or recorded myths tend to be closely related to the last poetically transmitted myths of its nonliterate days. Among the best documented and most intensively studied of Europe's early myths are those incorporated into the works of Homer.

The Greeks converted the Phoenician writing system into a proper alphabet some time after 750 B.C. (The earlier highly publicized Linear B writing, by the way, was designed for cataloging only, for records of taxes and commercial transactions, and was impossible to use for narrative purposes.) Until then they were still prehistoric, in the sense that they were still passing on the entire contents of their tribal encyclopedia, including the originals of the *Iliad* and the *Odyssey,* orally and musically. It was during this period that Homer composed his epics primarily for the education, by art and inspiration, of people who could neither read nor write.

The epic style is ideally suited for implanting information. The behavior of Greece's gods, the behavior of most gods most of the time, has long been recognized as anything but exemplary. They are frequently and notoriously out of sorts, angry and aggressive, jealous and promiscuous. They meddle incessantly in earthly affairs, punishing and seducing and visiting all sorts of plagues upon mortals, taking sides in battles and domestic and political disputes, often plotting against one another. At one point Poseidon, Hera, and Athena conspired, unsuccessfully, to put Zeus himself in chains. In short, the gods were conceived in an all-too-human image, as they had to be for the very best of reasons.

There is nothing duller, less inspiring, than thoroughly good individ-

uals, human or divine, consistently doing good deeds. Milton's angels are not exciting, but he had no trouble making Lucifer come alive. Heroes tend to be as fallible as gods, sulking in tents when they are not out killing or arguing about who and when to kill, and generally receding into the background after the battles are done and the unglamorous business of rebuilding begins. Evil, conflict and sex and violence, are what make lasting impressions; so myths must have them in abundance for memory's sake. That goes for the myths of the aborigines as well as those of the Greeks.

The central role of the gods is stressed by Eric Havelock of Yale University in a major analysis of the origins and nature of the Greek epic:

It is often said that the presence of deities in the mythology of so-called primitive peoples is caused by failure of comprehension; they are used to supply a causation for mysterious natural forces not otherwise understood. But the miraculous character of the acts they may perform is not the real clue to their function. They serve as a kind of shorthand, supplying a narrative framework in which flood and fire, earthquake, storm, shipwreck, the sacking of cities, the failure of crops, epidemics, and the like can be described as the acts of agents without impairing the essential quality of the phenomenon. A kind of mythic understanding, valid for its purposes, takes the place of that chain of cause and effect in which literate speech would seek to arrange the same phenomena.

Action is the key to memorability. Bare facts and theoretical concepts can be as dull as good deeds, a point which Havelock makes by citing the following Euclidean theorem:

The angles of a triangle are equal to two right triangles

and rephrasing it as it might be expressed in Homeric language:

The triangle stood firm in battle, astride and poised on its equal legs, fighting resolutely to protect its two right angles against the attack of the enemy.

The first version is factual and concise, completely appropriate when the information can be stored in a textbook for easy off-the-shelf reference. The second version, of course, is composed in preliterate oral tradition for ready recall. Actually, Euclid would have been impossible without writing.

The oral tradition demands heroes, glory and the rolling of drums, life larger than life, events unfolding on a vast stage. The epic was based on fact, but leaned heavily on fantasy, on a dream world of miracles and unlimited resources. The real Troy was just another military outpost, a fortress occupying rather less than 5 acres. The epic Troy was a mighty metropolis, "a wide-wayed city." Its walls enclosed space for some 50,000 soldiers and a magnificent palace with "smooth-stone cloister walks and . . . fifty sleeping chambers of smoothed stone," one for each of King Priam's fifty sons, each sleeping "beside his own wedded wife."

Agamemnon made peace with Achilles with a prodigious assortment of gifts. He not only returned the latter's beautiful captive-mistress whom he had abducted but not bedded with, but offered by way of further compensation "seven unfired tripods, ten talents' weight of gold [about 7500 ounces], twenty shining cauldrons . . . twelve horses . . . seven women of Lesbos . . . seven citadels," among other things—enough, Havelock comments, to bankrupt any Greek state. The Trojan War, no ordinary struggle, lasted ten years. Odysseus' return trip back home to the waiting Penelope, past tempting sirens and the one-eyed Cyclops giant and many other obstacles, took an additional ten years, and ended with the slaying of her 108 suitors. Adventure and exaggeration, the verbal equivalent of image distortion, commemorate the importance of the information being conveyed, of the messages imbedded in the narrative.

In the *Iliad*, for example, Homer sings for 249 lines of how to make armor for heroes. Hephaistos, the lame god of fire and metalworking who lives in a house of bronze, is sweating among flames at his anvil, twenty bellows blowing on as many crucibles, forging a huge five-ply bronze shield, a close-fitting helmet, and leg guards of "pliable tin" for Achilles. It is a tale within a tale, a set of nested messages. Homer uses the episode to describe not only the shaping of the shield but the decorations hammered into it, scenes depicting in great detail everything from shepherding, grape gathering, a marriage festival, and two men arguing before a judge to the clash of armies by a riverside and the universe complete with earth, sea, sky, and constellations—a panoramic vision of the Greek way of life.

Similarly specific passages deal with basic military skills and procedures for building defenses, maneuvering in chariot races, butchering and roasting meat, raising a funeral pyre. After trying for nine years to take Troy, the Greek forces rallied for a final effort, and Homer uses the occasion for a 266-line roll call of chieftains and cohorts from 29 regions in 1,248 ships, providing a verbal map of Aegean towns and rivers and, at the same time, an upbeat feeling of tribal unity and a new day for the frustrated invaders. The epic is concerned basically with social norms or precepts, but never expressed in terms of abstract principles. The expression is by concrete example, through action, conflict, and proscription, in the form of individuals rewarded for good deeds or punished for evil behavior.

Taking the passage in the *Odyssey* where Telemachus, Odysseus' son, has called a meeting of the elders of Ithaca to complain about the suitors of Penelope, Havelock presents a line-by-line analysis of what is being said explicitly—and implicitly. One of the elders speaks at the opening of the meeting, the left-hand column being what he says and the right-hand column what he means:

hearken now to me, men of Ithaca, whatsoever I may say	opening of proceedings requires audience to come to attention
never once has our agora been held nor council since Odysseus embarked on hollow ships	the agora and council should meet regularly
and now who has summoned the agora thus?	any citizen may request an agora
on whom has such great need come?	to raise a matter of public concern
either of young men or those who are elder born	involving interests of either junior or senior citizens
has he heard news of an army approaching?	an agora is summoned on news of hostilities
news that he would declare clearly to us when he learned of it first	early warning depends upon reliable word from those who first get it
does he disclose and orate-in-agora some matter of the demos?	issues of public concern should be disclosed and discussed.

This double sort of talk goes on as Telemachus replies and states his complaint in an address where the wisdom is "heavily disguised." It goes on throughout the epic, whenever highly charged personal exchanges take place. Rules, procedures, traditions are reinforced by repetition after repetition in each epic and each epic heard on numerous occasions, and over and over again in every line with the repeated beat of the hexameter rhythm— and internal rhymes and alliterative sounds echoing back and forth within and between lines like reverberations in hollow places. These and a great many other devices were at work simultaneously as Homer sang to the Greeks, accompanying himself on the lyre, the main purpose always being pedagogy.

"If it is a mistake to seek to separate the bard from the priest and prophet in oral society," Havelock emphasizes,

it is equally mistaken to view him as a mere entertainer. Entertainment was, to be sure, one of the objectives of performance . . . but this was subordinate to the performer's functional role as the reciter of preserved statements. A festival of recitation, of song and epic accompanied by dancing, was no more or less sacred, and so protected, than a ritual sung before a shrine, nor was it any more or less entertaining. The notion of poetry as the expression of purely esthetic values in the modern literate sense must be given up as we approach the poetry of preliteracy.

Nothing could be further from modern poets than the poets of preliterate times. They were not rebels or critics, not artists expressing themselves, not outsiders singing occasionally to small audiences and mainly to one another. They were high-ranking and highly popular representatives of the establishment, among the leading guardians of law and order, full-fledged

members of the elite, using their prestige and their genius to tell people how to behave and what to think and believe. According to Havelock, this explains the otherwise baffling problem of why Plato had no place for poets in the Republic, his ideal society. He distrusted poets in general and Homer, as the most powerful of poets, in particular. He himself was committed to intellect, to logic and mathematics and rationality, and he expected similar commitments from poets and the gods.

Plato objected strenuously to the unruly behavior of the Olympians, and to all poetry which appeals to "lust, anger and all the appetitive, painful and pleasant states of the soul . . . and feeds and waters these, whereas it should dry them up, and makes them our rulers, whereas they ought to be controlled in order that we might become better and happier." In this passage Plato is speaking out of another world, another planet almost, and speaking puritanically. For him poetry corrupts by playing up to and arousing the baser instincts, although he failed to recognize the mnemonic significance of such effects. He is speaking for the future, for the revolutionary notion that things can be improved, when he comes out on the side of change and writes of becoming "better and happier." Homer was his natural enemy.

Homer belonged to prehistory, to the last days of prehistory and the last days of Greece's oral tradition. In him that tradition reached a peak which, because of the imminent rise of writing, would never be reached again. The people of the Upper Paleolithic lived at the dawn of the oral tradition, and in a sense started what Homer finished. Their myths reflected the fact that neither they nor the animals they lived among were domesticated. They had to go out and track down and often fight their prey, while the Greeks simply harvested their tamed and waiting herds (and fought one another). It was the difference between the hunt and the slaughterhouse or abattoir. The wild animals that played direct, physical roles in the lives and art of the Magdalenians, and presumably in their myths, have become abstractions in Homeric myths, the subjects of long similes, as when a warrior goes after his enemies like "a lion which leaps on the neck of an ox or heifer that grazes among the wooded places, and breaks it."

One also has the feeling that the myths of the Upper Paleolithic, in contrast to those of classical times, were not nearly as widely standardized. To be sure, at any given period certain basic similarities may be seen in all cave art, local art styles may be closely related, and identical animal figures, abstract signs, and portable art objects have been found many miles apart. Nevertheless the similarities on an inter-regional basis are not overwhelming. The total body of figures in one art cave does not in general bear a strikingly close resemblance to what appears on the walls of another cave in another region. It is as if a number of localized bands were still

speaking localized languages, but coming together more frequently and working slowly toward a common language. Of course, the existence of larger "we" groups implies larger "they" groups, so, then as now, inclusion and exclusion proceeded simultaneously, ensuring continuing Tower of Babel problems.

For all the differences, however, the prehistoric, preliterate myths of the Magdalenians and the Greeks shared a common objective as well as certain common devices. In both cases, they provided the narrative structure for tribal ceremonies, and although the contents of Magdalenian myths may elude us, that need not be the case for their general style and tone. It is a safe bet that they were sung to a beat, and that they included heroes and miracle workers of some sort, and plenty of conflict. These elements would serve the purposes not only of initiations but also of rites concerned with such things as fertility, rain-making, and healing and curing.

The ceremonies of the Upper Paleolithic represent a unity which has gone, perhaps forever. For us things have differentiated, fragmented. There are individual institutions and, separated from them, individual arts—and, above all, individual human beings, each with personal idiosyncrasies and beliefs. For our prehistoric ancestors it was all one. Everything that happens now in churches, schools, town halls, and theaters happened concentrated and intense and all at once in the caves. It was the only way in those days to create a human unity, a body of conforming and obeying people. People who were individuals in the modern sense could never have survived.

Pressure for Planning 12

▷ The caves, with figures set in constricted and wide resounding spaces, emerge as focal points for indoctrination—places designed to prepare people for traditional lives, traditional roles. Yet traditions which had seemed unalterable were crumbling faster than at any time in the past, a mark of the human condition ever since, and the need for new traditions and new rituals was never greater. The problem may be more complicated today, but it was brand-new then. With no precedents to go on, people had no choice but to deal with it opportunistically, catch-as-catch-can, improvising for stability on the run in a world of accelerating change and conflict. They mobilized art and the arts in the service of ceremony and, in the process, created gods and elites, ultimately elevating a few of the latter to divinity.

All this was done under pressure, the most pressing of all pressures, the pressure of people on people, which in the last analysis is the main reason for elaborating culture and for the phenomenon of art in the Upper Paleolithic. There is danger as well as safety in numbers. Often and especially during crises we tend to act as loners, deeply self-immersed, and the more of us living together the greater the trouble. Two can be trouble enough. The most basic two-person relationship, mother and infant, involves the interaction of two strong egos and a set of conflicting interests as well as love and nourishment. Add a third person, say a father, and things become triply complicated. Three may or may not be a crowd, but it means three relationships instead of one, mother-father and father-infant as well as mother-infant.

There is a mathematics of conflict. According to Robert Carneiro of the American Museum of Natural History in New York, tensions rise rapidly with a rise in the number of two-person relationships or dyads as group size increases. The formula is $(N^2-N)/2=D$, where N is the number of individuals and D is the number of dyads. Thus, ten dyads exist in a five-person family, while the addition of one more offspring increases the number of dyads by five. When the Yanomamo Indians of southern Venezuela and northern Brazil reach the 100 to 125 level, 4,950 to 7,750 dyads, the atmosphere becomes so charged with hostility that the group must split in two.

191

The conflict formula holds up to a point only, of course. Compensating factors come into play at higher population levels. Otherwise cities of 10 or more million persons (about 50,000 billion dyads), not to mention towns and most villages, would be impossible. Violence must flare up under such conditions. The miracle is that a city can exist at all, that human beings who evolved as members of small bands do not explode in a chaos of mayhem. What saves the day is that so few people know one another. For all the muggings of strangers by strangers, fighting breaks out most often among close friends and relatives, particularly among parents and children. Being a stranger in an urban setting, the very impersonality of the city, has its evolutionary advantages.

The old problem of people living continually under the tension of needing one another and at the same time keeping their distance seems to have become acute, if it did not actually originate, during the Upper Paleolithic. It had a great deal to do with the appearance of art in caves and elsewhere. Another mathematics is relevant here, a counteracting mathematics of cooperation as applied to hunter-gatherers. Using a computer, Martin Wobst of the University of Massachusetts in Amherst followed the histories of each of forty simulated populations year by year for an average of 400 years (some five minutes of computer time per simulation), and then calculated the survival chances for bands of different sizes.

A "band" consisting of only a single individual would presumably be ideal from the standpoint of minimal conflict, but not from the standpoint of longevity. Loners, male or female, have a half-life of about a year, which means that half of them will die of disease or accident within a year, half of the survivors will die during the next year, half of that half during the third year, and so on. But a group out-survives an individual. The half-life of a group of five persons increases to about a generation, which indicates the heightened survival value of the family, and the half-life prospects for a five-family group of 25 persons is 250 to 500 years, even allowing for the effects of increasing conflict.

It so happens that twenty-five is a good representative figure for the logistics of living together, a compromise based on long experience of how much conflict can be endured for how much cooperation. Among the Australian aborigines most bands are made up of twenty-five individuals, with a range of from twenty to seventy, and similar figures have been reported in a series of studies of the Kalahari Bushmen, the Andaman Islanders, the Birhor of northern India, and other hunter-gatherers. A twenty-five person band includes about a dozen adults, which is generally sufficient to carry out the day's work. As a rough index of the relationship between group size and violence, Richard Lee of the University of Toronto found that in one group of Bushmen, 18 homicides occurred in the period from 1920 to 1969:

15 in camps of 40 to 150 individuals, and only three in camps of less than 40.

Even in small groups there are safety-valve measures to help relieve the pressure of being together. As indicated in Chapter 4, keeping the peace calls for a tradition of pointed putdowns calculated to discourage arrogance and the faintest hint of wanting to lord it over others, and for an ethic of giving to discourage any piling up of valued possessions. Among the Bushmen in one region gifts are continually circulating in exchange systems that may extend for as much as 300 miles, involve dozens of individuals and include more than 2,000 articles such as beadwork, decorated bags, arrows, blankets, knives, spectacles, and safety pins.

When all else fails, there is always the option of getting away from it all. A band does not consist of a fixed group, of people always together and seeing the same faces every day, month after month and year after year. According to Lee: "Unlike farming and city peoples, foragers have a great deal of latitude to vote with their feet, to walk out of an unpleasant situation. And they do so, not when their food supply is exhausted, but well before that point, when only their patience is exhausted." The population of one typical camp fluctuated from twenty-three to forty, and seventy-six individuals came and went—all during a single four-week period.

The flow of people is another sign that the band is not alone, not a self-sufficient unit. Bands as well as individuals need one another. They must come together periodically to share information, organize and carry out large-scale hunting or gathering operations, and obtain mates. The problem is how they come together, whether on a purely nearest-neighbor basis where the determining consideration is walking distance, or on a more formal, structured basis in which distance is a factor but membership in a recognized social system may be more important. Census studies among the hunter-gatherers of modern times indicate that they tend to be organized into "dialectical tribes," groups of bands all speaking the same dialect—and that, while a tribe may have as few as 200 members or as many as 800 or more, most tribes operate at about the 500 level.

In an analysis stemming from his computer-simulation studies, Wobst considers some of the possible reasons behind this observation. Mating rules are a major factor in determining the size of the tribe, the population needed to ensure its survival by providing mates for all eligible individuals. Assuming that members of a band generally have to go outside the band for mates, that there is a taboo against incest, that a man marries a woman younger than himself, and that the wife moves in with her husband's family, then a tribe would require at least 475 people to provide an adequate mating pool or a mating network of nineteen 25-member bands, a theoretical figure reasonably close to the real-life 500.

If culture in the form of mating rules is all-important in influencing

population sizes, biology in the form of human needs and available food supplies plays the central role when it comes to the distribution and density of populations. The component bands of a mating network would tend to space themselves according to a fair-share-for-all principle. They would be expected to divide the land into equally abundant hunting-gathering territories. For example, they might arrive at a two-ring hexagonal or honeycomb pattern, an inner ring consisting of a central band and its six nearest neighbors located at equal distances from it and from one another, and an outer ring of twelve equally spaced bands, an arrangement which also approximates what is often found in the real world.

This pattern provides a model for present-day hunter-gatherer tribes. As far as archeological evidence bearing on tribal origins is concerned, the record is a virtual blank until the Upper Paleolithic. The transition from an open system organized strictly along nearest-neighbor lines to a closed, formal system of affiliated bands depends above all on the carrying capacity of the land and how it is exploited. Today, with the aid of selective breeding, fertilizers, insecticides, and mechanized farming, the United States and the world support about 230 million and 4.5 billion persons respectively. If we were all hunter-gatherers using Upper Paleolithic weapons and strategies, the corresponding populations would probably be about 600,000 and 10 million, at the very most.

The carrying capacities of the wildernesses of western Europe during the Upper Paleolithic can be estimated by referring to the capacities of analogous environments today. According to Wobst, the sparsest lands must have been very sparse indeed, with some 200 square kilometers (about 77 square miles) required to provide enough food for a single hunter-gatherer. At the other end of the scale, the best lands might have been ten times more abundant, requiring only 20 square kilometers per person. In other words, to support themselves in the sparsest environments, 475 individuals in nineteen 25-member bands would need 95,000 square kilometers of land, about the size of all of southwestern France extending from the Mediterranean to the Atlantic, while the same population would require only 9,500 square kilometers of the richest land. This is indeed a wide range, and it has important implications for social organization.

Distance becomes the crucial factor in building a band society or tribe out of individual bands. The greater the distance between bands, the more difficult it is to keep in touch and maintain close ties, and the greater the odds that they will exchange mates with near and unaffiliated neighbors rather than with one another. The distance across a two-ring honeycomb pattern of nineteen bands at the lowest population density is more than 300 kilometers (about 186 miles), and only 96 kilometers (about 60 miles) for the highest-density system. Wobst argues that as population density in-

creased during the Upper Paleolithic in southwestern Europe, communication became increasingly effective, and that at some threshold or breakthrough point toward the high end of the density scale close-knit mating and sharing networks appeared. The stage was set for an upsurge of art and ceremony.

People who once enjoyed a wide-ranging freedom to move away from trouble, many of them emigrants from glaciated lands to the north (Chapter 4), now had fewer escape options. They could still pack up and go, but not as far perhaps and not as often. Compared to the way things had been, life was becoming more and more hemmed in. The times pressed for new visions, for imagination and planning to a degree hitherto unknown and unnecessary, the first applied esthetics. Adapting to natural environments, exploiting natural resources to the utmost, no longer sufficed for survival. Now for the first time the big problem was people, and that demanded, among other things, artificial environments—highly charged emotional, inspirational settings for the sharing, imprinting, and passing on of new traditions. The attempt, only marginally successful at any time, was to create loyalties extending beyond self and a few blood relatives to wider and wider communities.

Seen in this context, the art caves take on a new significance. Most studies reported to date have involved an inside or interior approach, concentrating on each cave as an individual site and paying relatively little attention to its position among other sites, with and without art. As a general rule, investigators confine themselves to the search for patterns in the selection and placement of paintings and engravings. Different kinds of patterns emerge when the caves are viewed collectively and from the outside, as sites distributed on a regional basis. In the process of organizing people into bands and bands into tribes, they were important not only for their contents but also for their locations in expanding social networks.

There may have been one or more such networks along Spain's Bay of Biscay coast during the Magdalenian period 15,000 to 16,000 years ago, in the countryside around Altamira. This site, with its Great Hall and narrow tunnel containing a final dead-end panel of black signs, obviously served some special "magico-religious" purpose. It is the most spectacular of a cluster of sites including La Pasiega, El Juyo, and more than a dozen other art caves. It has yielded a variety of artifacts, among them fifty-eight pieces of portable art, engraved bone and antler which Margaret Conkey of the State University of New York in Binghamton has examined as part of an effort to spell out Altamira's role in more specific terms.

Hers is a stylistic approach, the first attempt of its kind, based on a previous study of 1,200 engraved pieces collected from Magdalenian sites in the region. She identified a total of some sixty classes of basic motifs, a

repertoire or "vocabulary" of design elements that were combined in certain characteristic ways, and proceeded to test a hypothesis about the significance of Altamira. If hunter-gatherers from a number of sites in the surrounding terrain had met with the inhabitants of the cave, bringing their own decorated pieces with them, then it might be expected that the items found there would show a greater variety of design elements than items found at any one of the outlying sites.

This seems to be the case. The Altamira pieces use thirty-eight of the sixty design elements, while pieces in collections from three other sites use only nineteen, fifteen, and twelve elements. A fourth site represented by twenty-seven elements and located some thirty-seven miles from Altamira may have been another regional meeting place, a possibility suggested by the observation that it, like Altamira, also includes an unusually great number and variety of animal remains. This is a simplified version of Conkey's preliminary analysis. There are problems with her interpretation. Fifty-eight pieces is not a large sample, and they may have accumulated over a period of several centuries. In any case, the odds are that Altamira was a major ceremonial site, and this approach suggests important lines of future research.

Meetings may also have occurred during Magdalenian times in southwestern France, in the 2,700-square-mile Périgord, which includes the village of Les Eyzies and is recognized as one of the richest archeological regions in the world. Randall White of New York University recently completed an extensive study of the region, visiting about 185 sites in all, some 35 of them located in the open air and the rest in caves or rock shelters. He notes a tendency for the largest sites to have the most portable art. Four such sites, including one about 1.5 acres in extent, have yielded 1,450 engraved pieces of bone and antler, about 80 percent of all recorded Magdalenian collections, and one possible explanation is the coming together of bands. Similar associations are reported in studies of German sites.

White's study documents an important shift in where hunter-gatherers chose to live. The Neanderthals occupied hundreds of upland sites, high on Perigordian plateaus, but only about half a dozen or so plateau sites have traces of their descendants. The people of the Upper Paleolithic moved down into the valleys for easy access to rivers, a trend which may have begun 20,000 or more years ago. The majority of their sites, more than 50 percent, are located within 1,000 meters (about 1,100 yards) of the nearest river. The evidence is more specific than that. All large Magdalenian sites lie in the major river valleys at naturally shallow places or fords formed by geological upheavals millions of years before the appearance of humans.

This was no local phenomenon, not even "local" in the sense of just applying to the Périgord. The location of Upper Paleolithic sites near fords

has also been reported in Hungary, and in the Soviet Union along the Lena River in Siberia near the Arctic Circle. It is part of a time-tested "head 'em off at the pass" strategy. Today in Canada's Northwest Territories Eskimo hunters still lie in wait at such places, observe caribou moving by the thousands along riverbanks in search of easy crossings, and then close in for the kill as the animals swarm helplessly in the water. The location of many prehistoric ambush sites near modern caribou crossings suggests that the animals were using some of the same migration routes their ancestors used thousands of years ago.

White notes similar features in the Périgord. Large quantities of the bones of reindeer, Old World relatives of caribou, tend to be concentrated at large Magdalenian sites near fords. Fords also represent ideal locations for weirs, traps and nets used in harvesting fish, notably salmon, the "caribou" of riverine species as far as mass migrations and predictability are concerned. A word about shallows and narrow places in general. The main objective in planning kills on a large scale is to restrict the mobility, the escape options, of your prey. There was often a double restriction during the Upper Paleolithic, a double bottleneck, since many sites are located in the narrowest river valleys, a tendency also noted in later times among Levantine sites in eastern Spain (Chapter 9).

As evidence for mass exploitation accumulates, the question again arises as to why the Neanderthals did not also abandon life on the plateaus to exploit all the game down there in the valleys. And we still hear, although more and more rarely, one of the original explanations, namely, that they were too dim-witted to see the opportunities, and were ultimately wiped out by the Cro-Magnons, people like ourselves gifted with foresight and bulging frontal lobes. I cannot accept this notion, and neither can White or most other present-day investigators. It seems rather more likely that the people of the Upper Paleolithic were responding to pressures which were absent or not nearly as widespread during earlier times.

Pointing in this direction are numerous indications of subsistence stress—increasing reliance on mass kills, exploiting a wider range of species including limpets, mussels, salmon, and other seafoods, and probably more and more plants—all accompanied by evidence for rising populations and population densities. One of the most extraordinary signs of the response to threatened scarcities occurs at Duruthy, a Magdalenian site in the southwest corner of France, not far from Biarritz. Robert Arambourou of the University of Bordeaux, who has been excavating here for more than twenty years, describes it as a "seasonal village" where about a hundred hunter-gatherers lived during the fall and winter, probably moving to high grasslands during the summer.

The site has everything. Located at the foot of a steep cliff in a narrow

valley, near a conflux of two rivers and a ford, it has yielded abundant animal remains dominated by reindeer, as well as thousands of flints and portable art, including a recently unearthed reindeer shoulderblade engraved with a beautiful reindeer. These are classical features, fitting in perfectly with our ideas about the lifestyle of Magdalenian hunter-gatherers. But something strikingly unexpected turned up in late deposits perhaps 11,000 to 12,000 years old. That was just before the climate became warmer, oak forests spread into the area, and herds moved away and, with them, the people.

Arambourou examined more than 1,500 tiny backed blades, and found that about half of them had lustrous, shiny surfaces along the front or cutting edge. This feature has not been reported from any other site in southwestern Europe, but it is familiar enough in the tool assemblages of other regions, for example, the Near East. Known as "sickle sheen," it results from the polishing action of the silica-containing stalks of cereal grasses during reaping, and indicates that some of the Magdalenians at least were harvesting plants which may or may not have been domesticated. In any case, it represents one further hint of intensive gathering under subsistence pressure.

Similar developments were under way on another front, in the central French Pyrenees, one of the three regions richest in Upper Paleolithic art (the other two being the Périgord and the Bay of Biscay coast). It includes Tuc d'Audoubert, Trois Frères, Niaux, and other outstanding art caves. But the key site from the standpoint of social organization is the enormous Mas d'Azil cave, some twenty stories high at one entrance with a river and a major highway running through it. Most of the wall art in this "vast subterranean maze" is confined to a single gallery with half a dozen badly faded paintings in a chamber, and about a dozen engravings including eight bison and two fish in a narrow 130-foot passage leading off from the chamber and marked at the end by a single red dot. A newly discovered side branch of this passage, a particularly difficult chatière, which extends more than 150 feet and has not yet been explored to the end, has a number of signs and an unidentifiable animal figure.

What distinguishes Mas d'Azil from other sites in the region, however, is its portable art. It probably contained many thousands of decorated pieces of bone and antler, although because of decades of unbridled looting, no one will ever know the exact count. These items can tell us something about the extent of Pyrenean networks, as emphasized by Paul Bahn of the University of Liverpool, who has recently completed an extensive study of the region from the earliest Neanderthal times to the Iron Age, some 100,000 years of prehistory.

In an as yet unpublished paper, he calls special attention to a type of

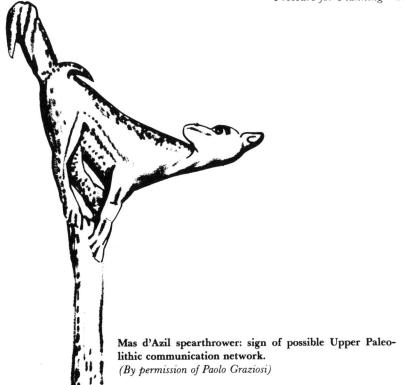

Mas d'Azil spearthrower: sign of possible Upper Paleo-lithic communication network.
(By permission of Paolo Graziosi)

Magdalenian spearthrower carved at the hook end with a fawn or young ibex, looking back over its shoulder and in the process of excreting an oversized turd upon which birds are perching. Whatever this design meant to the hunters of the region, it was certainly popular. Seven specimens have been found and reported at Mas d'Azil, two of them intact, and Bahn believes that they "must represent a tiny fraction of the scores, perhaps hundreds, originally produced." This may be the output of a single work-shop operated by "an individual or group of artisans"—and not only for home use. Similar items have been found far afield, an intact specimen from a cave about 20 miles away (perhaps a copy), and a broken piece at a distance of more than 100 miles.

Bahn has brought together a mass of such evidence, other "exported" art objects: seashells from the Atlantic and Mediterranean coasts; blades half a foot long which could not have been made from Pyrenean flints and required materials from remote sources, probably in the Périgord; and so on. Everything indicates that Mas d'Azil not only housed what amounts to large "seasonal villages" during the spring and fall, but also played host to bands of hunter-gatherers coming in from the surrounding terrain, as farm-ers do today at country fairs held in the nearby market town of Saint-Girons.

Another great center is located at the other end of the Pyrenees, not far from the Atlantic coast. Isturitz, a three-level cave that runs through a mountain, has been blocked near the middle by a huge collapse of rock. The section open to tourists features a massive broken-off stalagmite with a large, deeply engraved bas-relief reindeer and two other animal figures superimposed on it, another reindeer, and two horses. Only a few investigators go into the deepest gallery, reached by skin-diving through a siphon 100 feet long and then walking more than a mile. They stay for up to a week, communicating with the outside world by telephone. Still under investigation, the gallery contains a hearth and some two dozen red and black paintings, two mammoths and the rest mostly horses.

Isturitz, like Mas d'Azil, has been a notable source of widely distributed portable art as well as raw materials brought in from outlying regions. During Magdalenian times its workers produced large numbers of stone sculptures and, most striking, "baguettes"—rods of rounded reindeer antler decorated with overlapping squares, spirals, and other elaborate designs. These items, which may carry information in compact symbol form, are highly reminiscent of the Australian aborigines' carved spearthrowers described in Chapter 10. In the spearthrower case we know that some of the abstract designs represent waterholes, rock formations, animal tracks, and so on. In the case of the antler rods we know nothing. But Leroi-Gourhan, among others, feels that the as yet undecipherable designs had specific meanings for prehistoric hunter-gatherers. The rods have been found at sites up to 100 miles away.

So Bahn points out that the Pyrenean situation involves two supersites, Mas d'Azil to the east and Isturitz to the west some 135 miles away, each serving as a central place for local band society networks. There are hints of supernetworks, art objects linking Mas d'Azil and Isturitz with one another and with networks in other regions, for example, in the Les Eyzies region. Ann Sieveking of the University of London, noting many similar connections, also stresses the importance of large seasonal meetings and suggests that salmon may at times have been at least as important as reindeer in the food quest: "Pyrenean rivers along which Magdalenian sites are clustered are also those which, until the nineteenth century, had some of the richest salmon runs in Europe." As an example of past abundances, she cites Spanish records indicating that 8,000 to 10,000 fish were caught every day during the three-month fishing season.

Salmon fishing may help explain the intriguing distribution of Upper Paleolithic art. Ice sheets covered most of Europe during the last ice age, and most of the uncovered parts such as eastern France and central and southern Germany were too cold, too demanding and variable climatically, to support the sort of population aggregations which in general seem to

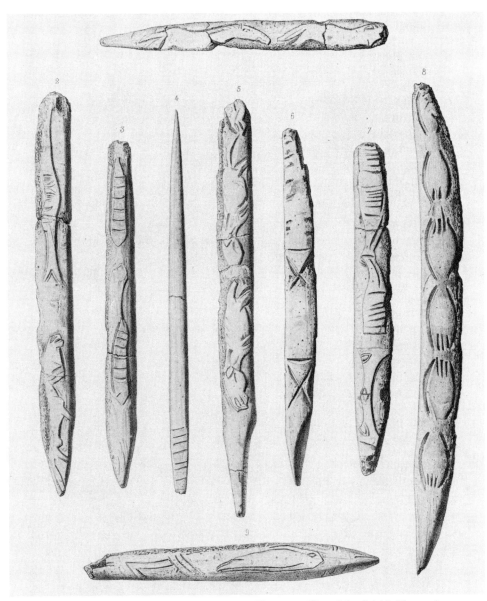

Carved antler rods from southwestern France. *(Copyright, British Museum)*

have called for intensive ceremonies and cave art. But that does not explain why some 90 percent of the art has been found in the restricted part of Europe which includes the Pyrenees as well as the Bay of Biscay coast of Spain and southwestern France.

Michael Jochim suggests that it may have something to do with the location and nature of salmon runs. Salmon are temperature-sensitive, pre-

ferring ocean waters with a summertime surface temperature range of about 35 to 65 degrees Fahrenheit. Fish migrating from waters in the central part of the range, from about 40 to 50 degrees, tend to stay longest in their inland spawning grounds and can be harvested by relatively simple methods such as spearing. Today this zone has shifted far to the north with retreating glaciers. But during the height of the last ice age it lay off the southwestern coast of France and the northern coast of Spain, precisely that stretch which includes the estuaries leading into upriver regions of dense Upper Paleolithic occupation.

According to Jochim, salmon fishing "tends to promote sedentism and territorial exclusion," people staying together for longer periods, and the need for more elaborate conflict-resolving procedures. Salmon became more and more important as a regular source of food in southwestern France, where large herd animals such as the bison, mammoth, horse, and reindeer dwindled sharply between 12,000 and 10,000 years ago. These conditions favored the establishment of permanent ceremonial locations like the art caves. Jochim associates portable art with a high degree of reliance on reindeer, which also encouraged aggregations but demanded greater mobility and the monitoring of wider regions, since reindeer migration routes are somewhat less predictable than those of salmon. Reindeer hunting thus required long-distance contacts, symbolized and reinforced by portable items serving as identification and membership emblems. Both more settled living and more extensive networks became important during Magdalenian times, which featured abundances of both cave and portable art.

Widespread networks, widespread information-sharing systems, existed early in the Upper Paleolithic, if the distribution of Venus figurines is any indication. These objects appeared in quantity during the period of increasing cold and glacial advance between 29,000 and 20,000 years ago, and most of them were made according to a definite convention—tapering legs, wide hips, and tapering shoulders and head, the whole designed as if to fit into a diamond-shaped frame. Clive Gamble of the University of Southampton in England points to the existence of a "Venus zone," a stretch of more than 1,100 miles from western France into the central Russian Plain between the Ural and Carpathian mountains.

Gamble regards this zone as evidence for "the first pan-European representational artistic tradition," and concludes that it had "a shared system of stylistic rules . . . which resulted in a standard design." Taking this notion a step or two further, perhaps a standard design implies a standard myth with local variations, and perhaps the myth featured a widely venerated female being. This is about as far as we can go toward inferring a widely shared system of supernatural beliefs and ceremonies. Gamble notes the rise of a later Venus zone, featuring rather more abstract figurines and

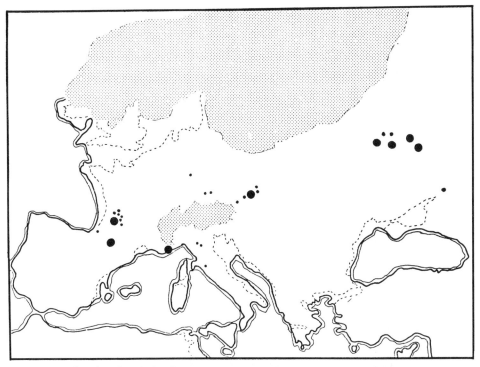

Venus figurine sites dating back 14,000 to more than 30,000 years (large dots represent sites where more than one figurine has been found). *(Clive Gamble)*

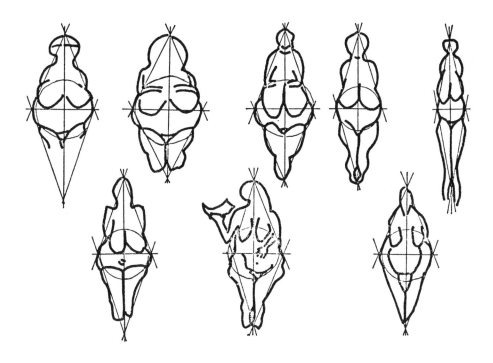

covering about the same region, during the last stages of the Upper Paleolithic 15,000 to 10,000 years ago.

Two points may have a bearing on the significance of these figurines. First, Trinkaus notes an appreciable decrease in the size of the pelvic opening, the birth canal, with the transition from Neanderthal to Cro-Magnon, perhaps related to the general decrease in robusticity. This might well have complicated childbirth, calling for enhanced prenatal and obstetric care, and some sort of accompanying ritual to help ensure the delivery of a healthy infant. Second, increasing group size brought increasing conflict—and increasing conflict in all societies, human and nonhuman, often means fighting over females. Both factors would therefore create tensions involving women, and a focus on female-centered ceremony.

Personal adornment appears in the Upper Paleolithic along with widespread contacts and art. As life became more complicated, as more people were on the verge of being built into more extensive social systems, perhaps they felt compelled to announce their uniqueness, to counter the threat of conformity in a harmless, nonrebellious way. That is how it may have seemed from the inside, to the individual. All we know from the record is that pendants, bracelets, and other ornaments turn up suddenly about 35,000 years ago (Chapter 4), and become considerably more common thereafter. Assuming a situation in which people tended to aggregate in larger groups, then ornaments might serve to signify band affiliations.

The wearing of ornamental markers, and the carrying of decorated tools, baguettes, and other portable art items, fall under the general category of "stylistic behavior," a subject which Wobst has considered in connection with his studies of information-exchange networks. A group in the process of growing—trying to increase its membership and at the same time solidify ties among those already in the fold—will be concerned primarily with influencing individuals at a distance geographically as well as socially, since they are the ones least frequently encountered on an everyday basis. It follows that the need for stylistic behavior increases as networks expand.

This holds for present-day as well as prehistoric people. For a modern perspective on stylistic behavior, Wobst investigated folk dress in Yugoslavia, "an appropriate testing ground" for his hypothesis because of its impressive social complexity—a nation made up of 22 million people representing nine ethnic groups and three major religions, living in six republics and two autonomous provinces, and speaking three official and some half dozen unofficial languages. One part of his study concentrated on hats, hats worn by males (Yugoslavia being strongly patriarchal) as universal items which can be distinguished at a distance, specifically before you get within lethal gun-shot range of a potential enemy.

Under conditions of stress Yugoslavs use hats to proclaim their loyal-

ties from afar, and hatmakers do a thriving business. The bazaar in Saraje-vo, a city noted for intense conflicts and competition among Serbians, Cro-atians, and Muslims, offers "a large section of hatmakers in residence," while hatmaking is a minor craft in Zagreb, where the population is pre-dominantly Croatian and life runs relatively smoothly. A similar relation-ship among hats, levels of conflict, and ethnic variety holds for other parts of the nation. Dress was a life-or-death matter half a century or so ago among feuding tribes in the mountains of the Montenegrin republic. Men indicated their affiliations by the wearing of strukas, cloaks bearing color codes like Scottish plaids—that is, until government troops put an end to raiding and vendettas, at which point tribesmen switched to hats to identify themselves by wider ethnic groupings.

Ornaments serve different purposes. As close-up rather than long-distance communication devices, observable at short range only, they might be expected to involve fine distinctions and convey information to a smaller number of individuals already recognized as full-fledged members of the community. Wobst's studies in Yugoslavia suggest that this is indeed the case: "The message content shifts from identifying social groups to defining an individual's position along a ranked scale such as wealth, status, or age." Observations among four ethnic groups, for example, show that the wealthier a man is, the more gold will be used in his belt buckle or the more gold thread in the decorations on his shirt.

With the exception of an engraved beret-like cap on a figure in a Spanish cave, a possible headdress of shells uncovered at an Italian Riviera site, and a few other examples, we know practically nothing about the prehistoric uses of hats or similar long-distance affiliation signals. When it comes to short-range dress signals, however, there is plenty of evidence. Ornaments often distinguished the individual as someone of importance. So did baguettes and carved spearthrowers and other intricately worked porta-ble art objects, and the first burials containing abundances of elaborate grave goods. As indicated in Chapter 4, the emergence of status, the break-down of ancient egalitarian traditions, was among the most outstanding marks of the Upper Paleolithic.

The glimmerings, the possibility, of status can be traced to the Nean-derthals. We can credit them with a kind of thinking not previously en-countered in the archeological record. Tool making, the construction and placing of traps, using spears, gathering plant foods—these things involve action and manual skills, work which in general can be learned by observ-ing and imitating and doing. The notion that an individual who seems dead has actually departed on a journey to another world, however, puts believ-ing above seeing, imagination and the abstract above the direct evidence of the senses. It represents special knowledge; and that of course implies spe-

cial in-the-know people, and the potential at least for acknowledged superiority.

All the major changes of the Upper Paleolithic promoted this form of inequality. For one thing, it is an inevitable consequence of social geography, of the basic structure of information-sharing networks. Any region occupied by a system of many affiliated bands will always contain favored and unfavored places. Bands on the outer edge of the network have the fewest near neighbors and are at the greatest distance from bands directly across from them on the opposite edge. But bands at the center of the network enjoy a built-in advantage. They operate at the top level of a natural locational hierarchy, because they are equally distant from all peripheral bands, and thus occupy a strategic position for communication and control.

There are also problems at the center. Tension tends to reach a peak there, because people cannot move away from conflict as easily as people living at the outer edges of the network. So they must deal with one another on the spot, often with unpleasant results. Among the forest-dwelling Yanomamo Indians of southern Venezuela and northern Brazil, for example, fighting among villages at the center of their territory is more frequent and more violent. In other words, the pressure here is most intense for some sort of conflict-reducing system.

Sooner or later some of the people in the network, most likely some of the people living in these central places, may acquire positions of authority. Band networks are buzzing with information from different sources, and a study of "the development of decision-making organizations" by Gregory Johnson of Hunter College in New York indicates that as society grows more and more complex and the number of sources approaches half a dozen or so, a critical point is reached at which the job of handling the information becomes too much for a group of equals.

The members of a band or a few bands can handle tool making, the food quest, and mate selection without undue difficulty. But when many bands get together and confront a complication of these matters plus the added burden of long-distance exchange, regular game drives, and a variety of planned ceremonies, information overload may threaten a breakdown of the communication system. The situation requires a new division of labor: an elementary two-level hierarchy of people of greater and lesser status, people concerned mainly with planning and control, and people concerned mainly with getting the work done. Forces moving hunter-gatherers toward this sort of solution were probably under way early in the Upper Paleolithic, during the formation of the first Venus-figurine zone, and the trend seems to have crystalized in the close-knit networks of Magdalenian second-zone times.

What probably did most to widen the prestige-and-power distance between the few and the many, however, was the explosion of ceremonies, including those held in the art caves. Among the Australian aborigines, who still live by the old hunter-gatherer tradition of staying small and equal, the elders are in absolute charge during initiations and other ceremonies, but at all other times they are simply ordinary members of the band without special privileges. It is doubtful that such a complete sinking back into the crowd occurred among the elders or their equivalents in Magdalenian times, individuals who had to develop ways of dealing with higher population densities, longer periods of aggregation, and more intense conflict.

As masters of illusion, specialists in the evolving art of social control, they held exalted positions. It could not be otherwise. As equals, they could never have done what they had to do, indoctrinate people for survival in groups, devise and implant the shared memories that would make for widening allegiances, common causes, communities solid enough to endure generation after generation. Learning in our sense of a continuing search for new knowledge and new insights would have been a disaster. Learning by ritual, was dedicated to the inhibition of innovation. The ceremonial life promoted, not inquiry, but unbending belief and obedience.

To ensure the future of the tribe, the odds are that the leaders of prehistoric ceremonies, the sorcerers and shamans, created a glorious past—something comparable to the dreamtime past of the desert aborigines as described by Theodor Strehlow: "Every creek and rill contains water. The plain is green with herbs and grasses; the mountains are decked brightly with a multicolored covering of wildflowers. The air is heavy with the scent of eucalypt and acacia buds. Clustering swarms of native bees hum around the pale yellow blossoms of the bloodwood trees, eager to collect the sweet honey. The rocky caves are filled with nimble wallabies, and in the burrows on the plains the sharp-nosed bandicoots are sporting carelessly."

We do not know what specific sort of ancestral past the people of the Upper Paleolithic looked back at. It could have been a time without ice, of perpetual summer in valleys that stretched from horizon to horizon and nourished vast herds of giant bison, horses, and reindeer. In any case, there are reasons for supposing that their past was no less idyllic than that of the aborigines. Such grand illusions are generally not kind to the present. They serve a special purpose for people confronting, and presumably resisting, change. Any vision of a bygone age so golden that everything since appears as a comedown tends inevitably and effectively to discourage innovation and experiment, offbeat persons and offbeat thinking. The positive effect is to put a premium on conformity in the name of preserving at all costs things

as they are, to achieve a peaceful community of like-thinking human beings.

The individuals in charge of ceremony were not gentle persuaders, tentatively putting forward suggestions to be mulled over and debated, proposing plausible alternatives. That is not how the inculcation of tradition works. It is more likely that they assumed a no-nonsense, authoritarian posture, far beyond take it or leave it, because there was no leaving it. The situation called for wholehearted, unquestioning faith and acceptance, and to achieve that they had to present themselves as somewhat above the ordinary run of mortals. If you are my equal and tell me to do something, I will if it makes sense to me. Otherwise, I may consider and reconsider, make countersuggestions, and decide on my own. Ours can be a reasonable, give-and-take relationship.

But what a world of difference if you expect me to respond right away and without thinking, to take everything you say as gospel truth. I might not be so passively compliant if you and I were familiars, if we worked and played and argued together on an everyday basis. To obtain obedience it helps if shamans, preceptors of any sort, can create a distance between themselves and the rest of the group. Furthermore, the distance must be greater the more demanding their instructions and the more utterly they desire to be obeyed.

There are degrees of deference and superiority. If the expected behavior does not go too much against the grain, if the message concerns something that seems reasonable on the face of it, such as sharing meat or respecting property, then the preceptor may be no more than an experienced person. If the message calls for something more arbitrary and painful, such as mutilations and long periods of sexual abstinence and fasting, the preceptor must appear all the more special to obtain submission. It is a matter of increasing effort. More thought and planning and more work are required to establish absolute authority when the commands involve self-sacrifice and a measure of suffering than when only mild inconvenience is at issue.

The first step in overcoming the natural resistance to indoctrination is to obtain and hold an audience's undivided attention. One must appear and remain extraordinary (by no means an easy task when one is a long-time member of a small group), look different with the aid of masks, body painting, and exotic ornaments and amulets such as a piece of amber glowing hypnotically by firelight like an eye—and sound different, using antique words and phrases, reminders of ancestors and a remote past, and special intonations conveying authority, fervor, inspiration.

The next step, given continuing attention, is to ensure that one's messages will be remembered. Attention in itself helps toward that end, but

additionally the messages must be associated with novelty and surprise as planned, for example, in the art caves with images and other special effects and a variety of performances located in selected niches, chambers, and chatieres, secret places designed for shock, for awe, and sudden revelation. The third and final step goes beyond holding attention and implanting messages in memory. The messages must be believed, obeyed to the letter, and acted upon, which calls for the establishment of laws, check-ups, and a system of punishments and rewards.

The Upper Paleolithic was a transition period in the evolution of status. Zero or near-zero status prevailed among earlier hunter-gatherers, judging by the egalitarian ethics, of present-day bands. Among the Bushmen of southern Africa there is nothing at all exclusive about being a medicine man; all boys want to become trance-dance healers, and about half of them make it. But population density was increasing in southwestern Europe (Chapter 4), and a basic response to that, among all animal species, is the formation of hierarchies. Increasingly exalted individuals appeared with the emergence of agriculture, cities, and city-states, everything from shamans specializing in communications with the spirit world to hereditary chiefs and kings regarded as official representatives of the gods and, finally, to superkings like the Pharaohs of Egypt who were gods in their own right. The big men of the Upper Paleolithic held positions somewhere in between these extremes, probably rather close to the shaman level.

13 *The Art of Memory*

▷ More than ever our research focuses on the effort to make band society work, and on art and the arts as part of the effort. People already well along in the process of adapting to the elements and expanding their food resources were beginning to become their own worst enemies. Acting to control conflict, they ran head-on into their own resistance to being controlled as they worked to extend the feeling of solidarity beyond the family circle, a none-too-stable unit at that—to deal with self-interest, the spirit embodied in the Arab proverb: "I against my brother; I and my brother against my cousin; I and my brother and my cousin against the world." Emotionally every man is an island.

Our prehistoric ancestors observed themselves as keenly as they observed other animals. The wisest among them presumably had intuitive, clinical insights into behavior under stress, and knew a thing or two about the sort of conditions which would evoke fear, wonder, submission. The planning of suitable ceremonies may have taken as much time and energy, and as much foresight, as the planning of big-game drives. Attention undoubtedly centered on the details of ritual rather than on self-conscious questions of motivation, just as the planning of a Fourth of July party concerns such matters as guest lists, the selection of fireworks, the order of firing, and the excitement of seeing bombs bursting in air, with relatively little thought about patriotism and reaffirming the Declaration of Independence in a world threatened by nuclear warfare.

Whether people of the Upper Paleolithic actually knew why they were holding ceremonies, or whether they were simply following sound instincts, the net effect was the same. Judging by the evidence of the caves, they certainly behaved as if they knew. Their techniques seem to have been sophisticated, and admirably geared to the requirements of the times. Indeed, it is difficult to see how they could have surpassed themselves, even given all the knowledge we have since accumulated about the workings of the brain as the organ supreme for the analysis and recording of information, a kind of benign tumor at the head end of the spine, a communications

network made up of some 10 billion nerve cells or neurons and interconnecting fibers.

There are many ways of preparing the brain for indoctrination, one of the most effective being sheer monotony, the more monotonous the better. The brain feeds on information, and it starves if you cut off or severely reduce the flow of signals it receives from the outside world. It goes into a state of "altered consciousness," a trancelike or twilight state between sleeping and waking. Anything that blocks sensory input may produce this vulnerable frame of mind—solitary confinement, concentrating on a hypnotist's lulling words, experimentally isolating individuals in dark soundproof chambers or immersing them under water in tanks.

The brain cannot go for long without signals of some sort to keep it engaged. At some level of monotony, if nothing exists out there to hold attention, it turns inward and proceeds to "daydream." Drawing on its records of times past and other stored information, it creates images of its own, seeing and hearing things that are not there. Extreme boredom may be as effective as drugs in eliciting hallucination, and may produce similar kinds of images—intricate grating, filigree, honeycomb, and checkerboard patterns, cobweb and spiral effects, forms described as tunnels and funnels and alleys, visions of people and places in vivid color. Drivers affected by the monotony of long trips report seeing such things as giant red spiders on windshields and strange animals scuttling across the road. Pilots may see unidentified flying objects.

Of all natural settings, caves are among the most effective for sensory deprivation. The power of suggestion may become irresistible, all-encompassing, during vigils in remote chambers and passages. To find out for themselves, the late Dennis Puleston of the University of Minnesota and some of his students took turns spending up to forty-eight hours alone without lights in the depths of a number of Maya caves in Belize. It was a revealing experience: "Although apprehension prevailed at the outset, within a few hours it was dissolving into wonderment. . . . Many-hued geometric patterns, mixed with a salad of memories from years ago, were being triggered by occasional sounds—a distant dripping stalactite, or the scrape of a foot on rock . . . The mind was strongly inclined to invent light. . . . Within less than a day a disposition developed toward supernatural interpretation of any unexplained phenomenon."

For a more realistic version of prehistoric practices, Puleston's experiment might have been carried a step further, but that would have been too much. Imagine the effect on a mind just beginning to wander, to hallucinate, of noises coming suddenly out of the stillness, a shift from sensory deprivation to sensory bombardment, from famine to plenty. We react to even the smallest of changes, responding to something as innocuous as the start of an everyday conversation with a measurable rise in blood pressure,

typically a 20 percent rise, an increase of 26 points for individuals with a normal arterial-systolic reading of 140. The impact of sounds in a cave would be far more drastic, especially sounds repeated over and over again with variations.

Exposing people to the darkness and silence of a cave, or to isolation of any sort, is a passive procedure, in the sense that it simply amounts to letting nature take its course. The use of rhythm, on the other hand, represents active and deliberate intervention. The rhythms that accompany aboriginal dances, whether produced by slapping thighs or stamping on the ground or drumming, are designed not merely to create but to intensify and control the twilight state. Drummers keep a close eye on a dancer, watching for such telltale signs of approaching trance as slight muscle spasms and faster deep breathing. They are quick to respond. They may suddenly break the rhythm and then step it up louder and faster, skip a beat, go into double time, raising excitement levels to bring on the trance.

What experienced drummers have learned by direct observation during ceremonies, during sensitive interactions with dancers, makes excellent sense in terms of what neurophysiologists have learned about the brain. As Andrew Neher of East Los Angeles College pointed out twenty years ago, of all musical instruments, percussion instruments in general and drums in particular can be expected to affect the brain most strongly when it comes to evoking the twilight state. Drums produce the sort of "steep-fronted" sounds, sounds emitted abruptly and explosively, best suited to stimulate the auditory cortex, the part of the brain's outer layer concerned with hearing. The sounds are also emitted over a wide range of frequencies, high overtone notes as well as low notes, effectively ensuring the arousal of large areas of the auditory cortex and interconnected centers.

Furthermore, drummers apparently know by intuition the most potent brain-stimulating rhythms. According to Neher, the predominant drumming rhythm used in a number of African dances as well as in Haitian voodoo dances is a fast 7 to 9 beats per second—and that happens to be about the same rhythm produced naturally by "brain waves" in the auditory cortex itself, groups of neurons charging and discharging in electrical unison. It seems that properly synchronized drumbeats drive the brain, force it into heightened activity. They work in phase with brain waves, amplifying them the way timed pushes impart more and more momentum to a swing, creating hallucinations and intense feelings of dissociation.

In a continuing study of brain and memory, Boyce Rensberger of *Science 82*, a magazine published by the American Association for the Advancement of Science, analyzes the psychological impact of the twilight state. He stresses three major effects, and all of them combine and reinforce one another to create a frame of mind ideal for indoctrination. First and

most direct, the twilight state lowers your guard. You lose the ability to doubt, to ask questions and criticize, "to distinguish between cause and effect, fantasy and reality," all of which leaves you wide open, ready to see and accept anything. Along with the gullibility comes a second effect, a deep-rooted need for outside guidance, for someone to heed and obey; in short, for a leader.

Finally, there is the third and perhaps the most significant effect of all, an extra twist which tops everything and puts the entire twilight-state phenomenon in a broader perspective. In such a condition you are not only ready for a master or guru to lead you, not only ready to believe. You are ready to believe beyond belief, so totally and enthusiastically that the message comes through with a halo, with the force of religious revelation. Here is what Rensberger has to say about the overwhelming experience sometimes referred to as "psychotic insight": "This is the feeling—well known to regular users of alcohol, marijuana and other chemical inducers of altered states of consciousness—that some thought or idea experienced in the trance state appears, at the time, to be a profound insight if not, indeed, the essential idea linking all of truth into one shining, cosmic whole. . . . It is widely recognized as a false or misleading feeling among, for example, serious writers who have had a chance to read, while sober and without illusions, what they wrote in the altered state."

The prevalence of twilight-state thinking, our very susceptibility to the condition, argues for its evolutionary importance. In extreme cases it results in pathology, derangements and delusions, persisting hallucinations and fanaticisms. But it is also the driving force behind efforts to see things whole, to achieve a variety of syntheses from unified field theories in physics to blueprints for utopias in which people will live together in peace. There must have been an enormous selective premium on the twilight state during prehistoric times. If the pressures of the Upper Paleolithic demanded fervid belief and the following of leaders for survival's sake, then individuals endowed with such qualities, with a capacity to fall readily into trances, would out-reproduce more resistant individuals.

Form was as important as content, setting the stage for ceremony as important as the messages to be transmitted. In selecting an appropriate indoctrination site, a glen in the forest or a secluded beach would have been just as suitable as a cave, and for all we know rituals may have been held in a number of different kinds of locations. It just happens that the evidence is preserved in caves only. The important thing in initiations and other rites of passage is that the site, whether underground or in the open, be off the beaten track and unfamiliar. Since novelty has long been recognized as a potent attention-grabber, it helps if everything is new, the place as well as the information and the appearance of the shaman.

The brain has a built-in bias for novelty and, since everything was once brand-new, memory consists primarily of a collection of one-time novelties. Experiments indicate that we start seeking out novelty at an early age. A newborn infant will keep looking away from a plain black background as if in search of something more interesting; it tends to concentrate on edges and discontinuities, marked differences of light, shade, and color, any unusual feature. Living for prolonged periods in the bush sharpens one's awareness of the unusual. Harald Pager, an authority on the rock art of southern Africa who spends months in remote wilderness regions, writes: "Everything that is in the slightest way different makes you immediately stop or jump. This might be a gray coil which you spot out of the corner of your eye, and which turns out to be a snake throttling a lizard, or a small round stone with the only distinction of unusual regularity. You break it, and it turns out to be the cocoon of a beetle."

No species could endure without some sort of novelty-detector, and ours has become more and more sensitive, more finely tuned, over the ages. It operates overtime during the passage through an unfamiliar cave, where every turning and precipitous descent and chatiere is a minor adventure. The shock of unexpected natural features was amplified many times by the sudden sighting of strategically placed figures. Created novelty, a cultural stimulant, served as an additional effect to heighten memorability. Furthermore, there were no distractions in those days, no books and no broadcasts competing for undivided attention. Ceremonies performed in public as well as private places represented the only formal source of serious messages.

In other words, the way was comparatively clear for conveying the most important social messages. The memory capacity of the human brain is enormous, conservatively estimated at 10^{12} or a trillion bits of information which, translated into *Encyclopaedia Britannica* units, would fill more than 500 sets of the standard work. But that is not nearly enough to store all we experience during the course of a lifetime. In the opinion of one brain investigator, "a man's head would have to be about the size of a small elephant to hold that much." So the problem involved the preparation of selected messages, messages italicized as it were and dealing specifically with technologies and traditions, and the promotion of group cohesion.

As far as taking in information is concerned, the brain operates under a peculiar limitation, a "rule of six." In scanning the world around us, we can count to about six and not much higher. Many studies indicate that this is about the maximum number of individual items we can perceive at a glance and accurately. For example, if dots or random sequences of letters are flashed on a screen for a fraction of a second, you can recall how many you saw as long as the number comes to about half a dozen or less. Beyond that, memory begins to falter, and you make more and more errors.

The intriguing thing is that, within limits, it does not seem to make a great deal of difference what the items are. You can recall a sequence of unrelated words like fog-whom-idiot-spinach-pink-yesterday about as readily as O-Q-V-B-N-S or any other sequence of letters. Furthermore, far more information can be conveyed when the words fall into familiar patterns based on previous knowledge. It can be a series of pairs of closely associated words which are remembered and retained as single memories, such as "flashlight battery" and "blue skies" and "home plate"—or entire phrases such as "four score and seven years ago" and "only God can make a tree." The result is the formation of hierarchies of remembered units, complexes of lumped-together information.

This process, known as "chunking," is the secret of our voluminous memory capacity. It is a way of beating the apparent limitations of the rule of six by successively more compact packaging, by cramming more and more information into a small number of readily recognized units, and then building other units into still more compact systems, patterns of patterns. According to George Miller of Princeton University: "We are in a position analogous to carrying a purse which will hold no more than half a dozen coins—whether pennies or dollars. Obviously we will carry more wealth if we fill the purse with silver dollars rather than pennies. Similarly, we can use our memory span most efficiently by stocking it with informationally rich symbols."

If their art is any indication, the people of the Upper Paleolithic were acting precisely in accordance with this principle. Confronted with an increasingly complex way of life and a pile-up of information, they were engaged in the first large-scale effort to organize knowledge for readier long-term retention and recall. The effort called for the invention of symbols, entire repertoires or vocabularies of symbols, in a burst of chunking which, incidentally, offers an intriguing parallel with another sort of chunking or coalescing. The process of building individuals into bands, and bands into intercommunicating networks can be regarded as an analog at the social level of what was taking place in the caves at the mnemonic and esthetic level.

As suggested in Chapter 4, the Upper Paleolithic must have witnessed a revolution in language, with an extra spurt starting about 20,000 years ago when the glaciers reached their maximum advance and we see signs of increased efficiency in tool making, and a new flowering of cave and portable art. The revolution took the form of more intense exploitation of the brain's image-forming and image-retaining capacities. When it comes to transmitting information, vision is the predominant sense, not just the viewing of real objects in the outside world but also the inner sort of viewing. Of all memory's subtleties—and they are legion—one of the most striking

and most difficult to account for is the physical nature of the records we store in the form of imagined pictures.

There is something amazingly real about the images we see with our mind's eye. The unique and distinctive patterns of real-life objects are somehow projected via the optic nerve onto layers of neurons in the brain, like images flashed on a magic-lantern screen. You would never recognize the projections if you could see them, however. They are not point-for-point projections, not faithful replicas, but topological versions of actual objects, generalized representations perhaps combining the features of extreme caricatures and abstract symbols. Yet, and this is the most amazing feature of all, they are stored in some detail and in three dimensions, the functional equivalents of miniatures, as if submicroscopic statuettes existed somewhere in the brain.

For the past decade or so, Roger Shepard of Stanford University and his associates have been investigating our cerebral representations of things seen. They have found that it takes time, real time, to deal with imagined objects. If you are told to think of opening a padlock, for example, you will respond differently depending on how the details of the situation have been spelled out. If the instructions specify that the key is in your right hand and the lock in your left hand with the keyhole facing you, you will accomplish the imagined unlocking rapidly. But if the instructions specify that you are holding the lock upside down, you will first have to flip it over mentally and perhaps rotate it, and the operation will take a correspondingly longer time.

A host of studies confirms the strange reality of our imaginings. When experimental conditions are appropriate, when the individuals being tested have been prepared by suitable instructions in advance, responses take place without hesitation, typically within half a second. But when further imagined operations are demanded, or when no image has been specified beforehand, reaction times increase sharply, often requiring another half second or so, and sometimes several extra seconds. Shepard points out that perception and imagination, external and internal viewing, involve many of the same cerebral centers and nerve-cell circuits. Whatever it is in the brain that signals the difference between the real and the unreal or imagined is impaired during twilight states and psychotic hallucinations.

The ability to form images serves memory well. Nothing illustrates our picture-mindedness, our general preference for concrete over abstract notions, better than the results of ease-of-recall research. Words like "dog," "river," "mother," "green," "book," and "table" rate high on the readily visualized scale, and are easier to remember than words like "amount," "fact," and "surtax," which do not usually elicit images of any sort. Add action to high imagery, and memorability increases further. Tests show

that pairs of concrete words like "river-dog" or "book-table" can be remembered better if, instead of thinking of them as separate items, you think of them in a related context, a dog swimming in a river or a book falling off a table.

Even more helpful is some sort of emotional commitment, the addition of meaning to the imagined incident. If the dog is swimming to rescue a drowning child, or if the book falls because the table is knocked over during a fight, retention and recall of the paired words are considerably enhanced. Tests show that subjects remember photographed faces better if they are asked to judge whether or not they would like the persons pictured than if they merely try distinguishing the faces by sex. This way of making relationships more interesting and vivid, which Fergus Craik of the University of Toronto refers to as "deep processing," helps account for the mnemonic effectiveness of a good story well told.

The Cro-Magnons probably invented a fair share of high-imagery words in the shaping of their myths. Also, and perhaps on a larger scale, they probably enriched their languages with a burst of new double-image comparisons, new metaphors which in a flash of fresh insight reveal new relationships between familiar things. Brooks run, arrows fly, and tempers flare only figuratively, only in language. These metaphors were poetry once upon a time, bright new perceptions, then clichés—and at last they passed beyond cliché into everyday speech. These and thousands of other comparisons are imbedded in language, ancient but age unknown, perhaps some dating back to prehistoric times. If we could only identify and date the oldest. There is a vast untapped linguistic archeology here.

As a start, we can examine the forces and circumstances that encourage metaphor making today. In an analysis of the process among the Apache Indians, Keith Basso of the University of Arizona has collected a number of recently coined metaphors, "private acts of discovery and recognition," including the following:

> Lightning is a boy
> Ravens are widows
> Carrion beetle is a whiteman
> Dogs are children
> Coyotes are Western Apaches
> Butterflies are girls .
> Burros are old women.

Notice that the commentaries, the criticisms, are oblique. The humans are always mentioned second in the metaphors. It is gentler that way. To say "A widow is a raven" or "A whiteman is a carrion beetle" would be bad manners. Furthermore, it might bring tensions out into the open.

Basso asked for explanations, and here are two of them:

Well, there is this way that carrion beetle reminds us of whitemen—they waste much food. Carrion beetle, when he is young and before he starts to eat meat, just eats a little hole in a leaf and then moves on to eat a little hole in another. He leaves plenty of good food behind him. It is like this with some white people, too. Another way they are the same, these two, is that in the summer they only come out from where they live when it is cool. You only see carrion beetles early in the morning and again in the early evening. It is the same with some white people. In the summer they always want to stay some place where it is cool.

Yes, young boys are the same as lightning. They both dart around fast and you just can't tell what they are going to do. They both act unpredictably. They never stay still. Both are always darting around from place to place. They will shoot aimlessly, too. They will both shoot anywhere, not aiming away from people's camps, not caring what they hit. That is why they both cause damage.

Explanations like these may be as significant for what they omit as for what they impart. Unexpressed in the Indian's boy-lightning metaphor are generation-gap overtones of crumbling traditions and young people out of control, and it was a combination of tact and caution which prevented Basso's informants from stressing the unflattering aspect of the carrion beetle as an eater of dead and putrefying flesh. Metaphors are open-ended, beginnings which trigger further comparisons and flights of imagination. The comparison of boys and lightning instantly and automatically includes qualities irrelevant at the time and in that context, but potential sources of new comparisons later on. Boys also explore, go on small-scale hunts, and become warriors; lightning may appear in branching, sheet, or zigzag patterns and is generally followed by thunder. And sometimes in creating a myth or decorating pottery, an Apache may use butterflies and lightning to symbolize girls and boys.

New metaphors are entering our languages every day, though no one keeps records. The odds are that the pace of linguistic invention has always picked up sharply during periods of rapid change and social stress. Physicists write routinely of subatomic particles with "flavors," "colors," and "charm," and a pattern that forms in supercooled liquids has been officially named a "boojum" after Lewis Carroll's imaginary creature which "softly and suddenly vanished away." Poets, including some of the most perceptive observers of our times and values, produce rather more metaphors than scientists and engineers, but it is more difficult to document the nature and extent of their contributions to everyday communications.

Their ancestors in prehistory may have been called on to compose verses for the most practical of reasons. Poetry, rhythm and rhyme as well as metaphor, may have evolved to help preserve tradition, to make information easier to remember. The Upper Paleolithic, as the first period of rapid change in human evolution, must have been a boom period for metaphor, if

only because so many new things were happening. An arithmetical increase in the sheer number of individual items, activities, and relationships brought an exponential increase in associations.

Fresh insights, the discovery of connections between things, must have come in a flood, enriching language and imagination. Some of them are recorded in art, in the paintings and engravings in the caves. We can only guess at what hunters or what human qualities were represented by the great black bulls, the "unicorn," the reindeer with webbed feet in Lascaux, or the man with a bird's head—or in the many engravings elsewhere of deer without heads, isolated heads and antlers, horses with elongated necks and "duckbill" muzzles. The uttered metaphors which accompanied the viewing of the images on cave walls may have been incorporated into the world's first myths and songs and poems.

The images themselves, like all ceremonial symbols, represented a high order of chunking. A picture may indeed be worth a thousand words but, even more important, it is comparable to a thousand words flashed on a screen all at once. Remembered words and statements provide sequences and successions, the narrative lines of song and myth. Images have a total, see-it-now quality. "Think of the sun and you simultaneously think of the sky," comments Allan Paivio of the University of Western Ontario. "Imagine your home and you have available, more or less at once, its components and contents—windows, doors, rooms, furniture, colors, and so on. . . . This means that large amounts of information become quickly available when they are stored in the form of integrated images."

Furthermore, under certain circumstances it may pay not to be too realistic or recognizable. Too much concreteness tends to limit free association and the power of suggestion. A picture of a typewriter or a dog may call a number of things to mind, but vaguer images such as those in the Rorschach inkblot figures offer a far wider range of possibilities. Incidentally, when viewing such figures, people seldom see inanimate objects; they see animals and humans predominantly, often in dynamic, emotionally charged scenes. Still vaguer, more abstract images like the signs in the caves or the more recent swastika and cross may evoke volumes of associated ideas and images.

Evolution has put a tremendous premium on the formation of associations. Each item in memory, each memory trace, has its own constellation of associated traces, with the remotest traces merging off into other constellations. "Apple," for example, is cross-indexed in the brain under "red," "round," "fruit," "sphere," "stemmed," and a large number of other subheadings. The "red" category is further subdivided into "red objects" (blood, tomatoes, roses, autumn leaves, stop lights, fire engines . . .) and "red concepts" (danger, fear, anger, blushing, revolution . . .) and each one

of these subheadings is further subdivided many many times. So "apple" can be regarded as the main or top heading in a multibranched hierarchy of associations, something like the organization chart of all the agencies of the Federal government, only far more complicated.

The "apple" hierarchy is hardly an isolated system. It is connected to the "Bible" hierarchy by a chain whose links include Genesis, man, Adam and Eve, the Garden, and the serpent—and with the "American history" hierarchy by industry, business cycles, the Great Depression, and unemployed men and women on street corners. A chart showing the relationships among these three hierarchies in fine print would be larger than a panoramic motion-picture screen. Since the average educated adult has a reading vocabulary of some 100,000 words, and each word has its complex of associations, we can think of memory as an almost-infinite network made up of legions of linked-together hierarchies. In this three-dimensional superlabyrinth, this 3-pound "large sponge coral" packed inside our heads, there are routes, direct or indirect, leading from every memory trace to every other.

In such an elaborately interconnected system, each new experience demands reorganization, readjustment on a grand scale. A face newly seen or a fact newly learned—or a new association, a new metaphor—is not stored passively in a particular nerve cell. It creates disturbances, showers of signals in the form of electrical signals that flash throughout large volumes of brain tissue. It is like a pebble falling into a pond, the big difference being that the pond returns to its former state when the ripples have died down, while the brain has been changed forever. The formation of a single memory trace, the recording of a single new experience, is believed to leave its mark on hundreds of thousands or millions of nerve cells.

The richer the experience, that is, the more associations attached to it, the more widespread its "ripple" effect in the brain and its ultimate representation in the hierarchies and networks of memory. That is why it pays to involve not only the dominant sense of vision in a ceremonial event but the entire sensory apparatus of the nervous system, or at least as much of it as possible. The symbol "bison" made a more lasting impression if it were expressed in many ways at once—if, together with the sight of a painted bison, there were drumbeats like bison hoofbeats, the singing and chanting and reciting of high-imagery words describing bison stampeding, and a dance based on the movements of bison on the run.

Total sensory bombardment was essential when, in the absence of libraries, the brain itself had to serve as library. The effort which today goes into the preparation of books, the research and organization and style and illustrations, went into the preparation of ceremonies during the Upper Paleolithic. Under ordinary circumstances our ability to store and recall

information is far from reliable. Conflicting eyewitness accounts of what happened at the scene of the crime or accident, the increasing distortion of tales passed along from one individual to another in rumor chains, the "recollection" of false events fabricated on the spot to please hypnotists, lawyers, psychoanalysts—these and many other observations attest to the fallibility of memory, that is, memory unaided and undisciplined.

Part of the standard procedure for memorizing is repetition, and that can produce impressive results. Among us everything must be new. Songs can go out of date in a week or two, fashions in a season; reporters and newscasters go out of their way to obtain exclusive stories, or at least new angles to make yesterday's news or last week's appear new. Tales told many times over, however, are in high demand among societies without writing. Around firesides when the work of the day is done, Kalahari Bushmen cannot hear traditional hunting stories too often. "Indeed, the fascination mounts with every telling," according to Barbara Hold of the University of Regensburg, West Germany. "Recounting takes the place of television or books."

Some kinds of repetition are superior to others. If it is very important for you to remember a name or a telephone number, the best way is to say it to yourself after a few seconds, again after a minute or so, again ten to fifteen minutes after that, still again an hour or two and several hours later—and finally, to make sure you have it firmly in mind, the next day. Recent studies indicate that this "expanding" pattern of rehearsal, allowing progressively longer intervals between repetitions, achieves better results than uniform intervals (say, rehearsing every ten minutes), contracting intervals (rehearsing half an hour, ten minutes, and ten seconds later), or random intervals. The same general principle holds for memorizing stories, poems, songs.

It would be interesting to know whether expanding rehearsal plays any part in the scheduling of rituals among present-day hunter-gatherers, specifically among the Australian aborigines. From his experiences with aboriginal ceremonies, Richard Gould feels that the desert people may have come close intuitively to what psychologists have found experimentally, that their scheduling of repeated songs, dances, body painting, and myths may follow some kind of expanding-rehearsal pattern. They certainly make extensive use of another technique, a time-tested technique known as the mnemonics of place and image. The idea is to picture a familiar setting, say your living room, in your mind's eye, and associate various items with various pieces of furniture. To remember a grocery list, for example, you walk clockwise through the room and imagine placing a carton of eggs on the mantelpiece, a pound of butter in the desk drawer, a dozen oranges on the sofa, a bag of potatoes under the coffee table, and so on.

A roomful of imagined places suffices for the mild demands most of us make now and then on our seldom-used and casually trained memories. Using memory to its fullest extent calls for heroic measures. As described in Chapter 10, the aborigines use entire stretches of desert filled with many thousands of places, everything from claypan depressions and rockholes to hollows in trees, to associate with the wanderings and adventures of their dreamtime ancestors along paths where water may be found. This vast body of information, imparted stage by stage during a series of initiations and meetings, is survival information. Most hunter-gatherers in the Central Desert know most of it by heart.

In Europe during the Middle Ages people imagined quiet places such as empty churches, "vast inner memory cathedrals," and one Italian mnemonist, Peter of Ravenna, started his career by walking three or four times through a selected church and memorizing some 100,000 places, a total which he expanded considerably in his later years. Among other things, he could repeat word for word the entire body of canon law, 200 of Cicero's speeches, 300 philosophical sayings, and 20,000 legal points. The late Frances Yates of the University of London suggests that Dante in his *Divine Comedy* narrates a tour of the universe involving "orders of places in Hell, Purgatory and Paradise" as part of "the intense effort to hold in memory the scheme of salvation, and the complex network of virtues and vices and their rewards and punishments."

The Greeks some 2,500 years ago, already masters of the art of memory, established a number of rules for efficient imagining. According to the poet Simonides, author of the first mnemonics text, the general setting should be deserted, because imaginary passing crowds like real-life crowds may be distracting. He also had definite rules for the kind of memory-places best suited for association with information to be stored. They should be medium-sized, well lit but not too brightly because the glare would tend to obscure mental images, and about 30 feet apart, "for like the external eye, so the inner eye of thought is less powerful when you have moved the object of sight too near or too far away."

Simonides compared memorizing to inner writing, and memorized places to image-bearing wax tablets, which can be erased and used again. He knew well the overriding importance of visual imagery and vivid images:

When we see in everyday life things that are petty, ordinary, and banal, we generally fail to remember them, because the mind is not being stirred by anything novel or marvellous. But if we see or hear something exceptionally base, dishonorable, unusual, great, unbelievable, or ridiculous, that we are likely to remember for a long time. . . . Ordinary things easily slip from the memory while the striking and the novel stay longer in the mind. A sunrise, the sun's course, a sunset are marvellous to no one because they occur daily. But solar eclipses are a source of

wonder. . . . The things we remember when they are real we likewise remember without difficulty when they are figments. But this will be essential—again and again to run over rapidly in the mind all the original places in order to refresh the images.

Some of the poets, scholars, and orators of classical times were accomplished mnemonists. They spent hours training themselves to reconstruct small worlds in their heads, complexes of many buildings with thousands of memory-places in each building. One Roman teacher of rhetoric would listen while each of the 200 or more students in his class recited successive lines of a poem, and then recite the entire sequence backwards, simply by mentally walking backwards through one of his imaginary buildings. Another Roman, by walking backwards through an entire imaginary city, could recite the 12 books and 9,700-plus lines of Virgil's *Aeneid* in reverse order.

The elements of mnemonics were probably discovered during the Upper Paleolithic. Certainly the caves meet Simonides' specifications for quiet, deserted settings. They contain an abundance of distinctive places, niches and drape-and-column stalagmitic flows and black holes leading into winding tunnels, which could be readily committed to memory. If, as seems likely, there were long and devious and strictly determined routes to sanctuaries, they could have furnished sequences of memory-places, cues of a sort associated with successive parts of myths and incantations. In other words, those in the know may have used the routes as memory-aids as they led others into the depths.

All this, mnemonic tricks as well as special sound-and-sight illusions, implies the existence of a large body of arcane, top-secret information (Chapter 11). It also implies a good deal more, notably the deliberate and systematic use of deception in staging ceremonial performances, and that is sufficient to produce a well-known boomerang effect. Practices designed to deceive others often tend to rub off and, eventually, to deceive the deceivers. In the beginning the shamans and sorcerers of prehistoric Europe were quite aware of what they were doing and why, just as physicians know about and take advantage of the suggestive value of placebos in prescribing harmless pills for their patients' good.

But, again like doctors, some of them probably proceeded to mislead themselves about the source and extent of their powers. A similar phenomenon is observed among character analysts and fortune tellers, people who make a living by gazing into crystal balls or by reading palms or cards or tea leaves. Ray Hyman, a psychologist at the University of Oregon and an amateur magician and mind reader, has studied and used many of the most effective tricks they have at their disposal—procedures guaranteed to work, based on centuries of accumulated experience in the art of deducing what is

on people's minds. An old standby is the stock spiel. The following example, made up mainly of statements taken from an astrology book available at newsstands, convinces most people that it applies personally and uniquely to them, generally rating between 4 and 5 on a scale of 0 for a poor reading and 5 for a perfect reading:

Some of your aspirations tend to be pretty unrealistic. At times, you are extroverted, affable, sociable, while at other times you are introverted, wary and reserved. You have found it unwise to be too frank in revealing yourself to others. You pride yourself on being an independent thinker and do not accept others' opinions without satisfactory proof. You prefer a certain amount of change and variety, and become dissatisfied when hemmed in by restrictions and limitations. At times you have serious doubts as to whether you have made the right decision or done the right thing. Disciplined and controlled on the outside, you tend to be worrisome and insecure on the inside. Your sexual adjustment has presented some problems for you. While you have some personality weaknesses, you are generally able to compensate for them. You have a great deal of unused capacity which you have not turned to your advantage. You have a tendency to be critical of yourself. You have a strong need for other people to like you and for them to admire you.

Other tricks are calculated to extract information from people without their knowledge, something which, as Hyman points out, is easy to do considering how anxious they are to confide and be reassured. For instance, if your specialty is reading palms, you might tell an entering customer that since time is limited, you could concentrate first on the heart line (love and emotional entanglements), or the fate line (jobs and money problems), or the life line (health and longevity). The concerned customer is quick to state his preference, thereby taking the first step in a continuing and skillfully guided process of revealing what is on his mind. He tells you what he wants to hear (what he wants you to tell him), often does most of the talking himself, and generally comes out utterly amazed that you could possibly have told him so much about things only he could have known.

Now imagine that time after time, year after year, you find yourself the object of awed amazement, bordering in many cases on reverence. Under such circumstances no one is immune to a sort of corruption, to a loss of insight so complete that it becomes firmly entrenched, blind conviction. There is a good chance that somewhere along the line your self-image will undergo a significant transformation. You may cease to regard yourself as a mere person plying a trade more or less skillfully and begin believing, by the sheer cumulative impact of being deeply and repeatedly believed, that you are a very special individual indeed, truly psychic and in touch with supernatural forces.

Similar things can happen to anyone placed long enough in a position to impress others. It happens now and then to hypnotists who, seeing how readily patients submit to suggestion and do to the letter what they are told

to do, may develop delusions of grandeur. It happens to magicians who, even as they perform their tricks, manage to convince themselves that they do not actually have to indulge in trickery to practice psychic surgery or see colors by the sense of touch or bend nails and spoons by willpower or communicate with the spirit world, in effect fooling themselves as completely as they fool their audiences.

It happened on one notable and duly recorded occasion among the Kwakiutl Indians of northwestern Canada, whose shamans have long been famous for their stage effects and feats of magic involving sudden appearances from secret tunnels, hidden trapdoors and partitions and speaking tubes, flying puppets, masks with movable parts, and other ingenious gadgetry. A westernized member of the tribe set out to enlighten his people by exposing the deceptions, pretended that he wanted to become a shaman himself, and began taking lessons in the art of healing. One day he visited a neighboring tribe to observe their healers in action and when they failed to cure one sick woman, obtained permission to try his technique. He did and, to his surprise, it worked. From that time on his fame spread and he became increasingly sure of his special powers, all the time continuing to expose "fakes" and "imposters."

I seriously doubt that there were any exposures during the early innocent days of the Upper Paleolithic, when shaman-like behavior was a relatively new thing. But it is possible that some of the older members of prehistoric hunting-gathering groups, who would presumably be responsible for organizing ceremonies, experienced feelings of omnipotence as they observed the dramatic psychological effects of what they had staged on those not in the know, and crossed the borderline between deception and self-deception. By so doing they would have increased their own credibility appreciably, since individuals who believe fully in themselves cannot give themselves away by telltale signs of guilt or insincerity, and are thus all the more convincing. Self-deception was probably an unavoidable consequence of the need for, and the rapid development of, new ways of impressing people.

14 *Searching for Answers*

▷ This investigation now concluded brings together evidence suggesting that the art which first emerges in the archeological record arose out of necessity. The art thus represents one of a number of developments marking the efforts of people like ourselves to adapt to the release of formidable evolutionary forces, forces which brought about changes in a lifestyle that had endured unchanging for millenniums. It points the way beyond itself, leading step by step to a consideration of problems which have not passed with the passing of prehistory, but which confront us today and can be expected to confront our descendants for a long time to come.

The paintings and engravings can stand on their own and without analysis, many of them masterpieces, and even the ones by lesser artists exciting because of the fantastic settings. The inevitable questions come afterwards, on the way out of the cave and that evening and months later when contemplating the cumulative experience of many caves, and always the same questions. What was on the artists' minds? Why did they go underground—and always why then, why after more than a million years of *Homo* and no enduring traces of art, starting a mere 30,000 or so years ago, with a notable spurt 10,000 years later?

Reviewing my approach to such questions as developed in the preceding chapters, I felt first of all a need to turn away for a while from the art. I wanted to emphasize what else was going on at the same time, other major changes—in tool technology, in the intensity of mass big-game hunting and the exploitation of the wilderness. There was a new restlessness and wider migrations and exchange networks along with decreasing mobility and somewhat more permanent dwellings, changes above all in age-old egalitarian traditions, the first signs of some people outranking others. All this took place suddenly compared with the slow pace, the almost unimaginable monotony, of earlier times. The prevailing picture is one of people in the process of reshaping their lives, under stress.

The art of the Upper Paleolithic appeared in response to stress, and the response was highly organized, as it had to be. Organization practically shouts at you in the Lascaux rotunda with its converging friezes, the great

226

bison-dominated hall of Altamira, the Salon Noir of Niaux, the Trois Frères sanctuary and its crouching "sorcerer" or "horned god." With repeated visits to those and other special places, repeated trips along ancient obstacle courses, comes a growing awareness of organization of the routes themselves. Sometimes the feeling of moving where you are supposed to move, past figures and natural features marking the way in, becomes so strong that it is almost as if you are being led by a prehistoric ghost-guide up ahead.

There is an overwhelming feeling, too, of secrecy planned and subtle, an ingenious nesting of secrecies one inside the other. The cave is the largest, the all-encompassing secret, the outer shell, the passage from open air taking one down and down into an involuted region without vistas, every chamber and corridor bounded by dark rock. The nodes of decoration, the sanctuaries and painted halls and alcoves tucked away in side branches, represent a second order of secrecy, secret places within a secret place. The third order consists of pits not far away and hidden crawl-in spaces, the most remote features of all, holding perhaps the innermost secrets accessible to the new elites only.

Gradually one begins to appreciate the extent of the planning, the use of detail piled upon detail to replenish and maximize surprise. So much, practically everything indeed, remains to be learned about the placement of the art and the way it was drawn; but what we do know hints at the application of some fairly sophisticated design principles, such as the enhancement of realism by taking advantage of natural rock contours to achieve sculptural, three-dimensional effects in depicting animals. Incomplete, distorted, ambiguous, and imaginary or monster figures added to the natural strangeness of the underground settings.

Furthermore, the artists had a fine sense of drama and illusion. What you see often depends on where your light is located and where you are located, whether you are standing, sitting, crouching, crawling, squeezing around a bend, or climbing a ledge. I am thinking in particular of those anamorphic figures which are distorted when viewed from one angle and normal when viewed from another, as well as figures which appear and disappear when your lamp is moved. When it comes to elaborate planning—so elaborate that a blueprint or something like it must have been used—one of the most striking examples is certainly the complex structure at El Juyo, which includes the stone face and multilayered mound.

The effort put into organizing, as well as the relatively sudden appearance of art in the human record, bears directly on questions of motivation. Summarizing my argument, it implies ceremony and an accelerating need for ceremony, and that is where the nature of the times assumes a special significance. Life had never before changed as rapidly as it was changing

then. Survival demanded new ways of transmitting, from generation to generation and before writing had been invented, the contents of an expanding tribal encyclopedia, a body of new rules and traditions about how to do things and how to relate to others. Viewed in this context, ceremony is to be regarded as communication. The mystery and the created illusions, all the thought that went into the selection of the caves, locations within the caves, and the placement of the figures, served to imprint information.

In focusing upon the mnemonic function of Upper Paleolithic art and ceremony, I am simply rephrasing in modern terms and expanding upon an idea suggested over the years by a number of investigators, including Breuil and Leroi-Gourhan. The notion of initiations, rites of passage, as ways of communicating never-to-be-forgotten information is reinforced by a detailed consideration of ceremony among our contemporaries the Australian aborigines, which suggests that unwritten knowledge may still represent the most important knowledge of all, at least among recent hunter-gatherers. It also suggests that ceremony then as now probably involved the combined use, the combined impact, of many arts.

One question leads to another. If the burst of ceremony was related to a burst of information, a development documented by the archeologists, then we must explain the information explosion itself. This confronts us with the problem of people in groups. The Upper Paleolithic saw a coming together of bands for mass hunting and other purposes, the formation of band societies, local and seasonal aggregations which put a strain on our limited capacity for getting along with one another. Judging by analogous situations in recent times, conflict soared under conditions of increased population density, and one of the most effective ways of keeping conflict under control was the invention of a special kind of coming together, ceremonial meetings designed specifically to promote group solidarity.

Ceremony worked within limits, and at a price. The irony is that in reducing one kind of conflict, it may have created or at least accentuated another kind. It depended more and more on the services of special individuals, masters of the art of deception and illusion, and guardians of secrets. People in the know, in a position to overawe, inevitably became potential victims of self-deception and feelings of omnipotence, the ultimate illusion. The existence of central places in band networks also helped create differences among individuals. Everything seems to have conspired to speed the passing of egalitarian traditions and the rise of status, thus laying the groundwork for future power struggles.

It should be reemphasized that ceremony and art, the arts, served a number of purposes, and that I have concentrated on the mnemonic function primarily as a rich source of hypothesis. Research proceeding along many lines indicates an increasing interest in the origins and uses of art

and symbols. The caves continue to attract explorers in search of adventure and physical challenge, with the added incentive of possible finds. Every fortnight or so brings reports of newly discovered figures, more raw data to be recorded, classified, analyzed—one of the latest being a new cave not far from Malaga, entered by siphoning through an underground river and a series of chatières barely wide enough for small and very slim speleologists, and containing a yellow bull and about sixty signs in red and black.

Furthermore, many long-known sites have yet to be fully explored, and some of them would almost certainly yield more figures if there were only enough qualified workers to do the digging (and enough money to support them). To cite only one example, the 65-foot frieze of low-relief sculptures at Angles-sur-Anglin (Chapter 1) may be only part of the original display. I visited the site recently with Suzanne de Saint-Mathurin, one of the original excavators, who pointed to a spot where the frieze disappeared behind the dirt completely filling the rest of the rock shelter: "I saw the back of a bison there some years ago and covered it again. That is for future archeologists. The frieze may extend to the end of the shelter, another 100 to 130 feet."

Art-cave archeology has suffered from the pressure of commercialism as well as from a scarcity of diggers and funds. Sites have been generally opened to paying visitors before investigators had a chance to explore, excavate, and record major features. Three notable exceptions are Fontanet, Tuc d'Audoubert, and Trois Frères, all in the French Pyrenees and all closed to tourists from the time of their discovery. During my last visit to Trois Frères, Bégouën and Clottes were completing work in a chamber about the size of a small bedroom but rather less comfortable, the lion chapel with its single large engraving of a lion located on a projecting ledge to the right of the squeeze-through entrance. The animal took quite a beating in prehistoric times. Its head is mutilated by repeated blows with a flint tool, and more than half a dozen engraved arrows pierce its body. Near its legs is an isolated human hand and arm, bent at the elbow, the hand apparently reaching for the lion's tail. (A similar disembodied hand-arm is located under a set of four red lines in another part of the cave.)

Using tape measure and folding ruler, Clottes and Bégouën were making a map of the chamber, not just its contours and the position of the dominant animal but also other features. Just below the head end of the engraving is a niche with a combination burin/end scraper inside, probably the same tool wielded thousands of years ago to inflict repeated blows on the lion. Another niche in the opposite wall contains a fossilized scallop shell, its inner surface blackened, perhaps with a manganese pigment, suggesting that it might have served as a palette. Still another niche contains two fragments of bone, while a fourth is crammed with five flint tools and a

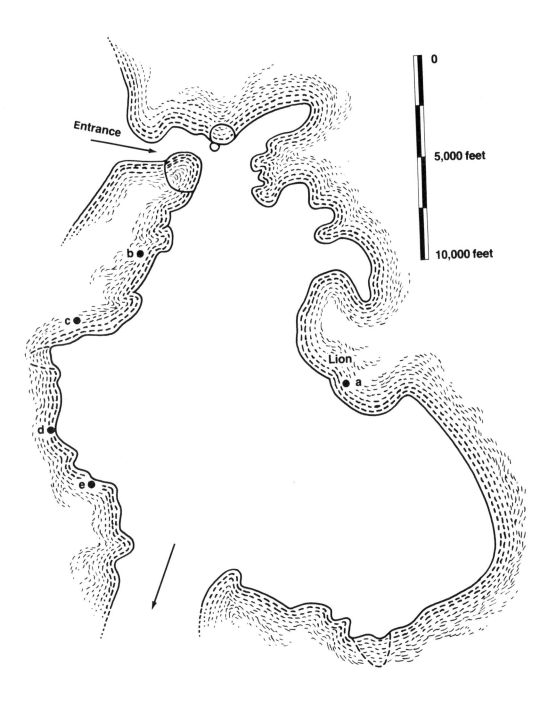

A place for ritual—Lion Chapel, Trois Frères: (a) burin-end scraper deposited in a small hole under the lion; (b) a fossil sea shell (pecten) in a hole of the wall; (c) two fragments of bone (not decorated) in a hole of the wall; (d) end scraper in a hole of the wall; (e) one bear molar and four flints deposited in the same hole. *(Jean Clottes)*

bear's molar tooth. Insights emerge from comparisons of many such maps, from accumulated details which reveal patterns in working habits and the use of symbols.

Some of the most painstaking research of all involves studies with microscope and magnifying glass. Archeologists have been examining cave and portable art specimens with varying degrees of intensity for more than a century, but most of their collective observations are superficial compared to those of Alexander Marshack of Harvard's Peabody Museum. When it comes to looking at prehistoric figures, really looking, with the aid of cameras and a mass of associated equipment that he somehow manages to carry into the most remote cave locations and the most difficult to get at, he has set high standards of close-up thoroughness and inspired similar efforts by other workers. His first publication, which appeared nearly twenty years ago, presented counts of four sets of marks—two on rock walls in Spain, one on a reindeer-bone specimen found in Czechoslovakia, and one on a tip of a mammoth tusk from the Ukraine.

The sets yielded counts of 29, 30, 46, and more than 120 marks respectively. The Harvard investigator interpreted the first two as representing lunar months; the third, which consisted of three subsets of 15, 16 and 15 marks, as "observational half months"; and the fourth as a four-month period. He stressed that these were only a few examples of the use of lunar notation: "The evidence is neither sparse nor isolated; it consists of thousands of notational sequences found on the engraved 'artistic' bones and stones of the Ice Age and the period following, as well as on the engraving and painted rock shelters and caves of Upper Paleolithic and Mesolithic Europe."

Marshack's work has been followed by related studies among other investigators. For instance, Boris Frolov of the Institute of Natural Sciences in Moscow observes that the careful counting of notches and other marks dates back to the 1850s, and notes with special interest sets that are multiples of 5 and 7. Maria Piacquadio Losada of the University of Sussex in England relates patterns of sixty-three notches to the period of sixty-three days or about nine weeks for "ear emergence, flowering and ripening" of certain possibly edible grasses; and Marshack himself has suggested the possibility of another set representing the eleven-month pregnancy period of the horse.

Playing the numbers game can be dangerous. Considering the number of periods and cycles in nature, one can see patterns everywhere and find significance in practically any combination of strokes and notches. On the positive side, whatever the verdict of future research, counting is part of a growing recognition of pattern in prehistoric art. Marshack has led the way in demonstrating sequences of marks, often made at different times by peo-

ple returning to the same object or place repeatedly, and apparently engaged in some sort of continuing activity. He now regards lunar-type notations as only one of more than a dozen symbol systems.

Sometimes the camera discloses details and entire figures which the eye cannot detect, even using magnifying lenses and the best lighting. Jean Vertut, an engineer associated with the French Atomic Energy Commission in Paris, has become in his spare time the outstanding photographer of cave art. His photographs, some taken with as many as half a dozen flash units, are the next best thing to being there. He uses special film to good advantage, as in Tito Bustillo where infrared exposures produced a kind of X-ray effect, bringing out from underneath calcite crusts red-pigment strokes used in drawing horses and other figures. Under certain conditions, film designed to pick up ultraviolet rays—which cause calcite to fluoresce—may reveal faded traces of figures drawn in black. Micrograph film, a variety produced especially for photographing through a microscope, may serve a similar purpose, an extremely faint red hand at Trois Frères showing up in clear detail.

Vertut is among those investigating new approaches to the old problem of dating cave figures. There is no way of telling when a figure was drawn, no direct and really precise way. When figures are superimposed one on top of the other, different colors and styles have been used in an effort to help identify early, middle, and late work. In a few cases, when intact archeological deposits happen to cover some of the art, one can do better than that. When some forty years ago Saint-Mathurin started clearing away deposits from the walls at Angles-sur-Anglin, for example, she found that the sculptures were partly covered by a layer containing bone harpoons with double rows of rounded barbs, small "thumbnail" scrapers, curved-back flint knives, and tanged points. These items were commonly included in the tool kits of people who lived 10,000 to 13,000 years ago.

But all the sculptures lay above an earlier layer containing such items as star-shaped boring implements, bone javelin points with long beveled bases, and reindeer-antler rods semicircular in cross section and often decorated, items typical of tool kits some 13,000 to 15,000 years old. So the art was produced during this period, a conclusion supported by evidence from the so-called atomic clock technique, which depends on the fact that atoms of carbon-14, a radioactive form of carbon, split at a steady rate so that the proportion of the element in charcoal and other organic materials decreases with time. Two carbon-14 samples from an ancient Angles hearth indicated that home fires burned there some 14,000 years ago.

Hearths are not always available, however, and Vertut is especially interested in a "thermoluminescence" test, developed recently for dating pottery and not yet used in caves. It measures the residual radioactivity of

elements imbedded in the calcite layers that cover much of the art. When a tiny sample of calcite (less than a ten thousandth of an ounce will do) is heated to about 850 degrees Fahrenheit, it emits a glow caused by the decay of its radioactive elements, and the spectrum of that light indicates the age of the specimen. Vertut plans to try this test, which could give minimum ages for underlying figures, in Trois Frères. Another test depends on measurements of the magnetism in certain deposits and has already provided dates of 11,200 to 11,600 years ago for a frieze of animals in Tito Bustillo.

Space-age electronics may soon be mobilized in the good cause of research underground. One of the most complex National Aeronautics and Space Administration machines looks like a cross between a mammoth television set and the control panel of a Star Trek rocket ship—and includes television-camera eyes which scan photographs and automatically detect and sharpen light-dark differences invisible to the naked eye. This so-called edge enhancer, developed originally to interpret obscure features in satellite photographs of planets and earthbound military installations, has been used in archeology to trace the courses of 1,000-year-old roads in the Chaco Canyon pueblo ruins of New Mexico. Vertut believes it may help in analyzing cave art.

The French engineer also happens to be an expert in robotics, suggesting that animated machines rather than people may some day be penetrating the most difficult and dangerous parts of caves. The Atomic Energy Commission is interested in advanced robots mainly to go into places where humans could not survive, handling radioactive materials and monitoring operations in "hot" areas of nuclear plants. In addition, they will be used in deep-sea and space explorations, and increasingly in automatic factories, a field in which Japanese engineers are making notable progress. Electronic speleologists, midget-sized and shockproof, may yet crawl into chatieres, pits, and high fissures too confined and difficult of access for even the slenderest, most supple of human speleologists, compiling detailed records as they go. It is sheer science fiction today, but if such machines ever join the search for prehistoric paintings and engravings, the odds are that they will be designed by Vertut.

Future research is likely to be even more demanding than the research of times past. It is necessary but by no means sufficient to find a figure or group of figures and note its existence for the record. The focus is more and more on relative positions—the positions of figure, viewer, and light source with respect to one another—and that could turn out to be exceedingly complicated. Investigators are beginning to observe more systematically than ever, from many different locations, near-far, high-low, and left-right, trying to find some rational basis for speculating about which locations may

have been significant in prehistoric times.

The British prehistorians Anne and Michael Eastham note that a panel in the Trois Frères sanctuary appears as a close-knit group of some half dozen bison with a human face at the center, when viewed from about a yard away with the face at eye level—and that "this viewpoint approximates fairly closely to the sitting position of up to five people of normal height with their feet in a wide fissure in the stalagmitic flow which covers the floor at the entrance." Judging by visibility and perspective considerations, the artist may have sat to the extreme left nearest the rock surface, holding a lamp in his left hand. According to the Easthams, most caves are "right-handed," figures being viewed best with lamps held to the left in the left hand, thus leaving the right hand free for painting and engraving. Another possibility: it may have been mainly a matter of surprise and illusion. Perhaps the lamp holders were guide-shamans revealing secret figures to novices.

Lya Dams is in the process of studying an entire cave from the standpoint of positioning: the vast Nerja site in southern Spain, with its upper and lower galleries and steep walls that must be scaled (Chapter 8). Having recently completed a detailed survey of more than 400 figures, most of them discovered by herself and her husband, she is devoting special attention now to the most intensively used places, places where prehistoric people decided to concentrate graphic information. Her plan involves, among other things, recording the placement of figures within each selected space, each densely decorated chamber and *chatière,* particularly the different appearances of figures when approached from different directions.

Nerja's lower gallery includes a recess about 16 feet long, featuring to the right as you enter a "drapery" formation, limestone sheets in thin vertical folds, something like a hanging curtain. At some later time movements in the earth caused the entire formation to tilt at an angle of almost 45 degrees, giving it a most unusual appearance. The recess is narrow and has only one entrance, so there is only one way to walk through, leading you past a sequence of red figures on the curved sides of the folds facing you. Then you come to a dead end where, on the floor and barely visible, there is a large ibex painted in red. Then you see another sequence of figures on the other side of the folds as you come out. The question arises whether the figures, two animals and more than a hundred signs, were meant to be seen in that order—and if so, can we ever hope to "read" the message?

As far as the first half of the question is concerned, I would answer with an only mildly qualified "yes." The notion of a planned sequence seems well within the capabilities of Upper Paleolithic artists, particularly in view of Denis Vialou's basic assumption that they had a good reason for practically everything they did. After all, every frieze is a planned se-

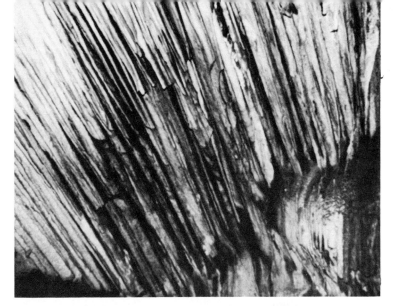

Nerja: "drapery" formation where more than 100 signs are hidden. *(Marcel Dams)*

Nerja: signs painted on limestone sheets. *(Lya Dams)*

Nerja: signs and a climbing hind. *(Lya Dams)*

quence. Each painted animal in the Lascaux rotunda, each sculpture at Angles-sur-Anglin, is so impressive in itself that one cannot help stopping and looking at it as a separate work of art, like an object displayed in a modern gallery. But that does not mean the artist thought of it that way. Actually, each figure is part of a series, a procession of a sort, and it may have been intended to be viewed sequentially.

Many caves include long narrow galleries such as the tapering tail passages at the ends of Lascaux and Altamira, which do not contain friezes but which, like the Nerja alcove, present different sequences of figures coming in and going out. The main part of Font de Gaume is a narrow gallery. Les Combarelles, located only a mile or so away, is a single corridor 260 yards long, made up of some ten right-angle bends, and often only a few feet wide, the walls of the last 80 yards being covered with hundreds of crowded-together engravings. Some of the sequences in narrow tunnels, and perhaps in not-so-narrow places as well, may have been designed for viewing one figure after the other while walking past.

Assuming some such planning, it is not at all clear where we go from there. The sequences were certainly not writing; that came about 10,000 years later. But what were they? It is all well and good to stress what they were not, but what were they saying to prehistoric viewers? Were they reminders of episodes in myth and belief like the symbols of the sacred boards and rock-shelter walls of the Australian aborigines? Some day perhaps we will have sets of sequences from caves in different regions, and discover repeated patterns of symbols among them. But even so the prospect of interpreting the patterns would not be encouraging—though not impossible, either.

The entire problem of regional differences is wide open for further research. At present we have a few facts and many impressions, for example, the overwhelming concentration of European cave art in a few parts of France and Spain, and the suggestion that abstract forms may be more common and more complex in Spain than in France (Chapter 9). Vialou notes certain differences within France itself. He points out that the artists of the Ariège region in the Pyrenees used claviform or club-shaped signs, and natural relief to attain three-dimensional effects, far more frequently than the artists of the Les Eyzies region. They also tended to use a cave more extensively, decorating surfaces in a number of galleries and chambers, as contrasted to the Les Eyzies tendency to concentrate art in one or a few special places (the sanctuary at the Pyrenean site of Trois Frères, by the way, being a notable exception).

There has been some talk of a survey of already described differences, and an effort to find new differences. So far archeologists have gone into the caves with an occasional artist or poet. But it is time for something

more systematic: visits to a set of selected sites by a working group made up not only of an archeologist and an artist but also of a dancer, psychologist, architect, acoustical engineer, a producer or professor of drama involved in staging and stage effects, and a zoologist with an experience in observing the behavior of wild animals. A team of this sort might have a good deal to say about caves as effective ceremonial sites.

Investigators are not spending all their time scrambling through caves, and recording and analyzing what they find. They may also play a more direct role in the study of Upper Paleolithic art, a do-it-yourself role analogous to the work of present-day flintknappers studying Upper Paleolithic technology. As part of a research project focused on the human form in prehistoric art, Rosemary Powers of the British Museum of Natural History in London has made a variety of Venus figurines, and has learned some interesting things about certain technical problems which confronted Cro-Magnon sculptors.

Experimental Venus figurines: "the shape within." *(Copyright, British Museum)*

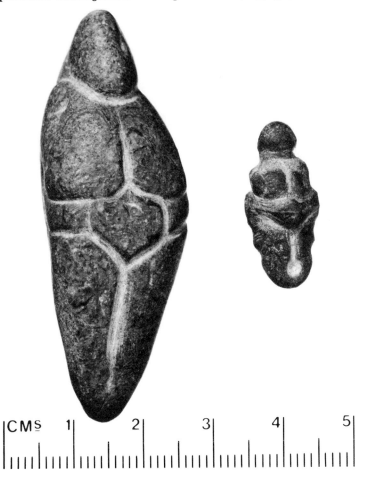

To start with, a great deal depends on the stone selected: "As the sculptors say, one can see the shape within, wanting to be freed." On one occasion, she wanted to make a figurine about 2 to 3 inches high, imitating an abstract style common in prehistoric sculptures of women, stressing vulva, breasts, and thighs, generally with little fine detail—and found a suitable pebble on a Southampton beach, a wave-smoothed piece of limestone. Preliminary cuts, made with a flint flake, consisted of two Y-shaped grooves, one to outline the leg-and-groin area and the other to mark neck, chin, and the cleft between the breasts.

Experience gained from a number of experimental figurines indicates how the size of the pebble, the task of working on such a small scale, limits what can be accomplished. Arms or breasts can be carved on a 2-inch pebble, but it is extremely difficult to do both, and prehistoric sculptors rarely developed both features in their figurines. Powers notes that the material dictates the rhythm of her work: "The flowing curves seem to be the natural outcome of working with a flint tool which, at the same time, discourages any tendency to obscure the basic form with fussy detail. After the main lines have been blocked in with the flint to a depth of perhaps a millimeter, larger masses can be removed by abrasion with sandstone. The shape of the pebble triggers off the imagination, and there is a feedback between shape and conceived image which evolves as one goes on."

Similar experiments are being conducted in painting. There is a cave in the south of France with only one panel of figures, which no tourist and very few archeologists have ever seen. A beautifully executed design, it includes ten mammoths, four bison, four oxen, and three horses, all done in black outline and covering a stretch of wall some 23 feet long and 8 feet high. Despite the location and authentic appearance, however, it is not a prehistoric work, but a recent stroke-by-stroke replica by Michel Lorblanchet of an Upper Paleolithic frieze at the nearby Pech-Merle cave.

After spending hours studying the original, he decided to recreate as closely as possible the style and total experience of the artist. One of the most difficult parts of his project was locating a cave with a suitable surface, a blank section of wall free of fissures, cracks, and hollows, and large enough for the entire frieze—a task which called for excursions into the depths of several dozen of the 1,000 caves in the Pech- Merle region, before finding a wall that met all specifications. Then he went in with photographs and drawings of the frieze, and a selection of upper Paleolithic equipment including charcoal crayons and animal-fat lamps designed from a prototype found in another cave in the area.

Lorblanchet had already examined each stroke of each figure so carefully that he was reasonably sure of the number of separate strokes required and the order in which they were drawn. For example, he knew

that in the case of one bison the artist had started with a sweeping line at the head end, followed in clockwise direction by successive lines for the back, tail, legs, and then to the head end again, exactly thirty strokes in all. Most of the figures took him from one to four minutes to draw, except for a number of schematic figures which he copied in less than thirty seconds each. The entire frieze took an hour or so, which is probably about the time required by the prehistoric artist or artists, since several individuals may have been working together.

Although the French investigator has not duplicated all of Pech-Merle in other caves, he has a good idea of the total time involved, a few hours perhaps for a panel with a pair of spotted horses in the main gallery, and no more than a few days for the whole cave with its seventy-odd figures. Timing the art, going through the same motions as the original artist, the same "gestures," provides a feeling for the pace and skill of the work. Even more important, it provides a feeling for repeated patterns, elements of style—knowledge of which may be useful in a number of ways, for one thing, in deducing when different figures were painted.

For example, there are some horses in a side gallery branching off to the right of the present-day entrance to Pech-Merle, a gallery which may lead to the original entrance. These horses were painted some 20,000 years ago, without spots, but Lorblanchet is convinced that they are the work either of the same artists who drew the spotted horses in the main gallery, or else of artists working in the same tradition. He bases his opinion on detailed studies of style. In all cases, the horses have the same body shape, the same hanging belly, legs drawn in the same manner, and with the same 1 to 15 ratio between the length of the head and the length of the body (horses drawn in other periods having different ratios). "Upper Paleolithic art is full of stylistic conventions from one period to another," according to Lorblanchet. "It is produced in line with special rules, a kind of code. We may never crack that code, but it is certainly worth trying."

Another investigator concentrating on the problem of style is John Clegg of the University of Sydney who, incidentally, has also engraved figures on rock experimentally and timed the results. (He finds that he can execute about 7 to 8 feet of shaped grooves per hour.) But his specialty is taking as little as possible for granted, part of a systematic effort to avoid statements based primarily on personal impressions and to arrive at objective stylistic criteria. In his reports he often writes "!animals" instead of "animals," "!legs" instead of "legs," "!kangaroos" instead of "kangaroos," and so on. The exclamation points stand for "so-called," and indicate that he is not assuming that the figures were actually drawn to represent what they look like to us but that they are being regarded merely as more or less standardized marks or symbols. Although I will not use exclamation points

in the following paragraphs, this qualification holds throughout.

Clegg and his students are seeking distinctive regional patterns in rock-art styles. For example, they note that aboriginal artists who worked in the Australian countryside south of Sydney drew animals with four legs, while two-legged depictions were the practice north of the city. Also, vertically depicted eels tend to be drawn head end downward to the south and head end upward to the north. In a more detailed investigation, drawings of kangaroos at a group of Cape York sites at the northeastern tip of Australia were compared for similarity on the basis of thirty-two traits such as size, length of legs, and body shape—and found to fall naturally into three stylistic patterns characteristic of three different areas.

The long-term objective of such studies is to do with rock-art paintings and engravings what archeologists concerned with more recent societies have done so successfully with pottery designs. The degree of similarity in the shaping and decorating of ceramic vessels of different regions implies close relationships, the existence of trade networks, the spread of religious ideas, a weakening of political ties or, if changes appear suddenly, invasion and conquest. Regional style differences among art sites of the Upper Paleolithic can be expected to provide analogous clues to the nature of prehistoric social organization.

Among those researchers dealing with the techniques rather than the styles of cave painting is Mark Newcomer, whose studies of bone tools and hafting are referred to in Chapter 3. The backyard garden of his home outside London might baffle future archeologists. It includes assorted traces of prehistory, marks of past and continuing experiments such as chunks of flint and struck-off chips and flakes, and a pebble painted with lines and dots using a frayed-twig brush, a copy of items found by the dozens in certain post-Magdalenian deposits. In another part of the garden is a slate with rectangular strips painted in various shades of red and representing six different paint preparations. Five of these paints contain red ochre, a natural mixture of clays and hematite or iron oxide, combined with various binders (egg yolk and water, egg white and water, whole egg and water, saliva, and slightly heated mutton fat). The sixth is a combination of egg yolk and water and pure hematite instead of ochre. The strips had been painted in 1976 and after six years of weathering, five of the six mixes had faded considerably; only the hematite mix retained its color.

There are painted hands on the walls in Newcomer's garage, negative images like those found at a number of caves and featured in the cave of Gargas, in the Pyrenees. The prehistoric images were undoubtedly produced by placing one hand against the wall and blowing pigment around it, but the question is how. Some investigators believe it was accomplished by filling one's mouth with paint and forcing the fluid out in a spray and, to

prove their point, they have done just that. The London archeologist has tested another, less heroic method. He sets a hollow bone about 3 or 4 inches long upright in a bone paint holder, like a straw in a milk shake, and then blows through another small hollow bone placed at the top of the "straw"—creating enough suction to cause an aspirator effect, forcing paint up and out in a fine mist. Somehow this procedure makes rather more sense than one which requires washing out your mouth afterwards, a routine probably as distasteful to our ancestors as it would be to us.

Experiments can do little to solve the mystery of hands painted with fingers missing or mutilated, a common observation. Newcomer has shown that faking it is easy, producing a perfect replica of a mutilated hand by bending a finger down and pressing his hand firmly against the wall. Although there may have been fakers in prehistoric times, however, a plausible explanation for most of the severe mutilations such as those found at Gargas which may affect as many as four fingers is disease, perhaps frostbite or some circulatory-vascular disorder. Ritual amputation is more likely for caves like Maltravieso in western Spain not far from the Portuguese border, which contains many painted hands—here all the ones clear enough to make out the details have the same mutilation, lacking the upper two joints of the little finger.

Newcomer recently completed tests of stone lamps. Starting from scratch with a set of flint tools and a limestone slab, he spent five hours making a teardrop-shaped model some 7 inches long and hollowed out at the center, a copy of a prehistoric original. It turns out that a lamp filled with any one of various cooking or animal fats and oils, such as lard or

Light to paint by: limestone lamp burning animal fat fuel, made by M. H. Newcomer; replica of lamp found in La Mouthe cave, southwestern France. *(Copyright, M. H. Newcomer)*

Spray gun, prehistoric style: (a) vertebra paint holder and hollow-bore spray elements; (b) blowing paint mist *(M. H. Newcomer)*

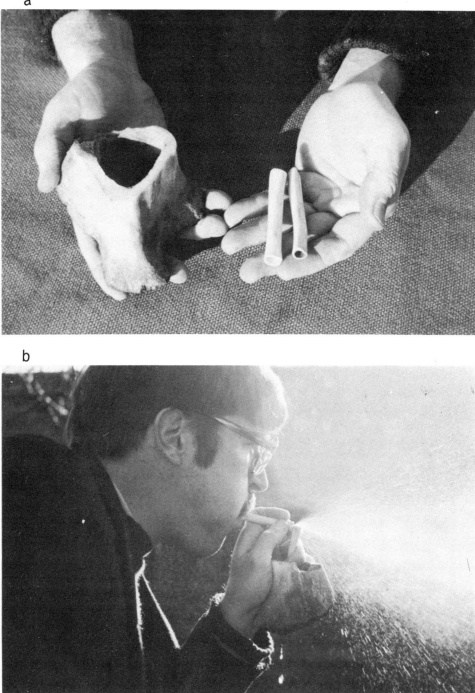

a

b

(c) target, hand with finger bent under to imitate mutilation; (d) hand stencil
(Copyright, M. H. Newcomer)

c

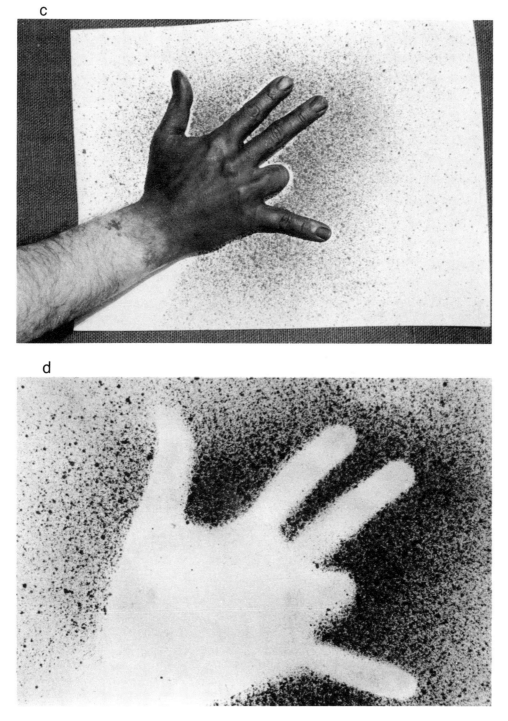

d

peanut oil, and a wick of rolled-up leaves or grass or moss ("anything that burns") provides five to six hours of light, enough to illuminate several square feet of wall surface. If you want more light, you can use several lamps or a single lamp with two or three wicks. Lorblanchet used a two-wick arrangement for a time when he was copying the Peche Merle animal frieze. Incidentally, the mystery of why the burning of prehistoric lamps did not blacken cave walls is a mystery no longer (Chapter 2). The oils and fats Newcomer used produce no soot.

A future study will deal with the prehistoric working of hides, the long and complicated process of transforming a stiff, bloody animal skin into soft and comfortable clothing. The process involved scrapers and other special tools to clean and soften the hides, as well as various chemicals. Thick deposits of earth colored bright red with ochre have been found at a number of sites, the traditional explanation being that the substance was brought in to paint the body or perhaps decorate sacred areas. Ochre was almost certainly used ceremonially. But tests indicate that it also acts as an abrasive or polishing agent and a preservative, delaying the decay of hides, and it may have been used for such purposes as well.

These and other projects in experimental archeology are based on the general notion that we can learn more about prehistoric people by going through the motions of what they did. It would be interesting to go a bit further, and combine the knowledge we have in reenacting more elaborate past behavior. The late Louis Leakey once conceived a typically ambitious plan to live through several million years of evolution in six weeks. Camping in the savannas of East Africa, he intended to start with a week of early-hominid living, no shaped tools and only clubs and rocks and his bare hands for survival, and to devote the last three weeks to Neanderthal and Cro-Magnon living, culminating with the bow and arrow during the final week. Leakey never had a chance to carry out his plan, but something more limited in scope might help recapture some of the spirit and substance of the Upper Paleolithic—say, the staging of underground ceremonies in a cave decorated by present-day artist-prehistorians.

Meanwhile alerted investigators are on the lookout for signs of art and ceremony in the open air, that is, signs over and above occasional pieces of portable art. At least one site provides definite evidence for above-ground ritual, a site unusual not only for its contents but also as an example of close collaboration between American and Soviet archeologists. Discovery of intricate arrangements of mammoth bones used in the construction of Upper Paleolithic dwellings is announced in a recent report by Olga Soffer of the University of Wisconsin in Milwaukee, and Nenelj Kornietz and Mihail Gladkih of the Academy of Sciences of the Ukraine and Kiev State University respectively.

The Mezhirich site, located in a river valley on the Russian Plain about 90 miles southeast of Kiev and dating back about 15,000 years, yielded a collection of amber and other exotic materials, suggesting that it was part of an extensive exchange network. It also yielded what may be the world's earliest map: a piece of mammoth tusk about the size of a file card, engraved with two wavy parallel lines, a row of X's and branched marks, and four ovals—which may represent a nearby river, trees and bushes, and the four oval-shaped dwellings actually excavated at the site. Prehistoric builders apparently used some 70 tons of mammoth bone from at least 200 kills as supporting posts and other structural elements.

The dwellings featured a series of precise mammoth-bone decorations. One of them had an outer wall or facing of ninety-five V-shaped mandibles placed in a circle and stacked one on top of the other in a herringbone or chevron pattern. Another had a facing of long bones stuck upright in the ground, also in circular formation; still another contained mixed bones and may not have been completed. The fourth dwelling was the subtlest of all. Its outer wall included the design themes of the others—a chevron-mandible section, a long-bone section, and a mixed-bone section. "In addition to this fascinating bit of architectural mimicry," Soffer comments, "we see also a rhythmic repetition . . . and a use of symmetry."

Patterns in bone: stacked mammoth mandibles, Mezhirich, U.S.S.R. *(Olga Soffer)*

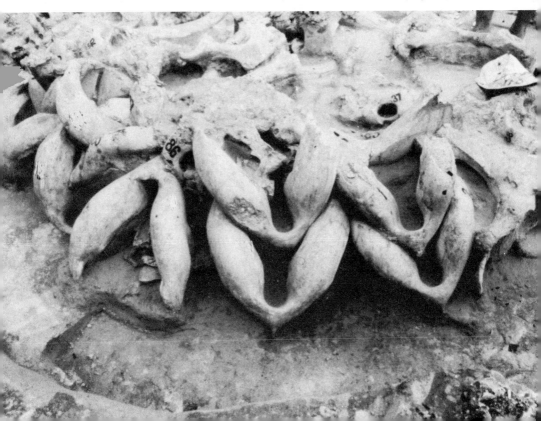

The elaborate planning and detailed specifications, as well as the time and energy devoted to setting everything in proper place, reminds one of the El Juyo sanctuary with its colored mosaics and alternating bone layers (Chapter 7). Built into the mandible section of the fourth dwelling was an alternating pattern of two stacked mandibles in a chin-down or normal-V position, two in a chin-up inverted-V position, and then another chin-down pair. Another section had a skull with a scapula-scapula-pelvis alignment on each side. These and other patterns were recovered during months of slow and careful digging. They indicate that Mezhirich served as an "aggregation" site where people, representing different bands or band societies, came together in a sharing and highly ritualized setting.

Similar sites, similar ceremonies, appeared at different times in different parts of the world, presumably as a result of similar evolutionary pressures. In other words, they appeared when needed. Unfortunately, the research record outside Europe is often too scanty even for informed speculation. India had an Upper Paleolithic of its own which in some ways resembles that of Europe. It seems also to have started 30,000 or so years ago, and has also yielded the earliest known Indian ornaments in the form of beads made of ostrich-egg and marine shells. Portable art is represented mainly by a single bone figurine about 3 inches high, a female, found in a northern river valley near Allahabad.

Rock art apparently came later in India than in Europe, most of it having been produced less than 10,000 years ago, although figures discovered recently in caves 600 miles to the south of Allahabad may date back as much as 20,000 years. The richest concentration occurs in central India, in dense hillside forests not far from Bhopal where investigators have discovered more than 500 caves and rock shelters containing many thousands of paintings from about 1 inch to more than 5 yards long. One painting, incidentally, shows a herd of animals, probably chital deer, falling over a cliff. As far as tools are concerned, India's Upper Paleolithic reminds one of Europe's, being marked by abundant backed blades, burins, tanged and shouldered points, and points and other implements made of bone. The evidence is not sufficient, however, to document changes in hunting techniques, population density, or band organization.

The same general situation holds for the Far East and Australia. In China, for example, the Upper Paleolithic occurred at roughly the same time as in Europe and India, and also featured an increase in the number and variety of tools, including microliths and bone tools, and the appearance of regional differences in tool kits. Kwang-chih Chang of Harvard University points out that blades typical of sites in the grasslands of North China, near the middle stretches of the Hwang Ho River, are identical to blades produced during the early Upper Paleolithic in Europe. Art ap

peared about 7,000 years ago, and ornaments more than 10,000 years before that; but the accompanying social changes are unknown and may remain that way for some time.

For insights into the origins of hunter-gatherer art, prospects are rather more promising in the New World, notably in North America. No official census of art sites exists, but 99 percent of them lie west of the Mississippi, more than 15,000 in California alone. The earliest figures, painted and engraved on rock-shelter walls, boulders, and stone slabs, may date back more than 8,000 years. In certain regions there is reason to believe that art and ceremony developed suddenly. This may be the case in the Great Basin areas of Nevada and Utah where people, some highly nomadic and others living in seasonal villages, began exploiting mountain uplands on a large scale.

Some major investigations are also under way in southern Africa, which ranks as one of the richest, if not the richest, prehistoric-art regions in the world. It includes more than 6,000 Bushman sites, almost all rock shelters, with perhaps 150,000 to 175,000 paintings, and that is only part of the total. There are many deep, dark, and incompletely explored canyons among the rugged Drakensberg Mountains, a range extending for hundreds of miles parallel to the southeast coastal tip of the continent, canyons where anyone in good enough physical condition can be guaranteed to discover one or more new sites in a few days of serious searching.

Among the most experienced Drakensberg searchers are Harald Pager, Patricia Vinnicombe, now at the Western Australian Museum in Perth, and David Lewis-Williams of the University of the Witwatersrand in Johannesburg. In a detailed analysis of 8,478 paintings in 308 rock shelters, Vinnicombe has drawn attention to the special significance of the eland, the largest and most impressive antelope of southern Africa. According to her, it is not only the most frequently depicted species (making up more than a quarter of all 3,600 animal figures), but often the largest in a scene (averaging 16 inches long as compared to a range of about 4 to 10 inches for the great majority of other animals) and the most elaborately painted in polychrome (three or more colors). She describes the eland as "the hallmark of Bushman art."

On the basis of similar studies of his own, Lewis-Williams has embarked on a task even more demanding, though in a somewhat different way, than mountain climbing—the most intensive effort yet undertaken to interpret the art. Insights come from Bushmen living today some 700 miles to the north. They no longer paint, have not painted for generations, and have no idea who painted the over-2,000 obviously Bushman figures in nearby hills, "unless it was God." When asked whether God loves one antelope more than others, however, they describe the eland as His favorite.

These and other responses indicate the existence of religious beliefs still held in memory, and probably once widespread throughout southern Africa.

For further detailed accounts of their beliefs and associated rituals, Lewis-Williams turns to published sources as well as some 11,000 pages of unpublished notes based on nineteenth-century interviews with members of an extinct group of Bushmen who lived to the west of the Drakensbergs. The notes are handwritten, often illegible, with crossed-out words and obscure references and an occasional untranslated and now untranslatable passage in native language. But they are invaluable when it comes to making sense of the paintings. Descriptions of headgear, rattles, magic sticks, and other paraphernalia not only help in identifying objects shown in the paintings but also indicate the sort of ceremony being conducted and, especially important, the folklore that shaped the ceremonies.

For example, the extinct Bushmen had a girls' puberty ceremony which included isolation of the girl in a specially constructed hut, a ritual which provided the key to what is probably going on in a well-known Drakensberg painting. A central figure of the painting shows a large figure inside a hut together with three clapping figures, and two figures on the outside apparently in the process of building the hut. Present-day Bushmen have a similar ceremony, and also isolate the girl in a hut. Furthermore, the most important feature of their puberty ceremony is an Eland Bull dance, in which men hold branched sticks over their heads to represent eland horns and women mimic the mating behavior of eland cows. In the painting, dancing male and female figures—a number of them shown with tails and crouching over in a "four-footed" posture—seem to be participating in such a dance.

Every interpretation requires a fitting together of clues, a search for mutually reinforcing associations, and wider implications. The eland is valued for its fatness, among other things, and unpublished myths as well as current rituals and new medical findings all demonstrate a relationship between eland fat, sex, and fertility. In a recent study, Lewis-Williams documents the central role of this antelope in rituals associated with a boy's first hunting kill, marriage, rain-making, healing dances, and with the entire structure of Bushman religion. Whether changes in lifestyle can help account for the rise in ceremony in prehistoric southern Africa, as was the case in Europe during the Upper Paleolithic, depends on the accumulation of more, and more reliable, dates for the rock art—and on a more detailed archeological record, which at present only suggests the possibility of decreased mobility and new practices starting some 12,000 years ago. Recent radiocarbon-date studies indicate that some of the art can be traced back at least 10,000 years and may be more than twice as old as that.

The future may see increasingly intensive studies of superimpositions,

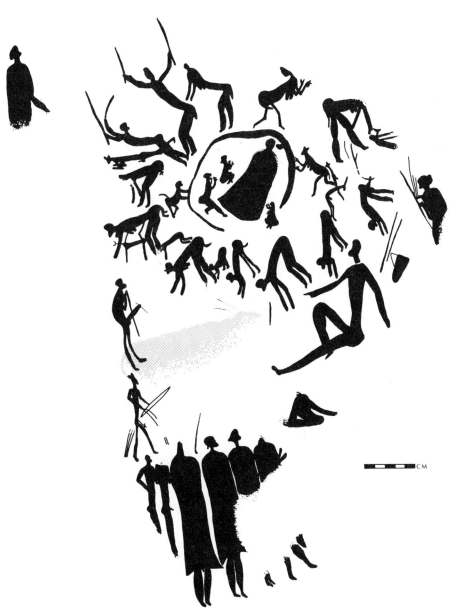

Drakensberg rock-art panel: puberty dance, with eland at center in faint stipple
(J. D. Lewis-Williams)

now used predominantly as a clue to developments in style and relative dating. Lewis-Williams believes that the painting of one figure over another (up to five layers in some cases, as at Altamira, Chapter 2), far from being a haphazard or random thing, had some method to it. In one Drakensberg region he studied 69 two-layer superimpositions out of a sample of 2,361 paintings, and found that elands were involved in 51 cases—25 cases of eland drawn over eland, 20 cases of eland drawn over human being, and no cases of human drawn over eland.

Research in a gorge some 150 miles to the northeast, reported by Pager, tends to confirm the observation that animals in general are drawn over humans rather than humans over animals, and suggests other rules governing what figures are painted over others. Studies of rock drawings in eastern California hint at the existence of such rules. It remains to be seen whether or not the artists of the Upper Paleolithic were similarly guided. Leroi-Gourhan doubts it, but the problem may be worth further analysis.

The most challenging problem of all concerns behavior that probably evolved long before the Upper Paleolithic. Remember the reference in Chapter 7 to the zoologist who could find no good reason, no adaptive advantage, in the "spontaneous tendency to create artistically." It is still a problem. My focus throughout has been on applied or institutional art—art produced in the service of belief, ceremony, and community. There is a possibility that this was also the world's first art, the earliest expression of the artistic impulse. But I do not believe it. It makes more sense to assume that the record is incomplete, that something significantly esthetic happened during the 1.5 million years between the first traces of symmetry in tools and cave art.

Art seems somehow to have arisen from play, in a uniquely human spinoff process which has acquired a life of its own. Both involve imitation, pretending, a measure of fantasy, the freedom to improvise, to make and break rules and create surprise. But this insight, however plausible and frequently voiced over the years, raises more questions than it answers, a major reason being that play is a complex and poorly understood activity. The word itself is highly misleading, an intellectual boobytrap. It implies something useless, something not to be taken seriously; and yet everything we know about evolution argues that it is to be taken very seriously indeed.

Play is something new under the sun. It appeared after 4.3 billion virtually play-free years, in times when the planet's surface consisted of a single great ocean surrounding a single land mass or superisland just beginning to split into continents. It appeared some 200 million years ago with the appearance of warm-blooded animals. At least this is one implication of a recent survey by Robert Fagen of the University of Pennsylvania, who points out that the evidence for play among reptiles and lower species is scanty and questionable, but abundant for higher animals, notably mammals: "The evolution of play mirrors the evolution of the brain. Play and a highly developed cerebral cortex go together." In general the most intelligent animals, including primates and dolphins and dogs, tend to be the most playful.

Play must have been extremely important in recent evolution, all the more so because it entails a number of major disadvantages. It uses up energy which might be better devoted to feeding, resting, or less vigorous

socializing, and often results in serious injuries from falls and collisions with rocks and trees. Furthermore, young animals may be so completely absorbed in their games that they become careless and extra-vulnerable to predators. To outweigh the risks, play must offer especially high survival premiums, such as providing training or practice for real-life fighting and escape tactics, and promoting friendships and cooperation among individuals who will be spending many years together.

Another factor, one which Fagen considers in some detail, is innovation. Play is a part of the mammalian bias for exploring, probing, examining. Place a new object in the path of an animal, and the odds are that it will soon be touched, sniffed, mouthed, bashed, bitten, and otherwise mauled. Out of a lifetime or several lifetimes of such encounters, one may turn out to the animal's advantage. A case in point is that of Mike, a wild adult male chimpanzee observed in the forests of East Africa. He discovered, first, that banging two empty kerosene tanks together produced a fantastic and unexpected racket; second, that the racket scared him and every fellow chimpanzee within hearing radius; and third, the payoff, that if he rushed banging and hooting toward other chimpanzees, they would get out of his way in a hurry. Without the cans, Mike had been no one in particular, ranking near the bottom of his troop's dominance hierarchy. With them, he became Number One.

Mike's successful social climb is a model of the human situation. Think of the hundreds of thousands of useless things that are going on somewhere in the world right now. There seems to be no limit to what people will do, providing it is sufficiently offbeat and has never been done before, all the new games and experiments and assorted forms of daredevilry—everything from double-somersault ski jumps, walking tightropes between skyscrapers, and setting records for the most parachute jumps in a 24-hour period (about 235) to wrapping cliffs in cellophane, swallowing new drugs and combinations of drugs, playing Dungeons & Dragons, attempts at levitation, and so on and on and on.

Such activities represent the cutting edge of evolution, human style. They are analogous to the random genetic mutations of organic evolution. The vast majority of mutations are harmful or useless, and so are the vast majority of offbeat activities. But some day as society changes at a mounting rate, one in a few billion may pay off, and it is impossible to predict which one. This sort of behavior, innovation heaped upon innovation with a vengeance, has become a way of life among us. I think something like it, although on a much smaller scale, was just beginning in prehistoric, pre–Upper Paleolithic times.

How did children and grown-ups waste their time in those days? Perhaps they were keeping pets, growing plants off season in warm cave cor-

ners, sliding down ice chutes, making snowmen, playing hide-and-seek, telling tall and can-you-top-this tales about the big game that got away, decorating their faces and bits of flint and bone. Imitators supreme, the best imitators in the animal kingdom, they may well have been improvising bison and horse and reindeer dances, simulating a variety of animal noises and bird songs, and drawing replicas of prey and predators in the sand or on hides, or carving ice sculptures—all glaringly unnecessary activities in a world where everything depended on hunting and gathering. Later when the pressure was on, when the times demanded ceremony for survival, skills developed at play may have been applied intensively and become art and the arts.

An exciting new exhibit has opened at the Capital Children's Museum in Washington, D.C. It is a walk-through, hands-on exhibit dedicated to the evolution of communication, and to the role of science in the unfolding human story. It starts in the Upper Paleolithic. You enter a replica of a cave with paintings on the walls and music such as the Cro-Magnons might have composed, move past areas commemorating the march from African talking drums and writing to worldwide broadcasting networks, and end up in the twentieth century, with a look ahead into the twenty-first: the exploration of space, the last wilderness, satellites and robotics, computers and computer graphics.

The underlying theme is continuity. Tomorrow will be a working out, at increasing intensity and on a larger and larger scale, of forces unleashed yesterday during the Upper Paleolithic. Information is still piling up, and faster than ever. The task of processing and analyzing it is still crucial, still formidable, and so is the task of communication—creating new, more compact symbols, more sophisticated images on television-type screens, more sophisticated chunking methods. Survival still depends on using all our resources, art, and ceremony as well as technology, to build stable societies out of increasing numbers of rugged and unpredictable individuals.

Notes

Each note is preceded by the page and paragraph number to which it refers; thus, 25:4 refers to page 25 and paragraph 4.

CHAPTER 1: **Hidden Images**

page : par.

1:3 Lya Dams of the Belgian Archeological Society estimated the number of art sites and figures (personal communication).

1:4 Sherwood Washburn of the University of California in Berkeley estimated early orangutan-human and baboon-human population ratios (personal communication).

5:6 Randall White of New York University estimated the number of recorded and unrecorded pieces of mobiliary art found in the Périgord region of southern France (personal communication).

11:6 The block with the painted foot on it was found by François Bordes during the late 1950s at the Laugérie Haute site in Les Eyzies. It is about 24,000 years old (personal communication).

CHAPTER 2: **The Discovery of Prehistoric Art**

page : par.

23:3 The artist's comments are from *The Cave of Altamira* by Henri Breuil and Hugo Obermaier. Madrid, 1935.

25:4 Edouard Lartet and Henry Christy comment on the supposedly "simian" and "brutal" aspects of the Cro-Magnons in their *Reliquiae Aquitanicae*. London, 1875.

27:2 Cartailhac's "Mea Culpa" appeared in the journal *L'Anthropologie,* Vol. 13 (1902), p. 348.

27:5 The ignored diary entry is cited in *Lascaux* by Annette Laming. London: Penguin, 1959, p. 16.

31:3 The cave discovered by stonemasons is known as Gabillou, and the cave discovered by dowsing as Cougnac, located south of Les Eyzies.

32:5 The 4-inch red horse which I missed is located in Nerja in southern Spain. The hind was seen for the first, and last, time by Lya Dams in another Spanish cave, La Pileta. Jean Vertut of the French Atomic Energy Commission relocated the figure he had photographed fifteen years earlier in the Trois Frères cave.

33:5 "L'Abbé H. Breuil," by Miles Burkitt, *Nature,* September 23, 1961, p. 1246.

36:5 The British archeologist was the late Dorothy Garrod of Cambridge Univer-

sity. Her evaluation of Rouffignac appeared in *Antiquity*, XXXII (1958), p. 231.

38:3 See Author's Foreword, *Treasures of Prehistoric Art*, by André Leroi-Gourhan. New York: Abrams, 1967.

38:4 Christian Archambeau, personal communication.

38:5 For an account of the alleged British art cave, see the *New York Times*, January 8, 1981, p. A12. For an account of the debunking, see "Pigments of the Imagination," *Punch*, February 18, 1981.

CHAPTER 3: **An Industrial Revolution**

page : par.

42:4 For a perceptive discussion of tool making, see François Bordes's "Physical Evolution and Technological Evolution in Man: A Parallelism," *World Archaeology*, June 1971.

42:5 Details of the four major tool kits are presented in "Upper Paleolithic Cultures in Western Europe," by Denise de Sonneville-Bordes, *Science*, October 18, 1963.

43:2 John Witthoft, personal communication.

46:5 François Bordes, personal communication, and *The Emergence of Man* by John E. Pfeiffer. New York: Harper & Row, Third Ed., 1978, p. 176.

47:3 The site where successively more sophisticated digging yielded increasing proportions of microliths is Gare de Couze in the Les Eyzies region (François Bordes, personal communication).

48:2 Mark Newcomer describes some of his studies in "Experiments in Upper Paleolithic Bone Work," *Colloques Internationaux du Centre National de la Recherche Scientifique*, No. 568 (1976).

49:2 "Notes on Experiments in Flint Knapping: Heat Treatment of Silica Materials," by Don E. Crabtree and B. Robert Butler, *Tebiwa* (Idaho State University Museum), Vol. 7, No. 1 (1964).

50:3 Richard A. Gould, "Spears and Spear-Throwers of the Western Desert Aborigines of Australia," *American Museum Novitates* (American Museum of Natural History, New York), February 18, 1970.

CHAPTER 4: **Hunter-Gatherers on the Move**

page : par.

54:4 The site estimates for the Russian Plain were provided by Olga Soffer-Bobyshev of the University of Wisconsin, Milwaukee (personal communication).

59:3 Population estimates based on discussions with Martin Wobst of the University of Massachusetts, Amherst, and Desmond Collins of the University of London.

59:4 "A Paleo-Indian Bison Kill," by Joe Ben Wheat, *Scientific American*, Vol. 216 (1967), pp. 44–52.

60:1 Mezhirich is the 200-mammoth site, Predmost the 1,000-mammoth site (Soffer, personal communication).

61:4 "Ice Age Subsistence in Northern Spain," by Lawrence Guy Straus, Geoffrey A. Clark, Jesus Altuna, and Jesus A. Ortea, *Scientific American*, June 1980.

63:5 Lewis Binford, personal communication.

63:6 Romuald Schild of the Polish Academy of Sciences writes about exchange networks in "The Final Paleolithic Settlements of the European Plain," *Scientific American*, January 1976.

64:2 Soffer has studied exchange systems in the Ukraine (personal communication).

65:3 Training infants to give things away is described in "Hxaro: A Regional System of Reciprocity for Reducing Risk Among the !Kung San," by Pauline Wiessner, in an unpublished University of Michigan Ph.D. dissertation, 1977.

65:4 The Sungir burials are described in *Illustrated London News,* November 7, 1964, p. 731; and March 7, 1970, p. 24.

68:4 "The Recognition of Leadership in Egalitarian Societies of the Northeast," by Nan A. Rothschild, paper presented at the American Ethnological Society meeting, April 1979, Vancouver, British Columbia.

70:2 "Two Comparative Psychologists Look at Language Acquisition," by Beatrice T. Gardner and R. Allen Gardner," in K. E. Nelson, ed., *Children's Language,* Vol. 2. New York: Halstead Press, 1980.

71:3 Speculations by Robert Dixon, personal communication.

CHAPTER 5: **The First 10 Million Years**

page : par.

74:4 The Edinburgh studies are reported in "Systematic Study of Chimpanzee Drawing," by D. A. Smith, *Journal of Comparative and Physiological Psychology,* Vol. 82, No. 3 (1973), p. 406.

75:1 Congo's artistic efforts are described in *The Biology of Art,* by Desmond Morris. London: Methuen, 1962. For an account of Moja's drawings, see "Comparative Psychology and Language Acquisition," by R. Allen Gardner and Beatrice T. Gardner, *Annals of the New York Academy of Sciences,* Vol. 309 (1978), p. 37.

76:3 Biochemical evidence for a relatively recent origin of the human family was first presented in "Immunological Time Scale for Hominid Evolution," by Vincent M. Sarich and Allan C. Wilson, *Science,* December 1, 1967.

77:6 For the story of *afarensis* footprints and other early hominid discoveries, see my article, "Current Research Casts New Light on Human Origins," *Smithsonian,* June 1980.

83:5 Glynn Isaac, personal communication.

86:2 "The Significance of the Fossil Hominid Skull from Petralona, Greece," by Christopher B. Stringer, F. Clark Howell, and John K. Melentis, *Journal of Archaeological Science,* Vol. 6 (1979), pp. 235–253.

87:2 Jelinek's "unimaginable monotony" remark occurs in his "The Lower Paleolithic: Current Evidence and Interpretations," *Annual Reviews of Anthropology,* Vol. 6 (1977), p. 28.

CHAPTER 6: **Neanderthal Beginnings**

page : par.

90:3 Boule's opinion of the Neanderthals is embodied in *Fossil Men,* by Marcellin Boule and Henri V. Vallois. New York: Dryden Press, 1957. Modern evaluations are presented in "The Neanderthals," by Erik Trinkaus and William W. Howells, *Scientific American,* December 1979; and "Facing the Past," by Boyce Rensberger, *Science 81,* October.

91:4 The statement that a Neanderthal, properly dressed, would attract no attention in a New York subway appears in "Pathology and the Posture of Neanderthal Man," *Quarterly Review of Biology,* December 1957, p. 359.

92:2 "Physical Evolution and Technological Evolution in Man: A Parallelism," by François Bordes, *World Archaeology,* June 1971.

93:6 For a discussion of Neanderthal tool kits, see "Mousterian Cultures in France," by François Bordes, *Science*, September 22, 1961.

94:5 Binford's encounters with Bordes are described in *An Archeological Perspective*, by Lewis R. Binford. New York: Seminar Press, 1972, p. 190.

97:6 François Bordes, personal communication.

98:3 Trinkaus-Howells, *op. cit.*, p. 127

99:4 See "The Flowers Found with Shanidar IV, a Neanderthal Burial in Iraq," by Arlette Leroi-Gourhan, *Science*, November 7, 1975, p. 562; and "Shanidar IV, a Neanderthal Flower Burial in Northern Iraq," by Ralph S. Solecki, *Science*, November 28, 1975, p. 880.

CHAPTER 7: **Special Places, Special Purposes**

page : par.

100:1 Clark Howell, *Early Man*. New York: Time-Life Books, 1971, p. 130.

103:5 See Author's Foreword, *Treasures of Prehistoric Art*, by André Leroi-Gourhan, *op. cit.*

105:4 Jean Clottes, personal communication.

107:5 For a description of the Trois Frères "sorcerer," see Leroi-Gourhan, *op. cit.*, p. 367.

110:2 Jean Clottes, personal communication.

112:2 Paulette Daubisse, personal communication.

113:4 For a description of staging, theater, and art, including Upper Paleolithic art, see *Essays on Performance Theory 1970–1976*, by Richard Schechner. New York: Drama Book Specialists, 1977.

114:4 "El Juyo: A 14,000-Year-Old Sanctuary from Northern Spain," by L. G. Freeman and J. Gonzalez Echegaray, *History of Religion*, August 1981.

CHAPTER 8: **The Information Explosion**

page : par.

119:3 Mircea Eliade, personal communication.

125:4 The "yellow seed" and "grass must stop growing" quotes are from *Going Under*, by Donald Finkel. New York: Atheneum, 1978.

126:2 *The Longest Cave*, by Roger W. Brucker and Richard A. Watson. New York: Knopf, 1976.

128:3 Lya Dams, personal communication.

129:3 The mammoth cave is Santimamine.

131:2 The two midget caves are Le Forêt and Tursac.

CHAPTER 9: **Surprise, Pattern, Illusion**

page : par.

134:2 *La Pileta*, by Lya Dams. Graz, Austria: Akademische Druck und Verlagsanstalt, 1978.

136:2 J. Gonzales Echegaray, personal communication.

140:2 Denis Vialou, personal communication.

142:4 For a recent discussion of anamorphic art, see *Hidden Images*, by Fred Leeman, Joost Elffers, and Mike Schuyt. New York: Abrams, 1976.

143:4 "The Origins of Art," by Desmond Collins and John Onians, *Art History*, March 1978.

143:4 "The Evolution of Paleolithic Art," by André Leroi-Gourhan, *Scientific American*, February 1968.

147:2 The final report is the already cited *Treasures of Prehistoric Art.*

148:2 The cave with the reclining nudes is La Magdelaine.

148:3 *Palaeolithic Art,* by Paolo Graziosi. New York: McGraw-Hill, 1960.

149:3 *Recherches sur les Limons Quaternaires du Bassin de la Seine,* by François Bordes. Paris: Masson, 1953, p. 445.

151:3 Lya Dams, personal communication.

151:4 "Prehistoric Rock Art of the Spanish Levant," by Marcel and Lya Dams, *Illustrated London News,* March 1973, p. 43.

CHAPTER 10: **Living Hunter-Gatherers**

page : par.

153:1 For a survey of aboriginal art styles, see "Art and Aboriginal Prehistory," by Robert Edwards, in *Aboriginal Man and Environment in Australia,* ed. by D. J. Mulvaney and J. Golson. Canberra: Australian National University Press, 1971.

155:2 *Yiwara: Forages of the Australian Desert,* by Richard A. Gould. New York: Scribner's, 1969, p. 41.

155:3 For a listing of water resources, see "The Walmadjeri and Gugadja," by Ronald M. Berndt, p. 179, in *Hunters and Gatherers Today,* ed. by M. G. Bicchieri. New York: Holt, Rinehart and Winston, 1972.

156:4 The fatal wrong decision, Richard Gould, personal communication.

156:5 For an account of water-search patterns, see *Living Archaeology,* by R. A. Gould. New York: Cambridge University Press, 1980, p. 70.

157:2 Keeping on the move, *Living Archaeology,* p. 64.

157:3 Richard Gould, personal communication.

158:3 A creation myth is described in *Aranda Traditions,* by T. G. H. Strehlow. Melbourne: Melbourne University Press, 1947, p. 7.

159:2 The track system is described in Berndt, *op. cit.,* p. 184.

161:1 Gould's meeting with the aboriginal artists is described in *Yiwara,* p. 146; also personal communication.

163:3 Condensed messages in song, Richard Gould, personal communication.

163:4 The 188-song cycle is referred to in *The Australian Aborigine,* by A. P. Elkin. New York: Doubleday, 1964, p. 278.

166:3 The breaking of the family bond is described in Bicchieri, ed., *op. cit.,* p. 260.

167:6 For a description of the circumcision ceremony, see *Yiwara,* pp. 104–116.

170:5 Some 400 remembered water sources, Richard Gould, personal communication.

172:1 Strehlow, *op. cit.,* p. 30; and "Culture, Social Structure, and Environment in Aboriginal Central Australia," in *Aboriginal Man in Australia,* ed. by R. M. and C. H. Berndt. Sydney: Angus and Robertson, 1965.

172:4 For a major study of aboriginal symbol systems, see *Walbiri Iconography,* by Nancy D. Munn. Ithaca, N.Y.: Cornell University Press, 1973.

172:5 "Betwixt and Between: The Liminal Period in Rites of Passage," by Victor W. Turner, in *Symposium on New Approaches to the Study of Religion,* Proceedings of the American Ethnological Society, New York, 1964. See also Turner's "Symbols in African Ritual," *Science,* March 16, 1973, p. 1100.

173:2 The use of riddles and ambiguity in West African ritual, Warren d'Azevedo, University of Nevada, personal communication.

CHAPTER 11: **The Ceremonies of Times Past**

page : par.

175:3 Turner, "Betwixt and Between," p. 15.

175:5 Michel Lorblanchet, personal communication.

177:2 Leroi-Gourhan, *Treasures of Prehistoric Art,* p. 40.

177:4 *Four Hundred Centuries of Cave Art,* by Abbé H. Breuil. Montignac: 1952, p. 176.

179:3 Jean Clottes, personal communication.

181:3 Lyle Davidson, personal communication.

183:2 Breuil, *op. cit.,* p. 171.

184:2 Freeman and Echegaray, *op. cit.,* p. 19.

184:5 Jean Clottes, personal communication.

186:2 *The Greek Concept of Justice,* by Eric A. Havelock. Cambridge: Harvard University Press, p. 50. Also *Structure and History in Greek Mythology and Ritual,* by Walter Burkert. Berkeley: University of California Press, 1979.

186:3 Havelock, *op. cit.,* p. 42.

186:4 For a brief description of the two Troys, real and Homeric, see *Atlas of Ancient Archaeology,* by Jacquetta Hawkes. New York: McGraw-Hill, 1974, p. 134.

187:1 Agamemnon's gift to Achilles: *Iliad,* Richard Lattimore translation, University of Chicago Press, 1951, Book 9, lines 122–132.

187:1 Havelock's comment on the gift, *op. cit.,* p. 93.

187:2 The making of Achilles' shield: *Iliad,* Book 18, lines 368–616.

187:3 Roll call of ships: *Iliad,* Book 2, lines 493–759.

187:4 Havelock, *op. cit.,* p. 119.

188:3 *Ibid.,* p. 31.

189:2 *Plato's Theory of Fine Art,* by Constantine Cavarnos. Athens: Astir, 1973, p. 74.

189:3 The lion simile: *Iliad,* Book 5, line 161.

CHAPTER 12: **Pressure for Planning**

page : par.

191:3 "A Test of Two Theories of Village Splitting," unpublished paper by Robert Carneiro.

192:2 "Boundary Conditions for Paleolithic Social Systems: A Simulation Approach," by H. Martin Wobst, *American Antiquity,* April 1974, p. 147.

192:4 *The !Kung San,* by Richard Borshay Lee. New York: Cambridge University Press, 1979, p. 446.

193:3 *Ibid.,* p. 367.

193:4 *Ibid.,* p. 255.

194:3 "Locational Relationships in Paleolithic Society," by H. Martin Wobst, in *Demographic Evolution of Human Populations,* ed. by R. H. Ward and K. M. Weiss. New York: Academic Press, 1976.

194:4 Wobst, personal communication.

195:4 "The Identification of Prehistoric Hunter-Gatherer Sites: The Case of Altamira," by Margaret W. Conkey, *Current Anthropology,* October 1980, p. 609.

196:3 "The Upper Paleolithic Occupation of the Périgord: A Topographic Approach to Subsistence and Settlement," by Randall Keith White, unpublished doctoral dissertation, University of Toronto, 1980. Also White's "Rethinking the Middle/Upper Paleolithic Transition," *Current Anthropology,* April 1982.

197:4 Arambourou, personal communication. Also *Secrets of the Ice Age*, by Evan Hadingham. New York: Walker, 1979, p. 84.

198:3 *The French Pyrenees: An Economic Prehistory*, by Paul G. Bahn. Cambridge, Engl.: Cambridge University Press. In press.

198:4 "Intersite and Interregional Links During the Upper Palaeolithic: The Pyrenean Evidence," by Paul G. Bahn. Unpublished paper.

200:3 "Settlement Patterns of the Later Magdalenian in the Central Pyrenees," by Ann Sieveking, in *Problems in Economic and Social Archaeology*, ed. by G. Sieveking, et al. London: Duckworth, 1976, p. 587.

201:2 *Paleolithic Cave Art: Ecological Speculations*, by Michael A. Jochim. In press.

202:4 "Interaction and Alliance in Palaeolithic Society," by Clive S. Gamble, *Man*, 1982. Also Gamble's "Resource Exploitation and the Spatial Patterning of Hunter-Gatherers: A Case Study," in *Social Organization and Settlement*, ed. by D. Green, et al., *British Archaeological Reports* 47, Oxford, 1978.

204:3 "Stylistic Behavior and Information Exchange," by H. Martin Wobst, University of Michigan Museum Paper No. 61, 1977.

205:3 The beret-like cap is on a large head engraved in the La Hoz cave in northern Spain (Echegaray, personal communication).

206:3 "Information Sources and the Development of Decision-Making Organizations," by Gregory A. Johnson, in *Social Archeology: Beyond Subsistence and Dating*. New York: Academic Press, 1978, p. 87. See also Johnson's "Organizational Structure and Scalar Stress," in *Theory and Explanation in Archaeology: The Southampton Conference*, ed. by Colin Renfrew, et al. New York: Academic Press, 1982.

207:2 *Aranda Traditions*, by T. G. H. Strehlow. Melbourne: Melbourne University Press, 1947, p. 36.

CHAPTER 13: **The Art of Memory**

page : par.

211:2 "The Pathology of Boredom," by Woodburn Heron, *Scientific American*, January 1957. Also "Hallucinations," by Ronald K. Siegel, *Scientific American*, October 1978.

211:4 "Pathways into Darkness: The Search for the Road to Xibalba," by Barbara MacLeod and Dennis E. Puleston, in *Tercena Mesa Redonda de Palenque*, Austin: University of Texas Press, Vol. IV, ed. by M. G. Robertson and D. C. Jeffers. 1978, p. 71.

211:5 "Talking and Tension," *Science 81*, July–August, p. 7.

212:3 "A Physiological Explanation of Unusual Behavior in Ceremonies Involving Drums," by Andrew Neher, *Human Biology*, May 1962, p. 151. See also "Percussion and Transition," by Rodney Needham, in *Reader in Comparative Religion*, ed. by William A. Lessa and Evon Z. Vogt. 4th edn., New York: Harper & Row, 1979, p. 311.

213:2 Boyce Rensberger, article and book in preparation.

214:1 "Visual Experience in Infants," by Robert L. Fantz, *Science*, October 30, 1964, p. 668.

214:1 Harald Pager, personal communication.

214:3 In his *Embodiments of Mind*, Warren McCulloch indicates that an elephant-sized brain would be required to store a lifetime's experience—Cambridge: M.I.T. Press, 1965, p. 292.

214:4 For an estimate of the memory capacity of the human brain, see *Automated*

Dictionaries, Reading and Writing. Washington, D.C.: National Institute of Education, 1979, p. ii.

215:2 "Information and Memory," by George A. Miller, *Scientific American,* August 1956, p. 44. See also "How Big Is a Chunk?", by Herbert A. Simon, *Science,* February 8, 1974, p. 482.

216:3 "The Mental Image," by Roger N. Shepard, *American Psychologist,* February 1978.

216:5 For studies of our picture-mindedness, see "Concreteness, Imagery and Meaningfulness for 925 Nouns," by A. Paivio, J. C. Yuille, and S. A. Madigan, *Journal of Experimental Psychology Monograph Supplement* 76, No. 1, Part 2 (1968), p. 1. Also *Imagery and Verbal Processes,* by A. Paivio. New York: Holt, Rinehart and Winston, 1971; and "On Exploring Visual Knowledge," by Allan Paivio, in *Visual Learning, Thinking and Communication,* ed. by B. S. Randhaus and W. E. Coffman. New York: Academic Press, 1978.

217:2 "Levels of Processing: A Framework for Memory Research," by Fergus I. M. Craik and Robert S. Lockhart, *Journal of Verbal Learning and Verbal Behavior,* Vol. 11 (1972), p. 671. Also "Human Memory," by Fergus I. M. Craik, *Annual Reviews of Psychology,* Vol. 30 (1979), p. 63.

217:4 " 'Wise Words' of the Western Apache: Metaphor and Transformational Semantic Theory," by Keith H. Basso, in *Meaning in Anthropology,* ed. by Keith Basso. Albuquerque, N.M.: University of New Mexico Press, 1976.

219:3 "Psychological Processes in the Comprehension of Metaphor," by Allan Paivio, *Research Bulletin* No. 434, Department of Psychology, University of Western Ontario, February 1978, p. 14.

220:2 George Miller of Princeton University made me aware of the importance of networks of associations.

220:5 For insights into the fallibility of memory, see *Remembering* by F. C. Bartlett. Cambridge: Cambridge University Press, 1932.

221:2 "Attention Structure and Behavior in G/wi San Children," by Barbara C. L. Hold, *Ethology and Sociobiology,* Vol. 1 (1980), p. 286.

221:4 Richard Gould, personal communication.

221:4 For a discussion of expanding patterns of rehearsal, see *Memory,* by Elizabeth Loftus. New York: Addison-Wesley, 1980.

222:2 *The Art of Memory,* by Frances Yates. Chicago: University of Chicago Press, 1966.

222:4 For Simonides' quote and the Romans' memorizing feats, see *The Art of Memory,* pp. 9 and 16 respectively.

223:5 " 'Cold Reading': How to Convince Strangers That You Know All About Them," by Ray Hyman, *The Zetetic,* Spring–Summer 1977, p. 23. Also "The P. T. Barnum Effect," by C. R. Snyder and R. J. Shenkel, *Psychology Today,* Vol. 8 (1975), p. 52.

225:2 For the story of the Kwakiutl shaman, see *Structural Anthropology,* by Claude Lévi-Strauss. New York: Doubleday, 1967, Chapter IX.

CHAPTER 14: **Searching for Answers**

page : par.

228:2 For a recent mention of the possible role of Upper Paleolithic art in initiations, see "Optimism" by Lionel Tiger, New York: Simon and Schuster, 1979, p. 74.

229:2 Suzanne de Saint-Mathurin, personal communication.

231:2 "Lunar Notation on Upper Paleolithic Remains," by Alexander Marshack, *Science,* November 6, 1964, p. 743. See also his *The Roots of Civilization.* New York: McGraw-Hill, 1972; and *Image of Man: The Beginning of Human Symbol, Art and Thought.* New York: Harcourt Brace Jovanovich, 1982.

231:4 "Numbers in Paleolithic Graphic Art and the Initial Stages of Development of Mathematics," by B. A. Frolov, *Soviet Anthropology and Archeology,* Vol. XVII, Summer 1978.

231:4 "Paleolithic Notation," by Maria Piačquadio Losada, unpublished paper.

231:5 "The Complexity of the Upper Paleolithic Symbolic Traditions," by Alexander Marshack, in *Le Préhistoire Française,* ed. by Henry de Lumley. Paris: Editions du CNRS, Vol. I, 1976.

232:2 Jean Vertut, personal communication.

232:5 "Paleomagnetic Dating of Cave Paintings in Tito Bustillo Cave, Asturias, Spain," by Kenneth M. Creer and John S. Kopper, *Science,* October 25, 1974, p. 384.

234:2 "The Wall Art of the Franco-Cantabrian Deep Caves," by Anne and Michael Eastham, *Art History,* December 1979, p. 365.

234:3 Lya Dams, personal communication.

236:4 Denis Vialou, personal communication.

237:2 Rosemary Powers, personal communication.

238:3 "Peindre les parois des grottes," by Michel Lorblanchet, *Dossiers de l'Archéologie,* September–October 1980, p. 33.

239:3 Michel Lorblanchet, personal communication.

239:4 "Science, Theory, and Australian Prehistoric Art," by John Clegg, *Mankind,* Vol. 12 (1979), pp. 42–50.

240:4 Mark Newcomer, personal communication.

244:3 For more about Louis Leakey's plan to run through several million years of hominid evolution in six weeks, see *The Emergence of Man,* by John E. Pfeiffer. 3rd edn., New York: Harper & Row, 1978, p. 346.

244:4 "Of Mammoths and Men: The Russian Plain Circa 15,000 Years Ago," by M. Gladkih, N. Kornietz, and O. Soffer, *Scientific American.* In press.

245:2 The possible map, Olga Soffer, personal communication.

246:3 For the archeological record in India, see *The Prehistory and Protohistory of India and Pakistan,* by H. D. Sankalia. Poona: Deccan College, 1974, Chapter III; the same author's *Prehistoric Art in India.* New Delhi: Vikas, 1977; *Bhimbetka: Prehistoric Man and His Art in Central India,* by Virendra Nath Misra, Yashodhar Mathpal, and Malti Nagar. Poona: Deccan College, 1977; "Recent Developments in South Asian Prehistory and Protohistory," by Jerome Jacobson, in *Annual Reviews of Anthropology,* Vol. 8, 1979; "Recent Research on the Upper Paleolithic Phase in India," by M. L. Murty, *Journal of Field Archaeology,* Fall 1979; and "The Indian Upper Paleolithic," by Shankar Annaji Sali, unpublished doctor's dissertation, Poona, Deccan College, 1980.

246:4 *The Archaeology of Ancient China,* by Kwang-Chih Chang. 3rd edn., New Haven: Yale University Press, 1977, pp. 61–79.

247:2 Great Basin social changes: David Thomas, American Museum of Natural History, personal communication.

247:3 The estimate of numbers of sites and paintings is based on information in *The Bushmen,"* by Peter Johnson, et al. Cape Town: Struik, 1979, p. 13; and

Ndedema, by Harald Pager. Graz, Austria: Akademische Druck und Verlags-anstalt, 1971.

247:4 *People of the Eland,* by Patricia Vinnicombe. Pietermaritzburg, South Africa: University of Natal Press, 1976; and "Motivation in African Rock Art," by Patricia Vinnicombe, *Antiquity,* June 1972, p. 124.

247:5 *Believing and Seeing: Symbolic Meanings in Southern San Rock Art,* by J. D. Lewis-Williams. London: Academic Press, 1981; and "Eland Hunting Rituals Among Northern and Southern San Groups: Striking Similarities," by J. D. Lewis-Williams and M. Biesele, *Africa,* Vol. 48 [2] (1978), p. 117. For a special stress on the central role of African paintings in community political and ideological information, see Lewis-Williams' "The Economic and Social Context of Southern San Rock Art" in *Current Anthropology* (August 1982).

248:4 Signs of social changes in southern Africa about 12,000 years ago are noted in "Comparability Between Hunter-Gatherer Groups in the Past and Present: Modernization Versus Explanation," by James I. Ebert, *Botswana Notes and Records,* Vol. 10 (1980), p. 23. New evidence for early art in the region is presented in "Dated Rock Engravings from Wonderwerk Cave, South Africa," *Science,* October 2, 1981, p. 64.

248:5 For studies of superimpositions, see Lewis-Williams's "Superpositioning in a Sample of Rock Paintings from the Barkly East District," *South African Archaeological Bulletin,* Vol. 29 (1974), p. 93; "The Rating of Superimposed Rock Paintings," by Harald Pager, *Almogaren,* V–VI (1974–75), Austria; and "A Quantitative Analysis of Superimpositions in the Rock Art of the Coso Range, California," by Klaus F. Wellman, *American Antiquity,* July 1979, p. 546.

250:4 *Animal Play Behavior,* by Robert Fagen. New York: Oxford University Press, 1981. The quotation is on p. 218.

251:2 Mike's story is told in *In the Shadow of Man,* by Jane Van Lawick-Goodall. Boston: Houghton Mifflin, 1971, pp. 112–121.

252:2 The cave in the children's museum was designed and painted by Princeton anthropologist-artist Catherine Slighton.

Bibliography

Auel, Jean M. *The Clan of the Cave Bear.* New York: Crown, 1980.

Baumann, Hans. *The Caves of the Great Hunters.* New York: Pantheon, 1954.

Breuil, Abbé H. *Four Hundred Centuries of Cave Art.* Montignac, 1952.

Brucker, Roger W., and Watson, Richard A. *The Longest Cave.* New York: Knopf, 1976.

Collins, Desmond. *The Human Revolution.* Oxford: Phaidon, 1976.

Conkey, Margaret W. *Art and Design in the Old Stone Age.* San Francisco: Freeman, 1982.

Fagen, Robert. *Animal Play Behavior.* New York: Oxford, 1981.

Golding, William. *The Inheritors.* London: Faber & Faber, 1955.

Gould, Richard. *Yiwara: Foragers of the Australian Desert.* New York: Scribner's, 1969.

————. *Living Archaeology.* New York: Cambridge University Press, 1980.

Graziosi, Paolo. *Palaeolithic Art.* New York: McGraw-Hill, 1960.

Hadingham, Evan. *Secrets of the Ice Age.* New York: Walker, 1979.

Havelock, Eric A. *Preface to Plato,* Cambridge: Harvard University Press, 1963.

————. *The Greek Concept of Justice.* Cambridge: Harvard University Press, 1978.

Laming, Annette. *Lascaux.* London: Penguin, 1959.

Lee, Richard Borshay. *The !Kung San.* New York: Cambridge University Press, 1979.

Leroi-Gourhan, André. *Treasures of Prehistoric Art.* New York: Abrams, 1967.

Lewis-Williams, J. D. *Believing and Seeing.* London: Academic Press, 1981.

Loftus, Elizabeth. *Memory.* New York: Addison-Wesley, 1980.

Pfeiffer, John E. *The Emergence of Society.* New York: McGraw-Hill, 1977.

————. *The Emergence of Man.* 3rd edition, New York: Harper & Row, 1978.

————. "Current Research Casts New Light on Human Origins," *Smithsonian,* June 1980.

Premack, Ann and David. *The Mind of an Ape.* New York: Norton, 1982.

Sieveking, Ann. *The Cave Artists.* London: Thames and Hudson, 1979.

Silberbauer, George B. *Hunter and Habitat in the Central Kalahari Desert.* New York: Cambridge University Press, 1981.

Strehlow, T. G. H. *Aranda Traditions.* Melbourne: Melbourne University Press, 1947.

Ucko, Peter J., and Rosenfeld, Andrée. *Palaeolithic Cave Art.* London: Weidenfeld and Nicolson, 1967.

Van Lawick-Goodall, Jane. *In the Shadow of Man.* Boston: Houghton Mifflin, 1971.

Vercors. *You Shall Know Them.* Boston: Little, Brown, 1953.

Yates, Frances. *The Art of Memory.* Chicago: University of Chicago, 1966.

Index

Page numbers in *italics* refer to illustrations.

aborigines, 65, 153–173, 222
 adaptations of, 155
 art of, 153, *160,* 161–165, 170, 172, 175–
 176, colorplates 17–20
 Cro-Magnons compared to, 174–177, 184
 desert image held by, 158, 170–172
 design elements of, 163
 importance of water to, 155–156, 159, 161–
 162
 initiation ceremonies of, 165–170, 172–173,
 207, 228
 intuition of, 157
 myths of, 158–159, 161, 162, 163, 165, 167,
 168
 permissive child rearing of, 165–166
 rituals of, 162–173, 207, 228
 sense of place of, 157–158
 size of bands of, 192
Abri de Poisson, 17
Afar Triangle, 77, 81
Africa:
 current research in, 247–250, *249*
 human origins in, 84
 initiations in, 173, 248, *249*
afterlife, belief in, 99–100
agriculture, transition to, 121
Alfonso XII, King of Spain, 23
Altamira, 19–26, 38
 authenticity controversy and, 23–26
 bison, 20–21, 22, *34,* colorplate 16
 Breuil's visits to, 33
 discovery of, 19–26
 Great Hall in, 20–22, 23, 33, 103, 176, 195,
 colorplate 16
 innermost gallery of, 22
 map or, 6
 stylistic approach to, 195–196
Angles-sur-Auglin, 5, 103, *141,* 229, 232
animals:
 cave art dominated by, 1–2, *4*
 human population vs., 2, 61
 incomplete or distorted, 138–142, *138,* 139,
 175, 219, 227
 Leroi-Gourhan's patterns for, 147
 suffering of, 151
 see also specific animals
annealing, 49, 71
Apache, metaphors used by, 217–218
apes:
 humans compared to, 26, 70–71, 73–76
 linguistic capacities of, 70–71, 75
 tool making of, 51, 74
 see also chimpanzees
Arambourou, Robert, 197–198
Archambeau, Christian, 17, 38
Arnhem Land, X-ray figures in, 153
art:
 of aborigines, 153, *160,* 161–165, 170, 172,
 175–176, colorplates 17–19
 anamorphic, 142–143, 175
 for art's sake, 17, 127, 140
 of Bushmen, 247–250, *249,* colorplates 21–
 22
 evolutionary role of, 12–18, 103, 121, 226
 Levantine, 149–152, 197, colorplate 23

 of Neanderthals, 100, 120
 overlooked, 19–20, 32–33
 play as source of, 250
 religion associated with, 100
 see also caves, cave art; Upper Paleolithic
 art; *specific sites*
atomic clock technique, 232
Auel, Jean, 69
Aurignacian subperiod, 42, *43,* 46, 95
Australia:
 climate of, 153, 154
 see also aborigines
Australopithecus afarensis, 77–81, *78, 81,* 86
axes, hand, 83–84, *84,* 86, 93

baguettes, 200, *201,* 204, 205
Bahn, Paul, 198–199, 200
bands, 192–196, 205–206, 210, 215, 228
Basso, Keith, 217–218
batons, 180
Bégouën, Robert, 105, 107, 128, 132–133,
 229–231
Bégouën brothers, 105, *106,* 109
Belize, Maya caves in, 211
Berndt, Ronald, 159
"Betwixt and Between" (Turner), 172–173
Bhopal, caves discovered near, 246
Binford, Lewis, 63, 94, 95, 97
bison, 5, 26, 35–36, 38, 130, 147, 179
 Altamira, 20–21, 22, *34,* colorplate 16
 Font-de-Gaume, 113
 hunting of, 59, *60,* 61, 202
 La Pasiega, 136–137
 Lascaux, 31
 Niaux, *14,* 103, 180
 Trois Frères, 107, 177, 234
 Tuc, 111, 132–133, 180, colorplate 12
blood pressure, sensory stimulation and, 211–
 212
boars, 21, 147
Boaz, Noel, 59
body painting, 100, 161–162, *162, 164,* 177,
 colorplate 20
bone:
 El Juyo, 116
 as fuel, 58
 hunting patterns and, 59–62, 96–97, 98–99
 tools, 42, *43,* 46, 47, 49–50
boomerangs, 153, *154*
Bordes, François, 31, 47, 55–58, 86, 91–95, 98,
 149
Boule, Marcellin, 90
bows and arrows, 50–51, 52, 59, 71, 122, 146
brain:
 of chimpanzees, 76, 80, *82*
 of Cro-Magnons, 25, 41, 72
 evolution of, 79–81, *82,* 86
 imaging capacities of, 215–219
 memory and, 210–215, 220
 of Neanderthals, 69, 72, 88, 90, 91, 120
 as novelty-detector, 213–214
 rhythm and, 212
 rule of six for, 214–215
Breuil, Henri, 31–36, 38, 82, 105, 107, 177,
 228
 drawings by, *34, 35, 108*
bulls, Lascaux, 1, 142, colorplates 8–9

burial customs, 11, 65–68, *66–67,* 77, 99–100, 102, 205
burins, 46, 47, 52, 71, 229
Bushmen, 50, 64–65, 192–193, 221
 initiations of, 248, *249*
 rock art of, 247–250, *249,* colorplates 21–22

cameras, in study of cave art, 231, 232
Candamo cave, 133
Cape York Peninsula, rock shelters on, 153
Capital Children's Museum, 252
caribou, Eskimos' reliance on, 97, 197
Carneiro, Robert, 191
Cartailhac, Emile, 26, 27
cave artists, 21, *21,* 40, 72, 227
caves, cave art, 1–5, *2, 3,* 13–39, 53, 102–118, 124–152
 animals as dominant figures in, 1–2, *4*
 authenticity disputes and, 23–27, 35–38
 categories of, 5
 code cracking and, 146–148
 collaboration in creation of, 17, 73, 117–118
 color in, 5, 23, 111–112, 113, 133, 136–137, 176, 179
 contemporary research on, 229–250
 cultural change symbolized by, 72
 dating of, 232–233
 destruction of, 13–17, 22, 103, 138, 177–179, 229
 discovery of, 1, 14, 17, 19–39
 domestic art vs., 11–12, 121
 dualistic patterns in, 117, 148, 184
 equipment used in study of, 231, 232–233
 first-hand experience of, 1, 5, 27, 113–114, 124–138
 geographical distribution of, 1, 148–149, 195–202
 geometric patterns in, 2–5, 134, 137–138, 179, 236
 human figures in, 2, 22, 31, 105, 107, *108,* 113, 116–117, 119, 128, 129, 136, *140, 141,* 148, 151, 177, *178,* 179, 184, 234
 human prints in, 2, 110, 111, 128, 132, 179–180, 184–185, 240–243, *241, 242*
 illusory effects in, 132–134, 136, 142–143, 175, 227
 investigators' problems with, 31–33, 148, 177–179, 180
 Leroi-Gourhan's patterns for, 146–148
 limestone formation of, *2, 3,* 125
 lunar notation in, 231–232
 meanings of, 5, 31, 127, 134, 234–236
 natural preservation of, 13–14, 22
 purposeful strangeness of, 132–143, *138, 139, 140, 141,* 175
 retouching of, 176
 "right-handed," 234
 secrecy and darkness of, 124–127, 131, 174–175, 227
 sensory deprivation in, 211–213
 silence in, 125–126
 social purposes of, 17–18, 39, 73, 119–121, 124, 127, 131, 174–190, 226–228
 style research on, 239–240
 superimposed figures in, 21–22, 176, 232, 233, 248–250
 survival value of, 17–18, 73, 119–121, 127, 131, 185, 228
 team investigation of, 236–237
 technique research on, 240–244, *241, 242*
 temperatures in, 13–14, 125
 theme of current research on, 38–39
 unity of, 38, 73, 103, 190

use of space in, 127–131, 143, 176
 see also specific sites
chatières ("cat holes"), 5, 33, 126, 131, 198, 229
childbirth, 204
children:
 burial of, 67–68, *67*
 heelprints of, 110, 111, 132, 180, 184
chimpanzees, 251
 esthetic spark of, 74–75
 genes in ovum of, 74
 kinship ties of, 74
 linguistic abilities of,,70–71, 75
China, Upper Paleolithic in, 246–247
choppers, 82, 83, 92, 93
Church of Saint Ignazio, 143
churingas (bullroarers), 163–165, 169, 180
circumcision, 167–168, 172
city life, conflict control in, 192
Clan of the Cave Bear, The (Auel), 69
Clark, Geoffrey, 61
claviforms (club-shaped), 2–3, 179, 236
Clegg, John, 239–240
climatic change, 149
 evolution affected by, 76–77, 88
Clottes, Jean, 105, 106, 107, 110, 179–180, 184, 229–231
collectors, damage to cave art by, 16–17
color, early interest in, 83, 86, 100, 176–177
color in cave art, 5, 23, 111–112, 113, 133, 136–137, 176, 179
Combe Grenal, 93–94, 97
Commarque, 136, *137*
communication, 52, 64, 69–72, 195, 228
 information explosion and, 123–131, 205–206, 215, 228
 see also language; memory; rituals
conflict, 191–195, 206, 228
 mathematics of, 191–192
 stylistic behavior and, 204–205
Conkey, Margaret, 195–196
consciousness, altered, 211–213
Coppens, Yves, 77
Cougnac, 103–105, 176
cows, Lascaux, 30
Crabtree, Don, 49
Craik, Fergus, 217
Cro-Magnons, 40–72
 anatomy of, 25, 40–41, 51
 artistic abilities of, 25–26
 emergence and characteristics of, 12–13, 40–42
 heating and lighting facilities of, 55–58
 hunting of, 52, 59–62, 63–64, 68–69, 122, 123, 144
 learning rate of, 123
 long-distance contacts of, 64, 122–123, 193–196, 199, 202, 205–206
 permanent quality in sites of, 55–58, 61
 tool making of, 42–52, *42, 43,* 71
 underrating of, 25–26
Czechoslovakia:
 Cro-Magnon sites in, 58, 60, 64
 skull specimens from, 42

Dams, Lya, 128, 129, 134, 151, 152, 234
Dams, Marcel, 128
dancing, 212
 of aborigines, 162–163, 165, *165,* 168, 169
 cave art and, 177–180
Dante Alighieri, 222
Darwin, Charles, 73, 74, 89–90
Daubisse, Paulette, 112–113
Davidson, Lyle, 181–182

death-rebirth theme, 169, 172
deer, 103, 105, 176
 Altamira, 20, 22
 hunting of, 61, 68
 La Pasiega, 136–137
 Lascaux, 1, 30, colorplates 10–11
Denmark, bows found in, 50
denticulates, 92, 95
dingo cult-lodges, 166
disease, 98–99
Divine Comedy (Dante), 222
Dixon, Robert, 71
Dolni Vestonice, 58
dolphins, Nerja, 129, *130*
Dragon Bone Hill, 85
dreamtime, 158–159, 161, 162, 163, 167, 168, 176
Duruthy, subsistence stress at, 197–198

Eastham, Anne and Michael, 234
Echegaray, J. Gonzales, 114, 115–118, 136, 184
egalitarianism, 64–69
 evidence of departures from, 65–69, 205–209, 226
 tradition of, 64–65, 206, 226
Eliade, Mircea, 119
El Juyo cave, 114–118, 195, 227, 246
England, hand ax found in, 86
epic style, 185–188
Escale cave, traces of fire in, 85
Eskimos, 63, 64, 97, 197
esthetics, 12, 64, 83–84, 140
 of chimpanzees, 74–75
Euclid, 186
evolution, 7, 73–74, 76–87, 192
 art's role in, 12, 18, 103, 121, 226
 of brain, 79–81, *82*, 86
 cultural vs. organic, 40, 73, 100, 103
 distrust of, 26, 89–90
 natural selection in, 96, 99, 100
 play's role in, 250–251
 twilight-state thinking and, 213
exchange, 64, 122, 193, 226

Fagen, Robert, 250–251
felines, 22
 El Juyo, 116–117, 184
fire, 55–58, 96
 earliest traces of, 84–85
fish, 105, *135*, 147
 aborigine drawings of, 153
 ambiguous, *138*
 Nerja, 128, 129, *130*
flint, 146
 annealing of, 49, 71
 chocolate, 64
 tools, 42–44, 46–47, 48–49, 68, 91–93, 100, 122
flutes, 180–182
Fontanet, 229
 Clottes's model procedure at, 179–180
 footprints at, 179, 180, 184
Font de Gaume, 111–113, 128, 236
 reindeer at, *35*
food, 59–63, 77, 82
 storage of, 96–97
 see also hunting, hunting techniques
fords, Upper Paleolithic sites on, 196–197
fossils, bimodal vs. all-ages patterns of, 61
France:
 major cave sites in, 1
 microliths found in, 47
 population density in, 59

portable art finds in, 7, 196
 prejudices of researchers from, 25
 tool kits found in, 42, 95
 see also specific sites
Freeman, Leslie, 114, 115–118, 184
French Atomic Energy Commission, 232, 233
French Ministry of Culture, 179
Freud, Sigmund, 103
Frolov, Boris, 231
Frontenac Island, 68–69

Gamble, Clive, 202–204
Gardner, Allen and Beatrice, 70, 75
Gargas, 240, 243
generation gap, 9–10
Germany:
 Cro-Magnon sites in, 64, 196
 Neanderthal sites in, 90
Gibson Desert aborigines, 157, 161, 163–170
Gladkih, Mihail, 244
Golding, William, 41, 69
Goodall, Jane, 74
Gould, Richard, 155, 156, 157, 159, 161, 163–165, 166, 169, 176, 221
Graziosi, Paolo, 148
Greece, *Homo sapien* finds in, 85–86
Greeks, ancient:
 mnemonics of, 222–223
 myths of, 185–190
Grottes des Enfants, 67–68, *67*

hafting, 48
hallucination, 211, 213
hands:
 aborigine images of, 153, *154*
 Newcomer's studies of, 240–243, *242–243*
Hauser, Otto, 16–17
Havelock, Eric, 186–189
head binding, 100
hinds, 22, 33, 129
Hold, Barbara, 221
Homer, 185, 187–189
hominids, first appearance of, 7–9, 76–79
Homo erectus, 83–85, 86
Homo sapiens, 79, 85–86, 88
 see also Cro-Magnons; Neanderthals
Homo sapiens sapiens, 13, 40–42, 174
horror caves, 5
horses, 128, 130–131, 143, 147, 177
 Altamira, 20, 21, 22
 Angles-sur-Auglin, 5
 Candamo, 133–134
 "Chinese," 30, colorplate 4
 Commarque, 136
 "dachshund," *139*, 140
 distorted, *139*, 140, 142, 175
 hunting of, 60, 61, 97, 98, 202
 La Pasiega, 136–137
 La Pileta, *135*
 Lascaux, 1, 30, colorplates 4–6
 Le Portel, *28*, *139*
 Niaux, 103, 180
 Pech-Merle, 105, 127, 176, colorplate 13
 Tito Bustillo, 142, 175
housing, 55–58, *56–57*, 59, 96
Howell, Clark, 86, 100
Howells, William, 98
hunter-gatherers, 53–72
 anticipation as characteristic of, 63
 dialectical tribes of, 193
 egalitarian principles of, 64–65, 206
 living examples of, 50, 64–65, 153–173, 192–193, 206, 222, 228

hunter-gatherers *(cont.)*
 migration of, 53–55, 58–64
Hunters, The (film), 50
hunting, hunting techniques, 59–62, 68–69, 226
 of aborigines, 166
 chimpanzee habits and, 74
 extended ranges and, 63–64, 122
 magic and, 119–120
 of Neanderthals, 51–52, 96–98, 120
 in Spanish Levant, 152
Hyman, Ray, 223–224

ibexes, 5, 35–36, 62, 128, 129, 147, 179, 234
 Altamira, 22
 Niaux, 103
ice ages, 88, 146, 200–202
 migration patterns in, 58–59
Iliad (Homer), 185, 187
imagination, 85, 97, 134, 205, 215–219
imprinting, 124, 131, 132, 209
India, rock art in, 246
information explosion, 123–131, 205–206, 215, 228
Inheritors, The (Golding), 41, 69
initiation ceremonies, 165–173, *171*, 184–185, 207, 228
 of Bushmen, 248, *249*
International Congress of Anthropology and Prehistoric Archeology (1880), 23–24, 26
internuncials, 80
Isaac, Glynn, 83–84
Isturitz, portable art at, 200
Italy, cave art sites in, 149

Jelinek, Arthur, 87
Jersey, bones found on, 96–97
Jochim, Michael, 58, 201–202
Johanson, Donald, 77
Johnson, Gregory, 206

kangaroos, 165
 cult-lodges, 166, 169
 drawings of, 153
kill sites, 8–9
Kornietz, Nenelj, 244
Kwakiutl Indians, shamans of, 225
Kwang-chih Chang, 246–247

La Ferrassie, 99
La Madeleine, 42, 68
 mammoth-tusk ivory from, 24, *24*
La Magdeleine, naturalistic relief at, *141*
La Mouthe, discovery of engravings at, 26, 27
lamps, stone, Newcomer's tests of, 243–244, *241*
language, 69–72, 75, 122, 185, 189–190, 215
 deliberate distortion of, 167, 173
 metaphor and, 217–219
 singing and, 167, 168, 169, 183–184, 185
La Pasiega, 136–137, 195
La Pileta, 134, *135*
La Riera, 61, 62
Lascaux, 14–16, 27–31, *29*, 38, 103, 112, 133, 151, colorplates 1–11
 "apse" in, 30, 127
 closing of, 15–16, 22
 discovery of, 14, 27–28
 distorted figures in, 142
 ecological problems in, 15–16
 entrance to, 1
 man-made version of, 16
 map of, *6*
 "shaft of the dead man" in, 30–31, *30*, 127
 side chamber in, 30–31, 127

side gallery in, 30
 size of, 28–30
 tourism at, 15–16
 "unicorn," 1, 140, 219, colorplate 7
laurel-leaf blades, 47
leadership, 64–69, 206–209
Leakey, Louis, 77, 244
Leakey, Mary, 77
Leakey, Richard, 81
Lee, Richard, 192–193
Le Fourneau du Diable, *8*
Leroi-Gourhan, André, 38, 103, 144, 146–148, 177, 200, 228, 250
Les Combarelles, 236
Les Eyzies, 1, 26–27, 33–36, 38, 42, 236
 Cro-Magnon rock shelter in, 25
 midget caves in, 131
 population density in, 59
 post-Magdalenian art in, 149, *150*
Levallois technique, 42–43, 44, *45*, 92–93
Levantine art, 149–152, 197, colorplate 23
Lewis-Williams, David, 247–249
Liberia, initiations in, 173
lighting, 55–58, 133, 136
limestone, formation of caves in, *2, 3,* 125
lions, Trois Frères, 229, *230*
Longest Cave, The (Watson), 126
Lorblanchet, Michel, 175–176, 238–239, 244
Losada, Maria Piacquadio, 231
Los Casares, distorted figures at, *140*
Lucy (Australopithecine), 77, 80–81, *81*

Magdalenian subperiod, 42, *43*, 44, 46, 47, 59, 140, 149, 190, 195–196
magnetism test, 233
Malaga, cave discovered near, 229
Maltravieso, 243
mammoths, 113, 143, 147
 hunting of, 60, 202
 mammoth-tusk engraving of, 24, *24*
 Rouffignac, 35, 36, *37*
Marsal, Jacques, 14–15, 28
Marshack, Alexander, 231–232
Mas d'Azil, *138*, 198–199, *199*, 200
Master of the Hunt, 119
mating rules, 193–194, 195
Maya caves, 211
"Mea Culpa d'un Sceptique" (Cartailhac), 27
meanders ("macaroni"), *3*, 110
Melentis, John, 86
memory, 72, 80, 123–131, 210–225, 228
 aborigines' reinforcement of, 159, 161–173
 associations and, 219–220
 chunking and, 215, 219
 as collection of novelties, 214
 deep processing and, 217
 expanding-rehearsal pattern of, 221
 human capacity for, 214
 images in service of, 216–219
 imprinting and, 124, 131, 132, 208
 of place and image, 221–223
 repetition and, 221
 special effects and, 133, 142
 unreliability of, 220–221
metaphors, 217–219
Mezhirich site, 244–246, *245*
micrograph film, 232
microliths, 47–48, 122
Middle Ages, mnemonics in, 222
migration, migration theory, 41, 42, 53–55, 58–64, 84, 226
 food quest as impetus to, 59–63
Miller, George, 215

Milton, John, 186
Monte Circeo, cave near, 102
Montespan cave, 111, *112*
Movius, Hallam, 36
music:
 of aborigines, 163–165, 167, 168, 169
 anamorphic, 183–184
 brain affected by, 212
 cave art and, 180–184
myths:
 of aborigines, 158–159, 161, 162, 163, 165, 167, 168
 of classical times, 185–190
 of Upper Paleolithic, 185, 189–190, 202, 217

National Aeronautics and Space Administration, 233
Neanderthals, 88–101, *89*
 art of, 100, 120
 burial customs of, 11, 99–100, 102, 205
 Cro-Magnons compared to, 40–41, 42–43, 44, 45, 51–52, 53–58, 61, 71, 72, 96, 119, 120, 122, 123, 196–197
 fictional portraits of, 41, 69
 fires of, 58, 96
 as fragmented breed, 122
 hunting of, 51–52, 96–98, 120
 linguistic abilities of, 69–70, 71
 nineteenth-century view of, 88–90
 physical characteristics of, 88, 90–91, 96, 98–99
 status and, 205
 tool making of, 42–43, 44–45, *45*, 46, 47, 51, 91–95, *92*
 in tundras, 54, 96
 vanishing of, 13, 41–42, 53, 69
needles, 46, 47
Neher, Andrew, 212
Nerja, 128–129, *129*, 234–236, *235*
 drapery formation at, 234, *235*
 Rotunda of the Red Fish at, 129, *130*
Nerpio, Levantine sites at, 151
Newcomer, Mark, 48, 49, 181–182, 240–244
New World:
 cave art sites in, 247
 migration to, 53–54
Niaux, 198, colorplate 15
 bison, *14*, 103, 180
 discovery of, 27
 footprints in, 184–185
 map of, 7
 Salon Noir in, 27, 103, *104*, 180

Odyssey (Homer), 185, 187–188
Olduvai Gorge, 9, 55, 83
ornaments, 64, 67–68, 86, 100, 204–205
ownership, 65, 69, 157
oxen, 22, 136–137, 147

Pager, Harald, 214, 247, 250
Pair-non-Pair, discovery of engravings in, 26–27
Paivio, Allan, 219
pebbles, painted, 149, *150*
Pech-Merle, 105, 127, 176, colorplates 13–14
 duplication of, 238–239
percussion instruments, 165, 180, *181*, 212
Perigordian subperiod, 42, *43*, 95
Peter of Ravenna, 222
phallic symbols, 31, 107
plant foods, 62–63
Plassard, Jean and Louis, 36
Plato, 189
play, 250–252

poets, modern vs. preliterate, 188–189
portable art, 7, 12, 53, 72, 144–146, 196, 198–200, 246
 information storage in, 170
 La Madeleine, 24, *24*
 see also Venus figurines
Port au Choix, 68–69
Portugal, cave art in, 38
Powers, Rosemary, 237–238
Premack, David, 70, 74, 75
psychotic insight, 213
Puleston, Dennis, 211

quadrangular shapes, 3, 22

Ramapithecus, 76
Rawlinson Range, 161
rehearsal, expanding vs. uniform patterns of, 221
reindeer, 128, 142
 antler rods, 200, *201*
 Font-de-Gaume, *35*
 hunting of, 97, 98, 202
Rensberger, Boyce, 212–213
rhinoceroses, 31, *37*, 113
rhythm, in control of twilight state, 212
rituals, 11, 47, 55, 119, 174–190, 228
 of aborigines, 162–173, 206, 228
 amputation and, 243
 arts combined in, 163–164, 167–170, 177–184
 burial, 11, 65–68, *66–67*, 77, 99–100, 102, 205
 hunting, 119–120
 modern reenactments of, 132–134, 136, 143
 preservation of art as, 175–176
 women-centered, 170, 204
Robot, 28, *29*
robotics, cave research and, 233
Rochefoucauld family, 15
rock scatter, 55, *56–57*
Romanillo, Moure, 142
Romans, ancient, mnemonics of, 223
Rossignol-Stock, M., 59
Rothschild, Nan, 68–69
Rouffignac, 33–36
 authenticity controversy and, 35–36
 description of, 35
 mammoth, 35, 36, *37*
 serpentine chamber in, 35

Sackett, James, 55
sacred boards, 170
Saint-Mathurin, Suzanne de, 229, 232
salmon fishing, distribution of art affected by, 200–202
Sautuola, Marcelino de, 19–27
Sautuola, Maria de, 19–23, 27
scavenging sites, 8–9
scrapers, 47, 48, 52, 92, 95, 100, 229
sculpture, 5, *8*, 110–111, 132–133, 232, colorplate 12
scutiforms (shield-shaped), 3
sea food, in human diet, 62
seals, stone, use of, 144, *145*
secrecy and darkness:
 of caves, 124–127, 131, 174–175, 227
 in initiations, 172–173
semitough caves, characteristics of, 5
sensory deprivation, 211–213
shamans and sorcerers, 213
 self-deception of, 223–225
 Trois Frères, 107, *108*, 119, 177, *178*
Shanidar, 99, 100

shells, 64, 68, 86, 205, 229
Shepard, Roger, 216
Siberia, 7, 53, 54, 197
Sicily, cave art sites in, 149
Sieveking, Ann, 200
Simonides, 222–223
social organization, 45, 52, 83–84, 191–209
 art's role in, 17–18, 39
 bands in, 192–195, 205–206, 210, 215, 228
 egalitarianism vs. status in, 64–69
 language and, 69–72
Soffer, Olga, 244, 245
Solutré, bones discovered at, 60
Solutrean subperiod, 42, *43,* 46, 47, 49, 50–51,
 58–59, 95
Solvieux, stone patterns at, 55, 96
Soviet Union:
 instruments found in, 180
 Upper Paleolithic sites in, 59, 60, 64, 65–67,
 66, 149, 197, 244–246, *245*
Spain, 128–131
 flint points found in, 50–51
 Levantine art in, 149–152, 197, colorplate 23
 major cave sites in, 1
 unexplored areas in, 38
 see also specific sites
spears, spearthrowers, 50, 52, 59, 67, 122, 146,
 205
 of aborigines, 165, 170, *171*
 Mas d'Azil, 199, *199*
speleologists, 5, 33–35, 36
 damage to cave art by, 16
 electronic, 233
spray guns, prehistoric style, 241, *242, 243*
status, 65–69, 205–209
stone:
 lamps, 243–244, *241*
 seals, 144
 structural use of, 55–58, *56–57,* 96, 115
 tools, 8, 11, 55, 82–84, 121–122
Straus, Lawrence, 61
Strehlow, Theodor, 170–172, 207
Stringer, Christopher, 86
strangers, evolutionary advantages of, 192
stylistic behavior, 204–205
Sungir, graves at, 65–67, *66*
surprise, as element of cave art, 132–143, 227

Taieb, Maurice, 77
Tanzania, 9, 55, 74, 83
tectiforms (roof-shaped), 3, 20, 113
Terra Amata, 55, 86, 100
tesselated patterns, 3
thermoluminescence test, 232–233
Tito Bustillo:
 anamorphic effects in, 142–143, 175
 dating of figures in, 233
 photographing of, 232
tools, 13, 42–52, *43, 44, 45,* 82–84, 91–95
 Bordes's discovery of four kits of, 93–95
 Bordes's stages of, 92
 classification of, 71
 cultural change reflected in, 83–84, 121–122
 in dating of cave art, 232
 functional vs. cultural approach to, 94–95
 human power amplified by, 50–52, 122, 146
 sickle sheen and, 198
 symmetry of, 83
 two-in-one, 47
 see also specific items and materials
tourism, 31, 35, 179, 229
 damage due to, 14, 15–16

tourist caves, 5
Trinkaus, Erik, 91, 98, 99, 101, 204
Trois Frères, 33, 105–109, *106,* 180, 183, 198,
 234
 dating of figures in, 233
 lion chapel in, 229, *230*
 map of, 229–231
 micrograph film used in, 232
 sanctuary in, *106,* 107, 128, 236
 sorcerer in, 107, *108,* 119, 177, *178*
Tuc d'Audoubert, 105, 109–111, 198, 229
 dancing in, 180
 rotunda of, 110–111, 132–133, colorplate 12
 side chamber in, 110, 111, 132, 180, 184
 stalagmite chamber in, 109, *109*
tundras, 149
 human adaptation to, 54–55, 96
Turner, Victor, 172–173, 175
twilight state, 211–213

Upper Paleolithic art:
 classical period of, 146, 149
 complicated developments in, 144, *145*
 in historical perspective, 7–12, 13, 144–146
 Levantine art compared to, 149–152
 location question and, 11, 12, 124–131, 226,
 227
 motive question and, 11–12, 17–18, 39, 102–
 103, 119–121, 124, 127, 131, 144–146,
 227–228
 primitive period of, 143–144, 146
 timing question and, 11, 12, 120–121, 146,
 226–227
 types of, 1–7
 see also caves, cave art; *specific sites*

Valltorta Gorge, 149–151
vandals, 17
Venus figurines, 7, *9,* 35, 143, 206
 distribution of, 202–204, *203*
 experimental, 237–238, *237*
 significance of, 204
Vertut, Jean, 232–233
Vialou, Denis, 140–141, 143, 236
Victorians, evolution as viewed by, 26, 88–90
Vilanova y Piera, Juan, 23–24, 26
Vinci, Leonardo da, 142
Vinnicombe, Patricia, 247
Virchow, Rudolf, 90
vulva signs, 5, 143

Wahl, Luc, 179
Walbiri tribesmen, *162*
Wales, false report of cave art in, 38–39
Watson, Richard, 126
weasels, 180
Wheat, Joe Ben, 59
White, Randall, 196–197
White, Tim, 77, 115
Willendorf Venus, *9*
Witthoft, John, 43
Wobst, Martin, 192, 193–195, 204–205
wooden tools, 48, 49, 50
writing, 157, 170, 172, 185

X-ray drawings, 153

Yanomamo Indians, conflicts of, 191, 206
Yates, Frances, 222
Yugoslavia:
 folk dress in, 204–205
 skull specimens from, 42